Mindful Movement

Mindful Movement
The Evolution of the Somatic Arts and Conscious Action

Martha Eddy

intellect Bristol, UK / Chicago, USA

Published in the UK in 2017 by
Intellect, The Mill, Parnall Road, Fishponds, Bristol, BS16 3JG, UK

Published in the USA in 2017 by
Intellect, The University of Chicago Press, 1427 E. 60th Street,
Chicago, IL 60637, USA

Please contact Martha Eddy for permission to use, for educational
purposes – Figure 1: Author's schematic view of interrelationships
between those people who began certification programs in Somatic
Movement Education and/or Therapy and Figure 17: First and second-
generation founders of Somatic Movement certifications still operative
today.

A catalogue record for this book is available from the
British Library.

Copy-editor: MPS Technologies
Cover designer: Sara Eisenman
Cover image: *Warm-ups I* from "Totem", Alwin Nikolais Dance Company,
1983. Courtesy of Artist: Agnes Mills.
Indexer: Carrie Giunta
Production manager: Amy Rollason
Typesetting: Contentra Technologies

Print ISBN: 978-1-78320-843-2
ePDF ISBN: 978-1-78320-584-4
ePUB ISBN: 978-1-78320-585-1

This is a peer-reviewed publication.

I dedicate this book to my daughter Kaya Lindsay Middleton who since her toddler years has had to leave her mom alone to write way too often, and my husband, her dad, Blake Middleton who with deep love and patience kept encouraging me to put pen to page, slash and burn, and feel inspired through it all.

Contents

Preface

Slush, Mush, Gush
Snow and Rain Mixed Together
Slush, Mush, Gush

(Martha Eddy 1965)

The Beginning

I basically fell into this book. While I have lots of curiosity and determination, it really was mostly providence that led me to my areas of expertise in somatic movement and supported my having the chutzpah to share this information. What would have happened if my life story hadn't fallen in place in the way it did? Serendipity is at core of my story. It led to the people and places that provided the perspective to see the elements of this integrative new field. These divine coincidences supported my ability to identify both the commonalities and the vivid distinctions of the different systems within somatic education.

Early Youth

While I've been writing this book for the past 15 years I actually began the research, however inadvertently, 50 years ago when watching my sister dance at the 92nd St Y, eight blocks from our tenement apartment in Spanish Harlem. The story goes – my sister didn't love the classes but I pined after them. My parents, Reverends Norm and Peg Eddy – community activists and congregational ministers, obliged me and so my personal trajectory of somatic dance began. It started with the ripe and busy atmosphere of the 92Y – being introduced to modern dance by Bonnie Bird (later to become an administrator at the Laban Centre in London), Susan Schickele (involved in the advent of the Laban/Bartenieff Institute of Movement Studies – LIMS – in NYC) and Laura Foreman (choreographer and director of dance at the New School for Social Research), while surrounded by scores and primers of Labanotation in the dressing room. I created my own solo that year to my haiku (see above), performing it alone on the huge stage of the Kaufmann Concert Hall at age eight

(along with 30 other kids, each getting their turns). By age 11, I was performing in the Y's Performance Workshop in works of Fred Burke (Israeli folk dancer) and Rod Rodgers (Afro-American identified modern dancer). After a few years Rod encouraged me to strengthen the arches of my feet by starting more rigorous technique classes; the nearest place to me was the Martha Graham School. After several years of steady training as the only teenager in the adult Graham classes, I began devotedly to also take Limon classes at the Clark Center with Lenore Latimer. I met Titos Sampos and felt the energy of the African Diaspora there, meanwhile beginning to study, teach and perform outdoor site-specific choreography with Laura Foreman and to find other choreography classes with Art Bauman (1975), James Waring (1975) and Daniel Nagrin (1976). I needed these chances to compose dance; keeping creative with the making of dances was my definition of dancing, born of the seeds at the 92Y.

High School Years

While I chose to study science at Stuyvesant High School instead of NYC's Performing Arts High School (now LaGuardia), I was able to dance more intensively in the summers at the Chilmark Community Center where I met Patricia Nanon and Sandy Broyard – women who were friends but easily could have been my mentors. They have nurtured choreography and improvisation on Martha's Vineyard through the Yard and What's Written Within. So what has this to do with somatic arts? Well, everything. Moving expressively and technically, dealing with hammer toes and falling arches, honing creativity and choreography that emerges from the inner voice, interspersed with learning earth science, biology, chemistry and physics, are all part of the fundamental mix within "somatics". And, come summer 1973 in Chilmark a high school friend of mine said as we each went off to college – "If they have Effort/Shape at your school take it; I think you'll really like it!"

College Years

Age 16, I read the fine print of the Spring 1974 course catalogue at Hampshire College and came upon "The Self That Moves." The title was already alluring, and within its description it mentioned that we would explore Effort/Shape – two key elements of Laban Movement Analysis! I signed up; my teachers, Francia McClellan (now Tara Stepenberg) and Didi (Diana) Levy embraced me even as a freshman in an upper division course, and launched me on my somatic career without knowing it. They were both studying to become certified in Laban Movement Analysis (CMAs) and excited about it. Meanwhile Diana was working with Brocca Boettiger (Janet Adler) and guided me on many private Authentic Movement journeys. This was the beginning of a lifelong Authentic Movement practice, in dyads, in groups and even with a video camera. Tara also introduced me to her neighbor – Bonnie

Bainbridge Cohen (founder of Body-Mind Centering® [BMC]), newly moved from NYC to Amherst, Massachusetts, a burgeoning Mecca for this concentration of experimentation with body studies. I studied with Bonnie and also went with her to yoga classes (launching a lifetime practice) and aerial gymnastic classes. We explored these and other movement traditions through the lens of BMC. Our Hampshire College cohort also studied Contact Improvisation (CI) with Steve Paxton and Nancy Stark-Smith and went on to work with Trisha Brown and Movement Research. Participants of "The Self That Moves" trekked down to New York City to an anniversary conference honoring Rudolf Laban, and I met Irmgard Bartenieff and Virginia Reed. The rest is my somatic history. I took a semester back in New York and attended a weekly class with Irmgard in Movement Choir, studied Bartenieff Fundamentals with Diana, took ballet with Collette Barry (who started a school with Susan Klein where they applied Bartenieff Fundamentals to their teaching – Klein Technique) and enrolled in an anatomy course with Irene Dowd. I returned to college where I researched the Cuban and Chinese ballet from a socialist-feminist perspective and earned money teaching in a pre-school where one of the teachers was an avid protégé of Barbara Mettler, a nationally renowned creative dance educator. Also formative was the unique experience of performing for several years with Susan Waltner, Tara Stepenberg and Eleanor Houston and five other students in the 5 College Dance Company touring the works of Daniel Lewis and the faculty throughout Massachusetts and New York.

Post Baclaureate Studies

After college and four summers of studying Body-Mind Centering I realized I wanted to be a better observer of movement as well as to earn some sort of certification (BMC didn't have one yet). I told my pre-schoolers I'd be leaving to study with a very elderly lady. One student said, "Are you going because she is going to die?" The child was prescient; I had two special years studying and assisting Irmgard Bartenieff before she died in 1981. I stayed in New York and began teaching workshops at LIMS on what would become my lifelong work – the merger of Body-Mind Centering with Laban/Movement Analysis (now called Dynamic Embodiment™). I also wanted to ground these studies in the academy. I went to Teachers College, Columbia University to earn a Masters in Applied Physiology and then completed a doctorate there in Movement Science and Education.

Somatic Studies

How does this lead to this book? In the 1970s I was always curious about how Bonnie Bainbridge Cohen was influenced by her year of study with Irmgard Bartenieff and what Bartenieff learned from Laban. I also went to visit Moshe Feldenkrais' classes while he taught at Hampshire College. I met Rolfers and Alexander Teachers in this Mecca and began

exchanges with Jessica Wolf, Alexander Teacher and founder of the Art of Breathing while studying at LIMS in 1979. I saw so many common features among these touch and movement practices and yet I was alert to the keen differences, thickened by strong identity politics. In the 1980s, as I engaged with the sciences at Columbia I taught in the graduate Dance Therapy departments at NYU and Antioch, intermittently at Hope College, and simultaneously for the School for Body-Mind Centering and the Laban Institute (in NYC, and with Peggy Hackney – now the Integrated Movement Studies program – at the University of Washington – where I took class with Joan Skinner, and at University of Utah – where I became friends with Sally Fitt, dance kinesiologist). When I moved to the Bay area I taught physical therapists, physical educators and qualitative movement analysts at the kinesiology department of San Francisco State University. While in the Bay Area I also coordinated the 1994 International Association of Dance Medicine and Science (IADMS) conference working closely with Dr Alan Ryan and Jan Dunn. Within that same year I attended The International Somatics Congress where I got to hear Charlotte Selver and Marion Rosen speaking together, and met Judith Aston, Stanley Keleman, Ilana Rubenfeld and dozens of other somatic leaders. I got to know Don Hanlon Johnson, Eleanor Criswell Hanna and Sy Kleinman while serving as a board member of the new IMTA formed by Jim Spira (James Spira, PhD).

Getting the Word Out

During this time I started to publish about the shared and distinguishing factors of different "body therapies," applying this knowledge in my own private practice; in creating BodyMind Dancing in 1986, and Moving For Life DanceExercise for Cancer Recovery in 1999, and presenting at the National Dance Associations Science and Somatics of Dance conferences in 1991–1992 that spawned the *Journal of Dance and Kinesiology*. In 1989 I met Martha Myers when she went on sabbatical and I was asked to teach her graduate level "Neuromotor Re-patterning" course. Imagine how surprised I was when she joined the class! Through her, and our ongoing IADMS conferences, I met other dance science and "somatics" luminaries. I participated in Thomas Hanna's session at a special plenary in NYC just before his untimely death. I followed the advent of this new field that he called Somatics, naming my own merger of LMA/BF with BMC – the Somatic Movement Therapy Training program (now rebranded as Dynamic Embodiment), teaching it in Massachusetts and then embedding it at Moving On Center, School of Participatory Arts and Somatic Research – a school I co-founded with Carol Swann in Oakland, CA, "to bridge somatics with social change". I lived with my family in CA for five years. I instantly registered my Somatic Movement Therapy Training (named as such to help establish the field) with the International Movement Therapy Association in 1990. I was active on its board for 15 years during which time we changed the name to the International Somatic

Movement Education and Therapy Association – ISMETA – to accommodate somatic educators and to distinguish ourselves from Dance/Movement Therapy. During these years I also co-taught with Certified Movement Analysts Robert Ellis Dunn and Bala Sararsvati (Shelley Sheperd H.) adjudicating choreography and launching many dancers into the use of somatics in improvisation, technique, composition, injury reduction/recovery and the art of knowing oneself. This work continued and also included teaching BodyMind Dancing at Bates and the White Summer Dance Festivals, as well as perceptual-motor dance workshops for the American Dance Festival and at studios around the world.

Thoughts to Page

Circa 2000, Nancy Allison asked me to write on the history of somatic education just as I had finished my dissertation – "The role of physical activity in educational violence prevention programs for youth." Maxine Greene, founder of the Lincoln Center Institute sat on my committee. I accepted the task, leaving the writing of the conflict resolution work aside only because, at the invitation of Jody Arnhold, I was invited to teach a graduate-level course in it at, where else? The 92nd Street Y as part of the Dance Education Laboratory!

While I had a strong experiential knowledge base, there was so much more to research; another dissertation really. I read every book I could get my hands on. I was also keenly aware that the best sources are the people themselves. I had already interviewed Bonnie Bainbridge Cohen and Emilie Conrad for an article in the *Dance Research Journal* and it only made sense to interview every other possible living progenitor of somatic movement. My first round of interviews occurred from 2000 to 2005. I am indebted to Sondra Fraleigh, Anna Halprin, Martha Myers and Elaine Summers as well as Seymour Kleinman and Don Hanlon Johnson for the time they spent with me and the ways each has touched my own life. It was great to meet with Peggy Schwartz to learn more about her brilliant sister Nancy Topf (who I met on a panel I coordinated that was jointly sponsored by LIMS and Movement Research in 1990) and to connect with the students of Judith Aston and Joan Skinner. Meanwhile I had given up on the book and was then focused on writing about somatic approaches to teaching anatomy and dance. It took another set of years, but the earlier historical somatic movement research I pursued through reading and interviews culminated in the article published in the inaugural volume of the *Journal of Dance & Somatic Practices* – "A Brief History of Somatic Practices and Dance" – which became one of the five most popular articles to be downloaded among the journals that Intellect Press publishes. It was a natural next step to develop this material with the assistance of Intellect, where working with Jessica Mitchell and Amy Rollason has been a dream. I thank them for all of their help in giving voice to sharing the advent and new directions of the somatic arts.

Those Who Have Contributed

While I have lived much of this history so have thousands of others. I chose to bring in experts at every level – in the history and the application of somatic education, somatic arts, somatic movement and somatic dance in order to flesh out the global roots and trajectories as well as the systems that I was less familiar with. Throughout this writing process I have turned to practitioners across all movement and somatic disciplines. I hope to learn more through responses to this book, which provides an overview of this emerging field. There are many others. Eleven unique voices are included here. I am indebted to Sangeet Duchane for her knowledge and steadfast assistance, to Kelly Mullan for her fervor in studying the European roots of somatic movement, to Rebecca Nettl-Fiol, Sarah Whatley and Sara Reed for taking time out of their busy busy lives to include their deep knowing and scholarship in this book, and to my colleagues in dance and pre-K-12 education – Mary Ann Brehm, Kate Tarlow Morgan, Lauren Lipman, Ali Spector Cuentos and Eve Selver-Kassell. We work with children – our future. As this missive is complete I am taking a deep breath and excited to get back to applying somatic wisdom with children at the Center for Kinesthetic Education, where we work with children who love to dance and those who don't, children with diverse challenges who are leading us to feel the body-mind-emotion-spirit connection in new ways every day. Thanks also to Megan Reisel (Gyrotonic), JeanMarie Martz (ballet and early modern dance), Caroline Kohles (NIA), Jamie McHugh (LifeArt Process), Marghe Mills-Thysen (Feldenkrais), Jessica Wolf (Alexander Technique), Teri Carter (Continuum), Elisabeth Halfpapp (Lotte Berk and fitness), Kiki Jadus (Topf Technique and Dynamic Embodiment), Julie Ludwick (Skinner Releasing), Amanda Williamson (Somatic Dance and Well-being), the faculty and staff of Princeton University Dance Program, Marianne Goldberg (in memoriam) and her Pathways Project, and ALL of the interviewees for sharing their historical knowledge and expert movement perspectives.

Part 1: Influences and Development of Somatic Education

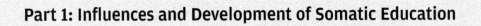

One View:
Founders of Somatic
Movement Trainings
and Their Influences
© Martha Eddy 2004/updated 2016

Figure 1: Author's schematic view of interrelationships between those people who began certification programs in Somatic Movement Education and/or Therapy. Please contact Martha Eddy for permission to reuse for educational purposes. Graphic Design: Eunjoo Byeon.

Chapter 1

Introduction and Overview - The What and Why of Somatic Education

Introduction and Overview – The What and Why of Somatic Education

> A soma is any individual embodiment of a process, which endures and adapts through time, and it remains a soma as long as it lives. The moment that it dies it ceases to be a soma and becomes a body.
>
> (Hanna 1976: 31)

Mindful Movement provides one view of the evolution of a field of study and practice called somatic education. It describes how the somatic arts inform mindfulness and conscious action. It recognizes the scholars, teachers, creative artists, and most notably dancers, martial artists and actors who have been central in the development of somatic movement practices and emphasizes that therapeutic and educational benefits of movement are best achieved by developing nonjudgmental self-awareness, that is, mindfulness. Furthermore, it shares a perspective on mindfulness that emerges from the body itself, the living body – known as soma.

The theses in this book are varied:

1. Somatic awareness enhances any movement practice and reduces injuries.
2. A somatic approach to mindfulness underlies self-empowerment and critical thinking.
3. Engagement in somatic movement can be useful in activism.
4. Mindfulness that includes somatic awareness opens the gateway to various types of "connectedness:" within a person, between people, and with the mysterious or unknown, and does so through neurological pathways often related to aesthetics.

What Is Soma and What Is Somatic Education?

Thomas Hanna, philosopher and early student of the Feldenkrais Method® – an approach to human movement and learning, popularized the terms "somatics" and "somatic education" by bringing attention to the Greek term, *soma* and relating it to the kinds of work that numerous people were doing with bringing awareness to the process of living inside the human body. As can be seen from the quote above, the soma signifies the "living body" as distinct from "body," emphasizing the soma's alive and changing status as a process, rather

than an object. Hanna found meaning in the Greek root of the word *soma* as "the living body in its wholeness." He rephrased it as "the body of life" (Hanna 1980: 5–6) and noted that the living body is able to be aware of itself. The experience of bringing attention to the living body while in stillness and moving came to be known as somatic education. Hanna developed a system of body re-education called Hanna Somatics (Hanna 1979), one branch of the larger field of somatic education.

The Body as Mind

In somatic education, the mind is perceived as existing throughout the body through nervous system connections (Bainbridge Cohen 1993; Juhan 1987). Therefore, by paying attention to the body, one is paying attention to the mind. This notion is further extended by studies in neuroscience indicating that the brain is only one part of the huge neural, neuroendocrine (nervous system and hormonal information exchange), neuro-enteric (gut-brain) and neuro-cellular network that extends throughout the body (Bainbridge Cohen 1993; Juhan 1987). This "mind of the body" has the ability to sense itself, interpret sensations as perceptions and then form thoughts, feelings, associations and imagery from these perceptions. Maxine Sheets-Johnstone, philosopher and dance scholar, contends that the beginning of consciousness emerges with the ability to choose whether to go toward or away from stimuli (2007). This basic action of going toward or away is foundational to all other actions in life (Kestenberg Amighi et al. 1999; Kestenberg 1977; Kestenberg and Sossin 1979; Lamb 1966; Loman and Brandt 1992). It shapes how animate life bonds with or defends against another influence (Bainbridge Cohen 1993).

The perception of one's own body is known as *proprioception* and the perception of one's own movement is *kinesthesia*. Proprioception and kinesthesia are basic senses, as omnipresent as the five exteroceptors: they are the "sixth and seventh senses" and make up the essential somatic awareness toolkit. Proprioception registers muscular tension and bodily position. Kinesthesia also registers information from the inner ear regarding speed of movement and whether one is aligned or falling. They are an untapped resource in the general public, but as neuroscience discovers more, the categorization and detailing of proprioception is expanding. For instance, a new term is *graviception* – experiencing the impact of gravity (Batson and Wilson 2014) on the body and movement. When these "interoreceptors," senses that pay attention to our inner experience, are consciously awakened, they allow for somatic awareness and bring "mindfulness" to movement. Extero-receptors are important in somatic education too – the five senses – vision, hearing, tasting, smelling and touching – connect humans to the outer environment providing information about the body in relationship to the world that people negotiate. With the five exteroceptors we perceive textures, temperature, location, color, shadow, vibration, sound, words, smells and more. Each of these perceptions shape knowledge. Ultimately, information about life is multi-sensory and ideally living includes a balance of both reading bodily sensations and

cues (intero-reception) and being alert to external experience (extero-reception).[1] Somatic education supports this balance – teaching how to pay attention to body sensations and interpreting them with a perspective that aims to enhance a quality of life in which one stays present, mindful, even while moving; consciously acting.

One example of this integration of an exteroceptor and interoceptor is mesopic vision, which happens at dawn and dusk. During these times when light is more diminished, the dynamic shifts of light are perceived not by the receptors of the eyes but by the body. This perception helps guide energy levels through the day. This is a circadian response to the ganglion cells that absorb photons. The sensation by-passes the visual cortex and instead sensitizes the body and kinaesthetic sense directly to light. It is common, especially in urban environments, to have to adapt to a lack of normalized light. With odd sleep patterns and the omnipresence of electrical light humans are missing this mesopic cuing and often drained of the recuperative resources needed to effectively engage in daily demands (King 2015; Lockley and Gooley 2015).

Another example is the importance of keeping alert to the sensations of the inner ear, which registers ranges of sound *and* shifts in movement – stopping and starting, swinging, turning, being off-vertical and changes in speed. Conscious movement helps us learn from these vestibular sensations, learning to not fall, or to fall gracefully, or to regulate speed of action – as is especially needed when a person has hyperactivity or attention issues.

In somatic studies, the body is perceived as *the* source of human intelligence – one learns through the living body. It is exactly because the soma is alive and conscious that it can remember experiences as well as respond with awareness to life events. The body awareness senses of proprioception and kinesthesia form the underpinning of communication networks within the living body, the *soma*. When being mindful about one's actions and behaviors, somatic information from the body is constantly integrated with information from the outer senses. The types of information gleaned are:

What is more comfortable (pain-free)?
More relaxed?
More natural?
More efficient?
More capable of full expression?

People familiar with this type of exploration will report that by paying attention to the personal physical somatic experience, vitality improves (Foster 2007; Franklin 1996a, 1996b; Wolf 2013), pain diminishes (Hanna 1997; Peterson 2011), and new patterns of behavior emerge (Dimon 2011; Fitt 1996). With somatic activity, new patterns of movement are explored, opening up different neural pathways (Bainbridge Cohen 1993; Batson and Wilson 2014; Eddy [2005] 2011; Hartley 1995; Murray 2005). By definition, somatic movement is done with self-awareness and self-reflection. The result is that new behavioral choices often become apparent. When one is locked into habitual patterns, it

is common to feel stuck. Somatic education is one way to unlock such blocks. Sometimes new information about one's health and even about wants and desires are discovered from the body – this is called "body wisdom." The release of tension that can come from somatic movement may be accompanied by an increase in energy or a wave of feelings and ideas supporting creativity.

Somatic education assumes that humans are self-regulating and recognizes that the process of self-regulation is often overridden by thoughts and lifestyle practices. When the body is disregarded and physical discomfort, exhaustion or frustration becomes the norm, the somatic skill of listening to the body and realigning one's lifestyle is useful. However, staying present with the body somatically is not always easy – consciousness means acknowledging stress and pain or even trauma. This is quite different from self-medicating with alcohol, drugs, and other forms of escapism. The supports and stresses of a given culture or milieu are formative of somatic awareness skills and determine whether or not the culture values "somatics." When one lives in a culture where the "felt sense" (Gendlin 1982) is not taught or known to exist, it is easy to see why people don't perceive proprioceptive and kinesthetic awareness as a resource.

Somatic work did not begin in a vacuum, it arose synchronistically in disparate locations around the globe from the turn of the nineteenth century into the twentieth century. Brilliant randomness, beauty, balance and natural intelligence were the stray seeds that became the strong survivors, establishing a steady presence of somatic art and education (Eddy 2009a). Its antecedents go back many more centuries and will be discussed throughout this book.

The field of somatic education emerged out of several streams before being further developed into three branches: somatic bodywork, somatic psychology and somatic movement (Eddy 2003, 2009a). While somatic bodywork and somatic psychology will be referenced throughout, the main focus will be on somatic movement and how movement explorations and systems inform mindful movement and conscious action. The importance of conscious action within the bodywork and psychological branches of somatic education is also referenced.

Book Overview

This first chapter introduces the word "somatic," gives an overview of the entire book and discusses in more detail what somatic education is, defining many of its terms. The evolution of somatic education is introduced in Chapter 2 through telling the story of the founders of the field – the first eight people to develop codified somatic systems that still are actively used today (Eddy 2009a). The choice of the eight pioneers who turned inward to listen to their "alive and intelligent bodies" led to a wide range of experiences: better alignment and posture, improved movement efficiency and performance, decreased pain, increased health and most remarkably the ability to go from inaction to walking, speaking, performing and

helping others (Alexander 1932; Bartenieff 1980; Dewey 1932; Feldenkrais 1977; Hackney 1998; Johnson 1995; Murphy 1992; Todd 1937; Trager and Guadagno 1987). With these revitalized actions also came a sense of agency. After regaining basic health, it was not uncommon for somatic practice to lead to numerous creative developments. In reflecting on the emergence of somatic education, one of the most striking features is how many of its leaders have a background in dance and modern dance, in particular (Eddy 2009a; Mangione 1993). Chapter 3 tells the story of two of the protégés of the first generation, dancers and unique women who also created their own somatic movement systems – Anna Halprin and Elaine Summers. Included in this "second-generation" section is the history of two other women who promoted the use of somatic movement awareness within the art of dance – Margaret H'Doubler and Martha Myers. The cultural climate in northern Europe and the US sets the initial tone for the advent of the somatic arts including explorations within the visual and performing arts. Chapter 4 describes the immediate twentieth-century European influences on the somatic pioneers, sharing how the lifework of the dance and theater artists Francois Delsarte, Genevieve Stebbins, Elsa Gindler, Rudolf Laban and Mary Wigman impacted somatic methods, and their relationships to the somatic arts that became popular in the twentieth century (Eddy 2009a; Mullan 2012, 2014; Ruyter 1999). In order to dig deeper into the antecedents of this fertile time, Kelly Mullan, historian of the "Movement Cure," was invited to describe the influence of earlier centuries including the advent of "Physical Culture" in northern Europe. Since there have been multicultural influences on the evolution of the somatic arts, it was essential to speak of movement practices such as yoga, chi gung and Haitian dance. Therefore, Chapter 5 – written by Sangeet Duchane, an expert in contemplative practices from Asia – investigates diverse Asian and Caribbean movement forms that have impacted somatics. This chapter is included to locate these ancient forms as distinct from the somatic methodologies, to demonstrate respect for the influences they have had on the development of somatics and to share how somatic education has since influenced the way they are being taught worldwide today.

Chapter 6 begins Part 2, which reveals the central role of dance in the evolution of the somatic movement field. Dancers, actors and athletes are trained to feel their bodies, have motivation to take care of their bodies and are inspired to keep moving even with injury, illness or aging. It continues with the second generation of somatic founders, the women who used modes of inquiry from dance education and performance, often derived from other cultures, to heal, express and teach somatically – Joan Skinner, Sondra Fraleigh, Bonnie Bainbridge Cohen, Emilie Conrad and Nancy Topf.

Each contributed to the improvement in health and performance through somatic movement informing the new field of "dance somatics" and impacting all somatic arts. The practice of physical art forms such as dance establishes discipline, provides an environment that fosters greater awareness of the body, anatomy, physiology and movement, and motivates inquiry about the body-mind connection. Speech, theater, martial arts and instrumental music have also been important venues for cultivating somatic awareness. This section discusses how somatic movement and dance have also led to offshoots such

as "somatic fitness." It discusses Judith Aston, who like Emilie Conrad applies her work to a unique approach.

In Chapter 7, the amalgams unfold. The "third generation" of somatic training programs are often a blending of first- and second-generation somatic movement systems, also often informed by dance. How dance is taught in order to increase somatic awareness and empowerment is discussed. Examples of how the universities around the world, including somatic psychology and dance departments, fostered the growth of somatic education is the aim of Chapter 8. It begins with stories from the UK, France and Canada. In Chapter 9, Rebecca Nettl-Fiol shares a vignette from a seminal somatic dance Mecca in the US – The University of Illinois, Urbana – where the Alexander Technique, the work of Joan Skinner and Nancy Topf come together with Laban/Bartenieff studies. Chapter 10 discusses the ways in which somatic education approaches can influence early childhood and youth education. It speaks to diverse subject areas, as well as diverse types of movement education within Montessori schools, Rudolf Steiner's Eurhythmie in Waldorf Schools, and the work of Ruth Doing at City and Country School in New York City. The interplay of the influence of John Dewey, forefather of current-day constructivist education, is made evident.

Part 3, Chapters 11–14, places somatic awareness in the twenty-first-century context of basic neuroscience and neurophysiology. It then shares various forms of applications of somatic education, dance and the somatic arts. This includes a form of social activism that is steeped in somatics, body conscious design, eco-somatics and the emergence of another new field – dance, movement and spiritualities. The Part concludes with concerns about the place and future of somatic inquiry vis-à-vis health, education and artistic expression.

This book tells stories of each of these trajectories, painting one picture of the history that came to shape the new fields of somatic education, somatic movement education and therapy, somatic movement dance education and their wide applications. This book, from its first chapter to its conclusion:

1. Defines the field of somatic education and its terms (Amory 2010), including the emergence of somatic movement education and therapy
2. Describes the stories of the original founders of somatic systems and the ensuing second generation of somatic dance educators who created their own somatic systems
3. Acknowledges western historical understandings of the body and the movement practices developed to foster health (Allison 1999; Knaster 1996; Mullan 2014)
4. Honors the pervasive influence of eastern movement practices, sharing descriptions of practices such as yoga, tai chi, chi kung, Aikido, Katsugen Undo and more to support the history of how these ancient holistic practices have been integrated into various generations of somatic movement education (Tohei 1978)
5. Shares continuing developments of new systems of somatic movement education and therapy that are often blends of what is preexisting and highlights that many of them were influenced by dance (Eddy 2009a)

6. Includes that a professional association has formed – the International Somatic Movement Education and Therapy Association (known as ISMETA) – which provides well-defined scope and standards of practice (www.ISMETA.org)
7. Recognizes the emergence of "somatic dance," also known as "dance somatics" (Brodie and Lobel 2012), and somatic movement dance education (Whatley et al. 2015) and its role in the emergence of somatic fitness
8. Differentiates between somatic movement education and therapy and dance therapy, massage therapy, physical therapy, the eastern movement practices and the conditioning systems of Gyrotonic, Pilates Contrology and NIA[2]
9. Highlights the role of universities in supporting the application of somatic movement to therapy and education (Fortin 1995) with examples from Britain, the US, France and Canada
10. Describes how somatic movement can be included in public and private education for children and young people of 3–19 years of age
11. Teaches about the anatomy of the kinesthetic and proprioceptive sense and how these somatic perceptual systems are essential in learning and recovery from injury, addiction and trauma
12. Explains how mindful movement goes beyond meditation into conscious action through newer subfields such as social somatics, eco-somatics, body conscious design and somatics, dance and spiritualities. It includes their influences on mindfulness while in action, engaged and moving, and postulates other potential directions of somatic movement in a twenty-first-century context.

Select chapters end with a practitioner profile providing personalized insights from one leader into highlights of that chapter. Many of these came from direct interviews with the author, who has been engaged with the field for over 40 years and sought out face-to-face meetings with somatic leaders throughout these decades. These special meetings also inform the contents of Chapters 3, 6, 7 and 10, which are dotted with citations from personal interviews and email exchanges. Direct, verbal and nonverbal, somatic experience with these erudite leaders of somatic wisdom informs this book throughout.

In keeping with a desire for having as rich and direct a source of knowledge as possible, guest authors who are experts in particular historical arenas or in specific application areas have been invited to contribute. Kelly Jean Mullan brings her passion for the root source of European lineages to somatic research and Sangeet Duchane her decades of understanding of eastern practices. Sara Reed and Sarah Whatley were invited to share their hands-on knowledge of how somatic movement dance education developed in the UK and for their excellence in scholarship about somatic dance in general. The same holds for Rebecca Nettl-Fiol who has also published widely and brings to this text her personal experience of being in an American university that was a launchpad for somatic study of the Alexander Technique, Ideokinesis and Skinner Releasing that had worldwide impact. Chapter 10, on the application of somatic strategies in early childhood through non-university adult

education begs for diverse perspectives, given how vast the field of education is. Lauren Lipman, Mary Ann Brehm, Kate Tarlow Morgan, Eve Selver-Kassell and Ali Spector each have been educators in diverse subject areas, working within classrooms of different age groups, and with multiple perspectives on movement, dance, educational values and methodologies. They share areas of personal inquiry vis-à-vis historical and current-day influences on education sourced from at least one person touched by the somatic legacy and with an additional thread that focuses on dance education.

What Makes Somatic Education Distinct? The BodyMind versus Mind-Body

Both body-mind and mind-body explorations aim to improve the quality of life and in this way link to wellness and holistic health. It is essential to understand, however, that somatic awareness is distinctly "body-mind" and differs from the class of holistic activities and professions labeled "mind-body." Mind-body disciplines, such as many forms of meditation, predominantly direct the mind to notice the body, or otherwise influence the body especially to "quiet it." This is in contrast to somatic awareness, during which one gives attention to the body with the goal of finding balance but continuing to spend time focusing on bodily signals even if they are a bit chaotic or stressed. The somatic process uses tools to find meaning from these sensations, contextualizing them within a whole body perspective. Hence, the terms "somatic" and "bodymind" can be considered synonymous, both signifying the *physical* portal to a holistic paradigm of consciousness.

How the Body Leads the Mind – Mindful Movement

People seeking to relax, focus, relieve stress or pain, or gain spiritual insight or practical wisdom often pursue mindfulness and many do so through learning meditation. Somatic awareness is also an entry point into mindfulness. It is the practice of directing nonjudgmental, open attention to one's body and listening to its messages. Somatic practices are generally secular, non-religious experiences. They can lead to the type of enlightenment referred to by Deepak Chopra.

> [Enlightenment is] a state of self-sufficiency that stands on its own ground. To be enlightened, you first have to be. Once you are secure in your own being – meaning that your sense of self isn't swayed or shaken by outside events – you can confront modern life differently.
>
> (Chopra 2015: 1)

The meaning-making component of somatic awareness and the physicality of somatic movement require more action than most forms of mindfulness meditation. Somatic movement has multiple contemplative attributes, that of 1) being deeply recuperative,

2) accessing support to stay mindful throughout the day and 3) teaching how to interpret body signals to better understand emotions and thoughts. Somatic awareness helps people cope with stressors by recognizing which sensations are distractions, and which can support creating a deeper experience of quiet within. In other words, practicing somatic movement helps nurture taking action that is guided from within – a type of mindful movement.

What exactly is mindfulness? Mindfulness is a word that is becoming familiar in households everywhere. *Psychology Today* defines mindfulness as follows:

> Mindfulness is a state of active, open attention on the present. When you're mindful, you observe your thoughts and feelings from a distance, without judging them good or bad. Instead of letting your life pass you by, mindfulness means living in the moment and awakening to experience.
>
> (*Psychology Today* 2015)

Mindful movement requires that one be aware of bodily sensations while moving, but without becoming attached or preoccupied by these messages. There is a time and a place for digging into the why of bodily posture and movement (Brody 2015). When being mindful, one is invited to awaken to all types of internal and external sensations; connecting outward to resources beyond oneself or not, and letting associated thoughts, emotions and sensations flow by.

Mindful movement links through somatic awareness to being intentional about one's behavior. The somatic movement process is highly focused on 1) the process of living and 2) making conscious what are often unconscious movements. While moving with awareness is the key aspect of mindful movement, the somatic field provides varying terms to help bring what is arising from the subconscious into a form that can be shared, creating a link to conscious communication. Somatic education values learning to communicate, access, repeat, practice, embody and eventually internalize the lessons learned. These skills link to becoming better at reading one's own body sensations and body language. This skill then extends to being able to read the movement and body language of others. Hence, somatic education values the language that allows people to speak about these perceptions – perceptions that to many people are only ineffable bodily experiences. A key element of this process is having words to describe the physical experience.

Definitions of Somatic Terms[3]

In order to advance the discussion of somatic education, it is helpful to have terminology, a common language (Eddy 1990). The following are some proposed definitions for the field. They are a work-in-progress based in the author's 40-year experience with various movement languages (Eddy 1990). These four terms are general ones used repeatedly in this book to help describe the phenomenon of somatic education.

Somatic Movement

Somatic movement brings awareness to our visible movements, such as walking, getting up from the floor or a seated position, gestures of the arms or legs or other actions engaged in while on the floor or standing. However, even the smallest of movements – breath, speech, eating, scanning with the eyes or the automatic rhythmic activity of organs – are of interest in somatic education. Any bodily movement can be executed with awareness, in an embodied manner. It is often these smaller movements that are linked to autonomic, unconscious movement that need to be "reeducated" as they are often the first areas to experience and retain stress. Somatic psychologists also spend time learning to notice these subtle movements in their clients (Shafir 2015; Sieff 2015). Somatic bodyworkers are skilled in addressing body tensions both in the large muscles and in these more autonomic and perceptual areas (Dimon 2011; Ford 1993; Foster 2007; Fraleigh 2015; Hanna 1998; Shafarman 1998).

Somatic movement processes involve intentionally engaging in conscious movement. The purpose is to amplify awareness of oneself through awakening the *kinesthetic sense*. The kinesthetic apparati in the body that perceive movement are the *organs of the inner ear*, together with the *proprioceptive receptors* in the joints and tendons. Somatic exploration of physical habits and patterns of behavior require noticing these moving elements of the body whether moving through space or in "stillness." For instance, the breath and blood are always moving through the body, and it is possible to feel these rhythms and pulsations. Somatic movement can be experienced through specific, even didactic exercises or more commonly through open-ended, improvisational explorations; in either case, staying alert and aware of one's physical sensations and related emotional state is central to somatic education. Somatic movement practice also embraces the idea that "movement is behavior" (Fitt 1996) albeit nonverbal behavior.

Much attention in modern-day life is given to how to change behavior, especially overcoming destructive habits, or how to make the body fitter and healthier or the mind happier. Yet, few books explore bodily self-awareness and how proprioception of movement through "first-person" self-perception can expedite positive change through the body-mind connection.

From the perspective of somatics, engaging in movement consciously is a key component in expanding behavioral choices and the overcoming of non-effectual habits. As part of the somatic movement learning process, one explores and pays attention to familiar movement, creates new movement patterns and practices new permutations of the learned movement. These activities change one's behavior – how one appears through postural carriage, how one moves throughout the day, how one touches someone else and in many instances how one thinks. This type of exploration opens doors to choice – the option to select old or new behaviors. In altering habits, one internalizes new cues and new rewards (Duhigg 2014) and with this new sensations and an altered sense of self emerges.

Somatic Awareness

Somatic awareness is about bringing sensations to consciousness and has special features. For example, conscious attention to the breath when exhaling, inhaling or holding the breath results in feedback from muscles, joints and the tactile sense through the nose. Each phase of breath awareness can lead to a specific body-mind connection with slightly different significance in healing or doing or learning (Wolf 2013; Cantieni 2012).

Somatic awareness of movement can provoke emotion, and intense emotion is often replete with somatic cues. Due to this wide range of responses, mindful movement can help to access cortical connections. Somatic awareness can also activate deep brain structures – limbic, basal ganglia, cerebellum, midbrain and even nerves and neurons of vegetative functioning (Bainbridge Cohen 1993, Fraleigh 2015). Movement needs sensory input as a key element of the stimulus-response, sensory motor or perceptual-motor cycle (Bainbridge Cohen 1993; Batson and Wilson 2014). Learning to sense acutely heightens responsiveness (Batson and Wilson 2014). Bodily awareness can also expose frozen tensions, blocked areas, bodily resistances and movement limitations. Awareness is a first step; next, somatic movement leads to practice of consciousness in daily life, which is empowering in its support of action.

Somatic Explorations and Processes

Whether following personal curiosity or guided by a teacher, somatic education leads an individual through *somatic processes* using *somatic tools* of touch, movement (including the movement of the breath), vocalization and language to further awareness. Somatic explorations are active investigations, and are the underpinning of the somatic arts. Curiosity fuels the investigation, which eventually leads to new awareness, balance and self-regulation. Somatic curiosity can be motivated by interest in self-discovery, pleasure, relieving pain, improved physical performance, new forms of social engagement or as a creative endeavor – the foundation of making art. Each of these motivations is resonant with dance; in this way, somatic explorations have been foundational to the art of dancing, and the art of dancing has been formative to the development of somatics.

Somatic Tools and Props

There are as many different types of somatic education as there are people. Examples of additional tools include the props that assist the somatic process – wide, open clean floors or perhaps a bodywork table or chair, mirrors or no mirrors, large physio-balls, mini-trampolines, blindfolds, small balls, the musical instruments or computers that one engages with in daily life (Bruser 1997; Eddy 1995a; Franklin 1996; Hitzmann 2015; Saltonstall

1988). Somatic educational tools have been developed into lessons, approaches, pathways and guided experiences.

During somatic awareness, one's physical sensations may be accompanied by thoughts and emotions; hence, somatic awareness is a psychophysical experience. Somatic movement experiences explicitly teach knowing how to perceive the body, how to stay aware during daily activities and how to make connections to derive meaning and purpose from these sensations. This attunement with self is also referred to as "embodiment" – being fully aware of one's body. This awareness comes from the body – the intelligence of the nervous system – the brain and the complete neural network.

Thinking, Movement and Body-Mind Awareness

Thinking is one type of activation of the brain, generally involving the cortex. Thinking from a somatic perspective is also a metaphor for the use of the entire nervous system – the neurological information exchange from the body's cells along the pathways within the brain and spinal cord as well as the nerves of the body. From this perspective, the entire body is a network for information exchange (Juhan 1987) – a thinking body.[4] Cellular intelligence is yet another layer of consciousness that is employed by some somatic leaders (Bainbridge Cohen 1993; Eddy 1992c, 2000a).

The "alive body" is capable of healing and self-regulation because the soma perceives itself and makes decisions – moving toward and away from stimuli as is best for survival. Choosing to listen to the "alive and intelligent body" leads to a wide range of experiences: better alignment and posture (Alexander 1932; Bernard et al. 2006; Dowd 1981; Matt 1993; MacDonald 1999), improved movement efficiency and performance (Bartenieff 1980; Feldenkrais 1949, 1972, 1977; Foster 2007), creativity (Alexander 2008; Bales and Nettl-Fiol 2008; Bernard et al. 2006; Eddy 2015; Gilmore 2005; Halprin 1995; Nettl-Fiol and Vanier 2011), healing (Halprin 2000; Saltonstall 1988) and a sense of agency (Aposhyan 2004, 2007; Hartley 1995; Shafir 2015).

This somatic embodiment process is also a tool for calming the nervous system in the face of anxiety, fear, anger, stress or trauma – a big part of twenty-first century life (Eddy 2010a, 2010b, 2010c). The opportunity to move somatically with awareness of one's body from within can be contemplative and deeply healing. Somatic practice can be perceived of as "body-mind meditation" because of the internal and self-reflective inquiry involved. At other times, it is profoundly active – leading to large movement in space or huge shifts in movement qualities and related moods.

Somatic activity is by definition self-regulating, providing the natural balancing process that can assist in relaxation and healing. The healing process is particularly creative and can call for either profound rest or expanded physical, vocal and emotional expression. At present, there are virtually no research studies about the impact of somatic education but

there are a myriad of life histories that attest to the potency of somatic awareness (Allison 1999; Dragon 2008; Johnson 1997, 2005, 2008; Knaster 1996; Mangione 1993; Moore 2014; Murphy 1992). While research is negligible on the impact of somatic explorations on health, somatic methodologies and applications are growing exponentially and have become the content of news (Drexel 2006), the focus of research (Batson and Wilson 2014) and the source of new research methods (Batson and Wilson 2014; Dyer 2009a, 2009b; Dyer and Löytönen 2012). These, together with history and current-day anecdotes, form the backbone of the systematic application of somatic awareness – somatic education.

An Educational Process: The Teacher-Student Relationship

Access to somatic experience is natural and free for each person to discover on her or his own; however, approximately one hundred years ago eight remarkable people created systems of somatic education and have helped thousands of people to experience their bodies with great awareness. These somatic founders have also spawned dozens of other systems through following generations. While any person can freely engage in bodily self-discovery as the original founders did, there are many people who are not inclined to pay attention to the body or have no clue how to do so. This may be because they do not have strong activation of proprioception or kinesthesia, the mechanisms that allow for self-perception, or because they repressed these sensations due to pain or strong discomfort. Or a person or culture may have been taught to ignore body signals.

What one discovers is completely dependent on "tuning in" or "attuning" with oneself. This becomes easier to do after practicing quietly, "listening" to the still body or practicing slow and simple movements. Over time one can stay "attuned" even while engaging in more complex movement than somatic movement explorations. When learning somatic awareness, it can become important to have an outside perspective to confirm one's inner sensations and solidify body wisdom. Having a somatic guide, a "bodymind coach," is helpful in this process. Somatic educators, somatic movement educators, somatic movement therapists and somatic therapists are these coaches. The best coach is someone that a person trusts and builds a comfortable relationship with because ultimately somatic awareness is subjective.

What does it mean to "make meaning" from somatic sensations? It is to learn what sensations "have to say." When regarding habitual movement patterns, the meaning is often derived by asking questions: Does this area feel pain? How long has this been going on for? What other lifestyle changes were going on during this time? Are there interpersonal associations to the habituated posture? Is there an emotion tied to the posture or the sensation? Does it evoke any associations or memories?

These discoveries will be different for each individual person exploring her or his somatic experience and are dependent on which style of somatic system she or he chooses to engage

with. Some practitioners will not speak much at all. Some will ask only physical questions. Others will investigate lifestyle. Others may be trained in dance/movement therapy or somatic psychology and be willing to guide investigation into more psychological realms.

The trust between mover and somatic movement specialist is at the heart of somatic education. Any excellent lesson includes honest sharing of what "might be" true about the mystery and complexity of the body. Outside corroboration from a teacher, a colleague, a friend or ideally a professional skilled in "somatics" helps in learning to slow down, knowing what to pay attention to, receiving touch to bring more awareness to an area and amplifying the learning process. Ultimately, the decision about what is true comes from the mover. This is the case in the practice of Authentic Movement whereby the therapist is a witness for the mover and the mover speaks first of her or his experience. Authentic Movement is a somatic practice that is used both in somatic movement trainings and in somatic psychology that derived from the Jungian concept of expressing the unconscious and was developed by Mary Whitehouse (Levy 1992).

Somatic movement education is a discovery process; the teacher works together with the student to confirm what is understood or to unravel what is confusing. Somatic experts facilitate somatic learning by using the educational tools of intentional imagery, skilled touch, guided movement activities and honest discussion. Somatic education is most often a relational process – a dyadic interaction between a teacher and a student, a therapist and a client. A teacher might support efficient or new movement action using skillful touch – also known as movement re-patterning. The expert also provides feedback during different stages of this learning cycle inviting the exchange of words. For instance, they may reflect together on the quality or efficiency of current movement experience, or may introduce new elements of movement style to experiment with. The expert also may devise homework for practice. Hence, somatic education provides both opportunities to more clearly experience the psychophysical nature of human movement as behavior, and the language to speak about it. In this way, somatic education builds "proprioceptive awareness," "kinesthesia" as well as "socio-emotional intelligence" as defined by neuroscientist Daniel Goleman (1995, 2009; Lantieri 2008, 2014).

Conclusion

When the body is experienced from within, a myriad of physical and mental conundrums can be revealed. In some cases, these mysteries are solved, and in most cases, learning transpires. Somatic students have experienced relief from pain and stress (Hanna 1977) as well as improved movement performance as actors (Jones 1987), dancers (Bartenieff 1977, 1980; Bersin 1995), educators (Dimon 2003; Gay 2009), executives (Koch and Bender 2007; Moore 2014), laborers (Hodgson 2001), martial artists (Gay 2009; Tohei 1978), musicians (Bruser 1997) and writers (Morgan 1991a, 1991b, 2008). Each somatic system provides a unique map of an individual's ability to gain awareness of the body-mind relationship.

What is fascinating is that somatic education has also led to supporting recovery in people who have been injured, traumatized or have become addicted; questioning social structures that impact psycho-physical health, including emotional balancing and the rethinking of organizational systems and performance processes. The significance of this is that the opportunity to move somatically, with awareness, can be either contemplative or serve as a form of activism.

Marion Rosen

Marion Rosen (1915–2012) is a case in point. She was influenced by the German physical culture movement, studied physical therapy and with Gindler loved to dance and make connections between the mind and the psyche. As a physical therapist, she "treated" her clients but also embraced the somatic principle of helping people to access their own body wisdom. She used touch and movement to facilitate freedom of expression and physical ease.

Both Rosen's life and work echo that of the pioneers of somatic education. As examples, Rosen began her life experiencing all that was changing in Europe – processes like breathwork, core exercise and massage in Germany – and exposure to great thinkers like Carl Jung. She also moved to another country – to America, influenced by the post-World War II diaspora. In addition, she combined her natural gifts with in-depth studies. She was recognized as having a healing touch and being an inspiring mover. She was creative, and intelligent, and she studied sciences as a medical professional becoming a physical therapist. As a licensed physical therapist, Rosen, like Bartenieff, was expected to "treat" people; however, her choice was to empower clients – acknowledging the healing power of each person's soma. Both Rosen and Bartenieff developed methods for somatic movement, somatic psychology and somatic bodywork. The Rosen Method beckons both somatic movement specialists and those interested in somatic psychology because of her choice to focus on eliciting emotions during bodywork sessions. Rosen's Bodywork and Movement methods combine movement, touch and emotional healing, perhaps a model for the future. In an interview with Roberts, Rosen shares:

> When I was 22 years old I was in Germany attending classes with a woman who was doing massage breathing in connection with a Jungian psychiatrist who was treating people. They found that when people had bodywork accompanying their treatment it was easier for them to access feelings and their treatments were shorter. Thirty years later, a young woman in America asked me about that work and if I could teach it to her. During my teaching, very exciting things began to happen with the people we treated. This is really how the whole method developed. We watched what happened to people when we treated them. We got quite a lot of information about what is happening when you treat people, when you let them be relaxed in a way that you

don't intrude: it allows them to get in touch with their feelings. Often we accessed their unconscious where they get in touch with experiences, thoughts and feelings they had totally forgotten about. All of a sudden these experiences were available to them again. With that great changes would take place in people.

(Roberts 1998: 1–2)

Like all somatic systems, the Rosen method is not meant to "fix" people or change people. "It is about experiencing our own truth. Rosen Method allows each of us the privilege of remembering and being who we are. Along with this comes the opportunity to make conscious choices" (http://www.mcn.org/b/rosen/mmarticle.html).

Notes

1 Multi-sensory engagement exists along a continuum that includes synesthetic sensing. Synesthesia, which means joined perception, is the integration of sensory information that neurologically crosses over from one sensory perception into varying other perceptions. For instance: hearing color, seeing sound, smelling taste.
2 The original term is Neuromuscular Integrative Aerobics, or Non-Impact Aerobics, though this is now rarely used.
3 Matt Amory recorded an interview conducted with Eddy in 2009 to shape a thesaurus of somatic terms. Amory has since completed a thesaurus of somatic terms (Amory 2010), which has influenced the indexing of this book.
4 This is the name of the book written by Mabel Todd in 1937.

Chapter 2

The First Generation - Founders of Somatic Education Technique

The First Generation – Founders of Somatic Education Technique

I am sure that I learned more through our common experience than Nora [his client] did. After nearly forty years of experience, I can observe a patient's movement and gather so much information that my students are often speechless, or ask who told me that, when I reveal something. People prefer to believe in miracles, such as guidance by the spirit of a dead doctor or some other far-fetched explanation, rather than to verbalize their inner sensations.

(Feldenkrais 1977: 38)

The more we learn of how the organism works, the more we begin to appreciate its vast complexities, the more obvious it becomes that we can not hope to achieve much by means of direct cortical intervention. (This is why admonitions are always hopeless.) The control that can be consciously exercised is a control of choice, a decision to act or not to act in a certain manner, in a certain direction, and at a certain time.

(Walter Carrington, Alexander Teacher in Gelb [1981] 1994: 46)

There are eight people who can be called the founders of somatic education (Eddy 2009a). Several of them suffered illness or accidents that left them unable to move or speak normally. They used their personal experiences and their ensuing somatic insights to develop systems that have become the foundation of somatic education. This chapter describes their life work in brief. These founders are: F. M. Alexander (1869–1955), creator of the Alexander Technique (AT); Irmgard Bartenieff (1900–1982), of Bartenieff Fundamentals of Movement (BF); Gerda Alexander (1904–1994), of the Gerda Alexander Eutony (sometimes Eutonie) (GAE); Moshe Feldenkrais (1904–1984), of the Feldenkrais Method (Awareness Through Movement and Functional Integration); Mabel Ellsworth Todd (1880–1956), of Ideokinesis; Charlotte Selver (1901–2003), creator, with her husband Charles Brooks, of Sensory Awareness; Ida Rolf (1896–1979), of Structural Integration, Rolfing and Rolf Movement; and Milton Trager (1909–1997), of the Trager Method. The founders have each created a synthesis of movement and life principles, with guided activities and each form a big part of the magic of somatic practices. The following is a snapshot of each.

The Alexander Technique

Frederick Matthias Alexander (1869–1955) was born in Tasmania, Australia. A son of farmers, "F. M." Alexander spent much time in the wilds of nature, even though he was sickly and weak throughout his childhood. As he grew older, he often stayed with his aunt and uncle in the city of Melbourne and exposure to the arts there gave him a positive direction. Alexander was drawn into the art of elocution and the theater. Unfortunately, as professional opportunities opened up for him, his voice would often fail while he was at work, and doctors could find no cause. Medical advice to rest his voice only offered temporary relief. He began to question deeply the cause of his vocal problems and wondered if they might have something to do with how he was using his vocal apparatus and his body. He spent many a long hour in front of a mirror exploring how different postures and movements affected his voice. Through these intensive personal explorations he found a method for "changing and controlling reaction," which he then taught in Melbourne and Sydney. He also returned to performing. Alexander continued to perform and teach in Australia and New Zealand. He then moved to London, and taught periodically in the US. By then, his work had become internationally known within the general public through his students; musicians, actors and educators including the educational philosopher John Dewey, who wrote the introduction to Alexander's book *The Use of the Self* (1932).

The Alexander Technique is an approach to education that emphasizes changing postural habits through self-care. It is essentially a preventative technique to improve and maintain health, and a method of education to help reduce discomfort and move with clarity and ease. It is an elegant system of self-awareness that represents the pure power of somatic awareness in bodily use and clarity of thinking. It has a strong focus on learning to inhibit deleterious habits regarding the positioning of the head on the spine. Typical outcomes are feelings of lightness and ease.

Bartenieff Fundamentals of Movement (and Laban Movement Analysis)

Irmgard Bartenieff (1900–1981) was born in Berlin, Germany. She studied dance and movement analysis with Rudolf Laban and performed dance with her husband Michail, a Russian Jew. They experienced an abrupt dislocation from home in 1936 when they caught one of the last boats out of Nazi Germany and traveled to New York. As Germans, they did not feel welcome in the dance community, which was then dominated by Martha Graham. Agnes de Mille was adamant about keeping the Graham lineage separate from Laban influences, even though Graham and Laban probably met in England at Dartington Hall. Being unwelcome in the dance community by necessity opened another door for Bartenieff. Both husband and wife studied to become physical therapists. In time Irmgard Bartenieff found her way back into the world of dance in New York by teaching the Effort/Shape concepts of Laban Movement Analysis (LMA) at the Dance Notation Bureau, a center for Labanotation. She returned to England to study with Laban, and be trained in

Bindegewebsmassage (known in the US as Connective Tissue Therapy). Like her somatic peers, Bartenieff remained inquisitive throughout her life and continued to study diverse movement forms. She discovered a chi kung teacher while in her seventies and found in this Chinese discipline a key to her own graceful aging; it aligned with her Laban-based philosophy of integrating the functional and the expressive in movement. Given this philosophical predilection, it is no wonder that she also was one of the five main pioneers of the field of dance therapy, a type of movement psychotherapy (Levy 1992), as well as a founder of a somatic movement system – Bartenieff Fundamentals.

Bartenieff helped to shape the field of dance therapy as well as dance anthropology. She established an institute to train in LMA in 1978, which is now called the Laban/Bartenieff Institute of Movement Studies (LIMS). Her book *Body Movement: Coping with the Environment* was published in 1980. Bartenieff's impact on somatic education has been the creation of a research institute – LIMS – and a master's level certification program in LMA at the Institute that includes a study of Bartenieff Fundamentals. Bartenieff Fundamentals has been the strongest influence of the first generation in the dance community – Bartenieff exercises now form the baseline for warming up in most contemporary dance classes. Bartenieff's powerful system of hands-on movement re-patterning, well known in the dance and fitness community, is only gradually becoming known as an approach to somatic education and therapy per se. This is in part because she was more focused on teaching her LMA curriculum to already established professionals.

The Bartenieff Fundamentals of Movement teach movement efficiency by experiencing body connections through deep and superficial kinetic chains, breath and core support, gradual rotation of the global joints when moving the limbs, efficient weight shift, clear spatial intention, developmental movement awareness and the active use of effort and shape elements from LMA. This system helps students to be aware of how they initiate movement, what their spatial intention is or could better be and the nature of appropriate preparation and follow-through for any movement. These Bartenieff Fundamentals concepts each link directly to Laban's interactive themes of stability/mobility, exertion/recuperation, internal/external and function/expression (Eddy 2016).

Eutony (GAE)

Born in Germany, Gerda Alexander (1904–1994) also founded Eutony (Eutonie or Eutonia), now referred to as Gerda Alexander Eutony (GAE). Eutony means "harmonious tonus," or good muscular tension. On a physical level, GAE strives to bring balance to the muscular tone of the body, but it goes much further.

Gerda Alexander says:

Tonus changes occur not only with different kinds of effort, but with every emotional change as well, ranging from deep depression with a low tonus, to happiness with a high

tonus. This function is called psycho-tonus. Flexibility in tonus change is also the basis for all artistic creation and experience. What you do not experience in your whole body will remain merely intellectual information without life or spiritual reality.

(Bersin 1995: 260)

Alexander began life dancing in her home and persistently begged her parents to allow her to study dance. Eventually she was able to study Dalcroze's Eurhythmics with Otto Blensdorf from 1915 to 1929 (Johnson 1995: 256). She became an assistant to Jana Blensdorf and continued to integrate dance awareness into her work. However, as Johnson (1995: ix) reports, Alexander contracted rheumatic fever. In an interview in his book she tells how she moved to Seeland, Denmark (thinking she would be going to New Zealand) because she had to stop dancing. She had hoped to move to the warm climate of New Zealand to work under the programs of Rabindranath Tagore (Bersin 1995: 258) who later came to Dartington Hall, where Laban was based. As it turned out she spent most of her professional career in Scandinavia and found her way back to health using her own system. Alexander's protégés take a Eurocentric stance about the development of her work, saying, "[t]he method developed completely from the western culture area" (Association Suisse 2003). Her work does reveal a strong European lineage, including studies with two singers who had lost their voices, the Rothenberg School (Bersin 1995: 262) and with Jacques Dalcroze. In her own words,

Were I to try to describe the ideas which guided me, I would draw attention to the relationship between Eutony and the creativity which developed in Europe and the United States of America after the First World War toward a new pedagogy and whose representatives joined together in the New Education Fellowship.

(Johnson 1995: 278)

Alexander was a dance and music teacher who incorporated deep internal awareness and sensitivity to the outer environment. It is interesting to note that GAE was the first somatic discipline to be accepted by the World Health Organization (in 1987) as a type of alternative health care, referred to as Complementary and Alternative Medicine – CAM (Chrisman and Frey 2005: 1). GAE teaches deep bodily awareness of diverse tissues of the body – most notably the bones, skin and muscles, and fluidity of each. Different emotions and attitudes are seen to arise from these investigations. The goal of GAE is not just bodily control – the process is an inroad into holistic experience – integration of body-mind-psyche-spirit. GAE seeks to increase sensitivity to self in relationship to the external environment. As one gains more access to proprioceptive awareness, one's muscles are able to find a proper, harmonious balance.

GAE was the first somatic system in Europe to touch upon changes in the autonomic nervous system[1] – Alexander worked not simply with the movement of the bones but the healing of the bones, areas usually not thought to be susceptible to subtle movement or

mental influence. Her work has influenced somatic investigators around the world through written documents and a diaspora of teachers. It is still most well known in northern Europe but has a growing following in the Americas.

The Feldenkrais Method

Moshe Feldenkrais, PhD (1904–1984) who was born in the same year as Gerda Alexander in Russia, traveled through and lived in different countries and on different continents. He immigrated to Palestine at the age of 13, traveling by caravan from Russia with his family. He studied engineering and earned his doctorate in physics at the Sorbonne in Paris. It was in Paris that he excelled in the martial art of jujitsu, and in 1936 became one of the first westerners to earn a black belt in judo, studying the method of Professor Kano, the originator of judo.

He was pushed to reaching new levels of awareness during World War II. After having injured his knee playing soccer, he re-injured it while working with anti-submarine research in England during the war. His knee could not be healed, even with the help of surgery and he was told it was unlikely that he'd be able to walk. He was motivated by his movement experience in soccer and the Asian martial arts to overcome this disability. He explored his own bodily movement to find out what the limiting conditions were. This inward road of exploring his body grew, in part, out of his interest in auto-suggestion, self-image and the workings of the unconscious mind. During the process of self-exploration he developed the Feldenkrais Method, incorporating principles from his various fields of expertise – physics, neurology, martial arts, cybernetics, body mechanics, and psychology and human development. His work blends both science and aesthetics (Reese n.d.). He developed his method by working with all kinds of people with a wide range of learning needs, from infants with cerebral palsy to leading theatrical and musical performers.

The Feldenkrais Method, identified as a form of somatic education by the Feldenkrais Guild of North America (2002), has two ways of working with people: group classes called Awareness through Movement (ATM) and private individual sessions called Functional Integration (FI). ATMs are movement lessons that work slowly and systematically to open new patterns of movement in the body using differentiation of movement and conscious repetition for continual re-investigation. FI involves working one-to-one with a practitioner, often on a low bodywork table with the practitioner seated on a stool. The practitioner guides movement explorations and uses hands-on support in doing so. Both FI and ATM emphasize bringing awareness to the differentiation between body parts and the integration of the bodies' many movement possibilities into one's experience of living creatively (Feldenkrais 1972). Students are taught to pay attention to subtle feedback that comes from moving through carefully crafted movement sequences, systematically practicing this ability to attend and respond either in class or in one-to-one sessions. Awareness exercises are often explored lying down and then practiced in a seated or standing position to help with transfer of knowledge.

The Feldenkrais Method and its extensive global community is one of the most organized and successful of the somatic systems. It is a recognized name that has a strong identification with somatic education, is occasionally seen as a type of alternative health application, and is known for its collaborations with professors within university motor-learning departments, which has strengthened its academic presence. Feldenkrais work is now being taught in colleges, community centers, fitness clubs and dance studios.

Ideokinesis

Mabel Todd (1880–1956) was born in Syracuse, New York and suffered kidney damage from a childhood illness. Like F. M. Alexander she was interested in improving vocalization and she had to contend with other bodily limitations. She had a paralyzing accident and was told she would not walk again. Unwilling to give up, Todd used thinking processes to heal herself, learning to walk again by developing imagery about the anatomically balanced use of the body. Her imagery resulted in a walk that was an improvement over her pre-accident gait (Matt 1993).

Todd studied voice at Emerson College in Boston, a school with a history of teaching the exercises of physical culture. Her studies began in 1906. She speculated that vocal problems were often due to bad posture and that a psychophysical or psychophysiological approach might be of help. With this hypothesis Todd began to study the mechanics of the skeletal structure, and she applied her discoveries in her studios of Natural Posture in New York and Boston. She later joined the faculty of the Department of Physical Education at Teachers College, Columbia University, where she taught anatomy, posture and neuromuscular awareness to physical education and dance professionals. At Teachers College, her work was further developed by her protégé, Lulu Sweigard, author of *Human Movement Potential*.

> She ultimately determined that the goal was finding balance, as opposed to "imposing upon our bodies a fixed position of any part which we feel to be the 'right,' 'correct' or 'ideal' one." In order to accomplish this goal, Todd believed that concentrating on a picture would result in "responses in the neuromusculature as necessary to carry out specific movements with the least effort."
>
> (Sweigard 1974)

The Ideokinesis work began with Todd and was then expanded upon by Barbara Clark and Sweigard (who coined the term). Todd's healing experiences became a form of motor learning that involves visualizing components of movement (either literally or through images evocative of human movement) and may have influenced sports psychology.[2]

Each of the protégés of Todd has contributed to the development of somatic education. The teaching and writing of Sweigard, Clark, Andre Bernard, Glena Batson, Irene Dowd,

Eric Franklin and Pamela Matt have helped to keep Todd's work active in dance, science and theater. Along with Rolf related-studies, training in Ideokinesis provides one of the strongest sources of anatomical understanding among the first generation of somatic disciplines. Its potential for helping with contemplative practices is also notable.

In Ideokinesis, mental practice guides the brain to stimulate muscles to organize for a specific movement. The images selected are based on principles of biomechanical alignment and efficient muscular functioning. Imagery can be of moving objects, occurrences in nature, human movement or abstractions. Bernard applied his knowledge to his work in radio announcing and Clark in her work as a nurse.

Sensory Awareness

Charlotte Selver (1901–2003) was born in Ruhrort, Germany. She learned the underlying theory and practices of her work in Germany with Elsa Gindler (1885–1991) and Heinrich Jacoby. Jacoby and Gindler began their educational work together in 1958 (Weaver 2014). Selver, together with Carola Speads, studied with Gindler, escaped Germany and brought the work to the US. She and her husband, Charles Brooks (died in 1991), developed her technique further and coined the term "Sensory Awareness" in the late 1930s. Selver cites Gindler as her primary teacher. The historical roots of this method parallel the work of other German innovators such as Bess Mensendieck and Ilse Middendorf. The somatic concept of deep internal reflection was an adaptation of a strand of Harmonious Gymnastik in which Gindler (Johnson 1995: 6) and Mensendieck brought a focus on concentration and awareness to movement regimens. For example, Gindler states:

> There is the difference between the breathing that occurs when the lungs and vesicles are open and breathing which occurs through the arbitrary inhalation of air […] if the movement occurs with open breathing, the movement becomes alive.
>
> (Johnson 1995: 33)

> The purpose of my work is not to learn certain movements but to reach concentration.
>
> (Weaver 2014: 34:02–39:00)

Selver met numerous great thinkers – Suzuki Roshi (Zen master), Suzuki Daishetz (scholar) and Korzybski (General Semantics) – as well as meeting with her neighbor Ram Dass. However, "she was responsive in her own unique way to each of them" (Laeng-Gilliatt 2001; personal communication 17 November 2015), and was described by her teacher Elsa Gindler as having "always asked the right questions?" (Laeng-Gilliatt 2001). She collaborated with Alan Watts (Laeng 2009), influenced Ilse Middendorf and Marion Rosen through her teachings (Haag and Ludwig 2002), and led sensory experiences with the eminent humanist Eric Fromm, among others.

Sensory Awareness carefully teaches how to slow down and pay exquisite attention to experiences using all perceptual channels. It does not explicitly focus on movement as an outcome, but rather teaches how to track experience during any activity: it was taught at Esalen and became known as a unique inroad for deepening meditation practice. Through the extensive network of students, Sensory Awareness impacted the development of Authentic Movement, Rubenfeld Synergy, Somatic Experiencing and Somatic Reclaiming as well (Weaver 2014). Gindler and Selver's work also had strong impact worldwide through strands developed in Europe – Elisabet Marchers Biodynamics, Biodynamic Psychology and Biosynthesis. Furthermore this sensitivity underlies the infant-parent education work of Pinkler and Gerber (Weaver 2014). Selver lived and taught until the age of 102, another testament to the impact of Sensory Awareness.

Rolf Movement/Structural Integration

Ida Rolf (1896–1979) was born in New York City. The inspiration for her work also springs from exposure to eastern practices, as well as friendships with Pierre Bernard, Fritz Perls, Sam Fulkerson and Korzybski. Other life-impacting phenomena were the shifts in employment during World War II and her serendipity as a woman at Rockefeller Institute, beginning in the department of chemotherapy. She had the intent to heal not just the symptoms but the causes of illness and disease; she saw causes as multiple and related to "the circular process that do not act in the body but are the body" (Feitis 1995: 174). Her work grew out of the sciences and alternative approaches to healing.

Rolf obtained her PhD in biological chemistry; as a scientist investigating the body and health she was exposed to osteopathy and homeopathy, and she developed an interest in yoga. From yoga she understood that one could work with the body to improve all aspects of the human being, and that, in large part, this was done through lengthening the body to create more space in the joints (Feitis 1995: 157). She learned about morality being linked to the body's behavior from Hindu philosophy, and that good use of the body supports a moral structure that is respectful of others. Dr Rolf continued to study movement throughout her life and took classes in the Alexander Technique from a Mrs Lee in Massachusetts (Feitis 1995: 160). She wrote *Rolfing: The Integration of Human Structures* in 1977.

Structural Integration, often called Rolfing, works deeply with the connective tissue and downward forces in the body. Rolf Movement is the movement education component of Dr Rolf's work, based in the work of Mensendieck and her study of yoga. By releasing the body's structure from lifelong patterns of tension using Structural Integration, Rolf Movement then sets the body up so gravity is able to realign it. The aim is that the experience of physical balance also leads to enhanced self-image and personal evolution.

Rolfing has strongly influenced the somatic bodywork field and is considered a type of somatic bodywork. Many Rolfers are also licensed as massage therapists, often due to state regulations on who has the scope of practice to engage in deep tissue manipulation. Rolfing

has a strong emphasis on impacting the fascia (connective tissue that separates muscle layers and supports organs). Separating of the fascia from the muscle breaks down any scar tissue that may be in the body and helps the body to move freely and be more balanced. Working with gravity in a conscious way supports the fascia to maintain its "tensegrity" – integrity through tensile forces.

Rolf Movement is less known and was developed with the help of Judth Aston and Dorothy Nolte. Like Rolfing it has a strong focus on the anatomy and form of the body, with an emphasis on the tensegrity established by the fascial system. The concept of tensegrity is finding its way into other somatic systems using Rolf's and Bartenieff's understanding of fascia. Offshoots of Rolfing and Rolf Movement include Tom Myers Anatomy Trains, Aston Patterning and Hellerwork. Numerous Rolf Movement practitioners have studied extensively with Hubert Goddard, scince and somatics-based movement analyst and researcher.

Trager Mentastics and Psychophysical Integration

Milton Trager, MD (1909–1997) lived in the US and was the founder of Psychophysical Integration. Like F. M. Alexander, he had to deal with physical weakness and illness from the beginning of his life, as he was born with a congenital spinal abnormality, but became an athlete and a dance through steadfast physical application. He made his first somatic discoveries at the age of 18 when he traded roles with his athletic trainer one day and touched him powerfully. The trainer took immediate notice and remarked on the effectiveness of Trager's touch in alleviating his physical discomfort. This was the beginning of the somatic research that led Trager to the development of the Trager Approach to Psychophysical Integration. Later in life, when he was in his mid-forties, he chose to go to medical school to become a doctor. He continued to give daily sessions in his unique somatic discipline in addition to maintaining a regular medical practice. As part of his approach, Trager developed a bodywork system as well as a system of movement education called Mentastics. Trager's work emphasizes moving "lighter, freer." After 50 years of developing his work, in the mid-1970s, he was invited to the Esalen Institute in Big Sur. "Because he lived in Hawaii, Dr Trager was unaware of the burgeoning California movement in holistic health and new age consciousness. He must have been surprised when he gave treatments at Esalen and was given a welcome befitting a conquering hero" (Trager Organization n.d.: 1). Even though one might surmise that Trager was applying his gift as a healer, he insisted that he was not a healer, and that anyone could learn these skills. He would respond to remarks such as "And yet Milton always denied that he was a healer" with his favourite comment: "I have this thing and it works [...] We're all healers" (Trager Organization n.d.: 1).

During the non-intrusive clothed tablework, the client's body releases muscular tension, mobilizes joints and experiences the body freshly from new sensations tracked by the brain. In the movement exercises the body becomes freer, lighter, easier. This method can lead to greater fluidity in the joints, balancing of the nervous system and, in turn, greater ease and

range of motion (Trager and Guadagno 1987). Mentastics are a relaxed and self-caring form of fitness.

Central to the Trager Approach is the concept of "hook-up." The practitioner is supported in her or his work by a phenomenon referred to as "hook-up" that involves feeling a union or support from a universal source. Trager was a connector to sports, health, medicine and the "new age." His choice to become a medical doctor and to bring his concepts into diverse settings helped to move somatic education more strongly into each of these arenas.

Summary

Somatic education began as discrete experiences of pioneering individuals – the wildflowers in an unidentified field. Each discovered that by paying attention to proprioceptive signals she or he could gradually use her or his body with a fuller range of motion and with more ease. In some cases, somatic pioneers regained movement capability after severe limitations or illnesses. The choice to work proactively in response to injury and illness is a recurring theme. Contact with great thinkers, travel around the globe and the generative work of students have been equally influential on the development of somatic thinking and somatic disciplines. The post-World War II diaspora furthered east-west connections and practices about the body, spawning this new wave of consciousness. While these explorations started informally, as each individual taught her or his work, their work became named, and was further recognized by students and the public. Within decades, each person established a training program to promulgate their successes and opened the work to the public.

While each of their methods stands alone as an active form of somatic education, each also has been absorbed into professions (e.g., Alexander Technique in theater, Bartenieff Fundamentals in fitness training and Feldenkrais Method in physical therapy, and all in dance with overlap in each of the performing arts). They have also influenced the development of new somatic systems. Furthermore, the ethos of their time had an impact on other creative people who were experimenting somatically as well.

Each of the somatic pioneers was influenced by some facet of the milieu of the Movement Cure or the transmigration of thinking from across continents. They were also challenged or supported by their own students. F. M. Alexander developed a friendship with his student John Dewey, who, in turn, wrote about his experiences with Alexander. Dewey explored his own body awareness with F. M. Alexander, learning about "bodily use." Through his writings and speeches, Dewey helped to give credence to the Alexander Technique (Boydston 1986) and to the importance of staying physically present even as students at school (Dimon 2003). Rudolf Laban was a member of the Bauhaus as well as a teacher for Kurt Jooss (choreographer of the Green Table), and Mary Wigman and he moved in the social circles of Dada and Jung, along with Dalcroze. He shared an interest in Rosicrucianism with Rudolf Steiner (Preston-Dunlop 2008). Feldenkrais traveled to study with Heinrich Jacoby

(Reese n.d.), met with Sensai Noguchi in Japan, worked with the violinist Yehudi Menuhin, actor Peter Brook and his Theatre Bouffes du Nord, knew anthropologist Margaret Mead, neuroscientist Carl Pribram and explorers of the psychophysical Jean Houston and Robert Masters (International Feldenkrais Federation of North America n.d.). Fritz Perls and Sam Fulkerson, proponents of the General Semantics work of Alfred Korzybski, were intellectual influences on Rolf. Selver had the opportunity to learn about the work of scholars from both the East and West – Suzuki Roshi (Zen master), Suzuki Daishetz (scholar), and Korzybski (General Semantics) and in conversations with Dass (yogi). Irmgard Bartenieff was a close friend of Margaret Mead, worked with ethnomusicologist Alan Lomax co-creating the Choreometrics project and was influenced by her meetings with Buckminster Fuller. These influences also have their offshoots and their own antecedents. The next four chapters describe the influence on future generations as well as providing cross-continental antecedents to form a picture of the evolution of the somatic arts. Dance emerges as an important catalyst for somatic movement education. All the intellectual crosscurrents, scientific developments and creativity within the performing arts contribute to the unfolding of somatic education and its subfields – somatic psychology, somatic bodywork and somatic movement. Each field recognizes the integration of body, mind, spirit and movement.

Figures 2–5: (top left) Charlotte Selver with Stefan Laeng-Gilliat at the last Sensory Awareness Conference at Fort Mason, San Francisco (2003); (top right) F. M. Alexander giving a lesson with a young boy © 2016 The Society of Teachers of the Alexander Technique, London; (bottom left) Ida Rolf working with a client. Photo credit: David Kirk-Campbell; (bottom right) Portrait of Mabel Todd. Courtesy of Pamela Matt.

Figures 6–9: (top left) Marion Rosen working with a patient. Courtesy of Rosen Method, Berkeley Center. Photo credit: Laura Oda; (top right) Moshe Feldenkrais teaching in Amherst, MA. Used with permission. Courtesy of International Feldenkrais Federation Archives; (bottom left) Milton Trager Courtesy of United States Trager Association; (bottom right) Irmgard Bartenieff Courtesy of Laban/Bartenieff Institute of Movement Studies.

Notes

1 Noguchi Sensai Katsugen Undo is another Asian system of autonomic movement, and Body-Mind Centering® derives some of its influence from it as does Setai.
2 Ideokinesis is well known in the dance community.

Chapter 3

Second Generation – Set One: The Influence of Dance on Somatic Education

Second Generation – Set One: The Influence of Dance on Somatic Education

> For me "somatics" is simply emphasizing the science of movement. If I understand somatics correctly, I think Margaret H'Doubler was the mother of somatics [within the dance community] because she taught strictly objectively, using anatomical knowledge. She didn't demonstrate movement. She wanted us to [explore and] understand how the body works.
>
> (Eddy Interview 2003b)

The stories of the second generation of somatic pioneers are told in two sets as bookends around two important chapters that describe influential history on the evolution of somatic arts. This is done for an explicit reason: The first set of this second generation – these pioneers of somatic dance – were taught by at least one of the pioneering somatic educators directly – Anna Halprin by Feldenkrais and Elaine Summers by Selver. These women instantly applied the work to dance education and performance, and developed their own systems of somatic education as well. Two other women are introduced, Martha Myers and Margaret H'Doubler, women who danced and promoted a somatic approach to dance education and performance, helping to name and shape the field as a whole. The chapter closes with a profile of Judith Aston, who was taught by Ida Rolf and has integrated somatic concepts into systems and products for health, dance and fitness exploration.

The second set of pioneers from this generation will have their stories told in Chapter 6 after more is described about the movement disciplines from northern Europe, Asia and Africa (and the Caribbean) that influenced them. The entire second generation is notable, whether most influenced by the East or the West because each woman was involved with dance, creating art throughout her life and keenly aware of how consciousness can arise from awakening the hidden senses through the art of movement.

Dancing into Science and Somatics: Martha Myers Links Physical Education, Dance and Somatic Awareness

It was Martha Myers who originally launched somatic education into the dance world through her work as Dean of the American Dance Festival (ADF). She did this in multiple ways – she introduced "body therapies" (one early name for somatic movement disciplines) to dance performers, educators and students, and simultaneously attracted the interest of

the medical community. Martha Myers has been a mover and shaker in bringing the science and the artistry of somatic thinking into two settings–professional dance venues and also into universities, including medical departments. As a result, somatic explorations are now often an experiential part of another new field that she helped to launch called dance medicine and science.

Myers gained a Masters degree (MS) Physical Education with a focus in dance. This background fueled her interest and comfort with the life sciences. Myers saw links between college education, physical education, health, dance and somatic education decades ago.

Myers remembers when "no one knew anything" (Eddy 2015) about the field of somatic education. Hers is a story of an active dance professional engaged also as a wife and mother. Throughout the 1960s and into the 1980s Myers worked in dance and media, while also dealing with her own health concerns. Each aspect of her life experience further opened her eyes to the value of somatic education. In different periods, she lived in Massachusetts (professor of dance at Smith College), Ohio (producer of TV news), Long Island (North Shore Center for the Arts), New York City (first administrator of the 92nd Street Y dance department) and Connecticut (Chair of the Department of Dance at Connecticut College and Dean of the American Dance Festival). Beginning in the 1980s she spent much time in North Carolina when ADF moved to Duke University. She worked for a short time in the University of Wisconsin, Milwaukee. Since her work was in different locations, she was able to share her excitement about somatic knowledge in diverse places, using her great speaking prowess.

Myers had a natural talent for communication. In a hiatus from her dance education career, while accompanying her husband, Gerald (Gerry) Myers to work, she was hired to produce an exercise program for television.

My husband was Chair of the Psychology Department at Kenyon College (Kenyon, Ohio) – I had no job; I saw a job announcement and was hired at WBNS a CBS affiliate to produce an exercise show. Next thing you know, I had a show "Exercise Girl" [opposite Jack LaLanne]. After doing this for about a year, the Director of the station asked, "Can you write a news show?" So I began to co-anchor Noon Day News. That was 1961 – I was basically the only woman in TV news besides one anchor at a major network. I even cooked up my own specials, and I took ballet classes at night.

(Eddy Interview 2002)

Later in her career Myers worked to create the public television program *A Time to Dance*, presenting most of the greats in modern dance (Martha Graham chose not to participate). It was filmed in Boston at WGBH. Myers and Gerry Myers proposed and wrote the show; Myers narrated it and Jacques D'Amboise produced it. Having her hand in the sciences, education and the media was a boon to both dance and somatic education. She set standards for both fields that continue to be respected (Batson and Wilson 2014; Eddy 2009a; Myers and Horosko 1989; Pierpont and Myers 1983).

As she met people and selected to work with them she noted,

[It] seems most of the people in the somatic field have in some way crossed paths with dance, perhaps through physical education. In those years, you couldn't get out of college without Physical Education credit. That's how many of us found dance.

(Eddy 2003)

Recognizing the Dance Teacher's Need for More Embodied Knowledge of Movement Science

From her days of teaching dance at Smith College and wondering "why students weren't learning" Myers felt motivated to reach them, especially those students

hiding out in the back row. It felt a pity they weren't finding the joy of dance. I also knew I could use the somatic information to teach dance more efficiently. [...] and I like to use Laban/Bartenieff concepts (LMA) in all of my choreography classes.

(Eddy Interview 2003g)

She doesn't remember how she first learned of Irmgard Bartenieff, but she remembers that she was motivated enough to travel into New York City from Long Island where she was working at the North Shore Community Arts Center, to study with her. Soon her young family moved to New York City, where she could take workshops in every type of somatic education. However, as a mother with a young child she was unable to spend the concentrated hours to get certified in any of them. Disappointed with that particular circumstance, she remained persistent and creative in her desire to learn everything about the various disciplines that were popping up. She found a way to take workshops and even managed to travel to California to study briefly with Judith Aston. She loved Aston's concept of "unraveling" the tension. These concepts helped her own body, performing and choreography.

Self-Exploration for Health and Dance Conditioning

Like the progenitors of the somatic systems, Myers has dealt with numerous physical challenges that motivated personal interest in the somatic systems. She credits her Laban/Bartenieff experiences with dance therapist and Laban Movement Analyst Virginia Reed with helping her cope with breast cancer. Her somatic learning with Reed was also predictive; Reed had warned her "if I didn't change my walk I was going to have hip trouble. She saw my Richmond, VA walk – too controlled, narrow and bound in flow" (Eddy 2003). Myers even went with Reed to take classes with Moshe Feldenkrais. She has since embodied

many somatic approaches and has adapted her gait. Yet she still continues to confront reoccurring "hip trouble." She credits the somatic approaches with helping her recognize difficulties sooner and discover more gentle methods for continuing to move.

Myers' methods for advocacy were completely in sync with somatic thinking. She chose to personally engage in experiential learning about each of the somatic disciplines she introduced, before producing events designed to best share this myriad of "body therapies" with others. Myers reached out to professionals in the health and medical fields at all times, in all places. She was so inspired by Laban's idea of communication through movement that while chair of the dance department at Connecticut College she founded the Institute of Non-verbal Communication with support from a LUCE grant. Myers drew together a faculty with representatives from psychology, theater, child development, dance, religion and French. The primary mission of the Institute was to offer an interdisciplinary course in which each member of the faculty led a class.

The American Dance Festival (ADF) – As a Somatic Launching Pad

As a result of these health events, travel, media experience and her dedication to dance, Myers sought out the pioneers who were involved with both dance and somatic studies or their best teachers. Her key criterion in choosing faculty for the summer educational sessions of the ADF was the ability to give people a clear and engaging experience of the somatic system they represented. She presented Irmgard Bartenieff in 1980, Aston in 1983, Summers in 1984, Bainbridge Cohen in 1987 and Halprin came in 1997–1998 as a choreographer (American Dance Festival Archives 1980–1996). The 1981 conference was dedicated to Bartenieff who sadly became ill and was unable to participate. She died later that year, a great loss to the movement community.

Myers began her workshop series at ADF with LMA and the Laban/Bartenieff approach as it is taught to a Certified Movement Analyst (CMA). She continued to hire Bartenieff-trained Laban teachers (CMAs), many of whom had studied directly with Bartenieff, and were facile with applying Bartenieff Fundamentals to dance (e.g., Martha Eddy, Laura Glenn, Peggy Hackney, Jackie Villamil).

> When I started to bring somatic work to the American Dance Festival at Connecticut College I was able to learn more. Kayla Zalk and Cecily Dell were the first Certified Movement Analysts to come and teach Laban Movement Analysis (LMA). Eventually Virginia Reed, Peggy Hackney (she taught an applied technique class) and many others came to teach. We taught Laban Movement Analysis on-going for years.
>
> (Eddy 2015)

After LMA, Myers next presented Aston Patterning and Ideokinesis. Within the first few years, she supplied exposure to the work of Alexander and Feldenkrais. Glenna Batson

trained in both Ideokinesis and the Alexander Technique and became a returning teacher. Over time, Myers included every possible somatic discipline with strong applications to dance, including Skinner Releasing and Kinetic Awareness. She also introduced Dance Therapy workshops, often led by dance therapists trained in Laban/Bartenieff perspectives. In 1992 Myers was bestowed one of the first two honorary CMAs ever given by the LIMS.[1]

Finding a Common Name

Like Hanna, Myers recognized the potential these disparate forms had for a cohesive identity and sought a common name for them. In her search she came across words from other cultures that meant "whole" and "of the body", the word *bottich* in particular.[2] For the American scene she chose the term "body therapies" and used it to develop a movement within dance. From 1980 until 1995 the somatic disciplines classes at ADF were called the "Body Therapy" workshops, and the term is still sometimes used in the dance community. For example, in 2014 it appears in the session descriptions of the National Dance Education Organization's conference brochure and in a LinkedIn discussion entitled "What is the difference between Body Therapies and Body Psychotherapy?" In 1995, the ADF workshop was renamed the Somatics Workshop. The workshops then became more focused on a wide range of somatic applications and performance goals, rather than on introducing somatic systems. Some examples of these new titles are "Virtuosity and Expressivity Workshop" (1997 and 1998); "Tools for the Integration of Technique and Expression" (1999); and "Self-Care Tools to Enhance Technique and Performance" (2000) (American Dance Festival Archives 1980–1996).

Advocacy for Dance and Somatics within the Medical and Scientific Community

Myers was instrumental in launching the field of "dance somatics," a rich ground for diverse applications of somatic principles. The seminal nature of Myers' vision remains apparent in a by-product of the workshops at ADF – a "pullout" section on "Body Therapies" in *Dance Magazine* (Myers and Horosko 1989; Pierpont and Myers 1983) is still being used as a teaching aid in dance and somatic education.

As part of her outreach during ADF at Duke University in 1978, Myers organized lecture-demonstrations to introduce the medical profession to somatic approaches to wellness, including dance injury reduction. When Myers talked about dance injury reduction, she was suggesting that with deeper understanding of the body the likelihood of injury can be reduced. Intent on using the somatic model of embodied understanding, she soon used creative means to encourage the physicians at Duke to physically take part in somatic classes. She reached out directly to the Duke University Medical Center; first inviting doctors and scientists to come speak to the students about their fields and to demonstrate

how each field interacts with the study of human movement. Then she engaged the help of her husband, and they scouted the halls of Duke to personally encourage the doctors and scientists to attend evening lectures about the body, movement and "body therapies" at the dance festival. Finally she influenced them to fully participate in somatic classes, aided by relationships that she built through this process.

> I gathered a physical therapist and professors and researchers from neurology, nutrition, orthopedics and psychology. The participating professor from the psychology department later became the president of Duke University. […] We got the blessing of the Director of Duke's medical department to let the doctors come to our classes. He was very sympathetic, perhaps because he had personal experience with a debilitating disease. We would invite them to come to our evening lecture demonstrations, and he encouraged it. We got at least six doctors to come over to conference and encouraged them to watch, listen or participate; joshing and heckling them into participation. Men in general won't get on floor due to hierarchical concerns. These doctors did!
>
> (Eddy Interview 2003g)

Thanks to Myers's intensive advocacy, her efforts were effective in introducing somatic education to the developing fields of dance medicine and dance science. Like numerous other somatic leaders she saw these disciplines as excellent partners (Batson and Schwartz 2007; Eddy 1991, 1992a, 1992b, 1995a; Fortin 1998; Hanna 1985, 1988; Johnson 1995; Myers and Horosko 1989). The early years of the Body Therapy Workshops at ADF brought together professionals from the health, dance and sports-and-fitness fields for experiential workshops, scientific lectures, research discussions and debates. Many of the issues raised there continue to be discussed today. In Myers's written summary of the 1981 conference, The Second National Body Therapy Workshop, she asks:

> How to define well-being or health?
> How do these definitions vary across cultures?
> What kind of research is needed to measure changes initiated by a particular body therapy, given the number of variables that are involved?
> Is it important to involve aesthetic choices in the work of somatic practitioners and medical professionals working with dancers?
>
> (American Dance Festival Archives [1980–1996] 1981: 1–7)

In this report, she also makes a compelling case for pursuing a field even if it is not "fully researched."

> It is empirically obvious that without movement, health is endangered, yet how can we assess how much and what-kind-for-whom without research to guide us? The fact that psychotherapy, psychoanalysis and, to an extent, even psychiatry and general medicine

operate without such data, or without irrefutable data, does not invalidate the criteria. There is a vast difference between "not knowing all," "not knowing yet" and "not trying to know".

(Eddy Interview 2003g)

Myers' methodologies for organizing and galvanizing people were successful. By the second annual workshop, in 1981, the faculty for the six-day event included 27 professionals, 18 of whom were medical doctors and/or physical therapists (American Dance Archives 1980–1996: [1981] 1–7). Fulfilling her integrative vision, the ADF workshop became a place to learn about medicine, health, movement and aesthetics. The emerging field of "dance science," like dance therapy, was supported by yet another "sister field" – somatics. Many of the doctors at Duke have remained active in dance medicine and were key in the development of the International Dance Medicine and Science and the Performing Arts Medicine Association. These international dance science and medicine conferences continue to include somatic presentations or workshops each year.

Engaged Through the Years

It is clear that Martha Myers lives a full life. Born in Virginia in the 1920s, she was motivated by a strong work ethic, a desire to prove herself to family members, and to keep moving. As part of her self-care process during her seventies and early eighties, she continued to work at the barre, go walking on the beach with tennis shoes and use Therabands® for upper body strength. Now a nonagenarian, she walks about New York City, attends dance concerts and receives private somatic movement sessions. She also finds that attention to her body through both dance and somatic work relates to spiritual health. She states:

The somatic work – honors the inner self, I hesitate to use the word spiritual because it gets thrown around so much – we all feel there is more beyond the body; the therapies acknowledge this if you want to take it in. You can also do the work on a purely physical level, but that would be too bad [...] and that is why it's so close to dance; the great dancers don't talk about dance they talk about spirit. [...] Somatic study does something to the nervous system [...] it wires you into a kind of sensitivity to those around you, animals, human and flora. There is also something aesthetic – yes, the aesthetic, the search for harmony [...] that need we have to decorate our own nests [...] the body is itself something aesthetically precious and needn't be accommodating itself to the cultural idea of beauty but with its own inner sense of peace creating, what, a sense of one's own beauty inner and outer. And there is recognition of the aesthetic in the somatic work and in dance. In science what is mathematically the right proposition is the most beautiful [...] I once did a paper for Physical Therapy Association using this concept.

(Eddy Interviews 2003g, 2015)

Simultaneous Developments

While Martha Myers was promoting the work of the first generation of somatic leaders in the dance community, dancers were beginning to develop their own systems. It is during this period that we see the emergence of somatic movement training programs from the second generation. Halprin, Summers and Aston created Life/Art Process, Kinetic Awareness and Aston Patterning, respectively. These are among the first of the somatic systems to be developed by women who were trained in dance and who continue to involve aspects of dance in their lives and somatic work. How they came to develop a somatic system emerges from their life stories. The following sections are based on interviews conducted between 2001 and 2004, supported by their own writings and research on their work.

Anna Halprin and Life/Art Process

Anna Halprin's award-winning work in dance has contributed to her somatic system – Life/Art Process – which has also inspired others to create new somatic systems. Halprin began her somatic explorations in dance studios. She learned many key dance concepts and pedagogical processes during her studies with Margaret H'Doubler at the University of Wisconsin from 1939 to 1942. Halprin stayed in close touch with H'Doubler until H'Doubler's death in 1982.

Halprin describes that dance majors, under H'Doubler's tutelage at Wisconsin, were required to do a pre-med course of study – classes in anatomy, physiology, physics, biology and kinesiology. They used Mabel Todd's book, *The Thinking Body* in H'Doubler's class, almost 70 years ago, assuring an approach to movement that was objective and rooted in the science of how the body functions as well as the aesthetics of imagery. She reflected that during her college career, from 17 until 20 years of age, she didn't totally appreciate what she was learning at the time but has come to integrate it fully now.

Anna Halprin absorbed much of H'Doubler's critique of dance education and the excitement of "free expression"; with these influences Halprin birthed one of the first somatic approaches to movement and dance. In working with H'Doubler's concepts, she changed the process of exploring the science of the body. Halprin emphasized more internal sensitivity, increasing the degree of somatic awareness. For instance, she describes teaching and having her students feel their heart beats as part of a movement exercise. When asked if H'Doubler took this type of somatic approach, she answered:

> I don't remember her doing that. She taught rhythm and the "kinesthetics of rhythm." I moved into it a little differently. She would show movement that was a down up accent. She would then teach it not just "as an accent" but teach how the movement extends from the accent. She loved to teach rhythmic analysis. What I got from her was the

internal dynamics of rhythm and the science of the body [...] The idea of awareness, of sensation is also important; and articulation about it and being able to identify what is moving.

<div align="right">(Eddy Interview 2003b)</div>

The Body-Mind-Emotion Connection

Halprin even makes a case for not being able to feel ecstasy until one can find the movement that supports it – for instance, to be able to lift ones breastbone to the sky with wide open arms. During the interview she demonstrated this movement and showed how knowing anatomy informs expression. She explained that ultimately one has to actually move muscles and explore their patterns to discover the associated feelings and expressive possibilities. She described:

> When I contract my trapezius muscle (the large muscle of the upper back that moves the shoulder blades together and up, and together and down), I have a clear image of them, what part is where, and how they fit. [She points to the different upper, middle and lower components of the trapezius muscle while saying "here and then another here."] If I contract all three sections, it will tilt my ribcage up and the front of my shoulder area will open [she demonstrates the movement]. I have to listen to this [balance of muscle use] like a musician listens to a note. Without that awareness and feeling the movement is empty. Until I learn to do this movement I will not have experienced ecstasy.

<div align="right">(Eddy Interviews 2003b, 2003)</div>

Halprin makes a link between these expressive explorations based in the bodily sciences and current approaches to somatic study by noting that H'Doubler was also interested in the science of movement in order to develop frameworks for art and philosophy.

And, H'Doubler didn't stop there. She always believed that the science was related to the art and the philosophy. If you could be objective with the movement, then the participant could make it subjective.

> My understanding of somatics is pretty much that [...] When I say that somatics is the science of movement, I realize now that this investigation really must include awareness, I mean refined awareness of one's own.

<div align="right">(Eddy Interview 2003b)</div>

Anna Halprin has spent a lifetime investigating the science of movement, adding in this deeper self-reflective, somatic dimension, while being driven to find ways of dancing that were personally meaningful and steeped in anatomical understanding. She was among the

first choreographers in the 1950s and 60s to use dance expression, together with touch, to work towards healing physical as well as psychological imbalances. She is a pioneer in using dance as a healing art. She developed methods of bodily exploration that included introspection, and which led to her own healing. However, she is less interested in somatic work for the sake of personal investigation and more interested in how it promotes changes of mind and action:

> I would say that my movement work is somatically based but that is not my primary intention. My intention is really to create art, and to use the art to encourage and promote creativity through movement.
>
> (Eddy Interview 2003b)

She went on to describe that her work is not just somatic, it is holistic and that of an activist:

> My philosophy stems from something else [other than the somatic principle]. It includes cultural awakening and cultural differences and respect. How can I say it [...] if you are able to approach movement holistically – I would say that holism is the basis of my philosophy – that is what I am after. And that does not stop with me. It needs to include my relationship to you. It has to move into my relationship with my family, my community and my planetary world. And it doesn't stop there; we don't exist without the air and the trees and the animals. It has to be totally holistic. And that philosophy has grown bit by bit over the years. It wasn't something I started out with. It wasn't anything that H'Doubler talked about. But if she was alive today she would say [...] that is absolutely right Anna, I've been saying that all along.
>
> (Eddy Interview 2003b)

Since the time of this interview and publication of facets of it (Eddy 2009a), several books have been written that link H'Doubler's methods to a somatic paradigm (Ross 2009; Brenna et al. 2006). It is not clear how deeply H'Doubler worked with the somatic principles that emerged with the first generation (see a list of defining features of somatic education in Chapter 7), but certainly through her students, most notably Anna Halprin, she has been seen as an important link in the legacy of somatic movement in the US.

One of Halprin's most unique contributions has been as a leader of large group dances and rituals performed in nature – Earth Run, Circle the Earth and Planetary Dance. Earth Run came about after five women were murdered by a serial killer on Mt. Tamalpais near the Halprin home and school in Marin County, California. It is a dance of prayer and dedication. It began as a dance to overcome feelings of hopelessness and to reclaim safety on the mountain. It became Circle the Earth in 1985, a community ritual with nine scores. The Earth Run was one score, it became Planetary Dance in 1987. More and more it became a dance calling for attention for the distressed Earth. It has continued ever since and is now performed in variations in over 36 countries.

The Planetary Dance is in its 30th year of annual celebrations. It is a spring ritual of renewal and healing. Each year different themes emerge – overcoming threats and war and prayers of hope are among them. As part of the dance there is an Earth Run that is a moving mandala, the heart of the Planetary Dance. It is a simple circle dance that everyone can do based on walking, running and standing still in the four directions. These achievements have led to a continual role as an attractor and gatherer; she has also gained dozens of awards and an honorary doctorate.

Halprin's outdoor group dances can be compared to Laban's movement choirs performed in Germany and Ascona, Switzerland in the early twentieth century (Green 1987), but they are distinct in that her purpose was to foster experiences that contributed to awareness and action for global healing and for healing from life-threatening illnesses. Projects of the Laban community like www.GlobalWaterDances.org now echo these themes.

The Intellectual Climate

Several thinkers besides H'Doubler contributed to the development of Halprin's philosophy. Some of her other early mentors were her husband, architect Larry Halprin and his cohorts in the Harvard Bauhaus group and Fritz Perls. The influence of the Bauhaus in Berlin and then in Cambridge, MA and the application of dance expression parallel the life story of Irmgard Bartenieff, 20 years Halprin's senior. Bartenieff applied Bauhaus-influenced concepts to health, gained through her study with Laban. Her work asserted influence in three new fields: as a physical therapist; in her foundational contributions to the field of dance therapy; as well as to somatic movement education and therapy (called Bartenieff Fundamentals™).

The diaspora of German intellectuals to the US spawned many great developments for America – scientific, nuclear, architectural and artistic. The migration of Jewish intellectuals was particularly important to somatic education. Examples include the fact that Feldenkrais was a Russian Jew immigrating to Israel. Laban came under house arrest when he was discovered to have a Jewish girlfriend and refused to pattern one of his huge movement choirs – the opening celebration of the 1936 Olympics in the shape of a swastika. Bartenieff fled to New York City because she was married to a Russian Jew. Selver also left Germany and joined other Jewish (as well as non-Jewish) intellectuals at Esalen in California.

Like other founders of somatic systems Halprin learned through physical and cultural dislocations; adjusting to new environments. As a mother, she made additional adaptations. In Cambridge as Larry studied and worked at Harvard, she interacted regularly with his Bauhaus colleagues, including Walter Gropius, Marcel Breuer and Ivan Nagy, all of whom had fled Nazi Germany. "Through the Bauhaus I got introduced to collaboration. I collaborated with musicians, artists, and architects" (Eddy Interview 2003). This collaborative process informed her dancing and her somatic work. She created works together with her dancers – including her daughters, "everyday people," and diverse artists – many from the

beat generation. These interdisciplinary collaborative experiences parallel Laban's Bauhaus experience.[3] Halprin's collaboration with artists from varying disciplines continued beyond Cambridge. She was the only dancer featured in a retrospective on the Beat Generation at the Museum of Fine Arts in San Francisco in 1996. She was also one of the few women engaging with Jack Kerouac, Alan Ginsburg and William Burroughs. Her experience collaborating with non-dancers at Harvard helped her in San Francisco. She describes:

> Those were the people [the beat writers] who I began to be influenced by; by their spirit of rebellion and looking for new points of departure. There weren't any dancers for me to be influenced by so I collaborated with other types of artists.
>
> (Eddy Interview 2003b)

The large cultural shift from Harvard's hubbub of intellectual post-World War II European Jewish diaspora to the quiet of the woods of Marin County, CA was particularly difficult for Halprin, softened by her times with San Francisco artists, and yet generative for somatic inquiry. Before the birth of her children, she spent long periods of time on her own in her "Dance Barn" studio designed and built by Larry Halprin, nestled among magnificent evergreen trees.

What led Halprin to go deeper – in the somatic direction – came in part from her isolation.

> I would do a lot down there in the Dance Barn by myself. I worked a lot by myself. [...] When I started working with gravity [an objective concept that she had already considered with H'Doubler] I had a roadmap [...] stopping it, resisting it, feeling dynamics changing, and moving through space. This brought me to inertia and momentum, and then ways to work with space emerged [including the body concept] of experiencing your plumb-line. I'd ask myself or my students – "Something has to change when you move through space – what do you think that is? What are you doing so that you are doing this [...] Do you see this? Someone will say, "It looks like she is beginning to fall." [She responds] "So if you want to change directions then we have to be ready to fall."
>
> (Eddy Interview 2003b)

During the process of investigating these bodily phenomena from physics, somatic ideas emerged.

Her somatic research usually began alone but soon she needed to share her discoveries with other people. When she found herself isolated or lonely in her studio, the possibility of returning to San Francisco to meet with other collaborators was critical to her creative survival. She would attract people back to her dance space within the woods, but quite often she had to go out to find anyone willing to dance and move, seeking people in their communities. To have a reliable opportunity for collaboration, Halprin founded the San Francisco Dancers' Workshop in 1955, leading dance experiences in San Francisco and Marin County. Two of the people were her own daughters; each performed in her company

for years and one is to this day, her collaborator in Life/Art Process, and Director of Tamalpa – the institute they started together.

The Development of Life/Art Process

Life/Art Process is considered both an expressive art therapy and a somatic movement therapy. The Halprins use therapeutic, expressive tools to help people to "move emotions" into an integrative experience.

Anna Halprin applied her somatic ideas, developed over twenty years, with students and company members in these more urban areas. In 1978 she co-founded Tamalpa Institute with her daughter Daria Halprin who brings her expertise as both a dance/artist and as a psychotherapist. Tamalpa Institute is a training site for people to become educators and therapists in Life/Art Process, an in-depth psycho-physical and aesthetic system of somatic inquiry. Daria Halprin's dual roles as artist and psychotherapist supported Anna Halprin's work as a leader of large group dances for healing – groups that included those with AIDS and cancer.

At Tamalpa, students pay subtle attention to the body and somatic wisdom through the Life/Art Process. To quote the homepage of the Tamalpa website in 2008,

> Our focus on the body, movement and the expressive arts as a healing approach is based on the premise that the imprints of life events are housed within the body. When remaining at the unconscious level, these imprints may lead to imbalance and conflict; when explored and expressed consciously and creatively, the connection between body, mind and emotion make a vital contribution to the artful development of the self.

The work has spawned other training programs as well. Students of Anna Halprin's, Alice Rutkowski and Jamie McHugh, have their own somatic training programs. Rutkowski has also helped to shape both the Leven Trainings and the In-Motion somatic movement systems.

Halprin Meets Moshe Feldenkrais and Other Body-Mind Thinkers

Halprin traveled to Israel and met Moshe Feldenkrais, whose freeing philosophy and approach to somatic inquiry echoed her style of guiding inductive process, rather than being a didactic teacher. During that trip she also met Noa Eskol who developed a system of notation and used it to notate Feldenkrais' work. She felt that Eskol was:

> Delving into a similar pot – objective, abstract, and a dancer. She would not have thought of herself as a somatic educator but I think she was […] I have a wonderful article on

Eskol analyzing emotion – through the thalamus etc. I think that Moshe brought in the nervous system [to an understanding of movement]. [...] I was quite at home with these thinkers. Neither [Feldenkrais or Eskol] would have been at home with Ida Rolf. (I have had 28 sessions so I speak from experience.) Both H'Doubler and Moshe had something in common [...] and that was creativity. Moshe wanted you to experience your movement. They would have been horrified if there had been an outside force (like when Ida brought in her famous elbow), forcing the body. It was a dogmatism. Moshe as a Jewish person mistrusted dogma. You see there is the Jewish philosophy that comes into this, which is a mistrust of any dogma. So he came at it from a philosophical point of view: He would say "try it this way, now try it this way, now that way, what feels best to you?" [...] constantly coming back to your experience. He gave you objective material to explore [for your own insights].

(Eddy Interview 2003b)

A seminal experience for Halprin in understanding the deeper emotional and therapeutic aspects of expressive movement came from her acquaintance with Fritz Perls. She states:

I worked with him on one dream for eight years. He gave me a road map (for working with the emotions) [...]. He used to do the vibration exercises from Alexander Lowen.[4] But Fritz had a philosophy that was similar to Moshe (Feldenkrais), H'Doubler, similar to John Dewey and Whitehead.

(Eddy Interview 2003b)

Halprin is still inspired by her experience of how these thinkers rejected dogma and the practicing of any preconceived patterns – be they nonverbal movement patterns or an approach to the unconscious. She feels this development of self is literally encouraged by engaging in making art, be it art for the stage, or art used in personal, familial or community settings. In some cases these art events become ritual, performed year after year with growing numbers of people. Her somatic work is a stepping-stone into communication with a larger global community. One begins by exploring the basic phenomenon of movement in one's own body and then interacts with others from these sensitivities.

In reflecting on how her own work has developed from H'Doubler, Bauhaus, the Beat Generation, Feldenkrais, Eskol, Perls, Halprin identifies with the somatic realm, recognizing how the freedom and ease of movement comes from self-awareness and becomes a doorway to greater emotional expression. She speaks of muscular and related emotional releases, highlighting the idea that when someone makes an emotional connection that they are also sparking their motivation for life and creativity. It is following this motivation within each person that becomes her interest; she works to cultivate this in others. She finds it especially important to link somatic experiences to expression and politics.

Halprin's goal is to engage people. She believes in starting with movement and the body – somatics – important. She states:

> If you can devise techniques that don't start with the physical body that's fine. It's just not what I like. I think I am quite a purist about dance. [This purism includes her somatic approach to dance.] Once you experience the physicality of a movement in its pure state it comes not from your preconceived belief systems. I have tried to avoid preconceptions and belief systems. I don't say you can't do that. I just don't want to.
>
> (Eddy Interview 2003b)

Is This Art? Is This Dogma?

According to Halprin, somatic experience helps "bypass the belief systems in the controlling mind." More importantly the somatic experience is only a starting point for further action:

> [W]hen you do that movement [with somatic awareness], you have the freedom to do it. I have the release (of tight muscles), when I *feel* sadness or I have an image – now the motivation is sparked.[...]There is a certain layering that I have observed. To have a dance that is somatically based is stage one; it grounds them[...][the somatic approach to movement exploration] is a lobby; then you enter the building.
>
> (Eddy Interview 2003b)

She credits her friend and colleague for teaching her Alexander concepts of inhibiting habitual behavior, and Feldenkrais for supporting her own belief in critical thinking.

> Moshe used to say this, now everyone says this – "You have to find your own truth, that will enable you to find a universal truth." If you go deep enough into your own truth you have found somatics.
>
> (Eddy Interview 2003b)

Halprin experiences somatic inquiry as personal investigation, free from dogma. Like Feldenkrais she questions dogma everywhere, even in postmodern dance. Contact Improvisation (CI) is a type of dancing where you remain in physical contact with at least one other person and often enjoy "giving and taking weight" – falling into someone or being lifted by him or her. By its nature it is meant to be spontaneous and an expression of freedom between two or more people. She says, smiling, the following about CI: "I feel Contact Improvisation can become dogmatic. Anytime Contact Improvisers come near me they fall all over me. I've worked out a system of dodging them" (Eddy Interview 2003b).

So Halprin physically dodges those dancers who move in a specified style 100 per cent of the time, in this case those practicing CI. She also does her best to help dodge her own habitual thoughts. She pushes willing investigators to question their habits and assumptions. She works to defy dogma. She also goes on to ask, "I don't know enough about yoga. I wonder if awareness is part of yoga? It is often so dogmatic" (Eddy Interview 2003b).

> In teaching – the creative part is *how* to teach that [...] how to structure the discovery without being dogmatic. I'd say, what is this? Students would find words like – "that's force" or "that's overcoming."
>
> (Eddy Interview 2003d)

Applying Somatics in Teaching, Dancing and Healing

The themes Anna Halprin has tackled are expansive – healing the earth and healing from her own cancer, as well as helping others in their healing processes with AIDS and other life-threatening illnesses. One of her goals was "finding roadmaps so that you can articulate differences." She formulated these movement maps and learned from their ensuing journeys. One outcome of collaborating on performances or rituals with diverse people was "waking up to racism and other isms." Anna Halprin has been a leader in connecting the physical, somatic process of articulation to expand the dancers' movement vocabulary as a tool for communicating across differences. As the movement and resulting descriptive language was increased and appreciated, more concepts were exported into wider and wider circles. The creation of Halprin's large group collaborative art events involved much dialogue, compromise and adaptation in terms of dance structures and movement elements. The exploration of momentum that was astounding then is now being used by most dancers and in varying forms among dancers who discover how to slam walls (e.g., Elizabeth Streb), those who propel in aerial dances and those who jump off the backs of horses inside dance theaters (e.g., Martha Clarke in *Garden of Earthly Delights*).

For Halprin another important momentum was politically motivated performance that expressed a full range of concerns within either a local or global society. To this day artists are using many of the same skills explored by Halprin in the 1950s and 1960s.

Elaine Summers and Kinetic Awareness

Summers, founder of the somatic education system Kinetic Awareness, was also an active choreographer with more than six decades of dance experience; performing just months before her death in 2014 at the age of 89. Summers attributed the development of her somatic system to the serendipity of certain people coming into her life. Similar to Halprin,

her approach to somatic study also includes a socio-emotional component – the importance of personal and interpersonal caring.

Summers emphasized that the kindness of friends, mentors and teachers contributed to her perception of delight in life, which fuelled her somatic investigation and her creativity. She felt she was is part of a greater network of explorers of human experience that supported her in her pioneering:

> I could never have imagined the wonders of being part of a universal development of realizations about the inner power of the human mind reaching separately and together to search for understanding of our kinetic/somatic powers. Now as I am one year from 80, I have had the chance to see and experience the incredible changes that the dedicated work and realizations of many minds have given our culture, our health and our ability to love.
>
> (Eddy Interview 2003d)

Dealing with Pain by Exploring Uniqueness and the Arts

With the insistence of her high school friends Lewis Gardner and Dussy Cavalo, Summers earned a BSc in Art Education at the Massachusetts College of Art. A dedicated art teacher, Priscilla Nye, opened Summers to the concept that "everyone has a unique, creative self." Nye believed in the innate creative force of every child and person and introduced Summers to the works of Herbert Reed, especially his seminal book, *Education Through Art*. She also exposed her to Carl Jung and Buckminster Fuller who have remained constant resources for Summers.

> Due to my love of dance I applied to the Julliard School of Dance at the age of 28 and they accepted me. While auditioning there I discovered that both Martha Hill and Norman Lloyd were admirers of my favorite book, *Education Through Art*. It was an incredible time, many classes every day! Martha Graham, Yuriko, Anthony Tudor, Louis Horst – a choreographers dream – studying along with Carolyn Brown, Paul Taylor, Ellen Van der Hoven. And then suddenly there came mysterious severe pain in my right hip joint.
>
> (Eddy Interview 2003d)

When three doctors diagnosed her condition as severe osteoarthritis, she gave up studying at Juilliard. Many might have said that it would have perhaps been wiser to give up dreams of becoming a serious choreographer, but Summers began to explore and seek out ways to dance and choreograph with her inflamed hip. She humorously describes herself as "motivated by some kind of perverse mentality that insisted on dancing" (Eddy Interview 2003d).

Summers used somatic inquiry in order to heal from this disabling condition. She studied with great dance teachers who had a deep understanding and spirit of dance as well as clues to the somatic process. She reports that Mary Anthony was already using breath and a wise intuitive use of tension; Jean Erdman, married to Joseph Campbell, has a "deep, cosmic

mind"; and Don Redlich, loved and understood alignment. "You could not study with Hanya Holm until Don had made sure that you understood alignment and you did not pronate," [allow the arch of the foot to collapse due to eversion and abduction of the foot]. Janet Collins invited Summers to be part of the modern dance company she hoped to create. "Janet's spirit was indomitable and she taught me the gift of the Lester Horton Technique." Lester Horton had numerous cultural influences including Native American dance and the Japanese choreographer Michio Ito, which contributed to the uniqueness of his approach to dance. The influences from Japan and Native America support a holistic approach to dance, that is, of course, an underlying premise of somatic exploration as well.

Deep Listening with the Proprioceptive System

It was during this time, of dancing with pain, that Summers began to get in touch with her proprioceptive system – the feedback from her joints and muscles. She discovered that when the body says that a movement, or group of movements, cause pain, you must avoid moving directly and quickly through or into that pain; but that you can still keep active by moving the area and the surrounding parts, gently. At that time the prevailing attitude was "no pain: no gain." Counter to this idea, she discovered that the fastest way for the body to remain healthy was different: "In order to heal you need to move every part of you often, [gently] without pain." Working in the studio she came to understand the way that

> our bodies talk to us (the language of the body), our proprioceptive sense; how our body loves to move; to experience and use its kinesthetic sense; the necessity to allow our bodies to feel the deliciousness of being in touch with all the senses of our kinetic self and the importance of acknowledging and sensing when our body is in pain.
>
> (Eddy Interview 2003d)

The great movement geniuses (or as Summers would say, kinetic geniuses) with whom she studied in New York during the 1960s and 70s were of enormous help to this learning process. Summers worked with Joseph Pilates (and his wife Clara, and teacher Heidi) at his studio on 8th Avenue and 54th Street. Holistic doctors also influenced her in the development of her own somatic approach. Dr William Elliott introduced her to osteopathy (the branch of medicine that works with the movement of the bones and muscles) and the importance of vitamins. She also gleaned much from Dr Jack Saltonstall, a chiropractor.

Summers expounds other inroads besides her dance background and personal healing process that guided her in the deep proprioceptive investigation and contributed to the evolution of Kinetic Awareness:

> A friend recommended that I work with Renee Nell, a Jungian psychotherapist. Renee understood the work of Elsa Gindler, a renowned teacher of bodywork in Germany.

Renee suggested that I might enjoy working with Charlotte Selver or Carola Speads both teachers of Elsa Gindler's work. I chose to study with each of them. Renee, like Charlotte and Carola, had escaped Germany. Gindler's ideas of meditation and listening to the language of your body and exploring *simple* movements slowly were revolutionary to me! It was especially difficult for me to give up cultural body images and the Ballet dancer's body image. I studied with Charlotte for two years and with Carola for five years. Carola is one of my great mentors and for many years was the honorary chair of the Kinetic Awareness Center.

<div align="right">(Eddy Interview 2003d)</div>

Somatic Proprioception Kindles Health, Dance and Creativity

Summers spoke of studying in New York City with Selver from 1954 to 1956. Selver acknowledged Summers' dancing strengths by saying "you know so much about movement." Then she worked for five years with Carola Speads, her great mentor. During this period she combined her knowledge of movement, her drive to choreography and her burgeoning somatic process.

I liked that Carola was matter-of-fact, not quite as romantic. I loved how Charlotte talked poetically and at the heart of everything [...] Serendipity is so exciting. I began to realize that all of these discoveries were the core of *dance*. The first of my "Energy Changes" dances was called "Dance for Carola," dedicated to Carola and performed at the Judson Dance Theater.

<div align="right">(Eddy Interview 2003d)</div>

After being diagnosed with arthritis she began studies with Selver and Speads. These classes taught her to find slow and gentle movement that allowed her to keep moving without pain. She then returned to dance classes, studying leg alignment with Don Redlick. She also investigated the body on her own, trying to find ways to open the gradually closing space of her hip joint. This is when she discovered the wonders of rolling over various sized (3–8") balls; a technique that came to be called by her students, "the ball work," and which is a signature feature of Kinetic Awareness. It was the first of the many "ball techniques" that have since been developed.

Gradually, Summers also realized the importance of understanding the structure of the human body and the way its multiple systems interrelate. She voraciously read and studied *The Thinking Body*, by Todd, *Gray's Anatomy* and other anatomy, physiology and kinesiology texts. Up until her death, favorite books remained the Isaac Asimov series of small pocket books; such as *The Chemistry of Life* and *The Image & Appearance of the Human Body* by Dr Paul Schilder, *The Alexander Technique* and *Character Analysis* by Wilhelm Reich (Eddy Interview 2003d).

Summer shares that the Judson Theater Movement had its influence on somatic education – the improvisational methods coupled with caring about *any* movement set the stage for deep investigation of the basic "happenings" in life:

> For many years I abandoned poetry and plays and read these fascinating books about the body [...] New York was such a sizzling, serious place to work, and [to] think and grow your kinetic imagination, to dance – and no one had any money. Because of all these [...]. friends would meet often to work together. [...] Part of the development of Kinetic Awareness came from the fierce logic of "everyday movement" as dance, which we had all been exploring at Judson [Church].[5] Artists in every media were talking and improvising with each other. I had begun studying with Merce Cunningham and then was involved with Bob [Robert Ellis] Dunn and Judith Dunn's choreography workshop based on John Cage's concept of "Chance." There I had the chance to work with Trisha Brown, Steve Paxton, Lucinda Childs, Yvonne Rainier, Deborah Hay, Simone Forti, and to hear of the choreography and the thinking of Anna Halprin. Choreographic conversations with Trisha Brown, gave me courage and support for this, then seemingly strange, approach to dance. The research and investigations of Yvonne, and Steve, and Lucinda, especially her kinetic sense of humor as in *Carnation*, are an integral part of the whole seminal development of somatics.
>
> (Eddy Interview 2003d)

The tools related to dance improvisation provided critical force in Summer's somatic investigations.[6] Summers mentioned that the parallel evolution of Contact Improvisation (CI) during the Judson Dance era also required deep kinesthetic listening. CI was developed by Judson dance member Steve Paxton, who was inspired by the martial art form – Aikido.

Becoming Bionic – Somatics and Postsurgical Recovery

Summers danced from her college years until the age of 50, when, in order to continue her lifelong passion of dancing, she was felt compelled to get hip replacement surgery. She recounts:

> At 52 with the tender encouragement of dance impresario, Bessie Schoenberg, who had just experienced the new operation for hip replacement; and with the loving help of my friends, students, and my husband Davidson, and son Kyle, I became a bionic woman. It is true, as my mother warned me, "dance is not a good way to support yourself." This was true financially, but, oh is dance an amazing, surprising, 100 per cent concentration of your life force.
>
> (Eddy Interview 2003d)

The exploration of dance from a deep proprioceptive perspective helped Summers regain her mobility after her surgery and further fueled her somatic research. The practice of Kinetic Awareness kept her active, concentrated, healthy and creative into her eighth decade and has influenced many other people and dancers' liveliness.

Elaine Summers' Interdisciplinary Work and Kinetic Awareness

The richness of Summers' creative process has been evident throughout her lifetime. Summers has enjoyed many honors: Grants from the National Endowment for the Arts and New York State Council on the Arts. She has become a Fulbright Scholar in Early Film Dance History and a Fellow of the Center for Advanced Visual Studies at the Massachusetts Institute of Technology. After her experience co-founding the Judson Dance Theater, Summers created the first multimedia performance in New York City, integrating multiple film images, sculpture and music also presented at the Judson Dance Theater in 1964, a work called, "Fantastic Gardens." Then she founded the Experimental Intermedia Foundation in New York City, and is recognized as a multimedia artist who combines dance with all art forms, including film and video. She attributes the growth and development of her career to serendipitous meetings with magnificent teachers of dance and diverse arts, and her ability to keep dancing for more than five decades, and, of course, her somatic sensibility. It is touching to hear her say "There is no one of us as great as Anna Halprin." Summers was a somatic pioneer who greatly valued appreciation of others and chose to demonstrate appreciation generously every day of her life.

Summers' lifework – Kinetic Awareness – emphasizes how the creative process of combining dance with somatic approaches guides a constant, yet gentle pathway for pain-free movement, or for managing pain and easing it with movement, as well as the ability to dance and innovate throughout the lifespan. Kinetic Awareness teaches graceful aging and continuously supports the creative process. From Summers' perspective somatic experiences are linked to serendipity, creativity and spiritual development.

From 2010–2014, from the age of 85 through 89, Summers curated several shows and choreographed performances in numerous locations. Cadres of beloved mentees supported the continued blossoming of her work, surrounding her in the Kinetic Awareness office, the dance studio, on film and on the stage whether indoors or outdoors. They also came out for her memorial service at the Judson Church. Elaine Summers died on 2 January 2015 at the age of 89. She had completed a full intermedia event in September 2014. See Appendix 1 for a program note from her memorial.

Aston Patterning

Judith Aston (Pare 2001, 2002) danced as a child and into her college years. At UCLA, she studied with Rudolf Laban's daughter, Juana De Laban, and with Valerie Hunt, both schooled in Laban Movement Analysis. She also worked with dance therapist Mary Starks Whitehouse. These mentors encouraged her to find her own answers, rather than studying their systems. After incurring spinal injuries from two sequential car accidents, one in 1966 and the other in 1967, she studied with Ida Rolf. Aston helped expand upon the Mensendieck-based movement program that Rolf was offering. Aston's work, together with some contributions from Dorothy Nolte, helped to shape what is now called "Rolf Movement" but began as "Movement Analysis" drawing on studies at UCLA. Aston states:

> Many people took the Movement Analysis course: Bob Prichard, Don Hanlon Johnson, Mark Reese, Tom Myers [...] in fact everyone who trained from 1971 to 1977 [with Ida Rolf] was required to take that course. Bill Williams, Roger Pierce, Joseph Heller, Annie McCombs Duggan, Heather Wing, Louis Schultz, and many others took my Movement Certification training and in fact took classes for years. I think we were called "the dancers." I was offended then – *now* I realize my highest goal is to continue dancing through this life and beyond.
>
> (Pare 2001: 7–8)

Since that time (1977), Aston has integrated dance, fitness and somatic awareness into Aston Patterning. Aston Patterning involves learning principles of movement that may be applied to personal growth, movement enhancement or to exercise and fitness programs. It is a process of "unraveling the layers of tension" found in the body to facilitate freedom of expression and comfort. Paying attention to the perceptions of the body, practicing self-expression, and being cognizant of the interaction with the physical properties of the planet and the environment helps to relieve tension. Aston recognizes that the human body is an asymmetrical three-dimensional structure that moves in spiral patterns. She also sees each human body as unique; therefore, sessions are individualized to meet each individual's structure and needs. In keeping with all somatic pioneers Aston found that challenges in a particular bodily area are best assessed in relationship to the whole body, and the whole person inclusive of their personalities, beliefs and habits. Diverse Aston approaches include Aston Kinetics, NeuroKinetics, ArthroKinetics, Myokinetics and The Aston Line products (Barber n.d.).

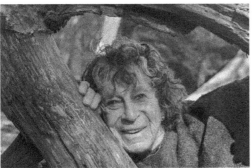

Figures 10–14: (top left) Barbara Clark (with Pamela Matt) – teacher of Bonnie Bainbridge Cohen, Nancy Topf and colleague of Joan Skinner. Courtesy of Pamela Matt; (top right) Martha Myers leading a Laban-based Choreolab 2001. Courtesy of the American Dance Festival Archives. Photo credit: Bruce Feely; (middle left) Anna Halprin at 91 Sea Ranch. Photo credit: Jamie McHugh; (middle right) Elaine Summers. Courtesy of Jill Green; (bottom left) Anna Halprin with Margaret H'Doubler. Courtesy of Tamalpa. Photo credit: Coni Beeson.

Notes

1 The other honorary CMA that inaugural year went to psychologist, Dr Martha Davis, one of the first members of the faculty for the Certification Program of LIMS trained before the title of CMAs was created.

2 The word *bottich* is used by Johnson in *Body: Recovering our Sensual Wisdom:* "Conceiving of the human organism as a 'brewing vat' [the origin of 'body', *bottich*] implies that its genius – its wisdom, justice, intelligence, love – is to be won through patient, cooperative work" http://donhanlonjohnson.com/bodyrecovery.html. Accessed 5 January 2015.

3 Many Bauhaus members, including the architect Walter Gropius went to the summer artists retreats with Laban in Ascona.

4 Lowen was a protégé of Wilhelm Reich's based in the US.

5 Summers explains

> After the two workshops [with Bob Dunn] which lasted for the entire winter/spring of 1960, Yvonne and Steve talked to Reverend Al Carmine at the Judson Memorial Church and asked if we could present a concert in their church. This was how the Judson Dance Theater, which has been described so brilliantly by Sally Banes, in Democracy's Body, came to be.

6 The form of dance improvisation that Halprin referred to involves staying in constant touch with a partner as one rolls, lifts, rests or leaps.

Chapter 4

European Antecedents to Somatic Movement

Kelly Jean Mullan

European Antecedents to Somatic Movement

> Gindler learned Harmonious Gymnastik – a fixed set of common movements and felt they were narrow. Gindler provided freedom for people to explore independently and to develop individually [...] offered opportunities for each person to become more aware of what was happening in their own organisms. She did not teach techniques. She changed using the word "exercise" to "experiment." The natural activities of every day life were the material for her classes.
>
> (Weaver 2014)

Summers provides a clear example of how the teaching of Charlotte Selver, a first-generation pioneer, impacted her development *and* how Selver's and her colleague Spead's teachers featured prominently in the process. What was motivating these teachers? The worldview of the body was in a state of great change at the turn of the twentieth century, especially in Europe. During the 1920s, the Free Love movement, Dadism and the barefoot dancing of Isadora Duncan are indicators of the cultural transformations going on.[1] These changes were partially a response to the rigid social norms and bodily effect of Victorian lifestyle, forming a mood fraught with the desire for rebellion, rebellion for freedom to explore the body. The Scandinavian and German exploration of the Movement Cure, sometime in scant clothing or in the nude was another contrasting trend. Shifts in attitude and lifestyle practices were evident in the realms of philosophy and spirituality, in the development of psychology, in the arts, health and education. As new systems of bodily exercise and exploration emerged, new forms of artistic expression were evolving. The work of Rudolf Steiner expanded to include the translation of geometry and poetry into dance (Maletic 1987: 36), and Delsarte's system of embodied study for singing and acting traveled from France to the Americas. Steiner developed harmonic movement exercises called Eurhythmy that were meant to be "a true expression of sound through the body" (Allison 1999: 254). Jacques Dalcroze, Rudolf Laban and Mary Wigman taught new forms of movement and dance that were based in expressiveness, rhythm and harmony. Their movement schools and programs emerged in diverse European locations to teach new adaptations of expressionistic dance while others explored new approaches to exercise or gymnastics.

To learn more about how the above dance and movement leaders had an impact on somatic movement and on how their own systems came into existence, it's important to gain insight into the entire phenomena of "Physical Culture" of Gymnastik and the Movement Cure era.

These were the active systems of physical training in Europe during the previous two centuries. Elements of Gymnastik could be found in the late nineteenth century in physical education texts in the US. This chapter seeks to show the lineage of the European Movement Cure over the course of almost three hundred years and a peek into its transmigration to the Americas where concepts like the interaction of doing and being and the importance of physical symmetry were being incorporated into physical education (Naismith and Gulick 1884). To understand this emergence better, the next sections review the advent of various systems of exercise including:

- Denmark – Franz Nachtegall (1777–1847)
- Sweden – Pehr Henrick Ling (1776–1839)
- Germany – Friedrich Ludwig Jahn (1778–1853)
- Switzerland/England/France – Phokion Heinrich Clias (1782–1854)

The Many Forms of Physical Culture

The first generation of somatic progenitors lived amid these currents and also interacted directly with outstanding philosophers and theorists. Starting in the mid-nineteenth century into the twentieth, Delsarte, Stebbins, Kofler, Steiner, Laban, Dalcroze, Mensendeick, Menzler, Kallmeyer and Gindler with Jacoby and Reich led thousands of people to experience the body-mind connection by advocating for and developing exercises, everyday movement and dance with a focus on conscious awareness. They became a major part of the cultural elite of that era. Whether an important integrative thinker and/or a creative innovator of a specific movement system, each had an impact, and all believed that movement was expressive and could be a source to health. Each emphasized these two different elements to different degrees. Some invited a third element – that these practices would open a person to consciousness of the spiritual realm as well.

Francois Delsarte's (1811–1871) approach, complete with a total and practical theory of body and human expressive behavior through movement, seems to have no precedent. Delsarte's general connection to Gymnastik is the historical fact that Gymnastik was the term for exercise found in most trainings at the time. Expert Joe Williams states:

> Individual points regarding human expression through movement had been recognized, of course, but Delsarte's gift was the discovery of a unifying theory, and developing a technique to bring that theory into utility and practice. This technique is comprised of relaxation exercises to eliminate tension that inhibits freedom, subtle balance exercises so that the body can move without resorting to tension, and exploration of the basic expressive range of motion of the body.
>
> (Eddy 2015b)

Delsarte's system will be described more below by expert Kelly Mullan. For now keep in mind that the Delsarte system includes prescribed and carefully developed movements

used to help actors, dancers and musicians in their expressiveness. However it is *not* simply a codified system of gestures to substitute for emotions on the stage, nor is it a system of exercise for bodily health benefit; it is both and more. (Eddy 2015b).

Williams describes one drawing by Delsarte used in his teaching;

> It is an illustration of the idea that the whole – the circle, is comprised of the invisible and the visible, both perfect reflections of one another – Delsarte identified the two triangles (duality) as a symbol for human life, inner and outer, and the three corners of the triangle (trinity) represent what we today call body, mind and spirit, both inner and outer. The circles on the three points of the triangle are repeats of the law of correspondence, that each point is its own circle, sub divisible again into trinities. This then shows up in the expressions of the body – the head, the thought center, the heart/chest for emotion and affection and the abdomen and groin as a center for "body" – fight flight, hunger, reproduction.
>
> (Eddy 2015b)

Kelly Mullan writes, "Delsarte's expressive theories grew out of the field of French Oratory. In the 19th century expressive delivery of rhetoric was known as Elocution. Elocution (elocutio) included delivery and action (actio)- not just of the voice but of bodily gesture and emotional expression. In America, the name Expression came to replace that of Elocution as a means of describing the whole body united in action; voice, mind, emotions and body. Expression was a form of training for orators, actors, singers, and educators. Schools of Expression were prominent before the advent of American theater and dance training institutions" (Eddy, 2015m).

An American protégé of Delsarte, Genevieve Stebbins, used these guidelines again some years later but separates them from the mystical or spiritual, taking a more direct physical approach.

> Stebbins believed that Delsarte was a great teacher who also draped some of his work in spiritual mysticism that was unnecessary for learning the practical side of his work. She referred to her own work as teaching "Practical Delsartism."
>
> (Eddy 2015b)

Bess Mensendieck, MD (1864–1957) was a sculptor and physician who built on Stebbins work. She has also studied Eurhythmy (aka Eurhythmie) with Rudolf Steiner, and became a teacher of Dalcroze's Eurhythmics. Each of these systems has prescribed movements organized in specific space and by time/rhythm, respectively. Mensendieck combined medicine, art and an understanding of Gymnastik as learned from Stebbins of the US. Her art form was sculpture, so it had both tactile and visual elements. With this integration, she developed a system of over 200 exercises for executing movement (often in front of a mirror with minimal clothing) in a "correct manner" to improve habits and functioning. Her work is found in physiotherapy, occupational therapy, dance and osteopathy, even today, especially in Europe (Johnson 1994).[2]

Williams goes on:

Regarding Stebbins work with Delsarte one could say that the American Delsarteans acknowledged the need for "more than Delsarte had provided" in order to use his work as a health regime, so Stebbins added other fitness exercises, while bearing in mind that exercises that damaged the balance and symmetry of the Delsarte exercises would prove unhealthy. She found the work of Ling was most appropriate to developing athleticism without damaging freedom.

<div align="right">(Eddy Interview 2015b)</div>

Elsa Gindler (1895–1961) was a key teacher for Alexander, Selver, Spead and at least indirectly, of Bartenieff and Rosen. Judyth Weaver (2014) contends that Gindler can be seen as the grandmother of Somatic Psychology and Body Psychotherapy. Together with her partner Heinrich Jacoby, she is central in both somatic movement and somatic psychology lineage. She had been a student of Stebbins and her colleague Hede (also found as Hedwig, Heidi or Hade) Kallmeyer. Her experiences with a severe illness affecting her breathing led her to develop what would now be identified as a somatic system, often referred to as Gindler-Jacoby work. Gindler's original studies were in Jahn's Gymnastik, yet after her training at the Stebbins-Kallmeyer school in Berlin she addressed the physical exercises in a new way, with an emphasis on mental concentration while breath, relaxation and tension were explored. This extra internal focus was true of one of Gindler's other teachers too – Leo Kofler (1907–1995).

Kofler lived in the US and strove to overcome tuberculosis through anatomical study and physical exploration. However, the dynamic breathing exercises of Stebbins were a stronger influence on Gindler's work than Kofler's technical use of breath awareness. Kofler's method helped him overcome his illness and was used by singers, but it was not integrated into a body-mind philosophy, as was Stebbins' work. His book *The Art of Breathing as the Basis for Tone-Production* was written for singers, elocutionists, educators and others intending to improve vocalization (Mullan, personal communication). Two other students traveled from Germany to learn from Kofler and then translated his book; it continues to be published in Germany today (Johnson 1995).

Ilse Middendorf (1910–2009), surrounded by the work of Gindler and Mensendieck, created a system focused on breathwork that is also still used today. Her primary teacher as a young woman was Dora Menzler, author of numerous books and famous for integrating yoga and Gymnastik, all done in the nude. While Middendorf became a teacher of the Mastanang Method and was mentored by leaders who were linked to Carl Jung, she developed her own work using the natural breath. "The Experience of Breath" was said to make room for the essence of a person to unfold and develop through breath explorations. These ideas and practices surrounded Marion Rosen during her early years while she was still in Europe.

The breathwork has had impact in the plastic arts as well. Veder (2009) traces the extensive influence of Mensendieck's anatomically sound and Delsarte's rhythmic and expressive movement systems on the paintings of modern portrait and abstract artist Arthur B Davies

(1862–1928) (and his models). Davies developed his own theory of the "lift of inhalation" described in his book in 1923, inclusive of metaphysical correlations derived from Delsarte (Veder 2009). His models, Wreath McIntyre, Elise Dufour and Edna Potter Owens, were active as dancers and influenced by the body culture milieu. Meanwhile, the art form of dance itself was impacted by these interweaving approaches. Specifically Ruth St. Denis and Isadora Duncan were trained in Delsarte's method by Stebbins and influenced by Mensendieck methods as well.

It was a rich era for movement exploration as well as discoveries of and about the psyche. By 1897, Wilhelm Reich, Freud's protégé – the psychoanalyst who worked with blocked energy in the body – was born. Mensendieck lived during the era of John Dewey, the great American philosophic educator and the movement innovator, and spiritual leader Rudolf Steiner. Leo Kofler was exploring vocal clarity and healing in the US. A decade later Rudolf Laban (Labanotation and Movement Choirs) and Emil Jacques Dalcroze (Eurhythmics) each developed a movement system of their own.

Moving forward into the impact of dance on somatic education, it is important to learn more about Rudolf Laban and his direct influence. Irmgard Bartenieff's life in Berlin was surrounded by the open exploration of movement and the body – the work of Delsarte, Dalcroze, Mensendieck, Gindler, Middendorf and Bode, among others, established a cultural milieu in Germany of exploring movement to transform health. Her primary influence was Rudolf Laban, the father of German modern dance expressionism and of DanceNotation.

Rudolf von Laban (1879–1954) was born Varatjai vereknyei esliget falyi Laban Rezso Keresztelo Szent Janos Attila, on 15 December 1879 in Bratslavia, formerly Czechoslovakia, and now Slovakia. He studied in France, lived throughout Europe, escaped from Nazi Germany to Paris after being under house arrest, and finally settled in England during World War II, although he continued to travel, including to the US. While Laban did not experience a bodily injury or limitation, he did feel confined by paternal pressures. Laban spent many of his late adolescent years traveling with his father in eastern Europe, in response to his family's desire for him to become the fifth generation to enter the military. During this time he had exposure to the movement forms of local Europeans and those that were passing through from Asia, and also became introduced to Rosacrucian practices (Eddy Interview 2003f). He also watched military exercises and folk dances and became deeply fascinated with human movement. Furthermore, he encountered an existential problem when struck by the desire to express the beauty of a sunset: despite his Architecture and Visual Arts training at L'Ecole de Beaux Arts, he found himself saying,

But how? In words, in music, in paint? But it was all too rich for that [...] I moved. I moved for sheer joy in all this beauty and order; for I saw order in it all. I saw something which is absolutely right, something which had to be so. And I thought there is only one way I can express all this. When my body and soul move together they create a rhythm of movement; and so I danced.

(Laban and Ullman 1984: 1)

Laban went on to study dance, and to create dances and schools of dance throughout Germany, and later in England, that valued personal expression. He was teacher to Kurt Jooss (choreographer of the Green Table) and of Mary Wigman (mother of modern dance in Germany). He also developed a system of movement notation called Labanotation that was furthered by his students Albrecht Knust and Ann Hutchinson Guest. He had become Ballet Master of the Berlin State Opera (Maletic 1987); after his house arrest and defection from Germany he was found in Paris and brought to England by Jooss and other former students. There he established the Art of Movement Center and was called upon during World War II to analyze movement in industry. The components of movement that he defined became the basis for what Irmgard Bartenieff (his student in Berlin) called Laban Movement Analysis. This work has since been applied to movement education, sports, anthropology, psychology and the performing arts as well as to health. Laban was noted for his ability to help individuals discover new movement and health potential. North (1971) writes:

> In the field of therapy the application of his effort analysis has produced remarkable results. Through his study of mind-body relationships and the psychological effects of certain movement patterns, he was able to achieve improvements in many emotionally disturbed people as was as in those with physical limitations.

Laban's biographer, Preston-Dunlap tells a story of how Laban helped a wheelchair-bound person walk again (Preston-Dunlap, personal communication, 2001).

As somatic concepts are used more in psychology, health education, meditation and the arts, innovators continue to call on older techniques from these predecessors – Laban and Wigman. Going back further in time Dalcroze, Stebbins, Kallmayer and Mensendieck emerge as key influencers. Indeed, these leaders and others in Europe and in the Americas continue to have direct influences on somatic explorers and their work continues to develop through their protégés. This Isadora Duncan quote also demonstrates a somatic process as a source of inspiration:

> I spent long days and nights in the studio seeking that dance which might be the divine expression of the human spirit through the medium of the body's movement. For hours I would stand quite still, my two hands folded between my breasts, covering the solar plexus [...] I was seeking and finally discovered the central spring of all movement, the creater of motor power, the unity from which all diversities of movements are born, the mirror of vision for the creation of the dance – it was from this discovery that was born the theory on which I founded my school [...] When I had learned to concentrate all my force in this one center, I found that thereafter when I listened to music the rays and vibrations of the music streamed to this one fount of light within me, where they reflected themselves in Spiritual Vision, not the mirror of the brain but of the soul.
>
> (Duncan 1927: 75)

Dancers who aspire to find their own voices, or to support others in doing so, usually gravitate to a more somatic approach. The following section was invited in order to map out the early European of these free-ranging thoughts, movement explorations and mental-physical skills.

The Movement Cure: Mapping the Roots of Early Western Body-Mind Methods

Kelly Jean Mullan

The history of western body-mind methods (what has come to be known as somatics) is connected with the European and American physical culture movement of the nineteenth century. Approximately 200 years ago, European physical culture systems were developed and designed to motivate individuals to improve their health by either increasing strength or by generating greater mobility, agility, range of motion and capabilities for physical expression. Movements were modified for working with people with injury, illness or disabilities. Some approaches encouraged experiential exercises as a way of developing personal awareness. Physical culture introduced gymnastics, which was at the time an all-inclusive word for self-cultivation and physical education. The word *gymnastics* described any form of systematic exercises used for bodily education, including voice and breathing exercises.

Physical culture was partly inspired by Ancient Greek civilization, as a revival of "ancient gymnastics," but incorporated new exercise systems and movements designed specifically for the ill, the average person, the more advanced athlete and also for military training. Starting in Europe at the beginning of the nineteenth century, physical culture quickly spread to America (before the advent of competitive sports) with popular gymnastic systems being promoted through educational institutions, military academies and private and public gymnasiums.

Genealogy of Ideas

The idea of movement as medicine exists in ancient practices around the world, including sacred ceremonies. Dance and movement were often essential components of these cathartic events for the community. Prior to the advent of Greek medicine and gymnastic practices, priests and priestesses were seen as being all-powerful healers in the ancient world. Gradually, movement became recognized as having curative effects on the body, the attainment of health became a science and these ideas became part of the philosophical discourse. "Know thyself" was inscribed on the Temple of Apollo, and in many ways physical embodiment was a spiritual experience. Outside of the temple, systematic gymnastic practices were developed and taught alongside academics as a means of increasing human potential. Academic study and physical practices were seen as being equally necessary for the full development of the individual. Physical culture educator Dudley Sargent wrote "with the Greeks, the mind and

body were treated as co-workers, the philosopher and gymnasiarch [teacher of gymnastics] both giving instruction at the Academy and Lyceum" (1906: 5).

Medicinal gymnastics, movements designed to maintain or restore health, were also taught in Ancient Greece. Indeed, the history of gymnastics is:

> Inseparable from that of medicine [...] it reckons among its inventors one of the ancestors of Hippocrates [...] Gymnastics appeared to act upon the euexia [Greek word meaning the good condition of the body and its entire well-being attained by training], as medicine does upon the restoration of health. It is for this reason that Gymnastics was dedicated to Apollo, god of medicine, and the directors of these schools [gymnasiums] were qualified with the title of physician.
>
> (Clias 1825: 3)

The European resurgence of gymnastic methods began in the early Renaissance. Evidence of the practice of ancient gymnastics can be found in historic European literature, such as the text *De Arte Gymnastica*, written by the Italian doctor Gerolamo Mercuriale (Latin name Hieronymus Mercuralis), which was first published in Venice in 1569 (Leonard 1923). Many university libraries housed historic gymnastic texts, and medieval books on gymnastics were found within the personal collections of physical culture innovators (Ekenberg et al. 2013; Leonard 1923).

Within this genealogy of ideas about movement and health, it is possible to connect ancient thought with the later advent of physical culture. According to Simonson (2013), classical education of the Renaissance era revived ancient thought and inspired an "overall re-imagining of antiquity that was connected with nature, the body and with self-cultivation" (50). This re-imagining drew inspiration from both Ancient Greek thought and the epic lore from Celtic, Scandinavian and German cultures and led to the development of new training systems as a means of personal development.

Educational Reform and Physical Culture

The European revival of forms of ancient gymnastics can be traced back to educators such as Johann Bernard Basedow (1723–1790) who created the Philanthropinum, an educational institute for children in Dessau, Germany, in 1774. When Basedow created this school for middle-class children, he sparked an educational reform movement known as Philanthropinism. His experimental approach built upon classical education by encouraging outdoor physical education alongside intellectual development (Leonard 1915/1922, 1923). Christian Salzmann (1744–1811) founded a similar school in 1784 (Naul 2010; Todd 1998). Salzmann hired the geography and gymnastics teacher Johann GutsMuths (1759–1839), a man who was to inspire a cultural revolution in physical education. GutsMuths published his book *Gymnastics for Youth* in 1793 (Leonard

1915/1922, 1923).[3] According to Lempa (2007), "by 1846 more than twenty new editions and translations of GutsMuths' *Gymnastics* had been published in German, English, Danish, Italian, Greek and Dutch" (76). His work inspired a revolution in physical education across Europe during the early nineteenth century. Initially these lessons were only offered to boys and men, but were soon introduced into girls' schools and encouraged in newly founded higher education institutes for women.

For his pedagogical gymnastics, GutsMuths also "chose the renaissance of cultural ideals of the Ancient Greeks" (Naul 2010: 41) and "created gymnastics largely from ancient exercise" (Lempa 2007: 74). GutsMuths appreciated how the natural vigor of ancient Europeans (including Germanic tribes) enabled them to withstand the elements and thrive in the wilderness. He thought that people needed to get back to their roots by building the body to be hardy, active and harmoniously developed. Professor of sport sociology Gertrude Pfister wrote that GutsMuths also believed that the intellect could only be "developed through the senses (i.e., action and perception) and that therefore the education of the body, the training of the senses and physical activities were indispensable elements of education" (2003: 64).

In his 50-year teaching career at the Schnepfenthal Philanthropine school, GutsMuths inspired many other teachers, including some of the most notable early innovators of physical culture, all of whom are "best studied in connection with the later results of their life work" (Leonard 1923: 81).

Physical Culture Systems: Branches on the Tree

Beginning in the early 1800s, physical culture systems were traditionally placed into four different categories, based on the Ancient Greek division: military, medical, educational and aesthetic. Some innovators of physical culture inspired by GutMuths came to develop "heavy gymnastics," which were physically demanding intensive training programs. Heavy gymnastic methods had both physical health and self-defense at their core, so they became linked with military training. Other approaches are linked to the later advent of somatic movement education and therapy.

- Military ("Heavy") Gymnastics: Included systems of movement training and conditioning used to train men for strength, for elite athleticism and for combat. Women were also taught some heavy gymnastics in institutions that encouraged "able-bodied women" (Verbrugge 1988). Heavy gymnastics required gymnasiums fit with specific apparatus including vaults, parallel bars, ladders, ropes and sometimes a low-hanging trapeze. Out of this lineage grew modern gymnastics, sports conditioning, military training and weight lifting.
- Medical Gymnastics: Included individually designed movement exercises and massage techniques used therapeutically for men, women and children with rehabilitation needs

due to weakness, injury or illness. Medical gymnastics came to be known as the Movement Cure (Georgii 1850; Taylor 1860). Methods included manual manipulations or passive movements, such as massage or the stretching of the body, and active gentle movements guided by a certified practitioner. Medical Gymnastics is connected to the evolution of somatics, sports medicine, physiotherapy, osteopathy, Swedish massage, kinesthetic structural integration, perceptual neuro-facilitation methods, applied kinesiology, physical therapy and most likely connective tissue therapy as well.

- Educational/Pedagogical (or "Light") Gymnastics: Included movement exercises designed for use in adult group classes or with children in school. These methods aimed to help those who practiced them achieve and maintain health, prevent disease, increase range of motion, improve posture and generate greater physical capacities (Clias 1825; Ling 1866; Posse 1890). Some of the light gymnastics were apparatus-free systems and did not usually require specifically equipped gymnasiums. Movement exercises consisted of either free-standing drills (non-competitive movement sequences) or stretching or strengthening exercises.
- Aesthetic ("Harmonic") Gymnastics: Included movement exercises and experiential explorations used to generate greater expressive capacities and physical harmony in the body by those in the public sphere, including orators, preachers, actors, dancers, teachers, socialites and performers. Methods included free-standing, apparatus-free exercises that could be taught in an open room or studio. This lineage is related to performance methods that incorporate nonverbal communication, such as modern dance, to physical theater methods, and to the origination of dance and theater training in schools. This lineage encouraged the development of natural abilities and personal awareness, and as such, it is also connected to the evolution of somatic movement education and therapies (Mullan 2014).

There is a fifth category of physical culture that is a sub-branch of aesthetic gymnastics:

- Vocal Culture/Vocal ("Breathing") Gymnastics: Included voice or breathing exercises designed for training orators, singers, actors, public speakers and those with lung problems or stammering issues (Guttman 1882; Kofler 1887). Vocal culture was a part of the field of elocution, and in addition, vocal gymnastic exercises were integrated into physical culture systems that focused on the importance of the proper use of breath (Stebbins 1892).

Swedish Ling Gymnastics

While there were many forms of gymnastics systems, one particular innovator is connected to the development of somatic approaches to movement. Pehr Heinrich Ling (1776–1839) created a military, educational, aesthetic and medical gymnastic form that became known in Britain and America as the Movement Cure. Ling's gymnastics systems were designed

to meet a variety of needs with a focus on "the oneness of the human organism" (Posse 1890: 29). Within Ling gymnastics "the harmony between mind and body constitute the fundamental principles" (29).

Pehr Ling studied at the universities of Uppsala and Lund (the Harvard and Cambridge of Sweden), earning a degree in theology. He later settled in Copenhagen, Denmark for five years where he learned fencing from French emigrants, who certified him to be a teacher. He studied gymnastics with Franz Nachtegall, and upon returning to Sweden in 1804 was offered a job as a replacement fencing master at the University of Lund where he also brought in gymnastic exercises (Leonard 1923). As his teaching reputation spread, he was provided the opportunity to train the military in gymnastics and bayonet fencing. He also managed to garner funding from the King in 1813 to found his own school in Stockholm, which the King named the Royal Gymnastiska Central Institutet. This institute was the first of its kind in Europe with teacher training programs and a medical gymnastics treatment center.

Ling's work at the institute not only focused primarily on medical gymnastics and therapeutic movement research, but he also introduced light educational gymnastics and heavy gymnastics exercises. In many ways the heavy gymnastics were advanced forms of exercises. Ling's light free-standing exercises were designed for the person of average fitness levels to encourage the "development of the human body by well-defined movements" (Roth 1852: 4). Educational gymnastics were designed for healthy individuals to maintain wellness and prevent disease, and they were most often performed in group classes. Those who were ill had one-on-one medical gymnastic treatments with movements and manual manipulations of the body, prescribed according to individual diagnoses and needs. Those in poor physical condition had slow movement exercises that demanded much less physical effort than would have been expected within educational light gymnastic classes. Group classes consisted of free-standing exercises and were "an essential and complete branch of educational gymnastics. Medical gymnastics made use of them principally in the after cure or treatment of the convalescent" (Roth qtd. in Rothstein 1853: 1). As the ill recovered their strength, more light gymnastic exercises were added.

The Ling educational and medical gymnastic systems were non-competitive and designed solely for cultivation of the body. Ling perceived the body holistically, and he believed that his gymnastics influenced the whole physical system in a curative manner "resembling those wave-circles we notice on the surface of the water" (qtd. in Taylor 1860: 53). Gertrude Pfister argued that, ultimately, Ling's

[A]im was to explain the relationship between the body and the soul and between physiological and psychological processes based on a rational and scientific approach to body and movement that was anatomically and physiologically effective and that could be universally applied.

(2003: 69–70)

The teaching of movements was accompanied with vocal directives guiding the participant to draw awareness to the breath and to particular actions of the body. Ling gymnastics can be considered as a form of somatic movement education, as internal physical cues guided actions, and movements were expected to be practiced with "undivided attention and full volition" to achieve any benefits from the work (Posse 1890: 27). Overall, the "collective, forming exercises of the system were to be adapted to the individual body and the result could be measured in its harmonious development, and not, as in sport, by the result" (Traugbaek 2000: 45).

Ling was an elected member of the Swedish General Medical Association. At his institute he focused on medical gymnastic research to advance his theories about the curative properties of movement. His methods were eventually embraced by many leading doctors across Europe (Leonard 1923). Courses in medical gymnastics were offered to medical students at the University of Uppsala, and a full medical gymnastics practitioner training program was created at Ling's institute. Doctors admired the efforts of Ling as "No approach was made to a method of designating and classifying the positions and movements of the body for the purposes contemplated in the Movement Cure, till the time of Ling" (Taylor 1860: 142). Ling used his knowledge of physiology and anatomy to test his movement exercises and to discover how muscular movements influenced various diseases of the organs, respiration, the nerves, spinal curvatures, digestion and circulation (Taylor 1866).

The Movement Cure – Medical Gymnastics – Svensk Sjukgymnastik

Medical gymnastics were used both in disease prevention and as curative techniques. Ling had personal experiences with the curative potential of movement. He was diagnosed with a grave lung disease that physicians could do nothing about and he set out to cure himself. Through experimentation "he noticed the favorable influence that the movements had upon his health. In the course of these experiments he cured himself of a disease that had been deemed incurable" (Taylor 1860: 54). He also had problems with gout. Having improved his own health issues, he dedicated his life to rigorous research into how movement affects the body.

Medical gymnastics were prescribed for those who found educational gymnastics exercises beyond their capabilities due to "unusually poor development" or illness, and those for whom more active exercise would have aggravated existing health conditions. Corrective movements were prescribed on an individual basis to be undertaken with a private teacher specially trained in medical gymnastics (Posse 1890). Dr Charles Taylor argued that many may misunderstand gymnastics, as they have often "been considered as certain contortions to be done, instead of certain physiological impressions to be made by means of movements" and not "stupid blunting of sensations by muscle over-work" (1861: 68).

There were definite distinctions made by the Ling Institute between movements prescribed within medical gymnastics and exercises given within educational light gymnastics. According to the American physician Dr George Taylor:

Movements are designed for *the sick* – Exercise for the *well* [...]. Movements have a *prescribed* manner, and break up old habits. *Exercises* have a *habitual* manner. *Movements* are confined to *designated* parts of the body, or *are localized,* – *Exercises* allow *all* portions to engage. [...] *Movements lessen* the frequency of the pulse, – *Exercise increase* the frequency of the pulse .[...] *Movements accumulate* nervous force, – *Exercises,* in general, are liable to exhaust nervous force.

(1866/1868: 25, original emphasis)

Movements were thought to cure diseased parts by bringing circulation, encouraging purity of the blood and oxidation of tissue, easing congestion through "tissue metamorphosis," strengthening weak and imbalanced muscles, influencing direct and reflex action of the nervous system by diminishing excitability and irritability of nerves, and helping with lymphatic drainage and overall nutrition within the body (Taylor 1861).

According to Dr Charles Taylor, medical gymnastics was used to cure such things as diseases and curvatures of the spine, paralysis due to inflammation, severe constipation, consumption and lung disease, dislocation of joints, chronic muscular spasms, nervous disorders, atrophy and retraction of muscle (1861). Limitations were recognized, and the system was not meant to be a cure-all. Medical gymnastics treated chronic conditions not acute ones, and they were used to address a wide range of disorders. Ling's medical gymnastics were a recognized treatment method supported by the medical field. Physicians and students came from across Europe and America to study and brought back Ling's methods to their own countries.

Ling gymnastics were initially introduced in Britain in 1838 by military gymnastics men who had trained in Stockholm, and later by graduate Karl Augustus Georgii (1808–1881). The head teacher of anatomy and practical gymnastics at the Ling Institute ten years prior to Ling's death, Georgii later established a medical gymnastic institute in London around 1849 and taught for 28 years (Leonard 1923; Sharma 1994). He published some of the first works in the English language on Ling gymnastics, including *A Few Words on Kinesipathy or Swedish Medical Gymnastics*; *The Application of Active and Passive Movements to the Cure of Diseases According to the Method of P.H. Ling* in 1850 and *The Movement Cure* in 1852, thereby giving the name Movement Cure to Ling's medical gymnastic system.

The first American to study the Movement Cure was Dr Elizabeth Blackwell (1821–1910), who was also the first American female allopathic (mainstream medical) doctor. Blackwell trained with Georgii in London sometime between 1849 and1851 and appears to have been the first person to bring the Movement Cure method to America. She introduced Ling's ideas through her own book on physical education for girls, in which she advocated the

use of "special movements." The book, which was a compilation of her public lectures, was published in 1852 (Todd 1998). Nine years after Blackwell trained in the Movement Cure, the Taylor brothers (George and Charles) traveled to Europe to learn the techniques and were the first American physicians to write at length on the subject.

Dr George Taylor (1821–1896) studied at the institute in Sweden in 1858, and published *An Exposition of the Swedish Movement-Cure* in 1860. Taylor established his own Movement Cure Institute in New York City, the first of its kind. His younger brother, Dr Charles F. Taylor trained with Dr Roth in London and wrote *Theory and Practice of the Movement Cure* in 1861. In the 1860s the Ling educational gymnastics system became popular. By the late 1880s American teacher-training programs for educational gymnastics were established (Verbrugge 1988). By 1913 major Ling institutions could be found in Paris, Berlin, London, Geneva, St. Petersburg, Denmark and Finland, and hundreds of teachers spread his work around the world (Bergqvist 1913).

Aesthetic Gymnastic Branch of Physical Culture

Aesthetic gymnastics is the branch of physical culture that deals with the art of physical and emotional expression, and it includes the sub-branch of vocal culture (otherwise known as vocal or breathing gymnastics). Movement and bodily awareness exercises within the aesthetic branch developed creative expressive capabilities for use in the performing arts or for those who worked in the public arena, including those in government, law and education sectors. The lineage of aesthetic gymnastics reaches back to Greek oratory and theater. The etymology of the word *aesthetics* is rooted in the Greek and Latin words *aisthetikos* "of sense perception" and *aisthanesthai* "to perceive," and the word is also related to kinesthesia – the perception of movement of one's own body and a spectator's perception of the motion of a performer. Within aesthetic gymnastics, inner senses and perceptions and the use of gesture (nonverbal communication) were analyzed and codified for artistic use.

French theorist, orator and educator François Delsarte (1811–1871) is one of the most notable figures to have established an aesthetics system based on the philosophy of expression. As a reputable voice teacher, he taught expressive bodily communication, singing and a system of oratory that included diaphragmatic breathing (see *Delsarte System of Oratory* by his students Abbé Delaumosne and Angélique Arnaud). He is now recognized for having contributed to the lineage of somatic pioneers (Dragon 2008; Eddy 2009a; Johnson 1994; Ruyter 1999; Veder 2011), although much of his influence was carried forward in a unique interpretation through Genevieve Stebbins.

Dance historian Nancy Lee Chalfa Ruyter described how Delsarte's work was influenced by artistic, cultural and social change in the late nineteenth-century western world that was moving from formalistic to expressive approaches in art. Ruyter noted how this cultural exploration of expression included "physical culture, pantomime, dramatics, and interpersonal communication as well as professional training for public speaking" (1973:422).

Just as the physical culture movement involved new ways of working with the body for health, Delsarte created theories about the body as an expressive instrument able to communicate through speech, movement and gesture. After his death his theories were incorporated into aesthetic gymnastics.

Delsarte was a part of the French movement of Realism in art, theater and aesthetic philosophy, which posited that truth and reality could be discovered by the individual through the senses. Artistic aims included finding authentic sources of emotion and creating realistic depictions of human life. Alongside his lectures on applied aesthetics, Delsarte developed a physical system of codified actions designed to help students discover how to embody different emotional and mental states. In her study of American Delsartism, Ruyter also pointed to the spiritual side of the practice, as it was thought that through focusing attention on the "human body as an expressive instrument" the physical nature of the person became a spiritual manifestation of the inner self (1973: 425). Delsarte "spent many years studying the movements, gestures, facial expressions, and vocal behavior of people in all kinds of situations to develop what he hoped was a complete, scientifically-based system of dramatic expression" based on emotional attitudes (Ruyter 1973: 422). Delsarte lectured in Paris from 1839 to 1871, addressing "painters, sculptors, orators, as well as musicians, both performers and composers" (Arnaud and Delaumosne 1893: 201), and "men of letters and scientists" (345). He also coached singers, preachers and a few young actors. The American version of the Delsarte system later spread across the US, Europe and Russia, and was employed by preachers, lawyers, politicians, dancers and actors in their hopes of finding greater expression in their work (Ruyter 1973, 1999). Delsarte never published any material about his methods (Ruyter 1973).[4] His ideas were preserved by a few of his French students and in America were expanded upon in the physical culture system of Genevieve Stebbins (1885, 1888, 1892, 1913).

According to one source, of the 96 Delsarte students traced 22 were singers, 18 instrumentalists and the "remainder in the 3's and 4's were composers, priests, lawyers, authors" and actor, Steele Mackaye (Macdougal 1960: 34). Mackaye (1842–1894) studied directly with Delsarte for seven months in France and became quite close to him as his heir apparent (Ruyter 1999); he integrated Delsarte's philosophies, physical attitudes of expression and "facial gamuts" into a system of practical exercises he called aesthetic gymnastics. It is worth noting that this term was already used in Europe, yet not by Delsarte. Mackaye brought his work to America in 1871, and soon after, Delsarte died. Mackaye's first lecture on Delsarte Expression (in Boston at the St. James Hotel) was attended by hundreds (Mackaye 1927: 148).

In 1877, Mackaye created a short-lived School of Expression in New York with courses in movement training for actors, relaxation exercises, posture work, breathing exercises and training in Delsartian "attitudes of expression." He was soon after invited by his friend Dean Lewis Monroe to Boston University School of Oratory, where he taught between 1877 and 1879. Mackaye incorporated Delsarte's ideas in his work with actors, insisting that dynamic performance relies on the complete integration of bodily expression and the mastery of vocal

delivery. His hope was to teach a "new approach to speech and gesture training and delivery to convey meaning that was in opposition to the mechanical and analytical techniques of traditional elocution" (Couch 2012: 29).

Genevieve Stebbins: Harmonic Gymnastics Innovator

Genevieve Stebbins (1857–1934) became the most established and accomplished educator and performer in the American Delsartean tradition (Ruyter 1973, 1988, 1999). When Mackaye came to the Boston University School of Oratory he invited Stebbins as a young, yet already established, actress to train with him, and she eventually took over his teaching duties (Ruyter 1999). After Monroe's death in 1879, Boston University closed the School of Oratory and Stebbins became a teaching partner with his head assistant Mary S. Thompson (Ruyter 1999). She taught Delsarte Expression at Boston University and in 1879 was "installed as leading lady in the new Madison Square Theater in NYC devoted to the new art [Delsartism]" (Wilbor 1890: 290). Stebbins wrote the first American work on the subject, *The Delsarte System of Expression* in 1885, establishing her as the leading American expert on Delsarte next to Mackaye. Her book went through six editions, and by 1892 *Werner's Voice Magazine* declared Stebbins a leader in the Americanization of Delsarte, proclaiming her "unexcelled in theory or in practice" (Stebbins 1893: 444). It must be made clear that Delsarte never created an aesthetic gymnastic system. Rather, he enunciated indisputable *aesthetic principles* that Mackaye, and more significantly Stebbins, built upon (Ruyter 1999; Soquet 2005). Stebbins drew upon Delsarte's theories to evolve her own unique physical culture system developed over a period of 30 years' work.

Stebbins asked, "How shall the artist translate the passion which he is called upon to express?" (1885: 58). She then went on to describe the purpose of aesthetic gymnastics. In the analysis of nonverbal behavior (semiotics), physical form was but a representation (aesthetics) to be used for artistic purposes. Aesthetics studied the human form in order to "reproduce the form by substituting individual will for its inherent cause" (Stebbins 1885: 58), or in other words, to create art.

Aesthetic gymnastics trained the individual to have embodied experiences and natural expression. Taylor Lake argued that Delsarte training helped students "internalize" actions "by repeating them until they became spontaneous experience" (2008: 7). Stebbins understood that her movement exercises were capable of changing internal attitudes and ultimately were able to mold experience. For Stebbins, "this was art's true psychology" (1913: 133), as the "willful expression of an emotion which we do not feel generates it by generating the sensations connected with it, which, in turn are associated with analogous emotions" (135). She stated that her physical culture system was based on this concept, as to "Practice in guiding the emotions and intellect is the sure road to [personal] power" (136).

Delsartean concepts in the hands of Genevieve Stebbins were used in the service of self-cultivation, as she meant for her work to be applied to any individual's personal evolution and needs. Stebbins also integrated other physical culture influences into her work, notably vocal gymnastics, the Movement Cure, and educational gymnastics. She also contributed numerous personal innovations including expressive dance and creative movement exercises.

Stebbins appears to have been the first American to create her own bodymind system. In her 1892 book *Dynamic Breathing and Harmonic Gymnastics: A Complete System of Psychical, Aesthetic, and Physical Culture*, Stebbins merged exercises in "vital breath" with Delsartean theories and practices, Swedish Ling gymnastic, and spiritual metaphysics. She called the work Harmonic Gymnastics.

Stebbins established her own school in 1893, The New York School of Expression, located at Carnegie Music Hall in New York City. Her school was designed to train students in elocution, dramatic culture and Harmonic Gymnastics. Stebbins pledged to make "every effort will be made to stimulate and bring to perfect fruition *the natural abilities* of the pupil, and direct them to that peculiar sphere best suited for their expression" (1893: 7, original emphasis). Her students were expected to become master teachers of expression and elocution, physical culture teachers of Harmonic Gymnastics, magnetic performers or vibrant public speakers. Stebbins' teachings became foundational for what would later become the somatic field, focusing on self-improvement, the relationship between the emotions and physiology, genuine personal expression, harmonious deportment and the stimulation of natural abilities in the pupil. Graduates of Stebbins' Harmonic Gymnastic program moved on to develop their own methods that were precursors to somatic systems, including Hade Kallmeyer and Bess Mensendieck (Ruyter 1999; Mullan 2016). Elsa Gindler was a student of Kallmeyer's Harmonic Gymnastic program in Germany. Gindler is commonly credited as the earliest originator of somatics (Eddy 2009a; Geuter et al. 2010; Hanna 1979; Johnson 1995; Mullan 2014; Murphy 1992; Young 2010). While the term somatics may have been coined in the twentieth century, it nevertheless incorporates numerous practices of self-cultivation rooted in nineteenth century physical culture.

Figures 15–16: (left) Medical Gymnastik, Swedish School of Sport and Health Science. Courtesy of Gymnastik-Och Idrottshogskolan Biblioteket (Swedish School of Sport and Health Science Library); (right) Genevieve Stebbins. Courtesy of *The New York School of Expression Prospectus*, 1893.

Notes

1 Duncan is now considered by some of her protégés as a somatic educator. Certainly much of her dancing could be considered somatic by its nature of free expression.

2 As mentioned in the prior chapters, Mensendieck's system influenced Ida Rolf's development of Rolf Movement.

3 The book later appeared in America, but was incorrectly attributed to Salzmann by the American publishers (Todd 1998).

4 More detailed scholarship on Delsarte can be found in 'Essays on François Delsarte', *Mime Journal*, 2004/2005 (Ruyter 2005), and in the works of Nancy Lee Chalfa Ruyter, Alain Porte and Franck Waille.

Chapter 5

Global Roots of Somatic Movement: Asian and African Influences

Sangeet Duchane

Global Roots of Somatic Movement: Asian and African Influences

> Many of the respiratory techniques taught today are from cultures other than our own. Their exercises, developed over thousands of years, are based on psychosomatic effects suited to a certain time and a particular culture, and they were taught by masters working with their disciples under special conditions. Our situation is very different. We have to find methods that correspond to our culture that can liberate the breathing process. People should be capable of understanding the physiological and mental influences of breathing with the help of the latest scientific findings.
>
> (Gerda Alexander quoted in Johnson 1995: 286)[1]

As discussed in Chapter 1, somatic education is a relatively new term – coined in the late 1960s by Thomas Hanna. However, the concept of paying attention to physical sensation in order to bring balance to the body and mind is not new. It has existed through the millennia. What *has* varied is how this information is delivered, and the extent of its usage. Nor did somatic education of the twentieth century arise in a vacuum. The somatic pioneers of the first two generations were influenced by work and practices from earlier times, both within and outside their own cultures. There were significant influences from eastern cultures – examples include concepts such as the use of breath tantamount within yoga practice (as in the work of Ida Rolf), the grounding in tai chi and chi kung (as in the work of Irmgard Bartenieff), the reflexive responses of judo (as in the work of Feldenkrais), and the autonomic responses in Katsugen Undo (as in the work of Bonnie Bainbridge Cohen). The understanding that movement can be part of a cure is a baseline that is shared in many cultures, especially cultures where dance continues to thrive. As in the Continuum work of Emilie Conrad, somatic ideas may be sourced from ancient and indigenous cultures. These long-standing movement traditions are practiced, appreciated and elaborated upon in unique ways within somatic paradigms from the founding generations through to the new "amalgam," somatic systems that are being developed each year.

This chapter covers the techniques and practices originating in the East that influenced early teachers or that are widely popular and are now informing the development of new systems of somatic education. Indeed, the spread of ideas has been accelerated by technology such that the developments of amalgam techniques in somatic education found today have been influenced by even more varied practices than those from earlier generations.

Influences from the East or West impacted the first generation at approximately the same time. The research for this book also revealed that some of the eastern traditions that are

being practiced today were later influenced by German and Northern European movement systems from the nineteenth and twentieth centuries. Research also shows that several eastern techniques took on a healing aspect for the "common people" at about the same time the Movement Cure was happening in the West. Prior to that the engagement in exercise also had a military goal – preparing men to be able warriors, just as in ancient Sparta. Throughout their development, both the eastern and western approaches to movement recognized that movement could benefit health. Sometimes the health benefit is a social one, as in Aikido, a non-violent martial art form developed in the twentieth century that has influenced Contact Improvisation and many newer forms of somatic education. There are other twentieth century eastern developments, such as Sotai and Jin Shin Jitsu, that have emerged from personal somatic inquiry; health investigations that eventually were systematized to foster the use of self-touch and movement in self-help for greater health (Hashimoto and Kawakami 1983).

Additionally, the valuable contributions from places outside the US and Europe have at times been incorporated because of the global history of colonialism – appropriating and claiming other cultural assets. Generally somatic education has had an ethnocentric focus with predominantly Euro-American perspectives. This is shifting due to globalization with more exchange of practice across continents, disciplines, scholarship and cultures. It can be assumed that people who study somatic education today have experiences that include an amalgam of input. This begs another important point – the need to cite sources of movement experiences. Given that movement is experienced in the moment and is impermanent, it is recommended that teachers, lecturers and practitioners orally cite their sources of learning during lessons as well as in any written supporting handouts to help students trace lineages (Eddy 2000a, 2015). This chapter seeks to acknowledge numerous global influences on the evolution of somatic practices; expert Sangeet Duchane provides an overview of the major influences.

Influences on Somatics from India, China, Japan and Africa

Sangeet Duchane

India's Contribution: The Ancient Roots of Yoga

The word *yoga* is synonymous in much of the West with a form of physical practice involving postures or *asanas*. In Indian cultural history yoga has a much broader meaning, covering a complex philosophy of religious thought. Yogic philosophy, though often referred to as Hindu, has roots much further back to early Brahmanism and perhaps to an even earlier shamanism.

Archeological evidence has produced ancient stone seals dated to around 3000 BCE, which depict seated figures in set poses (Diamond 2013). Whether these seated poses are an indication that a postural form of yoga existed 5000 years ago is disputed (Newcombe

2009). David Gordon White, a professor at the University of California at Santa Barbara, says, "since we find ancient images of figures in identical postures from such far-flung places as Scandinavia and the Near East, we cannot assume that any of them were intended to represent yoga practitioners" (White 2013: 35). Nonetheless, some practitioners of postural or asana-based yoga continue to claim the practice is 5000 years old.

The earliest written record of a yogic religious philosophy appears in the Vedic Period (circa 1750–500 BCE). Gordon White points out that the term yoga, used in the *Rig Veda* (circa fifteenth century BCE) "did not denote either meditation or the seated posture, but rather a war chariot" (White 2013: 35). It was more than a millennium later that a new meaning was recorded:

> Later strata of the *Mahabharata* (circa 200–400 CE) record another, more familiar use of the term *yoga* [...] While these practices were referred to as "meditation" in early Buddhist and Jain sources, the Hindu *Kathaka Upanishad*, a scripture dating from about the third century BCE, describes them within the context of a set of teachings on yoga. In these teachings, the link between meditation as a means for reining in the mind and the "yoga" of the ancient chariot warrior is a clear one.
>
> (White 2013: 36)

The first writing that talks directly about postural yoga practice, Patanjali's *Yoga Sutras*, were written around the second century BCE. In this sutra Patanjali describes an eightfold (*ashtanga*) yoga, as contrasted to sixfold (*shadanga*) yoga described elsewhere (Wallace 2011). These systems share the practices of breath control, withdrawing the senses, meditation, fixing the mind and perfect contemplation. Patanjali substituted the practice of seated postures (*asanas*) for rational inquiry and added two sets of ethical practices (White 2013).

We have little information about what the practice of asanas might have been in Patanjali's time. The evolution of yoga in the following centuries is a complex one, often including magic and tantric practices, recorded in art of the time (Diamond 2013). These practices involved burial grounds and rituals that were strange to outsiders, so that tantric yogis became stock villains in medieval Indian literature (White 2013).

There are also references to the asana practices in medieval and fifteenth- to sixteenth-century manuscripts. The earliest known illustrated manuscript depicting asanas still in existence is dated 1734 (Newcombe 2009). Early western empire builders who examined yogic philosophy tended to describe practitioners as degenerates or armed mercenaries. "By the eighteenth century, armed 'ascetics' formed the great bulk of the north Indian military labor market" (White 2013: 42).

Indian philosophy and religious thought and practice were heavily impacted by western influences during and after the sixteenth century, when the empire builders began to arrive. In 1539 Jesuit priests arrived in the Goa area from Portugal, bringing the religion of Christianity. By 1560 an Inquisition had been established (Dellon and Bower 1819).

In 1756 the British colonial period in India began, becoming the formal British Raj in 1858. Oxford scholar Mark Singleton points out that numerous travelogues of India in the

seventeenth century demonstrate that ascetics or people who practiced "strange" postures and religious rituals were regarded with feelings ranging from disdain to disgust by European travelers (Singleton 2010). As a result, by the end of the eighteenth century there was a gap between prior yogic practices and British-influenced Indian culture. It is unclear how much information about past postural yoga practices survived that period.

Yoga into the Twentieth Century

The West's perception of Indian thought went through a revolution in 1893, when Swami Vivekananda attended the World Parliament of Religion at the Art Institute of Chicago, part of the World's Columbian Exposition (Hammond 2007). Vivekananda presented a version of yogic thought aimed at a western audience, and he produced a popular sensation in the US and UK through his lecture tours in 1895 and 1896. Vivekananda did not talk about a postural form of yoga practice, but he opened the doors to new ideas from India.

According to Smith and Eddy (2015), while there was a period when the practice of asanas was relegated to the periphery of society, including members of the circus:

> The resurrection of Yoga asanas in India as a health-giving practice (versus use in circus or entertainment) is attributed to a group of Indian doctors and bodybuilders during a movement in the 1920s who sought to use Yoga for health, fitness, and happiness. For instance, in 1929 the Sun Salutation – known in Sanskrit as Surya Namaskar – was published in a magazine as a bodybuilding practice.
>
> (2015: 5)

In 1920 Parmahansa Yogananda, author of *Autobiography of a Yogi*, came to the US and began to teach a form of yoga that involved using the mind and breath to direct attention and energy to the spinal cord, the approximate location of the chakras or energy centers. This practice was originally called yogoda, but the name was later changed to kriya yoga (Hammond 2007). In 1929 the Theosophical Society brought Hari Prasad Shastri to lecture on yoga in London (Newcombe 2009).

Indra Devi learned a form of hatha or postural yoga from Sri Krishnamacharya and was the first teacher to bring his form of yoga to the US in 1950. Krishnamacharya's influence would continue to be significant in the West through his other students. According to Ruiz:

> Krishnamacharya's influence can be seen most clearly in the emphasis on asana practice that's become the signature of yoga today [...]. In the process, he transformed hatha – once an obscure backwater of yoga – into its central current. Yoga's resurgence in India owes a great deal to his countless lecture tours and demonstrations during the 1930s, and

his four most famous disciples – Jois, Iyengar, Devi, and Krishnamacharya's son, T. K. V. Desikachar – played a huge role in popularizing yoga in the West.

(2007)

Krishnamacharya is also significant because Singleton has argued that Krishnamacharya's form of asana practice was influenced by western approaches to movement (Singleton 2010, 2011). When Pehr Ling's gymnastics, and the related work of the Danish Niels Bukh, became popular in Europe (see Chapter 4), the British appear to have brought the movement practices to India, promoting them as avenues to good health. In the 1920s a survey by the Indian YMCA reported that Ling's gymnastics was the most popular form of exercise in India, with Bukh's Primitive Gymnastics coming second (Singleton 2011).

Krishnamacharya's patron in Mysore beginning in 1931 was the Maharaja of Mysore, Krishnaraja Wodeyar, who promoted the European forms of gymnastics at the same time he was promoting yoga (Newcombe 2009). Singleton has noted similarities between some asana forms used by Krishnamacharya and gymnastic poses used by Bukh, as well as a similarity in the way the practitioner in the two systems moves from one position to another (Singleton 2010, 2011). He said:

One only has to peruse translations of texts like the *Hatha Tattva Kaumudi*, the *Gheranda Samhita*, or the *Hatha Ratnavali*, to see that much of the yoga that dominates America and Europe today has changed almost beyond recognition from the medieval practices. The philosophical and esoteric frameworks of premodern hatha yoga, and the status of asanas as "seats" for meditation and pranayama [breathing practice], have been sidelined in favor of systems that foreground gymnastic movement, health and fitness, and the spiritual concerns of the modern West.

(2011)

Singleton's argument has been unpopular in some yoga circles, and other scholars claim that a continuity in thought can be traced from the *Yoga Sutra* to modern yoga practices (Newcombe 2009). Nonetheless, Singleton's argument would lead to the unsurprising conclusion that ideas and influences between England and India were going back and forth, not in only one direction, and that twentieth-century Indians may well have drawn on their immediate experiences to revitalize practices largely lost under colonial rule. The extent of European influence will continue to be debated by yoga historians.

Still, the link between movement/posture and meditation arose out of an initially Indian understanding of ancient texts, such as Patanjali's *Yoga Sutra*, and so were different from the European forms of gymnastics, in that they contributed to the mix of ideas about movement, the body and inner reflections on both, that was taking place around the world.

Ruiz comments:

> The yoga world Krishnamacharya inherited at his birth in 1888 looked very different from that of today. Under the pressure of British colonial rule, hatha yoga had fallen by the wayside. Just a small circle of Indian practitioners remained. But in the mid-nineteenth and early twentieth centuries, a Hindu revivalist movement breathed new life into India's heritage. As a young man, Krishnamacharya immersed himself in this pursuit, learning many classical Indian disciplines, including Sanskrit, logic, ritual, law, and the basics of Indian medicine. In time, he would channel this broad background into the study of yoga, where he synthesized the wisdom of these traditions.
>
> (2007)

As yoga moved into the West it began to be presented as a health practice, not necessarily connected to Indian religious philosophy. An Indian teacher, Yogendra, taught yoga as a health practice in Harrison, New York in 1920–1922 (Newcombe 2009). In 1950 Richard Hittleman, a student of Ramana Maharshi, returned to New York from India and began teaching an asana-based form of yoga practice. In 1961 he brought this practice to American television, promoting yoga's health benefits, rather than its spiritual basis (Hammond 2007).

In the late 1950s more Indian teachers, such as Swami Vishnu-devananda, a disciple of Swami Sivananda Saraswati, came to the US. Vishnu-devananda published his well-known book, *The Complete Illustrated Book of Yoga*, and began opening Sivananda yoga centers. A few years later the Beatles created a sensation about Maharishi Mahesh Yogi's Transcendental Meditation, fomenting an Indian fashion in the US and Europe in everything from spiritual practice to bedspreads, clothing and incense.

75 years after Vivekananda spoke in Chicago, Swami Satchidananda opened the famous Woodstock music festival in 1985. Westerners (like the former Harvard Professor and neighbor of Charlotte Selver, Richard Alpert, who became the yoga teacher Ram Dass and published *Be Here Now*) also contributed to the spread of Indian religious ideas. By the 1970s yoga studios and centers were spread across the US and Europe, with many different forms and approaches. By 2008 the number of yoga practitioners was estimated at 2.5 million in Great Britain and 15 million in the US (Newcombe 2009).

As somatic movement training programs grow in scope there is a steadily growing subset of yoga teachers who take a somatic approach in the US through Europe to Australia. Other Asian movement practices have an equally potent history with somatic education.

Internal Arts from China: The Legend of Tai Chi Chuan

Tai chi chuan (often called tai chi in the West), like many other forms of ancient movement practices, arose from a military-based context. In China that meant the martial arts, used by soldiers and monks alike.

There are several unsubstantiated legends about how tai chi chuan was developed, but the most popular says that a thirteenth-century Taoist monk named Chan San Feng created tai chi chuan. The story goes that Chan San Feng had been a Buddhist monk trained in the "hard" martial art of Shaolin (a Buddhist temple), but he wanted a "softer" method of training. A softer method meant the inclusion of an internal component of practice: watching the self. Legend also says that Chan was trained in Confucianism, Buddhism and Taoism, so that tai chi arose out of all three streams of thought.

At the Taoist monastery on Mount Wudang, Chan is said to have witnessed a battle between a crane and a snake. Though the bird was many times larger, the snake's movements eventually exhausted the bird and it flew away in search of easier prey. Chan San Feng is said to have combined the snakes "softness" with his expertise in the "hard" martial arts (Hine Tai Chi School 2014).

Tai chi chuan remained lost in the mists of time for several hundred years until the eighteenth century. A man named Wang Sung-Yeuh is said to have brought the techniques to Honan Province during the Ch'ien Lung period of the Ch'ing Dynasty (1736–1795). He wrote a *Treatise on Tai Chi Chuan*, which is still read today in China. There are various legends about the transmission of the practice, but historians know that the technique can be traced to his family in Wenxian County, Henan Province and that Chen Chang Hsing is considered the founder of the Chen style of tai chi. Many other tai chi style variations were developed after this point in history (Douglas 2002: 58).

It is also known that a man named Yang Lu Chan learned the Chen style, though there are various legends about how that happened. History shows he was invited to teach it to the Chinese Royal Family. He taught the style to his sons, as was the tradition in martial arts families. This was the beginning of the Yang style of tai chi, which is the style most widely practiced in the West.

At the time Yang Lu Chan passed on his linage, it was still primarily a martial art, drawing on Chinese religious philosophy as all the martial arts did. According to authors and international tai chi teachers Freya and Martin Boedicker, it differed from other systems because instead of using force against force, it overcame movement with stillness (Boedicker and Boedicker 2014), so that the weaker or elderly could easily repel the stronger. This required an internal focus on the part of a practitioner, and this inner focus would lead to other applications of the movement form.

"With the use of four ounces one can easily deflect a thousand pounds," shows that one should win without the use of force. Behold, an old man beats away several enemies. How can this be by fastness (*Taijiquan-Lilun Journal* 2, p. 8).

(Boedicker and Boedicker 2014)

and

In the *Taijiquan Classic* it is stated: *Taiji* is born out of *wuji*. It is the origin of movement and stillness and the mother of yin and yang. In movement, it separates; in stillness, it unites (*Taijiquan-Lilun Journal* 2, p. 8).

(Boedicker and Boedicker 2014)

It was Yang Lu Chan's grandson, Yang Cheng Fu (1883–1936), who brought tai chi out of the realm of the martial arts. He simplified the practice and promoted it as an aid to both physical and mental health for ordinary people, teaching it to hundreds of people throughout China (Hine Tai Chi School 2014). As a result of his efforts, the practice of tai chi spread throughout China, and groups of people of all ages and stations of life can be seen today practicing it daily in public places.

In 1964 Cheng Man Ching (1901–1975) moved from China with his family to New York, where he opened a school of Yang style tai chi at 211 Canal Street and then at 87 Bowery in the city's Chinatown, with the help of several American students. Cheng also taught students in the C. V. Starr East Asian Library at Columbia University. Other teachers soon followed.

The health and well-being approach to tai chi practice prevalent in the West has provoked discussion of whether self-cultivation, health or martial arts should be emphasized. Freya and Martin Boedicker argue that this is not a new question:

> Interestingly this issue is already commented in classical texts of Taijiquan. Thus, e.g. in the *Explanation of the Three Achievements of the Cultural (wen) and the Martial (wu) of Taijiquan*: The cultural (*wen*) is cultivated internally and the martial (*wu*) externally. Those who practice the method of cultivation equally internally and externally, will gain great achievement. This is the higher path.
>
> Those who gain the martial of fighting through the culture of physical education, or those who gain the culture of physical education through martial fighting are on the middle path. Those who know only physical education without fighting, or those who want only fight without physical education are on the lower path (*Taijiquan-Lilun Journal* 3, p. 9).
>
> (Boedicker and Boedicker 2014)

Chi Kung

Chi kung (also qigung) has such a varied history that even the legends take too long to tell. Basically, chi kung means working with chi (qi) or vital energy. This has been done in a variety of ways by a variety of groups through Chinese history over the past 5000 years. It is possible to trace a few milestones about the awareness of chi and the different groups who were engaged in working with it.

People are shown doing exercises resembling modern chi kung exercises in ancient rock paintings in many parts of China. There is a legend that a mythic emperor named Yu once cleared the land of a great flood by dancing and invoking the power of the Big Dipper. Legend says this taught people about internal rivers of energy as well (Cohen n.d.).

In the fourth century BCE the book the *Tao Te Ching* (*Dao De Jing*) was written and became the basis of Taoist practice. The book is attributed to the philosopher called Lao Tzu (Laozi), though modern scholars think it highly unlikely that the book was written by only one person (Lau 1963). The book recommended becoming aware of chi and making the body supple.

Over time chi kung was developed for different purposes. Within Chinese medicine it was used to heal and vitalize people, and in the martial arts to improve strength, stamina and so on. Cohen describes chi kung as follows:

> We live in a field of qi, "vital breath" or "life energy." Yet, like a fish in water or a bird in flight, we are unaware of the medium that supports us. Qigong means "working with the qi." It is the ancient Chinese art and science of becoming aware of this life energy and learning how to control its flow through a precise choreography of posture, movement, respiratory technique, and meditation.
>
> (n.d.)

This description makes it self-evident why chi kung provided support and inspiration for western somatic practice, both in terms of philosophy and of technique.

Japanese Contributions: The Evolution of Jujitsu

Judo

Japan's contributions to the milieu that produced the first somatic movement techniques came later than those of India and China. The earliest Japanese tradition that is recorded as a contribution is judo, which was not developed until late in the nineteenth century, but it traces back to the more traditional art of jujitsu (or jujutsu). The creator of judo, Jigoro Kano (1860–1938), lived at the time of the Meiji Restoration. When the Tokugawa shogunate fell in 1868, jujitsu was becoming unpopular in an increasingly westernized Japan, so Kano had difficulty finding teachers. Once he had learned the techniques he opened a school in 1882 with one of his instructors at a Buddhist temple in Tokyo that would eventually become Kodokan, the center of judo (Bishop 1995).

Aware of the negative reputation of jujitsu, Kano redefined his practice, which he called judo. He promoted it with three aims: combat, moral education and physical education. The first two purposes were already claimed by jujitsu and other Japanese martial arts under principles of Confucianism. Kano's emphasis on fitness could be traced back to early Chinese martial arts influences, where making the body fit, healthy and strong was a major purpose (Hoare 2007). The Japanese word *jitsu* (or *jutsu*) indicates a link with a military or war-based fighting method, while *do* means *way*. A *do* practice has a spiritual or self-improvement connotation. John Bishop says, "One could perhaps summarize and simplify the difference

between the two by saying that 'Jutsu' styles are concerned with defeating the opponent; while 'Do' styles are concerned with defeating one's self" (1995).

In the 1930s two teachers were instrumental in spreading judo in Europe. Mikonosuke Kawaishi toured the US and taught jujitsu in New York and San Francisco before moving on to the UK in 1928, where he set up a school in Liverpool with his friend Gunji Koizumi. Koizumi had already established a Budokwai Club in London and a school at Oxford University.

In 1931 Kawaishi moved to London and established the Anglo-Japanese Judo Club and joined Koizumi, who was teaching at Oxford. Kawaishi then moved to Paris in 1936, where he was hired to teach jujitsu to the French police and opened a school of jujitsu and judo in the Latin Quarter (Papenfuss [1995] 2014). One of his students was Moshe Feldenkrais, and they founded the *Jujitsu Club de France* that same year, which later became the Federation Française de Judo et Jujitsu (FFJJ) (McPartland 2012).

During the war Kawaishi attempted to return to Japan, but was captured and imprisoned in Manchuria. He returned to Paris after the war and developed a teaching style particularly for westerners. In Japan the Kodokan was moving away from jujitsu toward judo, banning certain moves, which Kawaishi continued to use. This created disputes and political splits with the Kodokan-based group. Kawaishi continued to help direct the judo federation in France, and with his old friend Gunji Koizumi organized the first international judo tournament between France and the UK in 1947 (Papenfuss [1995] 2014).

After the Allies had experienced combat with Japanese soldiers in World War II, there was a major interest in Japanese fighting techniques in the US. The American Supreme Air Command (SAC) brought judo instructors to the US. From 1945 to 1965 a major expansion of judo took place throughout North America and Europe.

Aikido

The next form of practice to emerge in Japan was Aikido, which was officially made a martial art in Japan in 1942. It was developed by Morihei Ueshiba (1883–1969), who had studied several forms of jujitsu as well as sword and spear fighting techniques. He eventually combined movements from several forms of martial arts, but his greatest influence was *Daito-ryu Aiki-jujutsu*.

He studied this form with Takeda Sokaku. Sokaku was a renegade fighter from an ancient martial arts family who had killed many opponents in challenges, so the government sent him to the Hokkaido frontier to help keep the peace. There he met Ueshiba, who studied with him for four years (Stevens 1996).

Then Ueshiba met a Shinto monk, Oni Subaro Deguichi, from the Omotokyo sect of Shintoism and soon became one of Deguichi's most devoted disciples (Bishop 1995). Ueshiba studied chanting, poetry and calligraphy, for Deguichi taught that art equaled religion (Stevens 1996).

This influence led Ueshiba to create a new form of technique in the 1920s, which he originally called akibundo, but which was later called Aikido. In this form the practitioner moves with the force of an attack until that force dissipates, and then redirects that force, using certain techniques. The purpose is to protect both the practitioner and the attacker from harm (Bishop 1995), so Aikido has been called a martial art for peace and Ueshiba is credited with integrating harmony and a nonviolent martial art (Abbott and Elson 2006).

His peaceful martial art was taught in an increasingly militarized Japan between the world wars. At the end of World War II, Aikido was still practiced by only a few Japanese. It began moving into the West in the 1950s. Minoru Mochizuki took it to France in 1951, followed by Tadashi Abe in 1952. Kenji Tomiki toured the mainland US in 1953, while Koichi Tohei spent a year in Hawaii. Visits by instructors were made to the UK in 1955, Italy in 1964 and Germany and Australia in 1965. Masamichi Noro was named the official delegate for Europe and Africa in 1961 (aikidohistory.com n.d.).

A compilation of Ueshiba's sayings has been published in English as *The Art of Peace* (Ueshiba 1992). The quotes were compiled by one of Ueshiba's disciples, John Stevens.

Japanese Internal Movement: Katsugen Undo

A twentieth-century Japanese movement technique that has influenced somatic movement was created as a healing technique by Haruchika Noguchi (1911–1976) to use in his healing practice. The name means something like "movement from within," and the technique involves triggering spontaneous movements ostensibly of the autonomic nervous system. Similar to Authentic Movement, people move slowly and with eyes closed in a large room together to balance the body and release repressed feelings and tensions. These movements may be initiated by following the rhythm of leader, preparing with prescribed exercises and/ or the experience of hands-on energy work by a healer. Katsugen Undo is not widely known in the US and is beginning to be known in Europe.

Another form of Japanese healing movement is Sotai. Dr Hashimoto worked with exercises that retrace a pathway of muscular misuse until it releases. This work shares basic concepts with somatic education, such as clear observation of movement in space, the goal of releasing muscles, the ability to reverse movement and make choices to change habits (Hashimoto 1977).

Influences of Japanese Dance: Butoh

Post-World War II Japan was a place of much chaos and change. Occupation forces were imposing western ideas of democracy, while some Japanese tried to hold onto traditional values and practices. Many national figures were in disgrace, and students and artists were in the streets. Theater and dance groups sought ways to express themselves in the midst of this turmoil.

Modern dancers Tatsumi Hijikata (1928–1986) and Kazuo Ohno (1906-2010) created an avant-garde theater/dance/mime form called Butoh. It was launched in 1959, when Hijikata gave a homoerotic performance of *Kinjiki* (Forbidden Colors) with Ohno's son, Yoshito (Fraleigh 1999).

Hijikata wanted a Japanese modern dance form that was not just copied from the West, but was uniquely Japanese. The idea behind this form was to allow the body to speak for itself through improvisation not guided by the conscious mind. This was initially called *Ankoku Butoh*, or Dance of Darkness, which referred to the forces hidden in the body and unconscious mind (Fraleigh 1999). Like Katsugen Undo, it often begins slowly but can have rhythmic outbursts. In the history books, Butoh dancing is sometimes aligned with the German Expressionist movement of Laban and Wigman descent, known as *Ausdruckstanz*.

Dance Out of Africa

Africa is the second largest continent, has one-fifth of the earth's land and a significant segment of the planet's population and has had more impact on the rest of the world than it is often credited with having. This is particularly true of African dance. Dance has played a major role in African culture since before historical times. It was not just used for performance, but for ritual, healing, connection within the group and with the ancestors and cosmos and for preserving the group identity. Traditional dances expressed emotion, celebrated significant events (rites of passage, births and deaths), healed and brought the group closer together in a shared identity. There is no single form of African dance, but many forms from varied cultures. Due to political influences on national boundaries, these often do not correspond to particular cultural groups, so that cultures and dance styles cross political borders (Welsh 2004).

African dance differs from the dance of other places because it tends to be polycentric, which means that different areas of the dancer's body are able to move in different rhythms with the music at the same time. Though there are similarities such as this in African dance forms, different styles and kinds of dance evolved among different groups on the huge continent (Miller 2006–2014).

In the sixteenth century the advent of the African slave trade not only caused the spread of African culture, including dance, to other parts of the world, it created new combinations and new forms. The captured and enslaved Africans were taken to North and South America, the Caribbean, and to Spain and Portugal. People from different areas of Africa were enslaved together and exposed to varieties of African dance, as well as to European-based dance forms. Slaves outside of North America were given more freedom to use expressive dancing, which resulted in the development of unique dance traditions in places like Brazil and the Caribbean. The African people used their dances to preserve their cultures and their traditions, and ended up having a major impact on the dance forms of the regions where they came to live (Miller 2006–2014).

African dance is now taught and celebrated around the world, and major cultural events like Carnival and Mardi Gras have been heavily influenced by these dance forms. Dance also plays a significant role in the life of Haiti, where it is used in celebration and religious ritual as well as plays a major role in social life. This tradition would eventually have a great impact on one somatic dance pioneer.

One of the most well known Haitian dances is yanvalou, which is a ritual "sacrifice" dance from the Voodoo (also Voudou, Voudon and other spellings) religion, honoring the snake god Danbala.

Writer Elizabeth Barad describes the importance of this dance:

> Voudon is a "danced religion." Beauvoir, the president of the National Body of Voudonists, explained that "in voudon we sacrifice to the gods, but the top sacrifice is dance. The greatest gift is one's entire being." [...] For politically oppressed Haitians the danced joy of their ceremonies keeps hope alive. The spirited movements of a ceremony also inspired Haiti's revolt in the early nineteenth century against its colonial rulers, making the country the first black republic in the Western hemisphere.
>
> (Barad 1994)

An African-American anthropologist, Katherine Dunham (1969), used Haitian dance as an inspiration for her own choreography. She described her first experience of yanvalou:

> The initiates – dressed in white, heads wrapped in white kerchiefs – were moving like white waves: Their knees were bent, their hands on their knees, their backs constantly undulating, and their shoulders rhythmically rising and rolling away from their bodies. They moved to the beat of the drums, which started slowly and burst into a feverish pitch.
>
> (Barad 1994)

Though Africans were not allowed as much freedom to preserve their dances in North America as in other regions (as in Brazil, where Capoeira emerged as a way for slaves to preserve their culture and strong bodies), their traditions significantly influenced popular dances like tap and the Charleston, and continue to influence many modern styles. African dance forms brought a new movement vocabulary, an orientation toward the earth, polyrhythms, percussion, pantomime, call and response and other qualities to European-based dancing, which have become part of the world's cultural milieu (Glass 2007).

Conclusion

Dance has been part of the healing toolkit of many traditions. Aspects of movement and dance from diverse cultures from antiquity up into the colonialist periods around the world have permeated somatic philosophy and somatic methods, and continue to do so today.

Seymour Kleinman's work in Somatic Education at the Ohio State University
(Based on an interview with Martha Eddy 22–24 April 2002)

The life story of Seymour (Sy) Kleinman, Professor Emeritus of the Somatic Studies program at the Ohio State University (the OSU) informs social somatics through the integration of philosophy, the East–West connection, physical education and dance.
Kleinman tells the following story:

> I often begin the first class by asking, "Where is your mind?" Usually, the students will immediately point to (or place their hands on) their heads. However, several years ago one person offered a different response: He placed his hand on his heart. He also happened to be the only one in the class who was not an American. He was an African student from Nigeria.
>
> (Kleinman 2001: 1)

Kleinman began his career as a professor of physical education. He studied at Brooklyn College and taught ballroom dance as part of his teaching assistant work. When his professor from the OSU retired, Kleinman was selected to teach the graduate research course. He was already actively dancing as he began his academic career. He revealed that dance gave him a different concept of "bodily being in the world." As a professor at the OSU he tried out for *West Side Story* and performed in it, joining the university dance company as a performance outlet. He then began to take courses in the dance program at the university with studies in dance history, dance technique and Labanotation with Lucy Venable (Labanotater and Alexander teacher) who was working on the development of a social dance book with notation of the rumba and the waltz.[2]

Kleinman had other experiences that informed his interest in somatic studies. He studied diverse approaches to physical education and also coached tennis. He became involved with the study of philosophy through the influence of his wife who studied Kierkegaard as a philosophy major. He became particularly interested in existential phenomenology; often publishing articles in professional physical education journals on this subject. Then he received a Fulbright scholarship to study Rhythmic Gymnastik in Jyvaskyla, Finland. This Fulbright experience in 1961–1962 was a watershed experience. He taught and coached the Finnish basketball team and became close with the host faculty member. They went into elementary and high schools and immersed themselves in the Finnish educational, recreational and sports culture. His wife, Jackie, introduced synchronized swimming (then referred to as Water Ballet). They also did a performance to the score of *Porgy and Bess*. They upset the leading basketball (men's and women's) teams with their different approach to defense strategies. In

observing schools in Finland he found that the physical education classes were creative, performance oriented and had the aesthetic qualities in much the same ways that one sees in dance education in England or the Americas. He recognized that this approach in Finland was similar to the Movement Education work happening in schools in England and believed it was developed out of the same German Rhythmic work. He noted that this period included mass demonstrations in outdoor fields related to the Laban movement choirs from the 1920s and 1930s.

Later Kleinman became familiar with Dalcroze and Wigman through his studies of dance and dance history and from Labanotation he began to see more links between European approaches to physical education, movement education – the Laban-based approach to early childhood physical education that is still used in Britain and Canada and to a small degree in the US – and Laban-based dance education. He returned to Europe to study more Laban movement work, spending time in classes and socializing in London at the Art of Movement Studio with some of the classic teachers; including Samuel and Susie Thornton, protégés of Rudolf Laban who specialized in community dance and movement choirs. After this exposure he became aware of Irmgard Bartenieff, Laban's protégé in New York. He also found colleagues in the physical education department who were teaching movement education.

> Naomi Allenbar was teaching the movement classes for the girls and integrating a British approach […] These worlds really opened me to a much more sophisticated approach to learning and teaching […]. I was taking what I saw in Europe and with the dance and movement education teachers at the OSU and put it into my teaching in physical education. […] I was seeing in physical education the same thing that attracted me to dance – art, creativity, and ways to take this to children […] it was not just sport.
>
> (Eddy 2004)

In the late 1980s Kleinman created a program where students could study the nature of human movement, human movement theory, concepts of the body, and merge the theoretical with the experiential. He drew many of the theoretical constructs from philosophy but recognized that philosophers generally were not involved in learning experientially.

> I got really interested in what the Europeans defined as physical culture – culture in the sense that we use the word in the arts – it imparts the notion of being cultured, rising up above the primitive. I sustained the use of the word culture [in the development of his somatics department].
>
> (Eddy Interview 2012)

He also developed a friendship with a colleague in Denmark who specialized in Scandinavian Physical Culture, offering workshops on the theoretical aspects through a humanistic approach to sport. This evolved into an annual three-week student exchange with students from the OSU going to Denmark. Simultaneously he had more exposure to the martial arts. His program was attracting students from Korea, Taiwan and Japan, as well as Asian-Americans.

Kleinman had become interested in the literature coming out of the West Coast and the writing from Esalen on somatic bodywork (Thomas Hanna, Michael Murphy, George Leonard). He felt that "somatic" was the term that was appropriate for describing the type of movement studies he found in Europe and was experiencing in parts of the US and that allowed for further investigation of the Asian martial arts. Gradually, through the 1980s Kleinman began to use the term "somatic" popularized through the West Coast thinkers to describe the overall synthesis of diverse studies in consciousness and awareness. He used Hanna's definition of somatic, "the body as experienced from within." He attended numerous conferences and was invited to teach at Esalen. He made a natural shift from a focus on the Movement Arts to Somatic Studies.

Notes

1 Gerda Alexander in discussion during her lifetime, in the 1930s–1960s.
2 As described by Nettl-Fiol in Chapter 9, studies at the OSU included learning choreography from Labanotation scores. Kleinman performed Doris Humphrey's *The Shakers*, with Venable monitoring the reconstruction. During Kleinman's early tenure other guest artists came, including Anna Sokolov setting the dance piece *Odes*. Venable then brought the Dance Notation Bureau extension to the OSU. The OSU dance department had begun within the women's physical education department and during this period (1960s) the university restructured and moved dance into the College of the Arts; Helen Alkire came to chair the department. Kleinman describes her as "the kind of woman that was capable of creating a highly specialized program, having worked with Louis Horst and on her doctorate at Teachers College."

Part 2: The Emergence of Somatic Movement Education and Therapy

Lineage of Somatic Movement Leaders

© Martha Eddy 2016

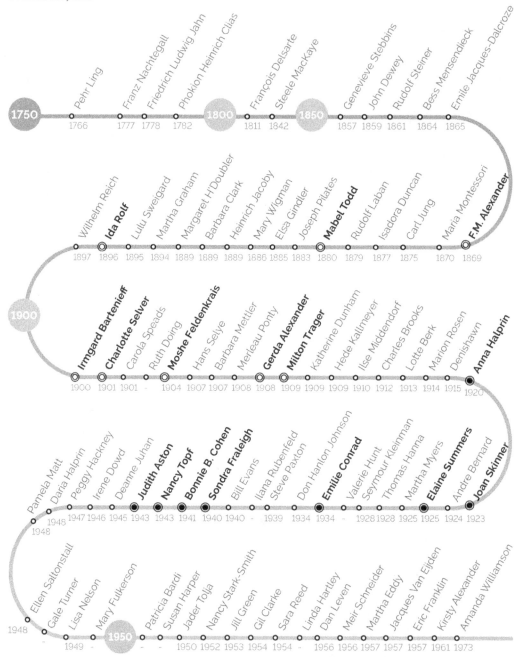

Figure 17: First and second-generation founders of Somatic Movement certifications still operative today (names in bold). Please contact Martha Eddy for permission to reuse for educational purposes. Graphic Design: Eunjoo Byeon.

Chapter 6

Second Generation – Set Two: Dynamic Approaches to Well-Being in Dance and Fitness

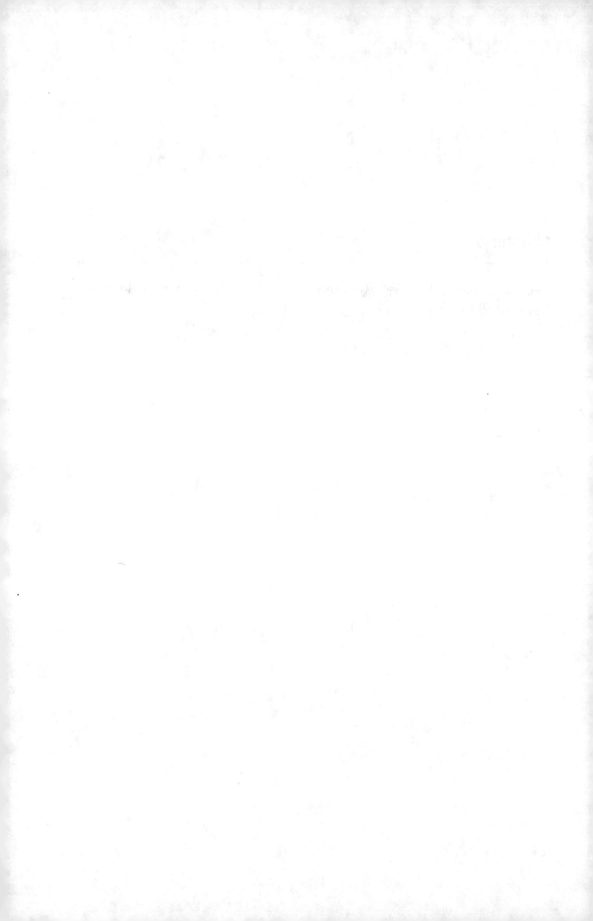

Second Generation – Set Two: Dynamic Approaches to Well-Being in Dance and Fitness

> Somatic Education is not only something new and unexpected, it is something of momentous consequence: It entails a basic transformation in our understanding of the human species and of the capacities of the human individual. That which we have believed to be unchangeable in the human creature has been discovered to be not, after all, so unchangeable. Such a discovery amounts to a reassessment of the nature of ourselves and of humankind.
>
> (Hanna 1993: 188)

This chapter tells the stories of the second set of the second generation of somatic pioneers. It includes interviews with Sondra Fraleigh, founder of EastWest Somatics; Bonnie Bainbridge Cohen, creator of Body-Mind Centering® (BMC); Emilie Conrad, creator of Continuum; and the sister (Peggy Schwartz) of deceased Nancy Topf, creator of the Topf Technique, along with a short introduction to Joan Skinner from one of her students, Julie Ludwick. Each studied a holistic dance or somatic system and created their own somatic healing discipline. Some had direct contact with the original dance sources related to the development of their method of somatic investigation, such as Haitian dance or performing with Mary Wigman in Germany. Some explored more ethereal concepts such as "the universal vastness of energy" and others the concrete experience of human expression through a detailed inquiry of the human body.

While all the key players in the second generation were dancers, this subset also used its knowledge explicitly for healing, fitness or aesthetic development. Throughout their development each continued to identify with the importance and potency of dance and included dance-related activities in their training methods. Thus, many dancers were drawn to study with them.

Sondra Fraleigh, EastWest Somatics and International Dance Experiences

Raised as a Mormon in Utah, Sondra Fraleigh, founder of EastWest Somatics, was exposed to hands-on healing or "the flow of energy" at an early age. But it was her self-proclaimed "obsessive" desire to dance that gave her a sense of freedom and made her a

strong worker. While traveling as a dance performer, educator and choreographer, she embraced "pathways to slow down and listen to what is most important," from both eastern and western sources. From the East, she was exposed to Japanese Butoh – an almost meditative approach to postmodern dance, and in India (and in the US) to yoga. From the West, she studied many of those somatic systems that were already in existence. She studied regularly with Alexander Technique teacher Ann Rodiger in New York City; trained and certified in the Feldenkrais Method; and experienced Marion Rosen's breathwork, through which she learned the relationship between breath and the emotions. Her Mormon experiences of lay people directing "energy to flow through you" followed by her experience of Japanese Butoh and the Alexander teachings, coalesced as experiences of the body, through touch and movement, that served as an entry point to a "spiritual state." From this came a core principle of EastWest Somatics – "I teach 'listening and not doing' – compatible with non-judgment." She also became educated in phenomenology and the work of Merleau Ponty, which supported being alert to sensory experience. Fraleigh describes this phenomenon as "something larger unveiling through, other than will" (Eddy Interview 2001c).

There was no real opportunity for Fraleigh to study dance in her hometown, except for tap dancing at a very rudimentary level. She loved the rhythm and saw lots of movies and a lot of exotic Hollywood dance. She remembers at age four imitating Betty Grable's imitation of the hula in *Song of the Island*, stating "I made my stage debut at 4 with this imitation of an imitation (Ruth St. Denis eat your heart out)" (Eddy Interview 2002c).

Diverse Influences on EastWest Somatics

Butoh, yoga, Alexander Technique, Feldenkrais methodologies and laying on of hands all interact in Fraleigh's system EastWest Somatics. Her somatic approach is also profoundly influenced by her avid work as a dancer and choreographer. She credits dance improvisation as one of her first paths for self-knowledge. Dance has led her to writing about the lived body, and about her experience with Japanese Butoh performance, as well as her own poetry. She also credits nature. In her own voice:

I grew up in a valley, and we didn't have telephones until I was twelve or TV until I went away to college. I loved movement and being in nature, riding horses into the mountains on the round-up with my father. In our village, we had a great many town socials, and we danced a lot; the ballroom styles of the times, Fox Trot, Tango, Cha Cha and Rumba. Can you believe it, these Latin styles – way out in the country? I loved dancing the Jitterbug in high school. When I was in first grade, Flossy (yes, that was her name) taught us square and round dances. She must have been a good teacher, because even the boys liked it. She took us on tour as her Wonder Children

Square Dancers. As our reward, we got to take a trip to Yellowstone Park in a big bus and stay overnight. That was 1945, the year World War II ended.

(Eddy Interview 2002c)

Eventually she studied dance in earnest at the University of Utah where they had and still have one of the most comprehensive dance programs in the world. Her teachers were Dr Elizabeth Hayes, Joan Woodbury and Shirley Ririe:

I owe them so much. Dr Hayes eventually became "Betty" to me, and helped me get my first job at the University of Montana in 1962. Then came my journey into German Expressionism. Joan Woodbury sent me to study with Hanya Holm, and Hanya recommended me for study with Mary Wigman in Germany on a Fulbright Scholarship in 1965.

(Eddy Interview 2002c)

At the Wigman school, she especially liked attending the children's classes – this along with all the other subjects: technique, composition, music, improvisation and gymnastic. The European gymnastics – Gymnastik – were not what is usually thought of as gymnastics, but can be described as somatic explorations in movement and stretching to begin the day. The prevalence of this form of investigative "warm-up" set the stage for Laban's work in self-discovery that influenced Wigman during her studies with Laban in Germany and Ascona, Switzerland. Fraleigh felt the philosophy of the school was particularly evident in the children's classes where the various ways of moving from felt impulses came to life at an innocent level of play and expression. She describes how after moving with rhythms, the children moved using gestures and painting, sometimes drawing monsters and witches, then dancing and cavorting, finding their own powers to overcome these forces.

I experienced at the Wigman School the foundations of what I think of as creative dance more than modern dance, though it was both in essence. Human expression was key in Wigman's work, and we were not pushed for results. Rather, we were taken into ourselves. Wigman's approach was a source for dance therapy as it eventually developed. She said quite tellingly that we dance to answer the question: "Who am I?" Even the performative function of dance served to answer an inner call. Dance moved out of the sphere of entertainment and art for me. More and more the therapeutic aspect of it appeared in terms of a personal ethnology […].

I remember the dance I did that year [1965] at the Wigman School that Frau Mary liked best. I called it First Sounds. It was based on a photograph of a deaf boy who had his hearing restored. I danced this work in silence while I searched my body's memory of first sounds. Wigman said I had touched her being by revealing mine. She had witnessed something authentic in my movement and reflected it back to me, much as Mary Whitehouse eventually taught dancers to witness in the Authentic Movement form of Dance Movement Therapy…

All of these great women have been mentors to me. Now that I'm going back over this history, I realize that my dance teachers have all been women. I did take classes with Alwin

Nikolais and Merce Cunningham, and consider their work important to my process, but the major mentors have been women.

<div align="right">(Eddy Interview 2002c)</div>

Modern Dance, Creative Movement and Butoh

Like Summers, Fraleigh feels the influence of serendipity – that she has somehow, through no great plan of her own, "fallen heir to three great traditions of modern/postmodern dance, the American, the German, and the Japanese." She became fascinated with Butoh, Japan's postmodern dance, after seeing Natsu Nakajima perform in 1985. She went to Japan to study and research Butoh for a brief time, and then again in 1990 for several months. After her return home, she was invited to bring an ensemble of student dancers from America to perform in Japan on two different trips. She choreographed a modern dance work influenced by Butoh and Zen, called Meditations, for the first trip, and organized a group called the State University of New York (SUNY) Friendship Dancers to perform a work called Therapeutae, at Yoyogi Olympic Stadium for the second trip.

> I choreographed this spatially expansive work for 10 American and 20 Japanese dancers. The Japanese learned it from a video I sent; then we had just three days to put it all together before the performance. The dancers I took with me were financially supported by SUNY and Japan, so I did pick good dancers, but I was really more interested in those who would be ambassadors of good will.

<div align="right">(Eddy Interview 2002b)</div>

While dancing, in both the East and the West, Fraleigh learned more and more keenly to listen to herself and to be present with whatever she was feeling, seeing, moving. This somatic awareness shapes her excitement to dance with people of many cultures, and her activism in the field of somatic movement education and therapy. Her sensitivity as a choreographer, dance teacher, accomplished author and recognized dance scholar is all steeped in her eastern practices of non-doing that have their links to the EastWest Somatics practices of "holding presence," grounding, synergy, balance and positive reflection on oneself.

Fraleigh's professional training is shaped like her choreography; it is filled with imagery and she groups concepts into complex but unified themes with titles such as Dancing Down the Bones; Healing Dances; My Body Remembers, Community Through Dance; and Dancing on Your Path, all designed to inspire people to explore movement whether they are laypersons or dancers. Fraleigh guides her students with words and polarities, such as Nearness-Distance, Softness, Clarity, Craziness, Amazement, Wonder, Love, Kindness, Disappearance-Reappearance, Vision, Sense, Phrasing, Rhythm, Form, Pattern, Perception, Play, Music, Poetry, Darkness-Luminosity, Compassion.

While she embraces the subjective she also values the objective; indeed, this is what she most appreciates about the western perspective. She finds objectivity important as an avenue to distance

oneself, analyze and understand another person's experience. Included in this understanding is the realm of kinesiology – the science and laws of movement – also important for a somatic movement practitioner. She found that existential philosophy, specifically phenomenology, held a view of the body-mind that she could incorporate into her EastWest perspective.

> The beauty of the East occurs as one looks inward, cultivating silence and patience, but the West also has its own particular beauty. Fair competition and productive dualism are two of the West's great innovations, and they are definitely related. I don't want to underestimate the power of the mind's alacrity, its ability to abstract, to make distinctions between things and its pull toward excellence. This is an intriguing part of the power of being human, but it is just one part. We also need the means to put things back together, and to see organizational wholes.
>
> (Eddy Interview 2001c)

The Value of Dance as Somatic Research and Spiritual Practice

Fraleigh also found that the study of dance forms in America provided fertile ground for exploring and applying somatic concepts and methods. She makes her own case for why the somatic perspective is so important for dancers:

> When we listen to our movement as we dance, we are experiencing somatic movement therapy. When we are unable to tune to the movement and ourselves, because of stress, self-consciousness, or the desire to please, we fall short of our full potential. I believe that dance in its first and most innocent manifestation is really about the freedom of moving with attention to the feelings that emerge. In theater we often dance out toward a viewer, another. This is fine, as long as we do not lose track of the original purposes of dance – pleasure, freedom, praise and the opportunity to listen to our hearts in the making […].
>
> A somatic perspective of self-listening and self-remembering through dance provides the basis of my teaching. Dance can renew the body. This comes first, before the performative function. In the scramble to get dance on stage, we too often forget about the restorative nature of dancing. So we teach students how to stress, and not about joy in the body, and we further alienate those who would like to dance for its intrinsic benefits, because they will never be performers. I like to teach those who want to experience the dancer inside him- or herself, not just a career dancer. I have had few models for how to do this. This desire came gradually for me, since I was first a performer myself and was prepared to teach dance from this point of view…
>
> My view of the value of dance for healing trauma, and for restoring emotional vitality have been informed by my research in philosophy and spiritual traditions with

psycho-physical foundations, eastern and western. The physical, social, intuitive and intellectual aspects all come together in dance, movement and healing.

(Eddy Interview 2001c)

Fraleigh considers her entire dance and somatic studies as active forms of research as well as a type of spiritual practice. They have entailed the values of being seen in performance, moving expressively, moving in developmental patterns and communicating effectively. Shodo Akane-sensei, her Zen teacher in Japan, spurred her explorations in dance as well as Zen. He gave her problems to solve and challenged her views of herself as a teacher who would do more than teach dance as a replication of her own learning. "He has told me to make every day beautiful and every dance a point of stillness" (Eddy Interview 2001c).

Incorporating Hands-On Touch Practices into EastWest Somatics and Dance

Fraleigh learned "hands-on" touch practices through her certification in the Feldenkrais Method. That experience is also framed in her dance experience.

I felt as though I was dancing with my whole body in my hands, and in a new way that allowed me to listen very deeply to another person's being. The mode was movement, the attitude was listening, not fixing, but the feeling for me was an extension of dancing .[...] Frank Wildman was my primary teacher in the Feldenkrais program, and I am grateful that he encouraged the dancer in me to manifest in the work. He also is a dancer. I think that one of the great things about the Feldenkrais work is how adaptable it is – even as the formats of the movement lessons, Awareness Through Movement®, and the Functional Integration® work with touch, is specific.

(Eddy Interview 2014b)

Her work with touch is based in the Feldenkrais Method but it has morphed considerably. She uses the paradigms of dance technique, improvisation and choreography to structure the hands-on work at EastWest Somatics, and also includes what she calls Contact Unwinding, a process of supporting and guiding movement in contact with a client/student. The latter is similar to Contact Improvisation, but the relationship of partners is asymmetrical. One partner supports and guides while the other receives and responds, and Contact Unwinding requires training in the hands-on application of touch.

Dance improvisation in its various modes is very important to her style of teaching at EastWest. Much like Anna Halprin's work, improvisation underlies the methodology for a therapeutic process.

Dance improvisation allows me a freedom of expression and being in the moment that is therapeutic. I use the word therapy decidedly, to indicate change in a positive

direction. "Therapy" is a wonderfully broad term that can denote many states of healing. We are beings in transition as I have learned through dance improvisation and through phenomenology. We only suppose we are solid in form, but we are moment by moment in a constant state of flux. We can ride this wave and use this realization consciously – to heal ourselves. Cures are never permanent, because we are "time beings." Some things that we suffer can get better though, and we can learn how to ease pain, both physical and psychological, and function better. We can have illness and still be whole. I'm not saying that attitude is everything, but it is certainly important.

<div style="text-align: right">(Eddy Interview 2003h)</div>

Thus to determine if the dance or dancing has a "somatic base," Fraleigh suggests that the mover reflects by "going underneath, and asking 'how is this done, what is it made of?' With this sort of inquiry, the somatic perspective can be applied to a dance class to "unravel the technique, and see what is there." Education, dance, therapy and all of the arts have great interplay – "when dancing is coming from a place of joy or pleasure or at least through the body as the emotions move the body and the person, it is therapeutic." Fraleigh repeatedly emphasizes that it is important not to force a person's expression into a specific form. This discovery is then often both educational and therapeutic, based in a living, somatic process. Feeling better and healing are "process" words, not an end point (Eddy Interview 2003h).

It is about personal growth, "learning how to learn," as Moshe Feldenkrais put it, and making choices. Interestingly, its means investigating how movement is done, more particularly what F. M. Alexander called "the means whereby." And somatics is also about experiencing infant developmental movement and the marvels of the body's interacting systems as Bainbridge Cohen's work initiated. Ultimately, the subject matter of somatics is consciousness itself. For instance, when I dance, what motivates my movement – the force of personality, or a loss of self as I give myself up to the movement? If I dance toward healing, it will be the latter. The self is a complex issue in dance as also in somatic studies; we want to gain it and we want to lose it, and I can get this ambiguous message from the West as well as the East, though it comes through different aesthetic means.

<div style="text-align: right">(Eddy Interview 2003, 2014b)</div>

Bonnie Bainbridge Cohen, Body-Mind Centering® and Experiential Anatomy

Bainbridge Cohen, founder of BMC, was a child of the greater Ringling Brothers and Barnum and Bailey Circus "family," replete with movement experiences. Her mother was a tightrope walker who also supported Bainbridge Cohen's study of dance. She describes how her childhood dance teachers conveyed the power of dance in joyful experiences and meaningful self-expression. Following this passion she too studied at one of America's great university dance programs – the Ohio State University (OSU). Her dance educators,

Helen Alkire and Vera Blaine, inspired her even while she was training in the allied health field of occupational therapy. Her dance training continued after graduation in New York with Erick Hawkins, from whom she absorbed the "art of doing without doing." From her dance experience with Erick Hawkins, who Bainbridge Cohen notes was a "classics major at Harvard, inspired by the Greek Urn," she learned about "the human embodiment of natural beauty." She notes that the writing of Isadora Duncan and Native American males dancing also inspired him.

In her book, *Sensing, Feeling and Action*, she cites over 40 people in the "Lineage of Body-Mind Centering – homage to my teachers," including professionals from the US, Asia and Europe. Before these international influences took hold she had many far-ranging dance influences. Marion Chace, one of the pioneers of dance therapy, taught her about "teaching in the present – an improvised process based upon the responses of the people with whom I am working" (Bainbridge Cohen 1993). Andre Bernard and Barbara Clark, teachers of Mabel Todd's work, also contributed to her understanding of embodiment of anatomical images and ideas, supported by sensitive touch. Bainbridge Cohen had the opportunity to travel to Europe and to study with Europeans here in the US. Her deep curiosity about the nuances of human movement led her to study LMA with Irmgard Bartenieff and then with Warren Lamb and Judith Kestenberg, founders of Movement Pattern Analysis (as well as Action Profiling) and the Kestenberg Movement Profile, respectively. Once BMC was established in 1973, she continued to gain knowledge in other bodywork systems, studying directly with doctors who founded them – Dr John Upledger (Cranio-Sacral Therapy) and Dr Fritz Smith (Zero Balancing: Dynamic and mutable life of bone).

BMC teaches inroads for embodying all layers of tissue in the body, inclusive of the cellular experience. This echoed the teaching of Rudolf Laban who talked about the community of cells and cellular awareness (Samuel Thornton in Eddy 1991). BMC's second major educational strand teaches the acquisition of movement skill and consciousness through physical exploration of patterns of movement from our developmental beginnings – from conception through to death. This developmental work has its roots in the field of physical therapy and motor learning theories of Arnold Gisell.

Developmental Movement as Antecedent to Bainbridge Cohen's Somatic Work

Early in her career as a dancer and occupational therapist, Bainbridge Cohen sought out knowledge from the physical therapy and research team Dr and Mrs Bobath, and traveled to England to study with them in March 1968, having visited Eastern Europe waiting for an opening to become available. The Bobaths were two pioneers in motor development whose work focused especially on young children who had developmental delays such as cerebral palsy. Their work has led to a system of rehabilitation taught worldwide called Neuro-Developmental Therapy.

Bainbridge Cohen's own work also focuses on the perceptual and motor experiences of the young child during the first year of life and its effect on the lifespan. The Bobath mentorship was particularly important in helping to root BMC in the neuro-maturational development process in both healthy and developmentally delayed children.

In my first workshop with the Bobaths here in the US, Mrs Bobath worked with two children. One was two years old, a floppy baby. Within about 20 minutes she had the baby sitting. Another 4 or 5-year-old child couldn't walk. Within 20 minutes she had her walking. I was blown away.

(Eddy Interview 2001b)

Bainbridge Cohen recalls Mrs Bobath's advice: "If you don't feel a change under your hands from moment to moment, then do something else." She recalls the eclectic mix of students:

We were from many different countries. [There was] one student from Greece that I hit it off with. In one instance, Mrs Bobath was doing hands-on work with us, moving us around, stimulating our reflexive responses. One woman from Sweden didn't support herself and hit her head. The Greek woman had such beautiful automatic responses […] I realized I had been inhibiting my autonomic responses through all the release work I had been doing.

(Eddy Interview 2002a)

As for Dr Bobath, Bainbridge Cohen recalls:

He was great. He called her Mrs Bobath. They were both Jews escaping Hitler. From Germany and Czechoslovakia, I think. He treated her with a lot of respect and formality. He was very Eastern European with lots of hand activity. A neurologist […] he was constantly conducting research to find the theories to support what she was doing. He would say that he was afraid that he would go to sleep at night and by morning she would discover something new that would disprove all that he had found theories for.

(Eddy Interview 2001b)

According to Bainbridge Cohen, Dr Bobath was motivated to help explain how it was that the neuro-developmental work was successful.

In the early 1990s, when the PT [physical therapy] and OT [occupational therapy] world was disproving some of his theories they didn't really understand that it wasn't the theories [themselves that were critical.] […] it was that the Bobaths were attempting to explain how these profound changes were happening.

(Eddy Interview 2001b)

Bainbridge Cohen once asked the Bobaths about the quality of touch that they used. "Mrs Bobath said it couldn't really be trained: either you had it or you didn't. Students with a

movement background were even better at working in this way." Bainbridge Cohen found this inspiring – and she was particularly compelled by what they learned from the children. The Bobaths offered her work, but Bainbridge Cohen "didn't feel confident" to join their project. "I needed to explore it in my own way" (Eddy Interview 2001b). Ultimately, the techniques she developed merged the intuitive and structural lessons from diverse global sources, European and Asian (Bainbridge Cohen 1993; Eddy 2002c; Eddy Interview 2001b; Hartley 1995).

Asian and European Influences on Body-Mind Centering

Bainbridge Cohen had opportunities to work in Japan where she learned movement systems designed to intensify internalized awareness – Aikido and Katsugen Undo. In the US she learned yoga from physical therapist Yogi Ramira and learned to meditate with the Zen teacher Eido Roshi.

Especially from her experience with yoga, Bainbridge Cohen began to find names for her experience. "It was learning from the inside, guided from the outside." Yoga and Katsugen Undo taught her that awareness could extend to the parts of the body under autonomic control, commonly thought by western thinkers to be inaccessible because it was part of the involuntary nervous system.

Bainbridge Cohen met physical therapist and Laban protégé, Irmgard Bartenieff in 1966 in New York City, one year after she had started intensive study with Erick Hawkins. Bartenieff's work with the skeletal system as well as some of her developmental concepts supported the evolution of BMC. Bainbridge Cohen was also influenced by Laban theoretician, Vera Maletic, and was inspired by Lisa Ullman, who came to the Dance Notation Bureau (where Laban classes were held) to teach the movement choir. She was asked to teach a movement class at the Hawkins studio, and at this point the influence of the concept of inner movement became particularly compelling to her. LMA concepts such as shape, effort and flow also became more central to her work.

Body-Mind Centering and Dance Somatics

While Bainbridge Cohen does not continue to teach dance professionally, she integrates dance education in her teaching and in her life. Her system, BMC, does not require prior dance training, but movement study is central to the curriculum. Dancing is invited and self-expression is encouraged as a way to integrate the embodiment of BMC concepts. Improvisation is also a keystone for much of the exploratory process of guided self-discovery used within classes. In other words, people often dance in the BMC classroom as a form of exploring a somatic concept and then as a way to integrate their learning into "larger movement." Modern dance pioneer Erick Hawkins taught her, "the body is a clear place" and supported her investigation into all corners of the inner physical universe.

Bainbridge Cohen identifies BMC as a student-centered inquiry-based form of education (Eddy Interview 2015d). She did not often use the term "somatic" in the early years of her training program. However, in the 1990s she advocated in the 1996 issue of ISMETA News for the use of the phrase "somatic movement education and therapy" as a fuller description of what until then was often referred to as movement therapy. Also in the 1990s, Bainbridge Cohen, along with Emilie Conrad, was invited by Don Hanlon Johnson to join the Somatic Study group at Esalen sponsored by Michael Murphy, another major proponent of somatic movement work. In this way these two women began to use the term "somatic" and identify with it. Bainbridge Cohen and her husband, and colleague, Len Cohen, share the following insights about what they refer to as "somatic mind,"

> People who have been dealing with the body-mind understand that the learning process is not just theoretical. You have to experience it. The question is no different if you are working to be a dancer, a soldier, or a somatic practitioner [...] it is all about how you become what you need to learn.
>
> (Eddy Interview 2001b)

Furthermore, Bainbridge Cohen has adopted the term "somatization" for the many guided journeys she leads in class. Most recently she delves deeply into embryology.

Bainbridge Cohen continues to be inspired by a talk given by Hawkins, 27 November 1947, entitled "Why the dance is important in these times." Hawkins felt that the role of performance is to present the mythic, and to represent the nature of the psyche: "We need dancers because we need to have someone guide the personal need of the rite." Somatic education espouses that dancers who learn how to work the body "as a clear place" are more prepared to learn from the inside, the soma, the embodied psyche. If as artists they also feel charged with the mission to present the nature of the inner psyche, they can craft dances as visible, physical expressions of this knowledge. Her current work is driven by an investigation of embryology and the process of passing her work on to the next generation.

Emilie Conrad, Continuum and the Influences of Haitian Dance

While many somatic leaders were influenced by Asian practices, Emile Conrad, founder of Continuum, was opened to new paths of expression through her Afro-Caribbean dance experiences. Emilie Conrad traveled to Haiti to dance. This dancing and travel became a primary source in the development of her work. First as a dancer studying with Katherine Dunham in New York City and then for five years in Haiti, she, like Bainbridge Cohen, experienced and developed "cellular" and "fluid" inroads to somatic awareness through movement and dance.

Conrad's stressful family life fueled her motivation to "break free" through dance and movement. She grew up in Brooklyn, New York as the grandchild of holocaust survivors. Her childhood was gruesome and fraught with witnessing and experiencing abuse. She found

dance to be a liberating force, and inspired by Katherine Dunham she retraced Dunham's path to Haiti. She writes:

Fresh from the streets of New York I entered the magic of the Dunham School and left my confused life behind. The blaring trumpets of Tito Puente melted into the drums of Yanvalou. [...] I couldn't get enough. Every day, seven days a week, I was there. Hours and hours of feet caressing floor, hours of hearing drumming voices, my life disappeared into the song of Damballah. I was coming home – 1955 – I'm twenty-one years old. Inspired by Katherine Dunham, I arrive in Haiti to see for myself, hear for myself, smell for myself.

(Conrad n.d.)

Studying Dance in Haiti

Conrad's time in Haiti marked her first exposure to a nonindustrial society. She was compelled by the history of a culture that had been recorded through movement forms. In Haiti it is striking how both African and indigenous Caribbean movements have sustained over time through the traditions of dance. Conrad's firsthand experience of these meaningful traditional dances changed her conceptions of dance's significance. In her writings on Continuum and indigenous dance, she states that she physically internalized the influence of African culture during her years in Haiti.

Her understanding of the Haitian culture was deepened by other life experiences while she was there. She lived in Haiti from 1955 to 1960 during a time of intense political upheaval. The postcoup militia reigned, and in 1957 the army organized the "election" of the brutally repressive "Papa Doc" Duvalier. Conrad remained in Haiti after Duvalier's installation, working as a choreographer for several more years. She also learned of the work of the anthropologist and experimental filmmaker, Maya Deren. From her experiences in Haiti, Conrad developed a somatic system that is based in fluidity, much like the fluid forms of Haitian trance dance.

Conrad attributes her initial somatic insights to the knowledge she gained through her Haitian experiences. Somatic exploration and application offered her a mode of communicating Haitian traditional knowledge to a wider audience. She was particularly inspired by the dance of the Haitian divinity Dambala. Dambala's movement, Yanvalou, is reminiscent of the motion of waves, or of the rippling movement of a snake. This specific movement was one strong inspiration for Continuum; it also taught her the process of internalization of embodied knowledge.

Laban and Studies at UCLA as Transformative Influences

After Conrad came back to the US, she studied with Laban-trained Valerie Hunt in 1974 at UCLA. Hunt's perspective on "movement as behavior" seemed to also influence Conrad. Conrad's goal was to make her accumulated knowledge from Haitian dance universally accessible. As she studied movement and movement analysis, she worked to broaden her

Haitian dance beyond a folkloric dance experience by using its fundamental movements as her basis for a somatic system with a focus on the communication of the human organism (and its clustering of cells) in its environment. In this respect, Continuum resembles yoga, in that it moves through physiological premises toward sacred movement and spiritual force.

Conrad was moved to translate her Afro-Caribbean experience so that westerners could understand it – focusing on the universality of the biological experience. For instance, her work uses nonculturally specific terms, such as the "cellular world," to describe a technique for the freeing up of bodily energy.[1] Conrad was active in the somatic movement, somatic fitness and consciousness movement until the moment of her death on 14 April 2014.

In the final years of her life, Emilie was actively engaged in video interviews of others and of her own story.

Teaching people to breath this way or that way is not the point. As there is less compression the breath knows what to do [...] we need to soften the inhibitors [...] in Continuum we take a baseline of our breathing before we begin our class. The breath can't lie. The breath is the indicator of the level of openness in the system, the level of receptivity, the level of bio-embrace [...] For me, I hyperventilated. This is typical for people who are terrified. [...]. Your tissue accommodates this lift, the shoulders are lifted up, the neck is squashed, and the bones get hard [...] you're maintaining the posture of a terrified child [...]. If there is a problem with mother in gestation – whatever is going on with mother is downloaded into the embryo [...]. If in the birth process there is a problem that impacts the embryo and that shows up in the tissue and it impacts the breathing. If the bonding with the mom is somehow not good, that embryo maybe is not wanting to come into the earth plane so our tissue accomodates what the primary fear is. [...] It's the story you play out. From my experience, I did try to go to therapists about this. I felt myself being manipulated. This is not arrogant. I felt the filter of their training and that I had to accommodate their training which had nothing to do with the truth in my body at all. In other words it was coming from some kind of ideas. I had [to go] for cathartic experience or in other words to get me to scream. I felt I had to perform what the therapist was trained to do. It felt like I was dishonoring what I knew. I knew that the intelligence of my system had to be honored [...] I began to attend to the inhibitor [...] And that sound is a way to soften the tissue and that the breath knows what to do. When breath is able to move through the whole body like a wave of connection that is there. It is not just my personal history being released. It was my ancestry as well, that I was not particularly aware of. It was a group that was objectified. As everything was beginning to move [...] the whole history of my ancestors begins to be released [...]. My conscious was following my body, letting myself be taught by what was unfolding. [38:20]

(McNay 2013)

Conrad goes on to speak about the spiritual-social implications of the interactions of engagement with feeling oneself truthfully. She saw the intensity of violence against women

and climate change coming to a head, and the status of water as part of this Continuum – themes that will arise again in Chapter 13.

Nancy Topf, the Topf Technique and Release Technique

Nancy Topf, founder of the Topf Technique, was born 29 October 1942 and died on the Swiss Airways plane crash in Peggy's Cove Canada on 2 September 1998. She was born in greater New York into a family of art appreciators and a generation of dance innovators. Topf studied dance together with her three sisters, and this section is based on an interview with her elder sister, Peggy Schwartz in 2003.

Each of the Topf sisters pursued work in education as well as in the dance field and each had a well-developed sensitivity to the creative process. One sister, Bobbi Straus, became a physical educator and pioneered a dance program in Manhasset High School on Long Island. She then opened a studio that offered classes and private sessions in fitness and rehabilitative movement work, and continues to maintain a private practice on Long Island. Peggy Topf Schwartz became the founding chair of the dance program at the Buffalo Academy for the Visual and Performing Arts in Buffalo, New York and served as the Chair of the Five College Dance Department in western Massachusetts. The fourth Topf developed a company and a school in Boston, MJT Dance Company. The school has continued under the name the Topf Center for Dance Education and brings dance to many students in underserved schools in the Boston area.

Peggy Topf Schwartz tells about the girls' formative dance experiences beginning with their earliest dance background in Dalcroze Eurythymics – taught by two Dalcroze-trained sisters from Poland, Lola and Mita Rom. Schwartz and Topf were three and four years old, respectively, when they began studying with Lola, the elder of the two Rom sisters, whose work was devoted to the youngest dancers. Lola was a gifted musician and dancer, who brought more dance than was usual into the Dalcroze training. Her classes included improvisations based on responses to music, storytelling and imagery. Mita Rom taught the older students a combination of ballet and modern as well as continuing with the Eurhythmic training, always ending with improvisation and composition. "All that groundwork became core to Topf's way of working with ideokinetic techniques." This groundwork was laid throughout the elementary and middle school years, reinforced by an excellent physical education teacher in high school. Topf and Schwartz went on to study at the Martha Graham School of Dance. One by one each of the sisters became president of Terpsichore, the high school dance club.

College Dance with Margaret H'Doubler and Ideokinesis with Barbara Clark

Topf continued dancing within a small dance program at the University of Rhode Island (URI) in 1960–1961. Her freshman year, the dance instructor at URI encouraged her in her desire to choreograph Stravinsky's "Rite of Spring." This work was so successful

that the teacher was able to help Topf receive a scholarship to the Hanya Holm Summer Institute at Colorado College. The Dalcroze and Wigman/Laban lineage, as expressed through the work with Hanya Holm, informed her development as a dancer. The summer at Colorado College was pivotal. She knew then that dance was her life. Topf transferred to the University of Wisconsin at Madison in 1961 and studied with Margaret H'Doubler.

Upon graduation in 1964 she lived for a period in New York City and then was hired at the University at Illinois where she was a colleague of Joan Skinner. During this time she met Barbara Clark, a protégé of Mabel Todd's, who taught Ideokinesis. Topf was fond of telling how one workshop with Barbara Clark changed her focus and her work. She began her own investigation into the form and function of human anatomy and bodily movement. Topf continued to develop this work with two colleagues there, the late John Rolland and Marsha Paludan. They used the term "Release Technique" for the work they were developing, not to be confused with Joan Skinner's Skinner Releasing.

Somatic Performance

Topf was an active performer and choreographer. In the late 1960s and early 1970s, she had a great range of performance experiences – performing, among other venues, at the Judson Church with the MerryGoRounders, and in plays at the Yiddish Theater. She studied Bioenergetics (Alexander Lowen's development of Wilhem Reich's principles) and Anna Halprin's work. From approximately 1974 to 1983 she and her family summered in Putney, Vermont, where she led workshops with Marsha Paludan and John Rolland, her colleagues from Illinois. Contact Improvisation innovators, Steve Paxton, Nancy Stark Smith and Danny Lepkoff were also on faculty during these summer intensives. At Putney, she would work with improvisational structures that developed out of her understanding of human anatomy – and related these improvisations to the outdoors. She was very attuned to and had a strong need to work in the natural environment.

In 1973 Topf married Jon Gibson, musician, composer and performer. Jon has composed for many dancers, including Lucinda Childs, Merce Cunningham and Nina Winthrop. He has also composed several operas. He and Topf collaborated on many performances at spaces such as the DIA Center for the Arts and the Kitchen. Jon has been a member of the Philip Glass Ensemble for many years. Their son, Jeremy Gibson also composes music, works with a band and creates music and dance videos.

Topf was an active choreographer. At the time of her death, she was working on developing a program in collaboration with the Merce Cunningham School of Dance. She traveled several times to Mexico to work with a company there and also gave summer workshops at Windhover, in Rockport, MA. She had just completed a residency at Windhover and was on her way to teach in Switzerland when she died in the SwissAir flight #111 on 2 September 1998.

Conclusions

The work of these innovative women and their relationship to the world of somatic theory and practice can be synthesized through the following ten observations:

1. Each of these somatic pioneers is a woman who trained in forms of dance that fostered both the objective and subjective aspects of somatic inquiry. This training included the study of anatomy, alignment, kinesiology and/or biology, as well as how to use movement to explore one's deep instincts, intuitions and feelings.
2. Each now teaches from objective phenomena about the body, drawing on movement sciences, as well as from subjective concepts that support being guided by the "alive body," the soma. Bainbridge Cohen leads this with the depth of her experiential anatomy inquiry.
3. As dancers/artists these women are well-practiced in crafting – making art work – hence even their teaching process and their word choices are creatively crafted. Their movement and verbal directives are an aesthetic weaving of concepts and words to guide a somatic experience. Language like "listening, waiting, accepting and allowing" are common in their classes. These words contribute to present moment awareness, a central somatic experience that is used to keep the body and mind actively engaged and always moving. Being present while moving counteracts rigid posture and allows for a full range of expressive options.
4. Experiences of not fixing, not doing, not interpreting and not knowing are shared within these life stories and live within each of their somatic systems. Their work serves as portals to self-acceptance, allowing for whatever experience is present in the body.
5. Somatic work often begins in silence, during which one quietly yet actively attends to sensations. This can be likened to the dance practice of Authentic Movement or to the pure experience of dance improvisation. As articulated by Sondra Fraleigh, somatic movement education and therapy is not about controlling the body through exercise or fixing anything, though you might accomplish these. Rather, somatic movement is an alive process of self-discovery and enhanced awareness – a constant improvisation. Somatic inquiry can result in injury reduction or rehabilitation, as by-products to a self-investigative creative process.
6. By making art combined with somatics, each found an equality of humanness and some found spirituality: all share the belief that no hierarchy is needed when exploring through a somatic foundation. This is quite opposite to what happens when virtuosity is the first aim for both artists and is also in high contrast to many religious paradigms.
7. Somatic experience reclaims movement as essential for everyone; it is not just a spectator event; "the performance infused with somatic practice" model emphasizes participation. The skilled performer may simply be more comfortable with making large-scale public statements: in somatics everyone moves!

8. Halprin, Conrad and Fraleigh provide examples of choreographers who are comfortable with a wide range of emotional expression, perhaps because of their own acknowledgment of the emotional experiences that shaped parts of their lives. They are skilled in using emotionally rich experiences as a springboard for the creation of dances or as the fuel for a passionate engagement with dance experience. This, in turn, leads to openness about emotional experience within their somatic work.

9. Fraleigh and Summers work from a deep sense of compassion. The compassionate state is common in most somatic experiences; however, the choice to work compassionately with individuals and groups, across cultures, is deliberately fostered by these dance artists.

10. Each somatic system may relate to embracing a full continuum of life experiences as articulated by Fraleigh, "amazement, craziness, wonder, love, rhythm, darkness, and clarity." However, it appears to be more typical for somatic dancers, and especially females, most of whom are dancers, to invite this full range of emotional experience, without trepidation; certainly, the work of Emilie Conrad echoes these themes.

The second generation – fueled by a range of forces from the embodied history of their ancestors, political forces, a love of nature, people and animals – have been courageous to touch audiences with new, raw approaches (for instance, nudity or strange sounds). They have chosen to interact with people of all cultures. They share stories of life's hardships or life's joys and understand the importance of caring touch, without shame. They exhibit deep caring, dancing with no apology, using clear thinking with depth of connection. They include people and familes who are in pain. The drive to keep dancing/moving is alive at all times and in diverse places. The conviction to stick with beliefs and artistic choices, demonstrates their broad capabilities, focus, and vision of the new. They move forward with practicality. Being ahead of the times they sometimes stand alone, and occasionally lonely, and yet they draw huge global communities together.

Looking Backward and Forward

The ideas and practices from the first and second generation of somatic education have been influenced by various syntheses, and this continues to evolve in the present generation as somatic concepts are merged across systems and with other disciplines. Given this it is also important to acknowledge that when adapting ideas and movement from other people or cultures the new form is its own permutation. The creator does not purport to be an expert in this influencing culture or system, or in the complete thinking of its leader (unless she or he was a protégé of that teacher) and may not even fully understand it. The movement or philosophical antecedent may have simply served as a springboard for creative, somatic exploration (Eddy 2015). This exploration, especially as it relates to improvisation and movement, will be investigated in the upcoming chapters.

The Skinner Releasing Technique™

Joan Skinner, former member of the Martha Graham and Merce Cunningham dance companies, pioneered release work in the US, beginning with experiments in 1963 that evolved into Skinner Releasing Technique (SRT). We learn more about Skinner from Rebecca Nettl-Fiol in Chapter 9.

Skinner attended Bennington College as an undergraduate student. After three years of working with the Graham company, in 1949 she left to pursue musical theater, as well as dancing in projects by Merce Cunningham, whose work she greatly admired. It was during a tour of Mary Hunter's "Musical Americana" that Skinner suffered a ruptured disc. After a number of recurrences, she left the tour, and upon advice of a friend, began taking Alexander Technique lessons with Judith Leibowitz. She continued for two years and was able to resume dancing professionally, plus her back injury never recurred. She attributes this recovery to her training in the Alexander Technique (Davis 1974: 9).

In studying the Alexander Technique, Skinner "experienced remarkable contrasts between the way she learned to move in the Alexander Technique and the way she learned to move in traditional dance techniques" (Davis 1974: 18). She found that she was able to move without tightening the muscles, finding a new sense of freedom in the joints and experiencing a release of musculature (Davis 1974: 18). In fact, she felt that the Alexander Technique opened up a new realm of technical possibilities (Davis 1974: 20). She explains in an interview with master's degree student, Bridget Iona Davis.

> It wasn't that the Alexander system said "Don't grab anywhere"; it was just that it showed me it's possible to have a sort of multi-directional balance: the head is going this way [she moves her head forward and up] while the back is going that way [she indicates lengthening and widening]. When you experience it, you feel the multi-directional state.
>
> (Davis 1974: 20–21)

These experiences were instrumental in her initial explorations of technique development. In 1957, Skinner returned to her home of Minneapolis where she continued dancing, teaching (especially children's dance) and developing as a choreographer. In 1961, she was hired at the University of Illinois where she taught modern dance, beginning ballet, dance history, theory and philosophy of dance, movement for singers and actors and experimental classes for children (Davis 1974: 10). During this time, she also earned her master's degree in dance in 1964. She left to become artist-in-residence at the Walker Art Center and Tyrone Guthrie Theater in Minneapolis. In the fall of 1966, she again joined the dance faculty at the University of Illinois (Davis 1974: 11).

She originated her technique in part as a response to dealing with injury, with the goal of preventing common dance injuries among elite performers. Skinner Releasing is a major influence on what is now referred to as contemporary dance (along with Bartenieff Fundamentals and other forms of release techniques). It elicits new perceptions through imagery, improvisation, music, floor work, partnering and writing. People with any level of experience explore together, often moving into deep levels of consciousness. The familiar and habitual then shifts into the creative and the new.

Skinner moved to Seattle to teach in, and later led, the dance department at the University of Washington. She returned to the East Coast regularly in the 1980s and 1990s to teach at Movement Research in New York City. She has been artist-in-residence in Amsterdam, London, Venezuela, New Zealand and Australia, and in 1996 her international residency was videotaped and archived. The Skinner Releasing Technique website provides this summary:

> SRT classes include imagery as a powerful tool for transformation. Part of the class involves hands-on partner studies (partner graphics), where we can feel ourselves letting go of habitual holding patterns, maybe for the first time. At times, the teacher's guided imagery quiets the mind, and coaxes us into a deeper state of wholeness, tapping into the imagination while working on technical aspects of movement. Movement unfolds, sometimes in quiet gentle ways, sometimes in surprising and inventive ways.
>
> (http://www.skinnerreleasing.com/aboutsrt.html: 1. Accessed 2 April 2015)

One releases immediate fixed states of being to become available to the aligning process. In turn, the aligning process releases psychophysical energy.

> The release of tension, of distorted alignment is, in effect, a release of perceptions, of preconceived ideas, of psychophysical habits which are manifested in alignment. In order to participate in the aligning process, one releases the tyranny of conscious control, of the intellect and of preconceived ideas to experience the natural laws of movement as they apply to the human organism. When one becomes more harmoniously aligned with these laws, a new well-being and freedom are realized.
>
> (Skinner et al. 1974)

Julie Ludwick describes a central feature of SRT as freeing the body of tension by getting around the ego through the use of oblique, poetic language in ways that don't force change or render judgment and shares one of Joan Skinner's quotes, "When we force things on the body, the body often has a way of resisting." Another way "getting around the ego" might occur is through "partner graphics" when a partner gently moves parts

of the body to facilitate awareness and letting go of tension. Another Joan quote applies here – "Awareness is the first step to change." This emphasis on awareness rather than "making a correction" helps students to experience physical changes in astonishingly short lengths of time because their ego isn't in the way.

All SRT images are based on principles of alignment. For instance, to address the idea of head-neck alignment, there are multiple images that help the student to let go of tension at the back of the neck. But the images are experienced through the imagination – intuitively rather than intellectually. When a student is "danced by the image" they are releasing / in a releasing state. Joan referred to this as "being in alignment with the universe" (a Taoist principle). Ludwick generously shares excerpts from her interview with Joan Skinner from 13 August 1992 at the University of Washington, which speak of Skinner's early training and influences, SRT's connection to eastern thought/philosophy and her specific use of language/metaphor/poetic imagery.

Excerpts of Interview Transcription August 1992: Joan Skinner with Julie Ludwick

Cassette in the collection of the author

Joan Skinner's Early Training/Influences

JS: … I was, I believe, blessed by having my early childhood dance experiences with a Todd teacher. She had studied with Todd and was teaching, was giving entire Todd table lessons to housewives and created a class, called interpretive dance in those days, for children. And she would use images in the children's class and I just ate it up…. I remember her alignment has been imprinted in my memory because she really lived it and was such a beautiful model. And she would say things like, "keep behind your little mask" as a way to not tucking the head forward, "keep behind your little mask." And then I forgot, on the surface, my childhood experiences in my consciousness because then I became a teenager and then I went to Perry-Mansfield Modern Dance Camp and then I went to Bennington College and then I went New York. And it seems like that [Todd influenced] experience never happened – I just became a modern dancer. And yet, as I was dancing professionally with Graham and Cunningham, taking my classes – you know the story – I just had to start asking questions about the training. … And I'm convinced without a doubt that it was that early experience

as a child that made me feel whole, integrated as I moved in a way that these traditional techniques did not.

Connection to Eastern Thought/Philosohpy

JS: … And then there were other things that contributed to the way that my work evolved. One of them is the teachings of Suzuki that John Cage introduced me to. That whole world was totally foreign to me – the world of eastern thought. And then I stumbled into its poetry – the Haiku. It was a powerful impact on me and it was that point of view – which has to do with everything. It has to do with respect for nature rather than manipulating and having control over things. It was viewing what your place was in the world of nature and the ego – where the ego fit in. And all of that had a tremendous influence on the way this influence evolved. ….. it was his point of view that had an impact on me even though his training was traditional. But his point of view was the same – it was softness and chance participating too – not controlling, not manipulating, no ego. All of that was there, all of that I experienced in dancing with me. So it isn't just softness but it's a whole outlook.

On Imagery and Ego, Stillness and Action

JL: When you use language you often use the implied "you." You might say, "The tissues of the back can soften and melt into the back" rather than "Your back can soften and melt." How did you discover this way of approaching the ego with your students?

JS: … I never sat down and thought about these things. I just went on instinct … as I was working by myself, having embraced the whole point of view of eastern thought, that the ego just simply just gets in the way …. I wanted to guide the students into realizing that there is much more to this life than their personal existence and they can experience that and open doors to that if they can set the ego aside for the time being ….

JL: The suggestive term "The back can …" rather than "Your back will."

JS: Yes, yes.

Figures 18–19: (left) Emilie Conrad guiding Bonnie Bainbridge Cohen. Courtesy of Don Hanlon Johnson; (right) EastWest Somatics class with Sondra Fraleigh in center. Courtesy of Sondra Fraleigh.

Note

1 Much of this section was published in Eddy (2002b); it is also based on a series of interviews that appear in Eddy (2001).

Chapter 7

Third Generation - The Amalgams: Somatic Movement Education and Therapy Today

Third Generation – The Amalgams: Somatic Movement Education and Therapy Today

You learn to sense where you hold, where living processes are not permitted to function. And when you are aware of the holding – where you are not allowing yourself to function – then it's possible to let go. But you have to sense it.

(Elsa Gindler c. 1925 quoted in Kulbach 1977: 15)

The attempt to experience being in one's wholeness, starting from a living contact and from experiencing the environment, stands in relationship to the fundamental thinking of the new pedagogy as the path to self-awareness through complete trust or confidence toward men and all the phenomena of life. Yet another thing becomes clear from this parallel between Eutony and the new pedagogy: the respect for the individual. The similarity between Eutony and the new pedagogy consist in their shared rejection of any standardization and any ritualized pattern of gestures or mechanization of movement or any coercive aims.

(Gerda Alexander quoted in Johnson 1995: 280)

The qualities of free-flowing movement and focus on the inner experience of moving, so characteristic of social dance [of the 60s], were joined with interest in "natural movement training," central to studies of the body therapies and martial arts. These qualities became central features of the movement experience of Contact Improvisation.

(Novack 1990: 52)

Somatic Movement Education and Therapy: A Growing Field

Since the blossoming of the work of the first generation of eight somatic originators and the second generation of eight dynamic women who were also "somatic dance" as well as somatic education innovators (discussed in Chapters 3 and 6), the field of somatic education has cross-pollinated in numerous ways. Most of the third-generation systems are known as amalgams – offshoots of one of the founder's systems, a blending of two or more of the first and/or second generation systems, and sometimes with content or pedagogy from other entirely different disciplines. Among this third generation, most of the founders are dancers and performers. Many practiced Contact Improvisation, a new form of dance,

which emerged from Paxton's study of aikido and his improvisational work with Judson Church dancers in reaction to traditional modern dance (Novack 1990), including his "Cunningham days."

The number of somatic systems have continued to grow steadily. With this growth, the field of somatic movement education and therapy (SME&T) was born. Diverse somatic education systems that focus on movement awareness coalesced as a profession due to the vision of James Spira, who named the field (previously referred to as the "body therapies" or "somatic education") and founded the International Movement Therapy Association in California in 1984. He invited eight different groups to coalesce – Alexander, Bartenieff/Laban, Body-Mind Centering, LifeArts, Feldenkrais and Trager were among the most known, together with Educational Kinesiology (his own work). Once it moved to New York, the organization evolved to become the International Somatic Movement Education and Therapy Association (ISMETA) – representing practitioners who preferred to call themselves somatic educators and those who were comfortable with an identity as movement therapists. The addition of the term "somatic" to the association was also meant to clarify the origins of the work and to help distinguish somatic movement therapy from dance therapy, which is often referred to as dance/movement therapy, movement psychotherapy or even movement therapy.

As of 2016, over 45 forms of somatic movement education or somatic movement therapy have developed, with several dozen approved by ISMETA to prepare professionals to become registered somatic movement educators or somatic movement therapists.[1] Examples of these include Dynamic Embodiment (BMC and Laban/Bartenieff), Franklin Method (Ideokinesis, LMA/Bartenieff, BMC), Global Somatics (BMC, Native American studies and spirituality), Leven's Expressive Movement Therapy (Dance Kinetics, Dynamic Embodiment, Halprin Life/Art Process, Motional processing and Trager), Somatic Expression (Halprin's Life/Art Process, Continuum and BMC) and Jacques Van Eijden's Somatic Movement Practitioner Training (BMC, some LMA and Coaching). Interestingly, once again, each of these founders is a professional who has performed and taught dance.

Alexander Technique International joined in the 1990s and much more recently, the Feldenkrais Guild of North America has become a professional association member. GAE, Rolf Movement and Sensory Awareness remain autonomous but have influenced other mergers, such as EastWest (Shin) Somatics and Kinetic Awareness. Ideokinesis and Laban/Bartenieff work have influenced Topf Technique and Aston Patterning respectively. Each somatic movement system continues to grow and, together with the new amalgams contributes to health, wellness and consciousness studies today. Many have a strong presence in the dance and fitness communities as well.

ISMETA has played a role in defining the common features of somatic movement education and therapy. Over time numerous practitioners and scholars have had chosen to provide a bird's eye view of the field (Allison 1999; Brodie and Lobel 2004, 2012; Chrisman and Frey 2005; Eddy 2009a; Knaster 1996; Murphy 1992; Steinman 1986/1995). This next section speaks to the types of pedagogies employed to transmit somatic movement information, through evidence gleaned from the author's 40 years of life practice, reading

and teaching (Eddy 1992a, 1998, 2006a, 2006b, 2006c, 2009a, 2010a, 2010b, 2012a, 2015; Williamson et al. 2014).

Characteristics and Roles of Teachers/Therapists/Facilitators

Somatic movement experts facilitate awareness of movement. Officially, Somatic Movement and Education (SME&T) practitioners may choose to refer to themselves as either educators or therapists. Each describes the process of guiding people to become aware of their own body knowledge, their own body wisdom. When this is successful, participants are empowered to continue this journey on their own or with peers for a lifetime. SME&T facilitators can be either therapists or educators or both. The work is both educational and therapeutic. The benchmark for educational rigor is whether the student is empowered to use these tools for her or himself. The therapeutic benefits are wide-ranging from learning about oneself, to releasing of physical tension, to recovery from serious physical or even psychophysical trauma. Almost all progenitors of a somatic movement system have been avid students of a physical art form, be it the performing arts of dance, theater, boxing, vocalization, music or the eastern martial arts. They are disciplined and able to "think on their feet." Artistic skills in observation, expression, creativity and improvisation serve the somatic teaching process. Improvisation is particularly important as a methodology that guides self-exploration. It allows the education to be student-directed rather than teacher-directed (Dragon 2015). All somatic facilitators – be they somatic movement, somatic psychology or somatic bodywork experts – must find a way to facilitate instead of dictate, guiding student/patients/clients to find their own body wisdom and answers to their dilemmas, be they physical or social or psychological challenges. This process is often led by asking questions and guiding people to pay attention within. This engagement can be contemplative or wildly expressive; it is always at least a little mindful.

A strong indicator of an ethical and knowledgeable somatic teacher is one who will remind students to *make their own choices* as they learn to "do less," find postural and movement support and access a minimal (or neutral) use of physical and mental energy. One outcome of the somatic process is that a person has more energy to be creative in diverse ways – another sign of empowerment.

Methods of Learning

Experiential and Constructivist

In the somatic movement field those tools that are highly typical in traditional educational settings become secondary. Instead of classrooms being filled with talking, reading and writing, somatic lessons are designed to get the learner moving in order to identify,

differentiate, interpret, select, execute and critique embodied experience. Somatic movement education and therapy is therefore characterized by the necessity of "learning by doing," constructivist learning, a central feature of Progressive Education as espoused by F. M. Alexander's student, educational philosopher John Dewey (1932). Somatic education deepens Dewey's student-centered paradigm by requiring learners to engage in movement in an open-minded exploratory and systematic process, bringing their awareness, their mindfulness to the experience. Self-reflection before, during and after the movement education process is a core value in the somatic learning process. One is asked to activate the proprioceptive and kinesthetic senses, taking note of changes in sensation and "body attitude." It is common to be asked to apply somatic principles to familiar, daily life activities. Finally, self-reflection is a type of critical thinking during which one is invited to formulate a personal meaning from the experience. Part of the cycle of reflection is also recognizing that even sensation (e.g., noticing how one now feels or thinks) is a motor act. Somatic reflection (Eddy 2004b) is a chance to harvest one's own experience (McHugh 2015; Cole 2015).

Some specific common features of somatic movement pedagogy include (Eddy 1992, 1998, 2006, 2010, 2015; Williamson, Eddy and Weber 2014):

- Somatic learning, much like socio-emotional learning, happens through interactive processes involving the practitioner and student/client. It is student-centered constructivist education (Beardall et al. 2007; Dragon 2015; Eddy 1998, 2010). Key methods identified within SME&T include experiential education, substantial focus on process (versus product), and having the whole person engaged in personal yet critical inquiry. It also espouses a recognition that each client or student has the most reliable knowledge of her or his own experience – in other words, somatic movement methods support the claiming or reclaiming of personal authority.
- Dance improvisation is a perfect inroad for the exploration of self using somatic inquiry models. Contact Improvisation is a quintessential context for learning somatic movement as it brings together the key tools of the trade: movement, breath and touch with constant self-awareness, checking in with proprioceptive cues, and reflective interaction with another person – all within the context of expressive dance. The journal *Contact Quarterly* has been a strong launching pad for somatic inquiry. Editors Nancy Stark-Smith and Lisa Nelson are key leaders.[2]

Experiential Education in Child and Adult Education

Somatic learning is the epitome of experiential education and supports constructivist models of education. Each somatic activity engages the nervous system and awakens mindfulness in the body, which can then be brought to a cortical (cognitive) awareness and be resonant with sub-cortical emotional ("gut feeling") responses.

The ultimate judge of the value of somatic knowledge is within the person sensing her or his own body. As somatic movement has grown into a field, research methodologies

have developed as well. Somatic movement education has become a potent vehicle for the development of a range of critical methods: from nonverbal decision-making (Lamb and Watson 1979; Shafir 2015; Lamont 2014) to phenomenological observations (Calamoneri and Eddy 2006; Fraleigh 1993, 1999, 2015) to highly analytic yet participatory cognitive processes (Dyer 2009a, 2009b; Bradley 2008).

Ultimately a practitioner presents ideas and facilitates embodiment and understanding, but it is the students/clients who decides what to believe, whether these ideas hold personal meaning, and whether to incorporate the information. The students also can help to reshape the information, based on their own measures of success and experience of movement. Once learned, these processes – often in partnerships or communities – may also be framed as research.

Community Building

When the teacher is a facilitator, then people can learn from each other's uniqueness (Hackney 1998). There can be a horizontal leadership in the room (Gantz 2016). Learners are supported to learn from within themselves as well as with and from the support of peers. The somatic movement field is a like a tapestry, woven with many strands, of many lineages. It is not uncommon for deep friendships to form between students and even with their mentors. The warmth of the holistic perspective serves as a potent bonding phenomenon. The potential for complex dual relationships is present and any guidelines for ethical behavior need to be carefully sorted by the teachers and their related institutions. ISMETA helps to provide this ethical scaffolding with its scope and standards of practice as well as providing a system for expressing grievances.

Exploratory Inductive Learning

The inductive methods involved in somatic education (student led, self-discovered, and having no one correct answer) work together to reinforce "somatic thinking" – the philosophy of embodied holism that underlies somatic movement investigation. "I am a soma, therefore I think." Being inductive results in an open-ended educational state of critical inquiry that helps to shape a somatic philosophy. As with all philosophies, there are some basic concepts and principles, some explicit and others implicit.

Core Concepts of Somatic Movement Education and Therapy (What Is Being Taught)

Each somatic movement system has contributed to the burgeoning of SME&T. Each is an innovative, experiential and educational process of self-investigation fueled by creativity. Despite the variations in whether they identify as somatic education, body therapy or somatic movement education and therapy, they all share the core concepts of somatic

education (Eddy 2003, 2009a, 2015; Williamson, Eddy and Weber 2014). The following can be found in each of the somatic systems, whether first, second, third and, now, fourth generations:

- Slowing down to feel (enhancing one's proprioceptive and kinesthetic sense including graviception);
- Using breath to find relaxation and ease of movement, while experiencing gravity (graviception) in the release of muscular and mental tension;
- Discovering three-dimensional space within and outside the body (visual-spatial-kinesthetic awareness);
- Exploring new coordinations of breath, movement and/or vocalization and thereby changes in movement habits, and potentially in self-image (brain-body connection).

These core concepts have numerous outcomes and can easily be applied to dance (Eddy 2008). They lead the mover to let go of excess tension, find relaxed and full breath, occupy space more fully and investigate novel patterns of movement, including the inhibition of unwanted habits (Batson and Wilson 2014). The experience of having more movement choice can feel liberating and relieving. In many cases people reduce or manage pain, experience a greater range of motion, feel freer and easier and develop a sense of personal power.

From the interviews throughout this book and years of personal teaching experience, these additional observations about the nature of somatic inquiry emerge:

- The lay public is often only motivated to learn about the inner body when experiencing physical pain or emotional stress. (This may be due to cost and is complicated by lack of access through the medical system.)
- The practice of discernment requires the acquisition of a wide range of "somatic registration" through finely attuned interoception (proprioception, graviception and kinesthesia) integrated with acute exteroception.
- Registering one's own sensations develops "somatic repertoire" and reinforces personal authority. Every individual is capable of making her or his own health and life decisions through personal body wisdom.
- Learning what is appropriate behavior for oneself occurs by tuning in to the felt experience. (This is also true for conflict resolution and any type of interpersonal communication work – Eddy 2010a, 2010b, 2010c; Goldman 1994).
- Gaining greater self-awareness occurs through perceiving the physical sensations that accompany behavioral, aesthetic and emotional choices. This integration of the emotional life is active in almost all somatic movement systems, but is particularly evident in the work of Halprin, Rutkowski and Leven.

Brodie and Lobel (2012) also emphasize the Bartenieff's "connectedness" as central across all systems of somatic dance. Somatic movement distinguishes itself by always observing the

interconnectedness within the entire body – "the foot bone is connected to hip bone" – the pelvis meets the foot through bone, fascia, muscle and other tissue such as blood vessels and nerves. The process of paying attention to the relatedness of any one part of the body to the whole body is central to somatic movement.

Many somatic educators embrace the concept of "Whole-Part-Whole" (Bainbridge Cohen 1993; Bartenieff 1977, 1980; Feldenkrais 1972; Hackney 1998) whereby students feel the whole body, learn more about the individual parts and then explore how the individual parts interact within the whole. What varies from training to training is the degree of focus: some systems seek to differentiate parts more and others place their emphases on unifying parts.

Specifics about Somatic Education Tools: Touch, Movement, Breath and Sound

Somatic teaching tools focus on the body and include:

- An informed verbal exchange about life experience inclusive of body use in different contexts throughout the day
- Nonverbal exchange – being observed ("witnessed") while walking, standing or dancing, or talking (including students' gesticulation while seated or standing)
- Inviting conscious awareness of movement patterns, postural habits and personality characteristics that have previously remained subconscious, often elicited through the use of touch
- Skillful and structured touch driven by a guiding set of anatomical, developmental or movement principles that are used to foster the learning of new movement choices
- Movement re-patterning – guiding new movement experiences using hands-on support and tactile feedback (a keystone of somatic movement work) but also sometimes verbally guided
- Toning and sounding – using the voice to stimulate breath, wake up the body or express a feeling. Recognizing vibration as a key to change, awareness and consciousness (as in quantum studies).

Examples of bringing subconscious experience to consciousness include noticing instances when the breath is held or breathing is shallow or overly controlled, observing changes in gait patterns within different situations, noticing postural habits or discovering gestures that surface repeatedly when in certain contexts or in relationship with certain people (Eddy [2005] 2011).

Those somatic practitioners that mostly focus on touch may refer to themselves as somatic therapists (Ford 1989), manual therapists, somatic bodyworkers (McIntosh 2005), bodyworkers (as in the National Certification Board for Therapeutic Massage and Bodywork), somatic massage therapists or somatic movement educators or therapists who are skilled in touch. Or as with somatic movement practitioners they may choose to only

identify by the specific discipline they are certified in. Well known somatic bodywork includes Breema, Hellerwork, Rolfing and Zero Balancing.

Concrete Assessment – Tangible Feedback

Whether identifying as educational movement therapists, therapeutic movement educators or somatic movement facilitators, all practitioners trained to provide concrete feedback. The exchange of information provides insights for assessment and solidifies subjective learning. Somatic inquiry lends itself well to "portfolio review", which is used in some K-12 and university classrooms. Portfolio review requires that students produce products to demonstrate the integration of their learning. Experiences in one mode of expression are presented in another form. For instance, learning about anatomy or math can be described back to the teacher in a movement (Selver-Kassell 2010), learning about movement can be demonstrated in an exam, or through creative writing or film.

In the therapeutic setting, discussing what may happen, what is happening and what has happened during the somatic session is valued. Generally, no intervention or discovery is meant to remain a mystery since it is access to the process of awareness that empowers a person. Having time to recollect a somatic process or exploration helps bring the often unconscious nature of what is normally automatic in movement into awareness. The recollection process is like "Ariadne's string" – a link back to the familiar, even through a labyrinth.

Assessment is an ongoing process, in which practitioners assess clients' movement upon initial "intake" and continue to attend using multisensory lenses throughout the lesson. For instance, there will be visual observation of posture and movement quality, tactile awareness of tissue tension levels and listening for changes of voice. In many cases the student is expected to continue self-observation. Self-observation may be assigned or suggested as "homework" related to practice, doing activities in life with awareness. To transfer the knowledge gained in a somatic movement session, clients may be asked to make note of feelings, sensations, experiences, connections, associations, concerns, questions and creative thoughts. This reflective and associative process is at the heart of being mindful about movement. "Mindful movement" is another way to describe engaging in somatic awareness during daily life – paying attention to internal body cues not just thoughts, ideas and pre-conceived constructs about the body.

Variations within Somatic Movement Practices

Each system of SME&T training is distinct in terms of focus, techniques and principles emphasized. While it is important to relish what is shared, it is equally important to honor and celebrate the differences. As in the world of identity politics, there is no attempt within somatic

movement to create a melting pot; instead imagine a salad with lots of distinct vegetables. In looking to find the "right teacher" students can seek to match personal learning styles with those of the teacher or the system by considering the following variations: philosophy, goals, choice of somatic tools and structural elements.

Philosophy and Goals of the Work

The intentions for a lesson/session are often shaped by the practitioner's expertise or interests (e.g., pain relief, improved motor performance, enhancing creative process, increased self-awareness, developing human potential or spiritual development) as well as the imprint of the training program they themselves graduated in. These imprints and personal preferences frame distinctions among the various practices. One example of the difference between programs and their resulting working style is the specific framework and related style of language being employed (e.g., types of the words or language phrasing that the practitioners are trained to use). Does the training dictate the use of a system of note-taking or not (i.e., Feldenkrais discourages note-taking during class; Laban/Bartenieff and Feldenkrais movements are notated)?

There may be emphasis on different constructs and types of principles – anatomical, kinesiological, musical/rhythmic, nature imagery, neuromotor, perceptual, psychological, spiritual, energetic, socio-emotional, ethical or a particular combination of any of these. How holistic is the work? Are a wide range of feelings, thoughts and connections welcome during the session, or not?

Choice of Somatic Tools

Distinguishing factors between somatic movement systems lie in the combination of methods and tools that a practitioner will use. A Feldenkrais practitioner might not spend much time with the student in a chair (an Alexander teacher might). An Alexander teacher might not typically have a student jump on a mini-trampoline (a BMC practitioner might). There can also be variation in whether somatic movement is predominantly learned through touch, demonstration, guided nonverbal or verbal facilitation. If there is a verbal interaction, the chosen language can vary – discussion may use imagery, anatomical-kinesiological language, movement principles from physics or biological metaphors. Emphasis within SME&T can easily be based on what the specific system was that was learned. It can also be different because each practitioner is different and the field gives each person the permission to develop their own style. Different disciplines vary in the amount of stylistic freedom they give or permit to their trainees.

The actual elements of a somatic movement class or session give each system its identity. The time involved, the ratio of movement to touch work, the use of vocalization or not

and the type of breathwork are key distinguishing factors. These reoccurring points of difference can be identified in the following ways:

- The degree to which hands-on touch work is used to facilitate greater movement and self-awareness (are the sessions predominantly hands-on or movement work?). Many practices use the same name or separate names for similar hands-on components and movement work (i.e., Rolfing/Structural Integration versus Rolf Movement, The Trager Method or Trager Mentastics)
- The style of hands-on work and the qualities of touch used
- How large or subtle is the movement being explored or learned?
- What range of movement qualities are explored?
- What types of qualities are typically seen in the movement of the client within a session (e.g., shaking, pressing, floating, releasing, driving)?

Structural Elements

Other distinguishing factors include whether students are asked to learn mostly through solo exploration or group interaction. Are props used and if so, what kinds? Typical equipment can be tables, chairs, mirrors, balls, mats, skeletons, pictures or models of the body, trampolines or specially designed equipment (e.g. slant board, ergonomic back boards, special balls etc.).

One of the reasons that there is such room for variation in somatic movement work is that its adaptations are endless. The somatic pioneers were less interested in codifying and more in seeking and discovering inroads to consciousness and renewed movement that will work for him- or herself, the particular student or group of students.

Despite the wide variety of methods, tools and structures, somatic movement education and therapy has culminated in a cohesive and distinct profession. Yet, as a new field it continues to be confused with existing professions that involve touch, movement or psychophysical elements.

How Does Somatic Movement Education and Therapy Differ from Other Fields?

Many people struggle to place somatic education or SME&T when they first encounter it. Is it based in tai chi? Is it yoga therapy? Or is it a type of psychotherapy? It must be dance/movement therapy! Or is it massage? Or physiotherapy? Is it exercise science? Or Pilates? By definition it is none of the above. SME&T definitely distinct from each of the ancient movement forms that have influenced its evolution (see Chapter 4). It is also not massage therapy, physical therapy, dance/movement therapy or psychotherapy and by law should not profess to be any of these. Yet it has common features with each. The following section seeks to clarify these distinctions.

Traditional Asian Movement Forms

Yoga, tai chi, chi kung, kung fu and other Asian martial art forms are important inroads to mindful movement and are allies to the field of somatic studies. These traditional movement practices are imbued with philosophy that integrates the body, mind and spirit as interrelated and in constant dialogue and inspired many of the somatic pioneers. However, they are to be honored as distinct multicentury, if not multimillennial, systems that were developed in specific cultures. The transmigration of these systems from East to West, and any adaptations of them during that process could easily be a subject of its own book.

Another feature that distinguishes SME&T from these traditional movement disciplines is how the information is conveyed. It is common for the Asian forms to be taught by a Sensai or a guru who takes an authoritarian role. In theory, somatic education involves leaders who provide facilitation for self-discovery instead of dictating specific behaviors and movement forms. At this time, however, there are certainly interactive influences and numerous examples of blending these two fields. Donna Farhi is one yoga leader who has integrated BMC into her training. Kevin Kortan teaches Evolutionary Yoga, which also has a BMC component. BMC offers an embodied anatomy in Yoga training. More and more yoga teachers are taking a more somatic approach. The approaches vary greatly and not all include a fully holistic approach to working with individuals and groups. It is also quite typical for new somatic movement education and therapy programs (and some of the first-generation programs as they are taught today) to include studies of Asian movement forms (chi kung, tai chi, yoga, kung fu, aikido etc.). Even if they are included in somatic movement programs, these traditional practices remain distinct. Their ancient philosophical and historical roots predate somatic education.

The emergence of the yoga therapy, in which yoga is applied to working with physical limitations and chronic issues, brings together different skills and principles. Therapists vary in how to support and nurture the emotional or psychophysical attributes of the movement practice. Yoga therapy, while represented by a professional organization, also does not specify the number of hours required for training – ranging from 200 to 600 hours (Kepner 2009; Seitz 2010). Nor does it provide a registry of practitioners. Certainly, the time is ripe for a yoga therapy program to be developed that incorporates a fully somatic perspective.

Gyrotonic, Pilates, NIA

Gyrotonic, Pilates Contrology and NIA are exercise, fitness and conditioning programs that have combined influences from the East/West and share elements of somatic movement, most notably coordination with the breath (Rouhianien 2010); however, they are not by definition or lineage somatic practices. Working with the breath provides an exciting beginning point that can lead into body-mind-emotional awareness with wonderful avenues for musculoskeletal alignment and the beginning of life changing experiences. Gyrotonic and

Pilates do not fall within the rubric of somatic movement education and therapy, mostly due to the lack of self-directed movement, guided by open-ended questions and explorations. The focus of the movement, in Pilates Contrology, as the name indicates, involves goal-oriented concentration on the physical body to gain control over posture and musculature. As Rouhianien (2010) expounds in her historical treatise on the roots of the Pilates Method, Pilates lived at the crossroads of a somatic self-investigation of the body-mind connection and the rigors of sports conditioning. However, the trainer typically prescribes movement. Gyrotonic (founded by former dancer Juliu Horvath) is steeped in yoga, but incorporates more diverse planar and three-dimensional fluid movement. Its goal of "expansion, flow and harmony" can easily be adapted to a somatic approach (Reisel 2010). The Pilates Method is also influenced by yoga but has other German influences Physical Culture like the Bode exercise movement. Both Gyrotonic and Pilates use equipment to provide resistance as do the somatic pioneers Emilie Conrad and Judith Aston. Summers, Conrad and Aston developed somatic activities using exercise equipment in order to increase awareness and consciousness with changes in body tone and strength as more secondary goals. The somatic methods of Aston, Summers and Conrad invite each person to explore with equipment and discover what feels best in her or his own body, tracking changes in tonus and in body and mind.

NIA is a younger system developed by Debbie and Carlos Rosas that combines martial arts with aerobics and emotional expression. It is a growing discipline attracting the general public. NIA, Gyrotonic and Pilates lessons have a strong footing as an entry into conscious movement and can be tools in the new field of somatic fitness as long as the practitioner and/or pedagogy includes the basic tenets of somatic inquiry. This is most likely if the training programs are taught by somatic movement educators or therapists. Of course it is important to find the ethical way to infuse a somatic paradigm into these trademarked systems – understanding how each of these influences can be orally cited while teaching lessons.

While there may be numerous Gyrotonic, Pilates and NIA teachers who are well-qualified to register as somatic movement educators or therapists, at this time their training programs are not based on somatic movement principles (slowing down to feel with proprioception or graviception, relaxing bodily tension or finding novel and self-regulated coordination). Nor do most of these programs meet the minimum study hours required for a somatic movement practitioner, and most are not taught by registered somatic movement educators or therapists. Most of these have training lengths ranging between 150 and 300 hours of in-class hours, whereas the minimal entry-level training in somatic movement education and therapy is 500 hours.

There are a growing number of individual practitioners and trainers who are choosing to integrate their personal knowledge of a somatic discipline into their conditioning and fitness practice. This knowledge is beginning to infiltrate training programs, for instance Lesley Powell, CMA, studied a brand of Pilates with Eve Gentry, who was also influenced

by Irmgard Bartenieff. The BodyMind Fitness™ program taught by Eddy and Powell is one "somatic fitness" amalgam; others are emerging. As a rule of thumb – does the method of teaching include self-directed or improvisational movement with time for sensing what the person senses, feels and wants to express? If not, it's probably not somatic.

While within somatic movement disciplines there are a range of ideals and goals, generally the mindstate of the work is one of nonjudgment, openness to being present, exploratory instead of goal oriented. When guided by concepts from anatomy there may be more of an ideal performance goal as in Bartenieff Fundamentals – leading to experiences of performing an exercise "right or wrong". However, there is always a choice in how to execute a specific movement, especially if it might cause pain or feel emotionally unsafe. A positive influence of the somatic field is that this respect for the individual mover is now more accepted in fitness venues than ever before.

Massage Therapy

Massage therapy is a profession that varies in its scope from state to state or province to province. Certification requirements can be as few as 100 hours and as rigorous as 3000 hours. Most massage therapy trainings are vocational programs and some are affiliated with degree granting institutions. Several degree programs add a somatic approach. Within the field of massage, one encounters a wide range of clothed and unclothed touch techniques – Swedish massage to Shiatsu – with long and impressive histories replete with research. This history is told in a book by Calvert (2002).

Physical Therapy

Physical therapists (physiotherapists) are important allied medical professionals usually covered by third-party payments (national insurance, or private insurance). They are trained in the academy with all levels of degrees, and are active participants in the medical system. They can specialize in pediatrics, neurology and rehabilitation, among many other options. Insurance often limits how long a physical therapy session may be or how many sessions will be paid for. If the goals of improved gait, range of motion or pain reduction are met or the work plateaus, physical therapy is terminated. The extra time needed to break old habits and learn new ones is challenged by this system. Physiotherapists who take a somatic approach may 1) have longer sessions of 1–1.5 hours long, 2) observe holistically connecting movement patterns in the injured areas to all parts of the body, 3) relate these patterns to awareness of habits and 4) have the patient practice remaining conscious during the session and throughout the day. When embracing the longer sessions needed for somatic approaches, they can often no longer accept insurance. It can be typical for physical

therapists to have short sessions, focus on the injured area exclusively and to give homework in chart format, that provides exercises without ensuring that the patient is practicing the movement with deep awareness.

Dance/Movement Therapy

Dance therapy is based in graduate-level education with a scope of practice to work with people with developmental, behavioral, and mental health distresses using dance, movement, an understanding of the physical body and diverse psychological and psychodynamic approaches.[3] While most dance therapy programs include the study of anatomy and movement observation, they do not typically include the in-depth study of somatic movement principles and techniques. Nor do they teach in-depth and sophisticated touch techniques. Generally, in the US it would be ill-advised for a dance therapist who is licensed as a mental health practitioner to touch a client. However dance/movement therapy and somatic education share practices such as Authentic Movement, the exploration of the body by bringing unconscious habits to the forefront of consciousness, a holistic approach and the joy of movement. Dance/movement therapy is somatic but dance movement therapists are not trained to work with the scope of practice of somatic movement educators and therapists. Dance/movement therapists overlap in scope with the work of somatic psychologists and, depending on their levels of training, may have similar standards of practice.

Somatic Therapy and Somatic Psychology

Somatic psychologists have graduate degrees in the field of psychology with a specialty in somatic awareness. This awareness is mostly accessed through the tracking of somatic cues while talking. In other words, they are often psychotherapists who spend most of the session in verbal dialogue but also "track the body." For instance, they can help their seated clients to be aware of their subtle body signals (e.g., the breath, heart rate, muscle tension) and gestural movements during the therapy session. They will often slow down or amplify the movement to help a client to make deeper psychological connections. Their work is often psychodynamic in nature. Some somatic practitioners who do psychotherapeutic work call themselves somatic therapists. Talia Shafir, RSMT, who teaches both somatic psychology and Dynamic Embodiment, makes the following observation about how somatic movement therapy and somatic psychology can interface:

> Dynamic Embodiment Somatic Movement Therapy (DE) is the embodiment of the journey from conception to individuation. DE-SMT tracks the sensory/physical story

of our individual and global relationship with people, places and things along the way. A learning process from the ground up, it tracks and re-patterns our sense of mobility and stability in the world. In that way, it brings us into awareness of the continuum of physical and emotional wellbeing. It gives us a sense of control and collaboration with both the limitations and potential of our navigation of the environment.

Psychotherapy gives conscious meaning to experience, interpretation of instinctive and habitual behavior patterns that signal our sense of safety or degree of perceived threat. It moves us into communicating to our growing consciousness, and the world, the truth of where we've emerged and who we are becoming. Psychotherapy wrestles with the mind's propensity for repression of what is disregulating to the nervous system, giving linguistic context to previously excluded content.

DE-SMT helps remove the resistance to reorganizing perception by waking up developmental connections that may have become fused with limiting behaviors. Restored support and resequencing of movement infuses and frees the all-important element of flow. DE-SMT is structured to address the spiral nature of that continuum, bringing tools to bear from "top down" thoughts (i.e. knowledge of systemic models) and "bottom up" (the bodymind). It is a skillful weaving of the internal nature of BMC with the external spatial expansion of LMA. It gives credit and support to the body's intelligence without interference from cognitive roadmaps. Psychotherapy crosses this divide with identification of triggers and resulting behavioral patterns.

Somatic Movement Therapy sparks realignment of how we think of ourselves by reorganizing how we physically feel about ourselves. Its developmental orientation creates a sense of agency, a capacity to act in ways either previously unexplored or impaired by trauma or disease. These are the building blocks of self-perception. The psychological extension of this is conscious awareness of the merging of sensory and cognitive models, framed in time and space, and one's resultant behavioral responses to the environment. One might say that DE-SMT creates an element of connection between a sense of oneself and the behavior that supports it in the moment.

(Talia Shafir, personal communication, 29 June 2015)

Shafir adds this quote from Rudolf Laban:

[I]t is important not only to become aware of the various articulations in the body and of their use in creating rhythmical and spatial patterns, but also of the mood and inner attitude produced by bodily action.

(Laban 1980: 22)

One responsibility of a somatic movement educator or therapist is to be able to recognize when the work done must be referred to another professional – a massage therapist, a psychotherapist (dance or somatic), a physical therapist or a teacher of an original

indigenous movement form. ISMETA asks that all somatic movement training programs include training in how to make appropriate referrals within their required coursework on business and ethics.

More Cross-Fertilizations: Examples of the Amalgam Generation Movement Therapy Systems

Dynamic Embodiment Somatic Movement Therapy (DE-SMT) was founded in 1991 by Martha Eddy, CMA, EdD, who is also a certified Teacher of BMC. Dynamic Embodiment (DE) teaches the practitioner to astutely observe a client's movement and body language. This compassionate witnessing process is followed by enhancing what is working well for the person – providing support for her or his strengths through movement activities, touch, or discussion. If desired, the practitioner also offers ideas and activities for practicing new ways of moving (or resting) that can be useful to relieve pain, experience greater ease or range of expression.

Dynamic Embodiment practitioners (DEPs) are trained to draw upon Laban/Bartenieff and BMC principles as well as those from Dynamic Embodiment, which grew from 20 years of blending the two systems. This includes somatic strategies that Eddy has created from exercise physiology, perceptual-motor development (e.g., EyeOpeners DVD *Relax to Focus*). A wide variety of touch and movement dynamics are used to cultivate embodiment and bring awareness to habits, underlying attitudes and options. The relief from physical discomfort, answers to movement challenges and awakening of consciousness are considered from multiple neuro-developmental perspectives. Each practitioner gains experience in embodying different physiological rhythms of the moving body and practices this with feedback from partners. Lessons in Eddy's signature dance classes – BodyMind Dancing™ – help students embody somatic strategies including solo, partner and group work dancing (Loman and Brandt 1992; Wozny 2006, 2010; Fortin and Sidentop 1995).

The Franklin Method was established in February 1994 by Eric Franklin, founder of The Institute for Franklin Method in Uster, Switzerland. The method is based on Ideokinesis, and applies ideokinetic imagery to different movement tasks, providing the brain with the feedback it needs to create improved ease of movement, flexibility and strength. This is steeped in anatomy and biomechanics, and is informed by Franklin's study of Body-Mind Centering and Bartenieff Fundamentals. It asks the questions – "How are thought patterns reflected in our body? How can a heightened body-awareness improve our mental condition?" He also asks the question – "What kind of mental conditions are reflected in the different organ systems?" Using movement, touch, voice and inner images, students discover weaknesses including cramps and tension, which are transformed into the pleasurable flow of movement. The ball, Theraband (Dynaband) and conditioning are other cross-fertilizing elements of Franklin's method. Martha Myers stated (Eddy Interview 2015c) that Eric was one of the most imaginative choreographers she ever witnessed at ADF.

Global Somatics was founded by Suzanne Rivers (1955–2014) in 2002. Through embodiment skills derived from BMC, Rivers developed a professional training that aims "to foster efficient embodiment, active engagement, and integrated learning of both the process and content of BMC." With a focus on individual learning styles and meaningful learning, the laboratory format classes use movement, touch, voice and consciousness to study anatomy, physiology, psychology and spirituality. Global Somatics applies both the scientific method and creative process to embodiment. Learning is experienced as co-creative process using the emergent desires of a learning community, and may lead toward community activism. Her work has a somatic-spiritual nature, drawing on her own Native American traditions. Rivers was an active performer and choreographer in the Minneapolis Minnesota community before and during the development of her somatic work.

SomaSoul: Somatic Expressive Therapy of the Leven Institute of Expressive Movement – Daniel Leven founded Shake Your Soul in 2001, and SomaSoul soon thereafter, which is one aspect of Leven's brand of movement therapy. Leven trains somatic practitioners to assist clients to free their bodies using somatic processes in order to have a more active emotional life. He draws upon the expressive movement process and a somatic psychological focus based on Body-Centered Gestalt therapy. The expressive movement process incorporates drawing, writing, speaking and moving. This is a creative and enlivening approach to self-development. The creative process breaks open the individual's limited view of her or himself, giving access to deeper feelings, intuition and one's gut-sense. In conjunction with the Body-Centered Gestalt process, the individual learns to feel and translate one's bodily reactions. Leven certified with Trager, and in Dynamic Embodiment's first graduating class, and has been influenced by the work of Anna Halprin. He included the Motional Processing work of Alice Rutkowski in many of his training programs.

Somatic Expression was founded by Jamie McHugh, MA, RSMT in 2000. According to McHugh, Somatic Expression is an experiential process that attends carefully through "breathing, sounding, movement, touch, and stillness, awakening all of the senses. The work often includes exploration outside, inviting playfulness with consciousness of nature. One goal throughout is pleasurable and spontaneous action" (Eddy Interview 2015g). His influences are vast: Continuum informs breath, vocal work, meditation and movement. Dance, writing, dialogue and drawing are well known in Life/Art Process at Tamalpa Institute, where he taught for decades. His touch and anatomy work draws heavily from the experiential anatomy of BMC. There is overlap of all somatic systems as well as a strong weave of McHugh's own artistry as a photographer, dancer, solo performer, naturalist and community leader.

The Somatic Movement Practitioner Training at the Institute for Somatic Movement Studies (ISMS) in the Netherlands was founded by Jacques van Eijden, RSMT and certified BMC practitioner, in 1995. Somatic movement practitioners focus on the moving body's sensations, feelings and actions. This system of coaching leads to an in-depth understanding of the "Moving Body as Consciousness." A key to this process is trusting an intrinsic process of self-regulation. Embodiment is explored through sensing, feeling and acting the body. Other principles include dynamic balance, development, guidance and self-organization. A

somatic movement coach practices knowledgeable, intuitive and empathetic ways of working with clients, facilitating connection to personal and interpersonal balance. Interpersonal goals incorporate independent and cooperative actions. Another central theme is to "embody, embrace and empower." Embodiment is supported through the use of the physiological coaching skills of sensory-motor awareness and hands-on training. Embracing takes form through psychophysical coaching – attuning with the psychological and emotional aspects of posture and movement. Empowerment arises from facilitating meaning-making within personal experience. Van Eijden's study as a somatic dance performer influenced this curriculum, as did his work in Ideokinesis and a form of Release Technique John Rolland and his collaborators, Nancy Topf and Marsha Palludan.

This list could go on and on. Other examples of dancers blending diverse somatic work to create in-depth training are Amanda Williamson at the University of Lancaster, Patricia Bardi's Vocal Dance and Vocal Movement Integration, Susan Harper's interpretation of Continuum and Jill Green's scholarship in dance education and Kinetic Awareness. There are also those dancers who have shaped the somatic psychology realm and the somatic movement field simultaneously – most notable are the protégés of Marion Rosen in the Bay Area, Linda Hartley's Integrative Bodywork and Movement Therapy, Susan Aposhyan's Body-Centered Psychotherapy developed at Naropa University and internationally, and the many practitioners trained directly by Irmgard Bartenieff who as dance/movement therapists have authored, taught or performed new paradigms (e.g., Katya Bloom, Debra McCall, Ute Lang, Virginia Reed).

How dance is taught through somatic processes is the subject of the next chapter, including the emergence of new terms related to somatic dance, also known as "dance somatics," somatic-based dance and somatic movement dance education.

On the Formation of the Association for Diverse Somatic Movement Professionals

James Spira RSMT, Ph.D., founder of Educational Therapy, was the leader in conceptualizing a joining of all the somatic movement disciplines under one professional heading – movement therapy. The initial professional registry and organization that he started – the International Movement Therapy Association – gradually morphed into ISMETA. ISMETA has established somatic movement education and therapy as field, approves training programs with over 500 hours of professional somatic movement studies and registers individual professionals who abide by the scope of practice and ethical standards of somatic movement education and therapy.

Spira is now a clinical psychologist, professor at the University of San Diego and a leader at the National Center for PTSD for the United States Department of Veteran Affairs. He leads groups and is involved in research including both mind-body and body-mind approaches to behavioral change.

Interview by Martha Eddy with James Spira, 12 August 2004.

MHE: What was the process of forming the initial professional association for Somatic Movement Practitioners?

JS: I found numerous barriers in the early 1980s:

Most individual practitioners were more interested in solidifying their identities with their specific organizations than identifying with a larger construct. They sought more immediate practice incentives than potential social/medical/educational influence.

Many organizations feared losing their identity or having it diminished through association with other movement disciplines. The leadership at some of the organizations lacked the inspiration and motivation to pursue this aggressively or were understandably focused on developing their own trainings and so, while encouraging of joining IMTA, were not able to devote the resources to sufficiently mobilize others to participate. And there were some who were jealous of other organizations and wanted parity (my 300 hour training is better than their 1000 hour training).

There was a fear among some practitioners of the term "therapy." Partly it was a fear of getting in trouble for using the term. In a few, it was a more philosophical concern that "therapy" was passive, while "education" was active learning.

© Peter Slade 2005

Figure 20: Gill Clark, 2005. Courtesy of Independent Dance. Photo credit: Peter Slade.

Notes

1 ISMETA only approves training programs that are a minimum of 500 hours. Some somatic training programs are quite a bit shorter and some of these are specifically geared to somatic dance education, such as trainings for Moving For Life Certified Instructors and Certified Teachers of BodyMind Dancing.
2 Indeed methods of somatic movement research are also evolving (Dyer 2009a, 2009b, 2012; Fraleigh 1993, 2015).
3 Dance therapists and somatic psychologists use the latest version of the Diagnostic and Statistical Manual of Mental Disorders (DSM) as a professional guide.

Chapter 8

The Universities and Somatic Inquiry: The Growth of Somatic
Movement Dance Education in Britain

Sara Reed and Sarah Whatley

The Universities and Somatic Inquiry: The Growth of Somatic Movement Dance Education in Britain

> Movement is not a fixed state, but a dynamic process. This process continues throughout life [...] When movement appears to stop, or ceases to be discernible, we have nothing more to observe.
>
> (Warren Lamb in Loman and Brandt 1992: 140)

Somatic Dance in the Academy: Two Stories

The next two chapters speak to the unique feature of dance bringing somatic inquiry into the academy with the creation of courses, degree programs at all levels, special laboratories and health care programming, as well as journals and books about somatic education. These chapters also feature two anecdotal histories, one written by British dance scholars Sara Reed and Sarah Whatley and another by American Rebecca Nettl-Fiol. Each author was invited to contribute based on her scholarship in this arena, inclusive of her personal experience as a somatic dance expert.

Similar to the first generation of somatic education, the advent of somatic dance or "New Dance," now referred to as "contemporary dance," has emerged in diverse cities around the world. While this book will speak strongly to the forces at work in the UK and the US, it is important to mention that the French and Canadian dance scholars have been key leaders in somatic research and curricular development in somatic dance within higher education. The French academic community has avidly engaged with somatic education from multiple intellectual, aesthetic and performative perspectives. The University of Quebec in Montreal has been a leader in establishing diverse degree programs inclusive of somatic study, spawning conference and community collaboration and research.

Association of Individuals Engaged in Movement (AIME) was created in July 2007, initiated by Julie Nioche, Isabelle Ginot, Gabrielle Mallet, Michel Repellin, Stéphanie Gressin, Sophie Claudel and Xavier Douroux. This group has had overlapping interests and the various sub-groups have set up festivals, performed, lectured, engaged in research and developed new audience–performer relationships. More recently, they have sponsored workshops, individual coaching and the creation of "sensitive spaces" to

facilitate audience awareness. The group strives for civic engagement that focuses the use and representation of the body in different fields – most notably contemporary dance, social work and the educational and medical worlds. One sub-group focuses on somatics, aesthetics and policy.

Similar stories could be told of the development of the School for New Dance Development at Arnhem and the State Theatreschool in Amsterdam, both in the Netherlands. Many students traveled internationally to these schools to gain a new perspective on dance. The Dutch programs, led by Margot Rijven under the leadership of Trude Cone, specialized in both creative exploration and well-being for their dancers, creating systems of monitoring individual dancer's health using an integration of dance science and dance medicine (Van der Linden 2004). Now, in the twenty-first century, there are dozens of stories that can be told from around the globe, including Argentina, Australia, Brazil, Colombia, South Korea, Mexico, Peru, Taiwan and numerous other Asian and European countries.

These selected vignettes are provided to make the point that somatic education today has come to be known because numerous academic departments have found somatic inquiry to be a useful and necessary area of study. Somatic bodywork has not had adequate academic support, as it is often viewed as a vocational study. However, in the Netherlands and in Israel, somatic movement therapy is a recognized part of the national health care system. Somatic movement has gained more prevalence within universities through the development of academic courses, research and publications where departments of Theatre and Dance have taken a lead. Departments of Somatic Psychology have a parallel story.

The UK and US have been fertile grounds for the development of somatic education, somatic dance experimentation and somatic dance within the academy. In the diasporas after the world wars, experts from much of Europe, particularly Germany, fled or moved to England or the US. These trained practitioners bought their expertise and training methods, and deepened inquiry in all areas of somatic education. In Canada, Regroupement pour l'Éducation Somatique brings together Alexander, Feldenkrais, Conscious Movement and Gymnastique Holistique associations and other somatic practitioners.[1] Gymnastique Holistique is the work of Lily Ehrenfried (1896–1995) – a contemporary of Bartenieff's from Berlin who studied with Gindler as a schoolgirl and then became both a therapist and a doctor. There is also an Association of Eléves du Docteur Ehrenfried in Greece.[2] Israel, supported by Feldenkrais' work, has kept a strong somatic flame alive. The advent of Gaga is one case in point. Ohad Naharin, Graham dancer and choreographer for the Batsheva national modern dance company of Israel, has developed a form of dance that focuses on sensation, pleasure and ease of the joints. These are all key principles of Feldenkrais, the somatic system his mother taught (Lurie 2010). Africa, Australia, South America and Asia have their own strong movement ritual and indigenous traditions of well-being. Some are choosing to investigate somatic movement and contemporary dance inroad (e.g. EcoDanza). As more studios start to hire teachers of "contemporary dance," somatic approaches to dance have taken widespread effect, and somatic dance has had an evolution of its own.

The interweaving of studio dance and academic inquiry can be told in many regions. Each continent is now fostering somatic work in private studios, smaller academies and at major universities.

Not all academic development has been through the lens of dance. The position of the somatic arts in the academy is buoyed by parallel somatic study within departments of cultural studies and psychology. Indeed some of the first full-degree programs in somatic studies were established in the field of somatic psychology in the US and in graduate programs of Dance Movement Psychotherapy in Britain and other parts of Europe. As the models of experiential adult education inclusive of embodiment activities grow (Kerka 2002), the role of somatic movement pedagogy in other subject areas should grow as well. The interdisciplinary approach to art education emerged along with the somatic movement practices.

Seymour Kleinman was a groundbreaker in developing a Somatic Studies department that stood on its own. Kleinman's work was unique and formative for the evolution of somatic study at all levels of education – pre-K through higher education. As his teaching became more identified with the philosophy of sports community and somatic studies, he always continued to stay in touch with arts education. He was asked to lead a small institute within the OSU called Institute for the Advancement of Arts in Education that was strongly inclusive of dance. Members of the faculty would create a work of art in their medium and art educators would have a chance to learn from them about the creative working process. The history of the evolution of the somatic studies at the OSU was driven by Kleinman's growth as a professional and by the periodic restructuring within the university. In 1993 one restructuring of how somatic education was represented at the university brought together professors of the History of Philosophy and of Education including feminists and postmodernists who were addressing issues in the body. This interdisciplinary amalgam emerged as a department of cultural studies, with somatic studies being a program within that department.[3] Interestingly, Kleinman never felt he had to defend the use of the term "somatic" at the university – only to explain it (Eddy Interview 2004b).

All this was going on [culturally] – somatics was a natural phenomenon and needed a name. We gave a name for it. Alexander came alive again; Feldenkrais came to be; massage took on a whole different meaning. And the Asian influence was significant. It became personal – a different view of the body, and I wrote about it. I tried to communicate this in physical education and health education. At times I became disenchanted with those fields; the arts education community was a critical support for fostering a holistic approach to education.

Somatic Studies became an entry point for interdisciplinary studies at the OSU. The majority of studies at the OSU focused on culture, education and the arts. While most courses were lecture style, students could take classes in the dance department. Numerous dance

153

educators completed doctoral dissertations in this department, with alumna Silvie Fortin doing groundbreaking work in somatic dance.

In England, in particular, the evolution of New Dance has spawned eddying currents of dance exploration using a variety of somatic systems. Two teachers who deserve to be noted include Mary Fulkerson, with her work in Skinner Releasing, and Gill Clarke, who taught extensively as an independent teacher and introduced a radical induction program at Trinity Laban.

When asked at the *Dance and Somatic Practices* conference in Coventry in 2012 who their major influences were, participants shared the following additional educators: Gabi Agis, Kirsty Alexander, Jane Bacon, Scott Clark, Emilyn Claid, Giovanni Feliconi, Linda Hartley, Thomas Kampe, Bettina Mainz, Monica Pagneaux, Helen Paynor, Sandra Reeve, Judy Sharpe, Miranda Turnell, Simon Whitehead and Amanda Williamson (Eddy 2012a). This listing of somatic movement dance educators crosses between studio and academy, the Alexander Technique, BMC, Rolf Movement, Skinner Releasing and a plethora of others including more recent amalgams.

As part of the somatic history, there has been a strong interplay with dance science, kinesiology, wellness and neuroscience. The International Association of Dance Medicine and Science was formed under the leadership of Dr Alan Ryan, Martha Myers and professionals from the Harkness Dance Medicine Center, and has grown to have representatives with links to hundreds of universities worldwide. Their proceedings were initially published through *Kinesiology and Medicine for Dance* and now by the *Journal of Dance Medicine and Science*. Each of these institutions and publications has supported somatic exploration, research and international exchange.

Specific universities have played historic roles in the advent and continuation of somatic inquiry within the academy. A major indicator of the growth of somatic inquiry in academia is in the publication of diverse types of somatic research and reporting on somatic pedagogy, performance, somatic dance and more. This is particularly evident in the development of journals for somatic psychology, somatic movement and somatic bodywork. Somatic dance has infused academic journals for decades but more recently has seen the advent of journals of its own. *Somatics Magazine Journal of the Mind/Body Arts and Sciences*, Sonoma, California, was the first journal to use the term "somatic." It was founded by Thomas Hanna, the philosopher and practitioner who coined the term "somatics." Numerous academic journals have developed over the past ten years.

Hence it is clear that somatic dance has now established its place in the academy in Britain, the US, Canada and France and in universities on every continent. With the advent of more interdisciplinary studies, it remains to be seen whether somatic movement methods will find their way into more degree programs in other subject areas from biochemistry, neuroscience and quantum mechanics to philosophy or religious studies, or any other domain that strives to encourage body awareness, biological knowledge, contemplation, creativity, embodiment, experiential learning, holism, a sense of presence or general wellness.

The Evolution of a Dance Pedagogy; Developing Somatic Movement Dance Education in the United Kingdom

Sara Reed and Sarah Whatley

It is fair to acknowledge that a somatic approach to movement and dance has been evolving for decades within the UK dance practitioner and teacher community, but has taken time to find recognition as a discrete and definable body of practice. Over the past decade or so the community has developed a voice, a growing discourse and more spaces to share and exchange information about somatic movement practice. As a consequence of a number of core initiatives in the UK, including the establishment of MA programs that include somatic practices at Trinity Laban (London) and at the University of Central Lancashire (Preston), scholarly publications and a series of gathering and conferences that have drawn together an international group of teachers, practitioners and researchers, somatic movement dance education (SMDE) has become more embedded within dance pedagogy in the UK context. It is the history, development and current state of the practice that is the focused on here.

The history of the development of different movements or trends in dance has been analyzed as forming itself through the work of a number of significant individuals, often described as the "pioneers." Eddy adopted a similar approach in her valuable "mapping" of the genealogy of somatic practitioners, discussing the "somatic pioneers," "the first generation" and "new generations of somatic leaders" (2009). Borrowing this way of tracking the seeds of a present-day practice, we offer a similar mapping to uncover and discuss the roots of somatics within the UK, to explore the role that the UK somatic practitioner community has played in the development and establishment of what has been coined in Britain as SMDE.

We begin with a discussion of those in the UK who have played a pioneering role in developing particular approaches to dance pedagogy, drawing in many instances and influences from and connections with practitioners (primarily) from the US and Europe, which have helped to establish what has become SMDE today. We look at how these early movers influenced subsequent generations. Important in this analysis is a review of the structures, institutions and organizations that have supported these developments, or have been established as a consequence of progression within the field of somatic movement practices. Our aim is to draw attention to the many who have contributed to this vibrant and progressive movement, often quietly and sometimes on a lone path, and to honor the collective wisdom at play.

The focus is thus not so much on an analysis of somatics within dance per se, or an analysis of the fundamental concept and proposition of somatics within a dance context, but rather to trace the developing presence of a somatically influenced approach to dance within a UK higher education context and thereby consider how it has shaped and informed this context.

Indeed, it is neither easy nor desirable to attempt a clear definition of what is a somatic practice. Many practices are considered to form part of the family of somatically influenced, informed or constituted practices; including, for example, Alexander Technique, Feldenkrais, Skinner Releasing Technique, Rolfing, Ideokinesis, BMC, Bartenieff Fundamentals, Authentic Movement, Sensory Awareness – as well as the outliers such as Pilates, Hellerwork and yoga. However, the presence of these practices within dance in UK higher education is widely variable. Some have had a long presence, often due to a single "champion" within a particular institution. The UK higher education dance context is characterized by a community of individual practitioners that has established a culture whereby somatic pedagogy is supported and promotes the integration of practice and theory. This culture allows for debate and critical engagement within and beyond the studio. These individuals draw on the writing and pedagogy of the pioneers of somatic practices, in particular that of F. M. Alexander, Moshe Feldenkrais, Elsa Gindler, Charlotte Selver and Joan Skinner, among others. Their work complements writing and research on dance-somatic pedagogy from scholars such as Glenna Batson, Martha Eddy, Sylvie Fortin and Jill Green whose work in Canada and the US has previously dominated this new area of higher education dance pedagogy.

The Beginnings – Entry of the Early Influencers

The dance writer and lecturer Peter Brinson (1920–1995) was a firm advocate for the development of dance within the education system in the UK. He provides a useful overview of the development of dance in education during the nineteenth and twentieth centuries (Brinson 1991). He relates the trajectory of dance education and training to a range of historical events, circumstances and developments. These include, for example, women's teacher training colleges, the introduction of physical training into the primary school curriculum, the first UK dance degrees and the development of community and contemporary dance in the UK. As Brinson points out, British modern dance developed from the early twentieth century through a binary system of education and training, reflecting historical influences such as sport, imperialism and the Church (1991).

The Calouste Gulbenkian Foundation's report on *Dance Education and Training in Britain* (1980) suggests that dance within British state education began with the Swedish educationalist Martina Bergman Osterberg, who opened the Bergman Osterberg Physical Training College in Hampstead, London in 1880, later transferring to Dartford in Kent in 1885, closely followed by a number of other colleges offering dance as part of teacher training for young women. Three other significant women influenced the teaching of dance in British schools and the private sector in the early twentieth century; Ruby Ginner, Madge Atkinson and Margaret Morris, thus extending the legacy of "Duncan-derived" dance forms (Adshead-Lansdale 2001).

From the mid-1930s onward, "Central European Dancing," as it became known, had a significant influence in the UK and beyond, and grew in popularity with key figures such as

Rudolf Laban, Mary Wigman, Kurt Jooss and Gertrud Bodenweiser taking the lead.[4] Laban came to Britain in 1938 as a refugee from Nazi Germany and was given shelter at Dartington Hall, Devon where Kurt Jooss was already based with his company of dancers. It was during his stay at Dartington Hall that Laban formed a strong friendship and working relationship with the young dancer and teacher, Lisa Ullman, who became Laban's constant companion and assistant from then on until his death in 1958.[5]

Although the Ministry of Education first formally recognized the teachings of Laban in the 1950s, this was at a difficult time for modern dance in Britain, with many calling for a "regeneration of excellence" after the war. However, this improvement was seen as coming mainly through classical ballet (Preston-Dunlop 2005). Nonetheless, the period of "intense activity" during the 1940s, 1950s and 1960s "revolutionized" dance education, but in some ways it also "polarized British dance culture" with classical ballet on the one side and Laban or Laban-based modern dance on the other (Brinson 1991: 95).[6]

It was in the late 1960s that it first became possible to study dance at degree level within the newly introduced Bachelor of Education degrees as part of physical education teacher training and therefore there became a requirement for a theoretical as well as practical study of dance. From this point on, the development of dance degrees within higher education flourished and by the end of the first decade in the twenty-first century there were nearly 500 courses where dance could be studied at degree level as a major, minor or double choice subject, including foundation degrees (www.ucas.com). There has been some shrinkage since with the changes in the funding structures for higher education.

Although the Central European methods were seen as the chief driving force of change and influence through the middle of the twentieth century from the 1940s to the 1960s, these were not the only influence on the development of modern dance (Preston-Dunlop 2005). Successive visits by American dancers and teachers to Dartington Hall from the 1930s onward established what became Dartington College of the Arts as a center for an unusual combination of dance technique and *bodywork*, as it was known during the 1960s to 1970s. At the same time, the opening of the London School of Contemporary Dance in May 1966 led to an exceptional time in the development of dance in higher education in the UK (Adshead-Lansdale 2001) and the seeds of a particular style of dance in higher education were already being sown at Dartington College of Arts.

Within the dance practitioner community there were developments that similarly took a cue from what was taking place elsewhere, this time the US and specifically, the postmodern dance movement; as visible through the work of the Judson Church movement in New York in the early 1960s. In the UK, a similar turn toward postmodernism was emerging through a number of key events. The arrival of American dancer Mary Fulkerson in 1973 at Dartington College of the Arts introduced a practice that she referred to as "release," which informed by a number of influences from her experiences in the US; for example, Todd's seminal work *The Thinking Body* (1937). Fulkerson's own experience of working with Barbara Clark, a former student of Todd's, and Joan Skinner are also significant.

Fulkerson stayed at Dartington until 1987 and her teaching was highly influential on what became the first generation of independent dance practitioners and teachers in the UK who together created a hybrid form of dance technique commonly referred to as "release" or "release-based technique." This popularity and hybridization of the work that Skinner began in the 1960s was something she recognized early in her career in the US, thereby prompting her to attach her own name to the work in order to protect its identity, specificity and uniqueness (Skura 1990). Thus, Skinner Releasing Technique was born. Fulkerson's influence in the UK was significant through those that she taught, such as Rosemary Butcher, and those that she worked with at Dartington, including at the Dartington Festivals, which ran until the mid-1990s and provided an annual event for independent dance artists to meet and dance together.

Fulkerson's influence extended to the activities of the X6 collective based in London in the late 1970s, which included a number of experienced dance artists eager to develop their own practice independently from the established touring dance companies of the day. X6 artists were part of a network of experimental artists, including musicians and filmmakers.[7] X6 had a hugely significant influence on the direction of UK professional contemporary dance and subsequently dance training and education from the mid-1970s onward, promoting the value of somatics in dance; the results of which can be seen in many performance companies, management contexts and performance teaching today (Claid 2006).

X6 also published the first issue of *New Dance* magazine in 1977, edited initially by Emilyn Claid and Jacky Lansley. *New Dance* became the voice for these artists and the growing community of UK-based independent artist practitioners. Consequently, New Dance was adopted by those artists as a way of identifying a broad and eclectic approach to dance practice and teaching that consciously focused on the experience of moving and which embraced a somatic philosophy. The main impulse for these artists was to find a dance practice and a writing alongside that enabled them to work holistically, bringing thought and action together, which would in some ways repair the body that had previously been subjected to physically punishing technical training. Issues of *New Dance* magazine provide a fascinating catalogue of activities, debates, articles and letters from this time relating to X6 and other independent dance artists during the years of its publication (1977–1987). The connection between somatics and what was developing under the umbrella of New Dance in the UK is evident within the pages of the magazine. For example, in the first issue of *New Dance* Kate Flatt writes:

> I took some classes in release work and began taking Alexander technique, to see if they would help my apparent lack of communication with myself. I also questioned the necessity of almost twenty years of technical involvement in dance.
>
> (1977: 7)

Flatt's comment indicates a clear alignment with the use of a somatic practice, in this case Alexander technique and "release" work, with the beginnings of a different way of thinking

about how to teach and learn dance. Even at this relatively early stage, Flatt was working with hybrid influences. Although Claid does not refer to this work as somatics, she refers directly to the need for a safer dance practice, a practice that looks after the dancing body rather than damaging it (2006). Her quote comes at a time when this type of dance approach had yet to be named "somatic."

Finding a Voice

Publications such as *New Dance* and the *Theatre Papers* series that were published by Dartington in the 1980s were important in circulating the knowledge that was being generated from within the growing independent dance movement in the UK while sharing the work that was influencing the practice from outside the UK, notably the US. Similar to *Contact Quarterly* published in the US (1975–) and *Writings on Dance* published in Australia (1985–), the writing was also capturing the dialogue that was taking place between those who were primarily located within the world of dance performance, the teaching community and those developing a practice within bodywork and therapeutic practices. More specifically, even though these writings were not particularly focused on dance pedagogy within an educational context, the publications demonstrated the porous borders between these communities showing that many who contributed to and subscribed to these journals were developing careers, sometimes second careers that combined performance, teaching, and bodywork practice. Some practitioners turned toward the growing interest in practices that encouraged a more holistic, thoughtful and introspective way of moving than traditional dance techniques had provided up until that time. The impact of what was happening at Dartington and what was subsequently to develop elsewhere in the country (for example, the New Dance Festivals in Coventry that ran for a decade from 1988 to 1998) led to what might be regarded as "the somatic turn in dance" and a parallel growth in dance in the universities in the UK, which provided opportunities for practitioners to work within the Academy and influence the curriculum.

The first generation of somatic practitioners in the UK were, on the whole, studying and training as 20-year olds in the mid-1980s at the time that *New Dance* magazine was still being published. Their dancing identities were considerably shaped by the challenges presented by postmodern dance. For example, Gill Clarke (1954–2011) experienced a range of practices during the 1980s, such as the Alexander Technique, Klein-influenced work (based in Bartenieff Fundamentals) and the Feldenkrais Method, which had a huge influence on her development as a dancer, dance-maker and in particular as a dance pedagogue (Clarke 2002; unpublished conversation). Clarke's teaching and writing has had a profound influence within the UK: for example, she established a somatic strand within the undergraduate training at Trinity-Laban Conservatoire of Music and Dance in London

and established the MA Programme in Creative Practice at Trinity-Laban, delivered jointly with Independent Dance and Siobhan Davies Dance.

By the turn of the millennium, dance in higher education in the UK was beginning to embrace a plurality of dance styles, techniques and pedagogical approaches and the influence of somatic practices was growing. But the consistent teaching of somatic practices within this context has, until very recently, been largely spasmodic and confined to a small number of institutions, with the work often led by one specific and charismatic individual. Nonetheless, as mentioned above the practice has gained visibility and validity through the introduction of the peer-reviewed *Journal of Dance & Somatic Practices* (2009–)[8] and related publications including the journal of *Dance, Movement & Spiritualities* (2014–).[9] The growing recognition of somatic pedagogy and research in dance in the UK has been consolidated through several conferences including the biennial *Dance and Somatic Practices* conference at Coventry University.[10] These events and publications demonstrate how the development of SMDE in the UK draws upon a multiplicity of disciplines including dance, dance pedagogy, somatics, sociology, anatomy, physiology, biomechanics, theories of the body, philosophy, psychology and consciousness studies.

Practices and Practitioners within the Academy

There are many different terms that may be used to describe somatic practices for example, bodywork, body-mind disciplines, "body therapies," somatic therapy, movement awareness and others, but this list is by no means definitive (Allison 1999; Eddy 1995; Knaster 1996). The rise of SMDE in dance in higher education has grown through the integration of these and other named practices, in the UK, such as Alexander Technique, Feldenkrais Method, Skinner Releasing Technique, BMC, Authentic Movement and Sensory Awareness. There is a growing community of teachers within higher education who have certified as teachers within one or more of these practices and their work is now shaping the curriculum within different institutions. For example, a number of articles written by SRT-trained teachers have provided a specific insight into Skinner's work and the development of this practice within UK dance higher education (Alexander 1999; Skelton 2002; Emslie 2002, 2006, 2010). One such teacher, Kirsty Alexander, points out that, "Skinner Releasing Technique forms a highly organised pedagogy. The primary function of the pedagogy is not choreographic or therapeutic but, since it deals with integration, its effect can be nourishing on many levels" (1999: 9). The running of the first SRT teacher training in the UK at Coventry University in the summer of 2010 is testament to the developing interest in Joan Skinner's work that is evident in the UK today.

Elsewhere, Jayne Stevens introduced the Alexander Technique, in the 1980s, within the dance program at what is now De Montfort University. Moshe Feldenkrais' work has been introduced to higher education since the 1980s through the work of Thomas Kampe at various Universities, while Richard Cave, through his work at Royal Holloway University

in London, is recognized as being probably the first person to introduce the Feldenkrais Method within a higher education degree program in physical theater (Igweonu 2010). Gindler's work continues to be transmitted through practitioners such as Rebecca Loukes at the University of Exeter, and BMC is now widely taught across a number of higher education institutions. However, SMDE within the British context is perhaps most visible in the MA Dance and Somatic Well-Being: Connections to the living body at UCLan/ New York, founded by Amanda Williamson who is a leading authority in SMDE and has published widely on the place of somatic pedagogy (2009, 2010; Williamson and Hayes 2014).[11]

Despite these advances, developing a strand of somatic practice alongside dance technique especially within undergraduate programs can be, and often is, problematic (Clarke 2002; Roubicek 2009; Weber 2009). Those who are teaching dance within this continuum of a dance-somatic pedagogy need to have had experience of somatic practice that they can remember and draw on in their own teaching, otherwise, their understanding of somatics remains purely abstract and therefore often without meaning. Consequently, much of the teaching of somatic practices within higher education is delivered through freelance dance artists and the many dance educators with permanent academic positions who have come originally from the professional dance world bringing with them an eclectic experience of dance training and education. Their contributions ensure that somatic work is well grounded and can complement other technical training in dance.

Kirsty Alexander, reflecting on her experience while on the faculty at the London School of Contemporary Dance, refers to a "continuum of somatic and traditional practices" relating to preexisting vocabulary through which students explore kinesthetic experiences and develop their own language, resulting in a cross-fertilization. This cross-fertilization, as she describes it, is becoming the more usual pattern for those higher education dance courses that already embrace dance somatics (Alexander 2008). However, such a cross-fertilization needs to be handled very carefully in terms of sound pedagogical practice to avoid what might be described as a potpourri method whereby students are unclear about what and how they are learning.

Conclusion

The recent surge of interest in SMDE within higher education in the UK in the very late twentieth and early twenty-first centuries may be seen to be the result of the postmodern and New Dance eras and the practitioners, teachers, performers and choreographers who came out of this experimental phase. There has been a discernable though subtle move toward the inclusion of somatics within dance degree courses in some universities and colleges in the UK, although this movement might be perceived as relatively modest, as indicated through a series of surveys conducted over a number of years by Sara Reed

(Reed 1998, 2006, 2011). While there are a growing number of curricula that are built on somatic pedagogy (such as the MA at UCLan and the BA at Coventry University), somatics is largely fitted within the traditional pedagogic framework and dominant discourse for dance higher education and training, with its focus on contemporary and classical dance techniques, composition and choreography classes.[12] There is support by "a small but powerful community of dance educators (who) are now working towards integrating somatic practices into their undergraduate and post-graduate degree programs" (Emslie 2010: 169).

A greater understanding of the nature, value and potential of somatics alongside dance in UK higher education appears to be gradually evolving. Supported by an integrated approach to theory and practice, and an active inclusion of other subject domains and philosophical perspectives within the curriculum, SMDE has found a place within the UK dance higher education context. The growing body of research and writing by those involved in dance and somatic practices is helping this evolution and is increasing knowledge about the pedagogical benefits of dance somatics, particularly in the training of a new generation of dance practitioners. The thoughtful inclusion of somatics and the balance of a dance-somatics curriculum provides for the development of a curious, knowledgeable, creative, strong, intelligent and technically able dance practitioner. There is more work to do, but SMDE is increasingly more central to a comprehensive program for a twenty-first century UK dance higher education.

From Kiki Jadus, Topf Technique and Dynamic Embodiment practitioner, about doing Ideokinetic-based "release work" with Nancy Topf, colleague of Fulkerson, who also studied with Barbara Clark and Joan Skinner:

In Nancy Topf's classes and sessions she offered access to feeling the principle thrust and counter-thrust, or "for every action there is an equal and opposite reaction." I appreciated the simplicity of her presentation: she would draw on a large drawing pad with a thick marker, first a large arrow drawn pointing downward, an equal sign and then an arrow pointing upward. She would draw it from left to right, very methodically, and by way of my senses being so open, I felt like the drawing bypassed my cognitive mind spoke directly to my body. I could feel the potential for balance of effort, that I didn't have to tense my legs to stand upright. In holding this theory in the same light as movement and release work, Nancy offered a means to facilitate a strong sense of support and release. The way Ideokinesis works is multisensory, through the eyes, the mind, the application of image to feeling, the feeling of image in movement, the way a gesture can transmit information to the cells of the body through completely enrolled curiosity and exploration.

Notes

1 http://education-somatique.ca/
2 Canada: http://education-somatique.ca/?page_id=103
 France/Greece: http://www.gym-dr-ehrenfried.fr/-
3 In 2002 the Cultural Studies department became Social and Cultural Studies. In 2004 Sy Kleinman retired and the Somatic Studies department was possibly going to shift into the Health and Wellness department. He died on the winter solstice 2013.
4 In 1954 the London College of Dance and Drama was opened and in 1967, with the assistance of Dartford College of Education, a new qualification for dance teachers was established that enabled graduates of the course to teach in state schools, thus, it is suggested, partly bridging that gap which had existed between professional and nonprofessional dance training (Calouste Gulbenkian Foundation 1980). Although this meant that dance was now a part of the mainstream state education system in England and Wales, through the 1933 Syllabus, it was largely only included in primary teacher training.
5 During the next few years, there was a significant development of interest in Central European Dancing, and a series of meetings, conferences and summer schools were held in which both Rudolf Laban and Lisa Ullman were involved.
6 The development in dance teaching at secondary school level was due to the training and education given in the pioneering teacher training colleges as outlined above and thereby laid the foundations for the widespread provision for the study of dance at Bachelor, Master and Doctoral levels available in higher education institutions and universities throughout the UK today.
7 Artists included Emilyn Claid, Jacky Lansley, Fergus Early, Stefan Szczelkun, Geoff White, Maedee Dupres, Mary Prestige and Timothy Lamford.
8 Published by Intellect and edited by Sarah Whatley, Coventry University, UK.
9 Published by Intellect and edited by Amanda Williamson, Coventry University. UK.
10 The first major British conference on dance somatics took place on 11 July, with the title: *Fostering Trans-disciplinary Perspectives on Embodied Process and Performance*. This conference followed other UK events that had a focus at least to some extent on dance, somatics and pedagogy, including *Finding the Balance: Dance in Further and Higher Education in the 21st Century*, Liverpool John Moores University Dance Department, 2002; *New Connectivity: Somatic and Creative Practices in Dance Education*, Laban Research Conference, 2003; *Immeasurable? The Dance in Dance Science*, Laban Research Conference, 2005; *The Changing Body: Symposium*, University of Exeter, Department of Drama, January 2006; *Somatic and Creative Practices: Learning and Teaching in Higher Education*, Liverpool John Moores University, February 2008.
11 Now continuing under the leadership of Penny Collinson, approved by ISMETA in 2006.
12 Eddy (2015) writes contemporary dance, in many settings, has become synonymous with dance infused with somatic methods – predominantly release techniques and Bartenieff Fundamentals.

Chapter 9

How Dance Has Helped Situate Academic Fields of Somatic Inquiry: Case Study University of Illinois-Urbana

Rebecca Nettl-Fiol

How Dance Has Helped Situate Academic Fields of Somatic Inquiry: Case Study University of Illinois-Urbana

> Somatics has become a current moving the river of a majority of contemporary dance performers today. It is taught in various guises in colleges and universities across the US and has migrated to Europe, where some of the systems originated.
>
> Martha Myers (in Bales and Nettl-Fiol 2008: 99)

This chapter highlights the unique place of one university – the University of Illinois Urbana – in the US, providing a striking example of how an academic setting was a fulcrum for somatic experimentation and scholarship in dance.

"A virtual somatic Mecca" – this is how the University of Illinois Dance Department was described in 2012 by Nancy Wozny in an article for *Dance Magazine*. Like many dance departments today, the dance program at Illinois weaves somatics into both the undergraduate and graduate curricula, exposing students to a variety of somatic practices throughout their time in the department. Many of the faculty are either certified teachers/practitioners or have invested deeply in a number of body-mind disciplines. Principles, values, philosophies find their way into courses, structures and creative projects. It is part of the fabric.

This chapter traces the threads of somatic practices at the University of Illinois, from the early years to the present, revealing a fascinating history that has had a significant impact on the dance/somatics field both in the US and abroad. A convergence of key figures in the development of release techniques, including Skinner Releasing, Releasing and Anatomical Release Technique, occurred at the university in the late 1960s to early 1970s, followed by an immersion of Alexander Technique into the dance program and the community, which continues to this day.

The Beginnings and Margaret Erlanger

The department owes its early development to Margaret Erlanger, who headed the dance program from 1948 until 1969, and continued as director of the graduate program until her retirement in 1974. Prior to this time, dance offerings at the university had included folk and social dance forms taught in the physical education curriculum in the early 1900s, followed by "interpretive" and "natural" dance courses, which were introduced by 1920.

Even earlier than this, dating back to 1898, dance played a major role in the annual May Day festivities at the university, under the direction of the women physical education teachers who taught dance classes (Knowles 2014). *Sweet Pea Waltz, Dance of the Corn Maidens* and *Shepherdess Dance* were just some of the dances that were performed during these festivals, which continued until the mid-1930s.

In 1929, Ione Johnson was hired to begin a program in modern dance (Knowles 2014). 20 years later, just one year after Margaret Erlanger was hired at the University of Illinois, a degree in dance was implemented under Erlanger's direction: a Bachelor of Science in physical education with a dance specialization (Knowles 2014). Erlanger was fortunate to have an advocate and mentor in Laura J. Huelster, head of Women's Physical Education, who had already laid the groundwork for a dance degree (Wilson 2008: 63). Interestingly, Huelster had been a friend of Lulu Sweigard during her graduate studies at New York University, a connection that proved to be significant later in the development of somatics at the university.

Erlanger had been a student of Margaret H'Doubler at the University of Wisconsin. After that she taught for ten years at the University of West Virginia. Her undergraduate and graduate work was in the sciences; in fact, her father, Joseph Erlanger, was a Nobel Prize winning physiologist. Erlanger danced as a child, but had not considered dance as a career. But during the Great Depression and without a job, she wound up leading a children's rhythm band at a settlement house in St. Louis. Here she began to explore teaching movement to the children, and soon she realized her need for a creative outlet in her life. This prompted her to enroll in the dance program at the University of Wisconsin in 1933; she then completed her Master of Science in Physical Education in 1935 (Wilson 2008: 62).

The educational philosophy of Margaret H'Doubler was clearly apparent in Erlanger's viewpoint on dance education. In an interview published in the Champaign-Urbana Courier in 1967, Erlanger commented:

> A student may not make dancing his life's work, but does this really matter in the end? The important thing is the dancing, the doing. Even beginners must be deeply involved, completely absorbed. [...] We not only want to free the body, but the mind as well. Our students grow in creativity, ideas, thinking – as people! It thrills me to see this growth.
>
> (Wilson 2008: 68)

Erlanger felt that her students should also be inspired and taught by professional dancers. Unlike H'Doubler who was focused on the science of movement and pedagogy, Erlanger was interested in dance as an art form, and was dedicated to bringing dance professionals to the academy. She immersed herself in learning from the dance luminaries of the time, spending summers taking classes with Martha Graham, Doris Humphrey and Charles Weidman, and traveling to Germany to study with Mary Wigman (circa 1937–1948).She began building the faculty by hiring three distinctly different dance artists. The first was Willis Ward in 1958, former dancer with Barbara Mettler and Anna Halprin and University of Wisconsin graduate. Next was Jan Stockman, another University of Wisconsin graduate and dancer

with the José Limón company, and Joan Skinner, who had danced with Martha Graham and Merce Cunningham prior to coming to the University of Illinois for a master's degree. At this time we begin to see glimpses of somatic beginnings, first through the H'Doublerian philosophy as it resided in Erlanger's perspective, and then through the work of Willis Ward and eventually, Joan Skinner.

Margaret Erlanger embodied an example of two divergent strands within dance education: (1) Margaret H'Doubler's belief in the value of dance as a "personal form of human expression and mind-body integration in daily practice that would train the whole person for civic life" (Ross 2000), a philosophy that resonates strongly with somatic practices; and (2) the emphasis on dance as an art form and training dancers for the profession. Author and dance administrator Thomas Hagood characterizes Margaret Erlanger as having a "liberal philosophy for dance education, juxtaposed against her groundbreaking work in bringing professional dancers and their values into the public university" (Hagood 2008: 59–60).

Erlanger remained head of the Department until 1968, leading it from Physical Education into the College of Fine and Applied Arts (to be discussed later in this chapter). The hallmarks of Margaret Erlanger's legacy, according to Patricia Knowles, department head from 1976 to 1991, included a core faculty of artist/teachers/scholars augmented by artists-in-residence; cross-disciplinary coursework and collaborative experiences; a broad-based curriculum that included movement science and cross-cultural connections (Knowles 2014).

Joan Skinner, The Alexander Technique and "Releasing"

In 1999, *Movement Research Journal* devoted two issues (18 and 19) to the topic *Release*. What is release? That was the question on the table. Many of the prominent figures in these two journals began their inquiry and investigations at the University of Illinois. In her article, "Release Work, History from the View of Mary Fulkerson" Fulkerson claims that

> Joan Skinner did her first year of research at the University of Illinois with Marsha Paludan working as her close assistant and with John Rolland, Nancy Udow, Pam Matt, Mary Fulkerson and other interested students.
>
> (1999: 4)

This section delves into this exciting time of the pioneers of this work, starting with Joan Skinner who as mentioned earlier, was hired by Margaret Erlanger in 1961.

During her time at Illinois, Skinner was encouraged by Erlanger to experiment with students in refining her own approach to technique (Skinner Releasing Network n.d.). In working with freshmen, she began introducing alignment principles and encouraging the idea of a neutral instrument as opposed to "the outer form that their teachers had grafted on them" (Davis 1974: 21). Her classes encouraged questioning and exchanging, and in trying to answer questions, she began to devise images, such as a head string where one

end of the string was at the center of the top of the head, and the other went out into space (Davis 1974: 22). She also had students lie on the floor with their feet on the floor and knees bent and gave them images to think about. It was during these informal, experimental classes that Skinner Releasing Technique began to evolve (Davis 1974: 21), and it was her students who coined the term "releasing" to describe their experience in her class. Skinner left the University of Illinois in 1967 to join the faculty at the University of Washington in Seattle.

A Gathering of Release-Based Work: The Four Friends

Skinner's work initiated an explosion of interest among students and some faculty in release and imagery-based work. Colleagues Marsha Paludan and Nancy Topf, both hired in the mid-late 1960s, and students John Rolland and Mary Fulkerson became keenly interested in exploring this work. Paludan had studied with Anna Halprin and Lulu Sweigard, and introduced students to the writings of Todd and Sweigard (Ideokinesis.com 2011a). Nancy Topf had trained with Merce Cunningham, Steve Paxton, Anna Halprin and Robert Joffrey, and was a graduate of Wisconsin's program under Margaret H'Doubler.

John Rolland was the son of a violinist who was pioneer in an innovative approach to string pedagogy, which emphasizes "freedom and ease of playing through the use of good motion patterns, and freedom from excessive tension" (Rolland 2008). John Rolland was both a visual artist and a dancer, earning a bachelor's degree in crafts from the University of Illinois and later a master's in dance. The story told by Topf is that while she was teaching a Cunningham class, she noticed that one of the students was doing "some strange wobbling of his head during the exercises. The student [John Rolland] explained that he was feeling his head balance on his spine" (Ideokinesis.com 2011b). Topf was intrigued and soon a friendship and working relationship emerged among Topf, Rolland, Paludan and Fulkerson, who continued to explore imagery, especially anatomical imagery, and its applications to dancing and dance teaching (Buckwalter 2012: 4).

Imagery: Barbara Clark and Pamela Matt

Another key player in this evolving story is Barbara Clark. A student of Mabel E. Todd, Clark developed her own approach to the work, calling it "mind-body integration" (Ideokinesis. com 2011d). Her work, like Todd's, was based on finding support through the skeleton and release of the musculature, through the use of anatomically based imagery. Clark worked with dancers (as well as others) in New York City during the Judson era in the late 1960s. In the early 1970s Clark took up residence in Urbana-Champaign. Why Urbana-Champaign? She was not sought out by the University. It was at the urging of her student Pamela Matt that Clark decided to settle in Urbana, Illinois, along with the groundwork laid by Joan Skinner and Marsha Paludan, with the support of Margaret Erlanger and Laura Huelster.

Pamela Matt was a University of Illinois student during Joan Skinner's initial residency; in fact, she followed Skinner to Seattle and completed her bachelor's degree there. In the early 1970s Matt returned to Illinois for graduate work, focusing on the study of body-mind integration (Matt 1993: 3). Matt met Barbara Clark at a conference in Kansas, which she attended with a number of other Illinois graduate students. In her introduction in *A Kinesthetic Legacy: The Life and Works of Barbara Clark*, Matt gives a colorful account of meeting the then 82-year-old Clark, "in the middle of our hosts' living room floor, sitting like a child on her heels" (Matt 1993: 3). Upon hearing that Clark was looking to move from New York City, Matt, with the help of Laura Huelster, convinced her to move to the quiet and simpler lifestyle found in Urbana. Clark arrived a few weeks later and moved into a small apartment near the campus.

Clark's apartment became a studio, frequented by students Matt, Rolland, Topf, Fulkerson and Paludan, among others. Clark worked on her writing, using her students as sounding boards (Ideokinesis.com 2011d), and published her third manual, *Body Proportion Needs Depth – Front to Back* in 1973, and developed material for her fourth manual, *The Body is Round – Use All the Radii* (published posthumously). Students John Rolland and Nancy Udow helped her to sort, type, redraw and organize her materials, and Pamela Matt immersed herself in Clark's work, culminating in her master's thesis, *Mabel Elsworth Todd and Barbara Clark – Principles, Practice and the Import for Dance*. When Clark passed away in 1982, she left all of her writings to Matt, who compiled them in *A Kinesthetic Legacy: The Life and Works of Barbara Clark*.

The Dance Department Moves to Fine and Applied Arts

Meanwhile, the department flourished under the leadership of Margaret Erlanger. In 1959, the Master of Arts in dance was offered as an interdisciplinary degree in physical education, art, speech and music. That same year, Erlanger invited Merce Cunningham as the first dancer-in-residence for a four-month residency, which marked the "first time in the history of dance in higher education that dance students performed professional repertory – a two-part work, 'Collage,' which included a solo for himself" (Knowles 2014). The university's Contemporary Arts Festivals (1954–1967) hosted major artists and provided Erlanger with opportunities to bring prominent choreographers and their companies to campus, including Paul Taylor, Alwin Nikolais, Katherine Litz, as well as Cage and Cunningham.

The Bachelor of Arts with emphasis on dance was established in 1962. The faculty continued to grow, with Beverly Blossom from the Nikolais Company replacing Joan Skinner, and musician Alan Thomas serving as music director. The curriculum included "daily technique classes, improvisation and composition, music theory for dancers, pedagogy, creative dance for children, dance history, theory and philosophy, and dance related courses in kinesiology, zoology, theater, and art" (Knowles 2014). Dance was becoming more prominent in the university overall; noted tai chi master and dancer Al Huang was a fellow in the prestigious

Center for Advanced Study in 1968–1969, performing with his wife Suzanne Pierce in several concerts during that time. He remains in Urbana to this day, where he is founder of the Living Tao Foundation.

In 1968, Margaret Erlanger won a long-fought battle to move Dance from Physical Education to become an autonomous department in the College of Fine and Applied Arts. Jan Stockman was appointed Acting Head of the new department, as Erlanger had made several enemies of upper administrators during the process. Erlanger became director of the graduate program. By this time, the department had 12 faculty members (some part time), including Marsha Paludan, Lynn Blom and Nancy Topf. Stockman instituted a plan to bring in a guest artist from New York for a semester at a time. The first was Steve Paxton, who was in his early days of experimenting with improvisation. Jan Stockman notes in her account of the formation of the dance department,

> I remember having to intervene when he was having the students undress on one of the stages of the Krannert. Then he took a class to a large shopping center in Urbana to do a Vietnam War protest dance. I received a call from the police on that one. But Steve certainly livened up the department and spurred the students to move in new directions.
>
> (Stockman n.d.)

Next was Katherine Litz, and then Barbara Lloyd, with her partner, Gordon Mumma. In 1969, the Krannert Center for the Performing Arts opened, housing Dance, Theater and Opera. An improvisational concert by the Yvonne Rainer Dance Company inaugurated the opening, joined by Steve Paxton and Barbara Lloyd. The Willis Ward Company also performed in one of the Krannert opening events.

Somatics Continues to Develop

This was a rich time in the department. In 1967–1968, the last year in Physical Education, there were 24 students majoring in dance. The first year in Fine Applied Arts saw a jump to 52 dance majors. By 1971, there were 100 dance majors and 25 graduate students. The faculty increased from five to twelve – all from the professional world. Ballet was added to the curriculum, there was a vigorous guest artist program and cross-disciplinary work was flourishing. The small group of faculty and students continued their practice of working with release-based principles into the early 1970s, attracting others to participate in the exploration. Improvisation was thriving in the department through the work of Willis Ward and Nancy Topf (both of whom had danced or trained with Anna Halprin), Beverly Blossom (from the Laban lineage through Nikolais) and Steve Paxton as an artist-in-residence. Contact Improvisation was another key component to the release work investigation that was taking place at that time. Contact Improvisation artist Daniel Lepkoff visited Urbana during those times and discussed his work with Fulkerson, Topf,

Matt, Paludan, Rolland and Clark as "significantly shaping his viewpoint and path as a dancer" (Lepkoff 1999: 7).

Fulkerson, Paludan, Rolland and Topf all eventually left Illinois, but continued collaborating and developing their work. In 1972, Topf, Rolland and Paludan began to work together in the summers, which developed into the Vermont Movement Workshops, where they experimented with Clark's work, finding new approaches to dance technique and performance. Contact Improvisation was also an important part of these explorations (Buckwalter 2012: 5). These summer workshops continued until 1985. Mary Fulkerson, instrumental in bringing the work to Europe, was hired at Dartington College in the UK where she introduced Release Technique and Contact Improvisation in the syllabus. She often brought in her friends and colleagues Paludan, Rolland and Topf as guests, as well as Steve Paxton and Daniel Lepkoff (Buckwalter 2012: 6). John Rolland began working at the Modern Dance Department of the Theaterschool (later named School for New Dance Development – SNDO) in Amsterdam, teaching Todd Alignment and Release Technique principles (Buckwalter 2012: 6). Rolland published *Inside Motion: An Ideokinetic Basis for Movement Education* in 1984. Marsha Paludan moved to Kansas, earning a PhD in Theater, and then took a position at the University of North Carolina, Greensboro. Nancy Topf moved to New York City and developed her own teaching practice and approach to anatomical release technique, which she called Topf Technique and Dynamic Anatomy. Unfortunately, both Topf and Rolland have passed away – Rolland of complications from AIDS in 1993 and Topf in the Swiss Air flight 111 crash in 1998.

The 1970s: Somatics Tapers Off, then Reignites

As the department continued to grow and thrive, the emphasis shifted from dancing to learn, to learning to dance. This was happening across the country, as evidenced through the newly formed Council of Dance Administrators (CODA) and later, the National Association of Schools of Dance (NASD). Dance programs, including the department at the University of Illinois, became even more focused on training and developing the professional dancer. As the department's emphasis on professionalism and technical dancing grew, and with the departure of Skinner, Topf, Paludan, Rolland and Fulkerson, interest and engagement in somatics waned for a time.

Patricia Knowles became department head in 1976, following a five-year period when Oliver Kostock led the department. Kostock had been Hanya Holm's assistant, and along with faculty member Beverly Blossom, brought an emphasis on the Holm/Nikolais/Laban lineage to the department. Improvisation continued to thrive through Willis Ward's and Blossom's work, along with various guest artist residencies. Knowles led the department for 25 years, working diligently to strengthen the performance-oriented degrees, revising the BFA and implementing an MFA degree. Knowles was instrumental in establishing dance standards in the US, serving as president of CODA and leading the department to become a charter member of NASD.

In 1977, two new faculty members, Angelia Leung Fisher and Ann Rodiger, both graduates of the OSU's dance program, were interested in developing a movement fundamentals course. Both had taken a similar course at OSU with Lucy Venable, Labanotation teacher who also studied with Laban protégés Irmgard Bartenieff, Ann Hutchinson Guest and Warren Lamb and became certified in the Alexander Technique. Venable began by teaching Alexander classes three times a week and then began a course called Fundamentals in which she introduced students to Alexander, Bartenieff Fundamentals, Ideokinesis and Feldenkrais. Also, both Fisher and Rodiger had studied Laban work at Ohio State and Rodiger had taken Alexander lessons with Bill and Barbara Conable while in Columbus. Eager to share this information with students, Fisher and Rodiger wrote a grant to develop their course, which emphasized the discovery process versus a product-oriented approach to movement, and they began offering the course for freshman dance majors. This was the first time a course in somatics was introduced into the dance curriculum. Labanotation was also added as a course during this time.

The Alexander Technique Comes to Urbana

The next surge of somatics into the dance program at Illinois began when Alexander Technique teachers Joan and Alex Murray moved to Champaign-Urbana in 1977 for Alex to take a position as professor of flute in the School of Music. The Murrays had trained in the Alexander Technique in London with Walter Carrington in the late 1950s to early 1960s. Both began training during the height of their careers, Joan an accomplished dancer and Alex a prominent flutist. The couple opened their Alexander training course in their home in Urbana in 1977, which continues to this day. Once again, like Barbara Clark's apartment back in the 1960s, a home in Urbana became a hub, attracting people in this case from all over the country to study the Alexander technique. The course has certified over 100 teachers, many of them dancers.

Ann Rodiger joined the training course right away, and began incorporating the principles in her work at the university, eventually giving some private lessons as she got further along in the course. The Murrays were invited by Patricia Knowles to give a lecture-demonstration about the technique, and gradually some of the dancers in the department began to take advantage of having trainees in the community that needed guinea pigs to practice with. Meanwhile, the Movement Fundamentals course and Willis Ward's work continued the somatic lineage in the program. In 1982, Rebecca Nettl-Fiol, an alumnus of the department and recent graduate of the OSU graduate program, was hired by Patricia Knowles to teach a number of courses including Labanotation and Movement Fundamentals. Ann Rodiger and Angelia Leung Fisher had both moved on to other universities. By 1983, Nettl-Fiol rewrote the fundamentals course to become a three-credit hour course that also introduced anatomy called Theories and Fundamentals of Movement.

Nettl-Fiol began studying with Joan Murray regularly and in 1987 joined the Alexander training course. Upon certification in 1990, she designed an introductory course in the Alexander Technique for dancers, which continues to this day, merging Alexander teachers, trainees and dance majors in an exploration of incorporating Alexander principles to dance. She also became a full-time tenure track faculty member in 1991.

During the 1990s, interest in somatics increased in the department, echoing the burgeoning of the field in dance in the US. The floating guest-artist position established by Patricia Knowles brought many dance artists from the field who were exploring various release-based practices. Susan Klein and Barbara Mahler's Bartenieff-based influence was evident in the technique classes presented by many of the guests that came in those days, as was the Alexander Technique. These included Ralph Lemon, Bebe Miller, Stephen Petronio, Mark Haim and Libby Nye, who had studied Ideokinesis with Lulu Sweigard, among many others. Bill Evans and Jackie Villamil brought further expertise in Laban- and Bartenieff-based work, and Lynn Simonson, who visited the department annually from the early 1990s through 2007, taught jazz, yoga and pedagogy classes – imbued with her keen interest in developing efficiency and ease and working with an understanding of anatomy. Many of these guests took Alexander lessons with Joan Murray and Rebecca Nettl-Fiol when they came to town.

In 1994 Nettl-Fiol established the Movement Fundamentals course as a required course, Dance Kinesiology and Somatics, where somatic practices were introduced in a weekly "body-lab." Amazingly, the small Champaign-Urbana community was home to many certified practitioners, and she was able to access guests in the Feldenkrais Method, Bartenieff Fundamentals, Rolfing, Pilates, Zero Balancing and Trager work to present their work to the students. The course continues to this day, evolving as the field has continued to develop.

After completing her Alexander training in 1990, Nettl-Fiol became increasingly interested in finding ways of infusing the Alexander technique principles into her dance technique classes, and to communicate the concepts to dancers in a way that would make sense to them, maintaining the integrity of the choreographic intent or style at the same time. Responding to perceptions of some dancers and dance educators who feared that somatic work would iron out or flatten the movement qualities, she was intent on cultivating a wide range of expressivity along with intelligence and efficiency in her dance students. The link that integrated this information came from her study of the Dart Procedures, which she learned from the Murrays.

The Dart Procedures were developed by Joan and Alex Murray in collaboration with anthropologist and neuro-anatomist, Raymond A. Dart (Murray 2005). This work distinguishes the Murrays' training course from others, as it provides a particular understanding of developmental and evolutionary movement in relation to the Alexander Technique principles. Dart felt that the Alexander Technique had become too static, and suggested that Fetal (movement) was most important to include in their work. The Murrays broadened the spectrum of movement possibilities, incorporating the fetal, or primary curve, and the opposing movement, secondary curve, and accessing the double-spiral

musculature of the body, as described by Dart in 1950 in his article, "Voluntary Musculature of the Human Body: The Double-Spiral Arrangement."

Nettl-Fiol investigated and explored working with these principles in the dance studio and in her Alexander for Dancers course, and began presenting the work in other venues, giving workshops and presenting at conferences. This led to a co-authored book, *Dance and the Alexander Technique: Exploring the Missing Link* (Nettl-Fiol and Vanier 2011), written with her former graduate student, Luc Vanier.

As students became more and more interested in pursuing Alexander, Nettl-Fiol devised a program where graduate students could obtain their Alexander certification with the Murrays, simultaneously with earning their MFA in dance. Through independent studies with Nettl-Fiol, students could receive credit for a portion of their Alexander training, and to date, nine students have taken advantage of this opportunity. Alexander Technique became more integral in the department as students and faculty members, including Philip Johnston and Contact Improvisation specialist Kirstie Simson, became certified teachers. A second training course opened up in Urbana (led by Rose Bronec and Rick Carbaugh) and a second course was added to the dance curriculum. A new initiative in the department, starting 2014, offers private lessons to incoming graduate students and junior dance majors, encouraging them to explore and engage in the somatic practices that spark an interest in them.

Somatics at Illinois Today

Today, somatics has become part of the fabric of the Department of Dance. The Alexander classes continue to flourish, and an introduction to Somatics course has been established as a requirement for undergraduates, in addition to the Dance Kinesiology course. Nettl-Fiol designed a graduate pedagogy course, Somatics in Dance Training in 1997, which continues to be a requirement. Kirstie Simson and Alexander teacher, with a background in Aikido, is on the faculty, as well as Jennifer Monson, who has studied various somatic practices such as Skinner Releasing and BMC. Linda Lehovec, who teaches ballet and modern technique, offers yoga each semester. Sara Hook is a CMA and incorporates the Laban work in technique and choreographic process classes. Department Head Jan Erkert incorporates knowledge from studying BMC and uses developmental movement concepts in her technique classes. Graduate students with backgrounds in somatics are called upon to teach in their areas of expertise, which have recently included Feldenkrais, Pilates and Contact Improvisation.

Champaign-Urbana seems to be a fertile ground for the growth and evolution of the dance somatics field in the middle of the cornfields – a place where you might least expect it. Reflective of trends in the dance field, but also a leader in the development of somatics in dance training and choreographic inquiry, the Dance Department at Illinois continues its legacy.

Stories Shared by Rebecca Nettl-Fiol

During my freshman year as a dance major at the University of Illinois (1971–1972), I noticed a group of dancers working together outside of the regular curriculum – doing something rather mysterious, involving a slight wiggling of the head, minimal movement overall, investigating something about imagery and releasing. I remember seeing them at work in the old gymnasium in the English Building where some of our classes were held back in those days. What were they working on? I could see they were intent on investigating something that seemed profound, and unfortunately, it didn't come about that I would become a part of this group. But it was intriguing enough for me to remember, and little did I know at the time that the people in this group would become some of the world's foremost somatic practitioners.

Willis Ward, though not a practitioner of any specific somatic genre, was a teacher of body/mind/spirit. He was a spiritualist, and in fact moved after his retirement to Camp Chesterfield, a spiritualist camp in Indiana. Yogi Reverend Ward, as he was called there, was a clairvoyant and a healer. As a freshman, I was selected by Willis to perform at Camp Chesterfield one summer, because apparently I had a vivid aura. From then on, he became a mentor to me during my undergraduate years. If someone became injured during class, we would all gather around and put hands on them. The power of the mind and the presence of some kind of spirit in the room were prevalent in his teaching.

The OSU link is significant, as I was inspired to attend OSU for my master's degree (1977–1979) after taking a few Labanotation classes with Angelia at the U of I, after completing my BFA. Once at OSU, I got a dose of Laban studies, both through Labanotation (I eventually received my Teacher and Reconstructor certifications), and through Vera Maletic (daughter of Ann Maletic, who studied with Rudolf Laban), who taught Effort and Space Harmony. I had Vera during her first year at OSU, when she came to replace Lucy Venable who was on sabbatical doing an intensive study with Alexander teacher Marjorie Barstow. I also assisted Lucy Venable in the freshman version of the graduate-level movement fundamentals course that Angie and Ann had taken. It was a course that integrated concepts from Alexander, Bartenieff and Ideokinesis. Laban terminology was a common language among students and faculty during those days at OSU, and the work made a huge impact on me and on my understanding of movement.

One never knows where students will take the information they gather from a course. Several years after Jane Hawley received her MFA at Illinois, she called me, excitedly telling me about a curriculum she had devised as a result of learning about the somatic practices in my class and at the university. She no longer believed in teaching discrete technique classes like "jazz" or "modern," but felt it was necessary to train dancers free of style. Her curriculum at Luther College in Iowa, described as "groundbreaking" by Nancy Wozny in Dance Magazine (Wozny 2009: 14), consists of three levels of "Movement Fundamentals" and experiences in Contact Improvisation, composition and dance history.

> We use ideokinesis, constructive rest, the language of directions through space for spatial intent, Bartenieff Fundamentals, developmental movement patterns from Bonnie Bainbridge Cohen, and Lulu Sweigard's nine lines of movement. All the vocabulary is based in anatomical terms rather than the traditional French terminology.
>
> (Wozny 2009: 16)

Graduate students entering our program come with a much more sophisticated knowledge and interest in somatics than in past years. I imagine this is due to a combination of the integration of somatics in the field, and the draw of our program to dance artists interested in our approach. I developed a graduate pedagogy course in 1997 to address questions of integrating somatics into dance training, and we always used to start the course with discussion about the interplay of somatics and dance training, eliciting lively debates about the co-existence of somatics within a dance technique class. More recently when I brought up this topic, the students looked at me askance, wondering why I would even ask the question. In fact, the tide has turned in some cases, where I observe that the graduate students teaching non-major classes are much more invested in teaching from a somatic viewpoint, and at times seem reluctant to give set phrases and technical combinations.

Figure 21: Joan Murray giving an Alexander lesson in Champaign, IL. Courtesy of Rebecca Nettl-Fiol.

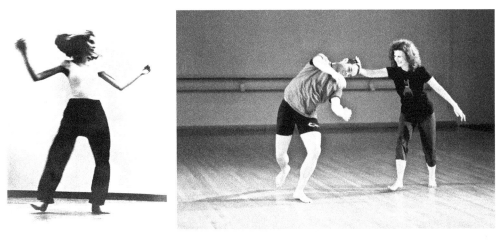

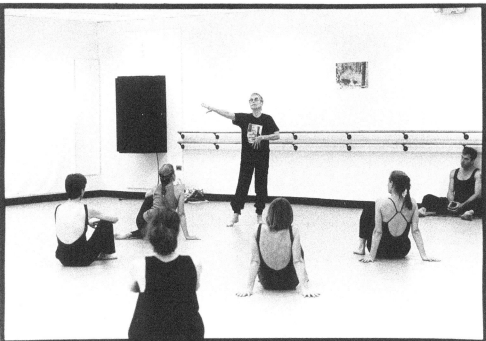

Figures 22–23: (top left) Pam Matt dancing. Courtesy of Pamela Matt; (top right) Rebecca Nettl-Fiol guiding while dancing. Photo credit: Natalie Fiol; (bottom) Martha Myers teaching 1997. Courtesy of the American Dance Festival Archives. Photo credit: Bruce Feely.

Chapter 10

Somatic Movement and Dance Education in pre-K-12 Education

Kate Tarlow Morgan, Eve Selver-Kassell, Lauren Lipman and
Mary Ann Brehm

Somatic Movement and Dance Education in pre-K-12 Education

Miss Alys Bentley, of the Ethical Culture School in New York, is now doing some very remarkable work with young children in the schools, with classes in various parts of the country, and at her summer camp in the Adirondacks, in developing musical exercises. Beginning with the large muscle masses and guided by carefully selected music the child is led through a series of correlated movements, some of them based on the activities of the animal world. Working from the spinal column as the center, the children acquire a freedom of movement and the power of expression through [a] correlated series that extend to every part of the organism. Through this perfected rhythmical body, the student is then led on to express the feeling awakened in him by various musical compositions. This preserves the individual variant and it should prevent excessive intellectualism.[1]

(Jones 1915)

Just as somatic education has infused higher education, especially in dance education classrooms and on stages, so it has pervaded elementary education and is now growing in middle and high school education. This chapter has two sections that provide examples of how somatic education and its early precursors inform childhood education in both dance and other subjects. The first section, by Kate Tarlow Morgan, contextualizes the American Gymnastik and physical culture movement in American cities as it unpacks the work of music and movement educator Ruth Doing. Doing conveyed principles emergent out of the cultural tide of Northern Europe and America in a private elementary school in New York City. She, like Margaret H'Doubler, was a student of Alys Bentley, a music educator who taught music through movement fundamentals, rhythm and song-writing at Columbia University, Teachers College. Links are seen between present-day use of Doing's movement system, steeped in somatic antecedents, and specific somatic disciplines (i.e., those practicing developmental movement, and Ideokinesis) as well as to the creative process in general. Doing's work provides a link to somatic education in its style of opening children to personal agency based in the experience of the felt body.

The second section, by Martha Eddy and Eve Selver Kassell, with research by Ali Spector, shares examples of various types of somatic education being used across K-12 education – music, math, English, art and dance. It links to forms of somatic movement education and

therapy available to children with special needs, both in group and individual settings, through organizations such as the Center for Kinesthetic Education in New York City, Developmental Movement Consultants in Seattle Washington, Jabadao in Suffolk, England and Institut fur Bewegungs Und Lernentwicklung (Institute for Movement and Learning) in Hamburg, Germany.

The chapter ends with two vignettes of other key influencers in movement and dance education that have had applications in children's education – the current-day teaching of Eurhythmie and movement teaching in a Montessori and the vision and teaching of Barbara Mettler. Mettler developed a form of dance education used by many early childhood educators and adult dance educators that has its roots in both the H'Doubler and the Laban/Wigman traditions. Her teaching and writings has influenced diverse somatic dance educators including Jamie McHugh (personal communication, 16 September 2012) and continues through organizations around the world (e.g., Hampshire College, *Conscious Dancer* magazine, Community Dance).

Learning the Fundamentals: The History of Rhythms and the Natural Mind[2]

Kate Tarlow Morgan

If we say here that our philosophy embodies self-discovery, development of the whole child, learning by doing and the flowering of individual creativity, then Rhythms makes the most of it. All children have an organic urge for rhythmic motor activity. Since each child is born with their own individual muscular, intellectual, creative rhythm – each Rhythms class aims to reinforce and strengthen these, so that each child may experience "harmony of body, mind and spirit."[3] How about that as a challenge!!

(Joan Zuckerman Morgan quoted in 2004,
Rhythms teacher at The City and Country School, 1968–2001)

Making the Connections

The US "physical culture movement" of the late nineteenth century owes its origin to several cultural-historic trends – including the great influx of an immigrant population needing proper housing, clean water and air as well as the influence of evolving body-mind practices coming out of Europe employed to "cure" a modern lifestyle that was becoming increasingly sedentary.

The German *Gymnastik* programs brought to this country after the 1850s entered the curriculums at American colleges, public schools and immigrant settlement house camps.

By 1900, Gymnastik, as a practice, became the mainstay of American progressive era's Health Reform Movement, which embraced a twofold mission – temperance, on the one hand, and freedom of expression, on the other. The subsequent liberation movements, formal and informal, of Women's Suffrage, mandatory early education, and the abandonment of the corset might be attributed to contemporaneous physical health reforms.

The post-World War era was one where the healthy body was exercised, cared for and celebrated; just as the seeds of modern dance were also being planted, giving way to the exploration of natural movement (Isadora Duncan) and the three-dimensionality of a curved spine (Martha Graham). Paralleling these new, creative options for movement and physicality were quality-of-life discoveries such as the invention of the "air shaft," which gave overcrowded tenement buildings more light and air.

In the field of psychology, psychologists – such as Mesmer, Breuer and Freud in the late nineteenth century and Wilhelm Reich, Fritz Perls and others in the twentieth century – were all pioneering the idea of the brain-body connection (Morgan 1991a, 1991b) as a matrix for understanding human emotional causality and memory. But it was the educators of children during what was called "the progressive era" in urban centers of the US, who opened up the territory for the essential connection between movement and cognition – and cognition at every level of sense and sensibility.

In 1922 a music teacher, Ruth Doing, was hired by the founder of The City and Country School in New York City, Caroline Pratt, to teach a skills-based movement class for children that she had named Rhythms. Pratt – pioneer in her own right and inventor of the unit-block system that 90 percent of US schools have in their pre-schools and kindergartens – gave free rein to Doing's "experiment" as a vital component to her *own* experiment, which celebrated its 100th anniversary year in 2014. Pratt and Doing bonded their work together to create a schooling experience that was both interdisciplinary and holistic. Rhythms was a core of the school curriculum and could still be described in 2005 as "a place where everything happens" (J. Z. Morgan, personal communication, 2005). It was not Gymnastik nor was it theater.

An eighth grade teacher at City and Country School (and co-founder of the Elizabeth Seeger High School) wrote this about Rhythms:

Rhythms is extraordinary times in the gymnasium. I had in the past dreamed of such times to fulfill all I try to do in the classroom to let words come alive to the children. To music, not just any music, but music well-played, carefully chosen for the age and kind of movement, these lithe, limber, well-coordinated children move in a thousand different ways, involving acrobatics, gymnastics, pantomime, dramatization of something out of our daily lives or studied in the classroom, and dance. [...]. Within the teacher's direction and the limits of the music the children move with wild spontaneity and freedom, with fantastic invention and skill. I have watched many of these classes and not one is the same as another. I start to take notes, but I see too much; the room is too full of dazzling,

rollicking, but controlled life, sometimes sober, often joyous; I put down my pencil and simply stare. Rhythms is to me all that lurks under words.

(Alford 1979)

Clearly, Doing was breaking new ground in the field of education in relation to both artistic and self-expression. We must assume Doing was aware of her antecedents – Jacques Dalcroze (France) and Rudolf Steiner (Austrian) who also utilized the word "rhythm" to describe their teaching systems. But Dalcroze's Eurhythmics, first employed to train young musicians, and Steiner's Eurhythmy, teaching movement patterns that transmitted the complexities of language, did not match the holism of Ruth Doing's Rhythms work. In Doing's class, the student was free to go beyond music and language, and encouraged to form "his/her own inner rhythm" (Doing 1927), whereby formulating an individualized, personal vocabulary for movement and dramatics within the fail-safe template of Nature, that is, the natural movement patterning that derives from early human development and the movement of animals.

Nature and Neurological

In Doing's time, the working term guiding these patterns was inspired by Haeckel's Recapitulation Theory or, "Ontogeny recapitulates Phylogeny." This phrase was her scientific anchor for her work by explaining the journey of all species – fish to fowl – that the human fetus experiences during its nine months of gestation that occurs in in utero. This theory has since been biologically disproven, but there are still profound aspects of human movement development that continue to archive the phylogenetic parade before us. We only have to look at the classic ontogenetic texts to associate the biomechanics of a new infant to that of swimming water life, a seven-month old to that of crawling land life, a toddler to a climbing spider monkey; and possibly some faint recognition to a pair of vestigial wings during those moments when we manage to leap or fly through the air.

Doing took this "recapitulation" as a guide for human movement patterning and built an entire system upon which she named The Fundamentals. The Fundamentals was a movement series that included eight basic patterns with at least five accompanying variations (see Appendix 3). She saw The Fundamentals as a way for child and adult alike (for she also ran adult summer camps in the Adirondacks) to be fully engaged in the "building blocks" of their physical signatures: rolling, crawling, creeping, cruising, brachiating, and walking, running, jumping etc, as well as honing perceptual/cognitive skills team work and creative invention.

Concurrent with this thinking was Todd's *The Thinking Body* (1937), which supported the idea that dancer and non-dancer alike could achieve optimum postural health by supporting the natural curves of the spine and the foot. The point to be made here was that

it all made sense because it was natural. We do not know if Doing and Todd met to discuss these potent ideas. But we do know that every Rhythms teacher who apprenticed themselves to a Rhythms mentor, for this is how the work has been passed along, was also handed *The Thinking Body* (1937) to read.

Another educational innovator was Arnold Gesell (1934, 1943, 1946), whose pioneering research into the movement development of the child paved the way for the connection of movement and the brain. Gesell's work elevated physical education into the field of neurobiology, in that it provided a slide rule for children's physical/cognitive growth. Gesell was able to prove that movement was not just fun and healthy, it also developed the brain and helped children "think." We are able to see, then, the connections that Howard Gardner made in his seminal book, *Frame of Mind* (1983), naming the seven intelligences of the child – one of them being the bodily-kinesthetic. Gardner has since added two new categories of intelligence: the Existential and the Natural.

The pioneering work of Bonnie Bainbridge Cohen picked up these threads from the early Physical Culture Movement. It is no coincidence that The Fundamentals would echo in Gesell's studies of young children's movements and in Cohen's movement series based on the Basic Neurological Patterns, now referred to as Basic Neurocellular Patterns (Eddy Interview 2015d, Eddy Interview 2015b).

Progressive Education and Developmental Movement(s)

The City and Country School, and respectively, Rhythms, were very much a part of the experiment of Progressive Education, which held the important premise that children were individuals with a voice. It was believed that the best way to educate such individuals was in a democratic community that offered real experiences that would utilize academic skills, i.e., "learning by doing." *Project-based learning*, which has only fully reached US public schools in the last 30 years, was actually started earlier, in these experimental schools. Howard Kilpatrick, a colleague of John Dewey, one of the founders of Progressive Education, coined the term in 1918. Then, as now, the drive for such good education was a moral one: to build strong citizens with strong bodies and independent minds.

A further connection between Dewey's educational experiment and physical development can be seen in his concept of education as "unfolding" rather than "continuous growing." He understood that development (of mind and body) did not always occur chronologically or linearly. His educational theory, though specific in its focus, clearly resonates with subtlety of the "overlapping" progression of the Developmental Movement Patterns of BMC (Morgan 2007). This is why or perhaps *how* Doing's *Fundamentals* were easily accepted into the milieu of Progressive Education. Her work and the Rhythms Program sought to liberate the body from rote and/or militaristic exercise, and return to natural and basic movement patterns. At the same time, the approach provided sequencing and skills that, when individually tailored, charged the Rhythms teacher to

nurture each and everyone's "inner rhythm." This core principle is, without a doubt, a progressive reaction to the doldrums of the factory (industrialization) and the dangers of Fascism. Doing left specific directions *not* to include any military marches in the musical accompaniment choices for Rhythms.

As for Dewey's democratic ideal, perhaps nowhere else was it as clear, than in Rhythms, where children were learning to work together through group dialogue, movement and dramatics. The school play that was conceived and produced by the students on their own, would be a perfect example of democracy-in-the-making.

The Delicate Organ

In the Rhythms Room, what starts off as the Science of Origins (human movement patterning and the history of the animal kingdom) soon becomes a Proscenium for Cognition (dance, drama, self-expression). And yet, performance is only a by-product of the true goal, which is not only to build muscles, but also to build innovative minds. The only way to achieve this was for Doing to develop a *praxis* for creativity – how to mine it, how to extract it and how to preserve it. She called it "the delicate organ of expressive need" (1932), an exciting and provocative phrase that turns creativity into a delicate "organ" that must be protected. The meaning of this extends beyond the name to state its purpose, that is, the extreme "need" for humanity to be creative as if there were no choice to be otherwise.

In the true progressive vein, the preservation of the creative spirit, like the democratic experience, was a moral task:

> The proper procedure in Education, I believe, for both mental and emotional health and activity, is to start with the exercise of this creative faculty and let it grasp the factual tools and use them to further the vision. [...] We cannot start with a regimented curriculum and hope to work backwards to spontaneous invention as this just adds to the burden of subject matter debris to be cleared from the teacher's as well as the child's plane of consciousness during the activity program. *The child's job is to initiate the activity, attack his media, and develop his techniques as he proceeds, and the teacher's job is to preserve that atmosphere of detached absorption within which creative effort flourishes and becomes operative.*
>
> (Miller 1933, original emphasis)

Would that this wisdom would come charging across the decades to us again. For there is no greater benefit than to remain confident in one's own learning – through origins, through creativity and through democracy – all fundamental principles of the natural mind and body.

Bringing Somatics into K-12 Education

Martha Eddy and Eve Selver-Kassell

As education and life speeds up with the wave transmissions of technology, and society becomes more sedentary, while the impact of widespread trauma within families and in random violence is more revealed, numerous educators are striving for balance by introducing increased physical activity and bodily awareness in the classroom (Block 1997; Eddy 1984, 2000c, 2007; Gay 2009; Jensen 2005; Ryan 2012; Selver-Kassell 2010). Several practitioners have been working to bring somatic movement into the lives of children in K-12 academic classrooms and beyond. Some, like Bette Lamont, work with individual clients to enhance their social and academic development; others, like Marianne Locke and Seymour Kleinman, entered schools to educate the administration, teachers and students. Trained in varying somatic disciplines, these individuals are working hard to enhance the lives of children through movement and to prove that the work that they do has a lasting effect. Eddy, as a Dynamic Embodiment practitioner, works with groups and provides individual therapeutic sessions for children.

Faced with the challenges of an educational system focused more on testing than on experiential learning and self-awareness, Lamont, Kleinman, Locke, Eddy and Green Gilbert provide examples of how bring physical engagement and movement into the schools and the lives of children. These educators are inspiring new generations to use somatic movement as an alternative approach to academic subjects, a tool to reduce stress and increase student focus, a key inroad to dance-making and as a therapeutic tool to increase cognitive capacity in students with learning and physical disabilities (Johnson 2014).

The goal is to provide insight into the value and potential reward of integrating somatic-based movement into K-12 academic curricula and daily lives of children. This is done through the description of general theories and principles, and a few examples – applications of somatic education in the K-12 grade classroom and in special education by five somatic educators.

Why Somatic Education in Early Childhood Education?

Somatic education encompasses diverse disciplines that emphasize the healthy and efficient use of the body and mind through increased awareness of movement in daily activity. Through the use of set movement sequences, and particularly those based on the developmental stages of a baby's motor development, somatic educators guide students to become mindful and aware.

Developmental movement, an integral element of BMC and Bartenieff Fundamentals/ LMA (and also studied by Feldenkrais and Dart Method students), is the movement done

by babies starting in the womb and continuing through to walking (Bainbridge Cohen 1993; Dart 1950; Dimon 2003; Eddy 2012a; Feldenkrais 1989, 1997b; Green Gilbert 2006; Miller 1933; Murray 2005). This early movement is divided into the six stages of breathing (both cellular and respiratory), core-distal, head-tail, upper-lower, body-half and cross-lateral (these are the terms used in BF/LMA; the same stages are described with slightly different language in BMC). These categories describe the patterns that underlie the movement that babies do as they learn to roll over, stand, crawl and walk. Although each child develops in her or his own in response to internal and environmental conditions, these patterns are present in most children and they serve as the scaffolding for all subsequent movement. The invisible activity of neurological and cognitive development occurs simultaneous to the more visible developmental movement. With the belief that developmental movement corresponds to cognitive development, somatic movement educators and therapists have students and clients retrace the patterns of developmental movement as a way of working toward more efficient cognitive function (Eddy 2000c, 2007, 2011; Green Gilbert 2002, 2016).

In BMC there are particular series where people of all ages literally move as babies move, rolling and crawling on the floor, always following the developmental progression. BF/LMA practitioners use these patterns more loosely, translating them to sitting and standing or any variation that resonates with the people moving (some ages are not willing to or comfortable with crawling). Although the physical activity may be modified, the order in which the movement is done always follows the developmental progression. Each pattern supports the proceeding pattern, just as each level of scaffolding supports the level above.

A key factor that distinguishes somatic movement from other movement activities such as physical education games (sports) and dance classes is the focus on individual awareness. The kinesthetic activity of a game of tag or memorizing a dance routine provides students the opportunity to move their bodies. These activities work on coordination and social skills; however, they do not provide tools for students to track their internal physical experience. One goal of the somatic educator is to provide the time and the language for students to shift to an internal focus and to begin to be aware of and to understand their personal experiences (Eddy 2001a). For example, by leading children through an experiential anatomy class using a somatic approach, the educator is not only teaching them the placement and function of a particular body part but also bringing their attention to the existence and sensation of that part of their own bodies. This is done through breathing, visualization, movement and hands-on contact. This emphasis on internal focus and individual awareness can also be encouraged by offering recess activities that allow students to work quietly and connect with themselves, such as gardening and arts and crafts (Eddy 2001, [2005] 2011; Enghauser 2007a, 2007b). This connection to self serves as a foundation for the internal exploration and increased awareness that are cornerstones of somatic education. Exploration and awareness serve to complement the socio-emotional benefits of cooperative games and to compensate for the disproportionate amount of time

spent on external focus in test taking and the use of computers (Block 1997; Dewey 1932; Eddy [2005] 2011).

Applications of Somatic Education: In K-12

Somatic education, as it is applied to and incorporated into K-12 education, is a multipurpose tool. In the classroom setting, somatic education can be used as the foundation for experiential learning. For example, allowing students to learn anatomy through exploring each body system as defined by BMC (Bauer 2008; Olsen and McHose 2002) or teaching musical rhythm through the physical experience of creating a rhythm as is done with Marion Locke's work detailed later in this chapter. On an individual basis, the principles and practices of particular somatic disciplines can be applied in a therapeutic manner: for example, addressing developmental disabilities based in neurological challenges through retracing of developmental movement sequences as they are taught in both BMC and Bartenieff Fundamentals of Movement or stimulating a child to explore developmental patterns as is done in Lamont's Neurological Reorganization. On a broader scale, somatic education offers a pedagogical foundation that can support many other aspects of K-12 school curricula Somatic practitioners use movement for stress reduction, conflict resolution, classroom management, experiential learning and in adaptive education to address developmental and learning disabilities. as well as to help children to self-regulate (Eddy 2002; Chiate et al. 2016). This pedagogy, as described and taught by Kleinman, is based on the principles of *integration, connectedness, grounding, relatedness* and *holism* that span the field of somatic education. This can be applied physically through the inclusion of practices such as yoga with somatic awareness in a physical education program or Rosemary Clough's Creative Kids Yoga, dance in conflict resolution (Eddy 1998, 2000d, 2001, 2010a, 2010b, 2010c), somatic education in health and wellness course. It can also be applied cognitively through emphasis on the *relationship* between and *integration* of all subjects. Indeed there is a seamless intertwining of including physical movement during the school day and experiencing more holism (Eddy 1998).

Who Is Doing This Work and Where?: Somatic Education in Schools

In Northern California, Marianne Locke worked with Eleanor Criswell Hanna, in conjunction with Young Imaginations (an arts education agency), under a California Arts Council Demonstration Projects Grant to implement an interdisciplinary curriculum incorporating movement into the study of math and music in Tomales Elementary School. With a background in Hanna Somatics, Locke emphasizes calm and focused attention as a crucial element of the somatic approach. This project focuses on three main goals: The first

is to link the arts disciplines of multicultural music and dance through educating teachers of each subject and increasing students' interest in the subjects; the second goal is to connect music and dance with mathematics through team teaching and student exploration of where these disciplines overlap; the third goal is to enhance effective learning through music and dance by using a somatic approach to the body-mind, focusing on attention and self-regulation (Locke 2004: 46).

Based largely on Hanna Somatics, the project was implemented weekly in kindergarten through fifth-grade classes devoted to this particular integrated arts and math curriculum. The results were carefully tracked through focus groups, journal writing and numerically rated data collection. A two-year report of this data was submitted to the United States Department of Education (US DOE) and a three-year summary of the findings at Tomales Elementary School was produced. As a result, the US DOE funded a replication of the program in two schools in San Francisco. Despite the contrast of the urban environment of San Francisco, the newer program has had similarly positive results to those found in rural Tomales. According to Locke, "the somatic effects show up most directly in the children's behaviors: visual attention, auditory attention, on-task behaviors and positive attitude" (Spector 2005). Interest in and implementation of the program is continuing to increase through conference presentations, and the development of marketable tools and teaching aids such as CDs to accompany the dance classes, and outside funding.

In Columbus, Ohio, Seymour Kleinman worked with the founding board of the Arts and College Preparatory Academy (ACPA), a charter arts high school that aims to create an environment for the arts (Eddy Interview 2004b, 2004c). From this post, Kleinman has been actively encouraging the use of somatic education in both the physical education and academic curricula at the school. Kleinman combined the five principles of *holistic, integrated, connected, grounded*, and concerned with *relatedness* to establish a pedagogical framework that he believed can be used as a foundation for the general class environment and in curriculum development of any subject. The inclusion of yoga and tai chi into the Physical Education program at ACPA serves as one example of Kleinman's approach at work. Yoga and tai chi (see Chapter 5 in this book) are included to encourage full-body movement through connectedness, grounding and awareness that stands in contrast to the externally focused movement of competitive sports. Kleinman collected data to show that as students engage in the grounding and centering of traditional eastern movement forms, they benefit both physically and mentally, resulting in improved grades and focus. The fact that the teachers at ACPA were open to such alternative programming was an encouraging sign.

In New York City, Dr Martha Eddy, RSMT, CMA, EdD founded The Center for Kinesthetic Education to bring movement into the NYC public and independent schools as a tool for creative expression and self regulation through dance, wellness, academic achievement, conflict resolution and recess enhancement. She is also working to incorporate somatic education into special education and as support for academic subjects through

multisensory individual and group activities. As a part of her extensive effort, Eddy created a series of movement protocols, derived from her Dynamic Embodiment method, that are able to be implemented by classroom teachers for 3–40 minutes throughout the course of the day. One such program is Relax to Focus©, a series of movements based in the motor development of infants, but done seated or standing (as taught in BMC and LMA). This movement program is based on the theory that re-experiencing neuro-developmental patterns stimulates the brain and neuro-pathways, organizes coordination and helps us to regain focus. Relax to Focus movement can be used at any point during the day for three to ten minutes when students' attention needs to be brought back to the subject at hand. For example, Eddy has implemented Relax to Focus in a second-grade classroom that was having a hard time transitioning back after recess. This particular classroom was having socio-emotional difficulties originating from conflict between different cliques. "Relax to Focus" was used as a tool to improve the classroom environment through encouraging internal focus as a transition after emotionally charged recess. When asked to evaluate their experience with this program, the students all gave positive feedback and recommended that it be used at any point during the day to help them transition between activities and regain focus.

Another example of Eddy's work is her Peaceful Play Programming. As a part of this work she uses the tools of LMA to help adults calmly engage with students in charged emotional states and help students to identify and modulate their own reactions to challenging situations. It has anti-bullying components. She also teaches educators to use these skills through a course called Conflict Resolution through Movement and Dance offered at the 92Y – Dance Education Laboratory. Her newest program grows out of her own certification project in LMA in 1980 – a study of how movement and somatic awareness can improve vision. She has taught Eye Relaxation and Eye Yoga classes since the 1980s and created a DVD working with first- and second-grade children with attention and/or vision challenges called Eye Openers (Chiate et al. 2016).

Working with Individual Children and Groups with Special Needs

Working on an individual and small group basis allows somatic practitioners a chance to design unique somatic movement therapy programs for children with specific needs based on varying types and levels of disability. In an individual session, unlike a classroom setting, the somatic educator can use her or his highly developed observation skills to note the strengths and weaknesses in the child's movement patterns. She or he can then engage with a student at their neuro-developmental and learning level and instantly begin to provide intervention and support (Eddy and Lyons 2002). Attention deficit disorder, brain injury, cerebral palsy, nonverbal learning disorder, autistic spectrum disorder and sensory integration issues are among the disabilities that are addressed in a private session

with a somatic educator/somatic movement therapist. This work often includes dialogue with medical and educational professionals to further support the client's experiences in daily life.

In Seattle, Washington, Bette Lamont, CMA and Neurological Reorganization Practitioner and Trainer, directs Developmental Movement Consultants. This is a laboratory where Lamont and other somatic practitioners worked one-on-one with people of all ages struggling to overcome neurological imbalances due to developmental disabilities, abuse and injury. Lamont's evaluation and treatment for her clients is based on the principle that all developmental problems are related to movement.

> Therapy programs are based on the concept that academics, social, and emotional functioning depend on the integrity of each level in the brain hierarchy, beginning at the lowest levels. So children on Neurological Organizational programs will repeat [movement] activities that reflect the brain level where there is a gap in functioning. These children may be asked to do creeping, crawling and other developmental activities.
> (Lamont 2014)

Although Lamont is not working directly in schools, the work that she does enhances the academic and social performance of her clients and thereby directly affects their educational experience. With a background in LMA and Bartenieff, as well as study with the nurse and child advocate Florence Scott, Lamont focuses on movement re-patterning as well as breathing and self-awareness. "When children explore they are engaging their cortical brains which cannot help but override some of the very deeply, preconscious growth process [...] between the milestones a lot of growth is happening" (Eddy personal communication, 2015). The idea is that children are truly self-regulating and if we as adults provide a safe and stimulating environment (for instance, introducing specific movement stimuli) they can engage in naturally occurring movements with *no* correction allowing their movement coordination to improve through continued engagement, over time.

Similar to Lamont, Eddy and other professionals at the Center for Kinesthetic Education work individually with clients to address neuro-developmental delays and learning disabilities. Using her observation skills based in the vocabulary of LMA, Eddy assesses the movement patterns and quality of movement of her clients, noting their modulation, tone and effort among other parameters. Focusing on the client, rather than the diagnosis (children often have a combination of the aforementioned disabilities, some of which have not always been identified by a medical professional), Eddy works to recognize the assets of each child and to engage with them at their level of function. From this point of observation, she is able to develop individual movement interventions to address the perceived gaps in function. Working alone with a child for 45 minutes to an hour is a privilege for the client as well as the practitioner. It allows the somatic educator, in this case Eddy, to make a connection with the child, attuning, addressing specific needs and tracking progress. For the client, one-on-one time with a somatic practitioner provides an opportunity to receive

personal attention and treatment designed specifically to their strengths and weaknesses (Eddy and Lyons 2002; Eddy 2007).

Eddy has also developed neuromotor assessment tools strategies that have been piloted with Ballet Met in consortium with Columbus, Ohio's Head Start programs, The Learning Diversity project with Manhattan Country School and in numerous NYC public schools. They have also been used by dance educators working with the general population and those with special needs.

Teacher Training and Curricular Support

In addition to his work with the physical education department, Kleinman has developed a professional development program for educators that was implemented at ACPA with the aide of funding from the Fetzer Foundation. With a strong emphasis on somatic principles, the program focused on the spiritual, emotional and personal influences that inform both teacher and student. Through self-learning, teachers were encouraged to integrate the principles of connectedness, holism, relatedness, grounding and integration into their philosophical approach to teaching and the details of their curriculum development. Kleinman hopes to encourage the inclusion of somatic principles in classrooms around the country.

Although based in Seattle, Washington, Anne Green Gilbert's work has an international impact. The creator of BrainDance and author of Brain Compatible Dance Education, Green Gilbert has established a program that can be implemented by any willing teacher, regardless of their training. BrainDance is a program documented in both book and video form. It uses the developmental movement sequences found in Bartenieff Fundamentals and BMC (this is the same foundation used by Lamont and Eddy in their private sessions and movement programs, such as Relax to Focus) and can be adapted for any K-12 classroom. Green Gilbert, a dance educator offers suggestions for how students can move through every stage of movement development without getting on the floor or even leaving their desks. BrainDance can be used as a foundation for developing a curriculum for a dance class – initiating each dance exploration with the movements that we do in early childhood, or it can be used as a simple warm-up in a social studies class to help students focus and to activate each level of their brains. "These fundamental [developmental movement] patterns lay the foundation for appropriate behavior and attention, eye convergence necessary for reading, sensory-motor development, and more." BrainDance is becoming widely accepted in part because it is based on brain-based learning, is frequently presented at conferences for classroom, dance and physical educators and because Green Gilbert teaches her own movement classes and engages with schools in her region regularly. In addition to her website and trainings, Green Gilbert advertises through the enthusiasm of her students. She spoke of one group of elementary school student who took the BrainDance work that they learned at her dance studio and implemented it as part of an in-school science project.

It is the accessibility of the BrainDance to students and teachers alike that has enabled it to support in-school work, rather than distract from it.

In addition to supporting teachers through curricular development and teaching aides, somatic educators are working with teachers and administrators to bring the internal awareness and movement support of somatics into their lives. As a part of the Inner Resilience/TIDES program (originally entitled Project Renewal), a New York-based program developed to cope with the aftermath of September 11th, Eddy facilitated workshops and co-led retreats for the faculty and staff of New York public schools located near ground zero. The goal is to help individuals connect with their inner lives as a tool for sustainable living and then in turn help them bring these same tools to their students (Lantieri 2014). To this end, Eddy led the school staff through movement experiences that emphasize relaxation and community building. She has also been going into schools to mentor guidance counselors as they lead their students through similar exercises. The work of Inner Resilience/TIDES exemplifies the application of somatic education as a therapeutic tool as well as a physical and educational tool.

Eddy also shares somatic experiences with educators by using somatic methods to teach perceptual-motor development and sensory functioning. In particular, she developed numerous activities specifically for attention, focus and vision. Her EyeOpeners DVD (Chiate et al. 2016) is filmed with first and second graders in inner city New York. There are numerous opportunities to relax with breathing and palming and others to invigorate with quick or smooth rhythmic movement of the eyes. Adults benefit from this too.

Who Benefits from This Work?

Working together and individually, these somatic practitioners and somatic educators are bringing movement to students across the country in both public and private settings. Although it might be assumed that the poorest communities living in urban areas and attending schools with minimal funding are at the highest risk for movement deprivation, Lamont argues that children of all racial and socio-economic backgrounds are in need of and can benefit from this work. The benefits of moving freely as a child are universal and whether inhibited by a walker or a cramped urban apartment, the developmental risks are equal. Lamont cites the age of technology and computers as a crucial social factor that is keeping kids from engaging in physical activity. Similarly, Locke makes a point of placing her efforts in general education classes in a public school setting where the benefits of somatics are available to all children, not only those with severe, diagnosed disabilities. The work of Green Gilbert goes one step further by providing literary and visual aids that can be used by teachers that are not trained in any somatic discipline so students do not even need to have the privilege of a local somatic practitioner to benefit from the field of somatic education.

When asked who benefits from somatic movement, Eddy cites author Alan Block who argues that not providing movement and somatic experiences is a type of violence that

schools are inflicting on students (Block 1997). In other words, movement is a necessity as well as a right for everyone (Eddy 2007). Hanna Kamea is completing a film, *The Moving Child*, on this topic.

Challenges

While working hard to incorporate movement and somatic theory into K-12 education, these practitioners have come up against many challenges and discouraging signs. Kleinman remarked that the biggest challenge for him has been trying to open the minds of the administration, getting them to break away from tradition and trust the value of movement. A part of this challenge comes from the fact that the positive results of including somatic movement into the daily lives of children are often best expressed through anecdotes that, though moving, are not substantial enough to sway the school board. And without approval from the administration it is difficult to get financial funding, an issue that Lamont addressed, noting that funding has been cut for public schools in Washington State and often physical education and the arts are the first programs to go. Naturally, a field like somatics that straddles physical education and art education will be challenged to survive.

Citing both the problem of funding and the problem of general interest in and acceptance of somatic education as a valuable addition to K-12 education, Green Gilbert spoke of the problem with working in a field that is not easy to commodify and commercialize. Somatic education is a body-based discipline – there are not a lot of props and accessories to enhance its appeal in a consumer culture. Without the material appeal, it is difficult to get somatics on the radar of adults and children alike. Compounding this challenge is the nonverbal/sensory nature of somatic education that makes it difficult to put into words. One of the most prominent obstacles preventing somatic education from reaching a broader audience is that there is very little research or literature on the subject and the material that has been published is too complex to be universally accepted. Ann Renee Joseph (2014) has done some promising research on the role of dance in learning in the Seattle School system.

Successes, Hopes and Wishes

Despite these challenges there are many success stories to go around. Bette Lamont spoke of an 11-year-old girl that she worked with over the course of one year. The girl started out the year clumsy and socially inappropriate, throwing tantrums when she had to do homework. By the end of the year she was interacting with peers at an appropriate level for her age and her grades were up to A's and B's. Lamont received an email from the girl's mother reporting that her daughter had said she was happy, expressing a basic joy for life for the first time.

Locke's work combining music, math and movement in the Tomales Elementary School reported similarly positive results. Because she and her colleagues were implementing their program as a part of a research project they were very careful and intentional in collecting data and tracking results. Data collection included journal entries written by both students and teachers. The children were quoted as saying things such as "I sooo love math; I learned that we can get better at whatever we do; I learned you have to be patient for directions; I like numbers," while the teachers noted the benefits of the programs by making comments such as "a lot of math is happening – patterns, sequence, shapes and number sense; we enjoyed watching student step up to different leadership roles that were provided" (Locke 2004: 47–48). When asked about how she tracks the success of BrainDance as it spreads across the nation and around the world, Green Gilbert reported an entire file of emails describing success upon success around the world. Among these was teacher from Kalamazoo, Michigan who reported after a summer workshop on BrainDance:

> I have used a ton of movement with the kids. We start every class with BrainDance and I teach more in the remaining 25 minutes than I ever have in 30 minutes. Many of the general education teachers use it as well, even if they do not quite understand the concept of it. All they know is that the kids behave better and learn more after it.
>
> (Spector 2002)

Similarly, Eddy's Relax to Focus has been adopted by teachers across the Kindergarten to eighth grades. One foreign language teacher chose to use it as a short break, daily, with all nine grades and reports success of participation and of focus.

Perhaps it is these success stories that have kept somatic educators working relentlessly and dreaming of making a greater impact. When asked about their goals, hopes and fantasies for the future of somatics in K-12 education, there was a consensus that what is needed is increased awareness and acceptance of the field. Locke said she would like somatics to become a household word, while Lamont expressed hope that the cultural pendulum would swing away from technology and back toward the body where we all begin.

From the work with children, many subsets of somatic movement and dance education have emerged: a brand of somatic movement therapy called developmental movement therapy; ecological work that is part of the new field of eco-somatics (Chiate et al. 2016; Eddy 2003, 2006b); the need for "fit kids" – somatic and non-denominational spiritual education that is embodied in schools, and finally the need for sensitive and high-quality dance education for all – somatic movement dance education. In a time when few children have access to regular physical education or dance education, there emerges another need – that of social somatics. Each of these topics will be addressed in Chapter 12.

Can Rudolf Steiner's Eurhythmie Inform the Montessori Method? Potential Amalgams in Children's Movement Education

Lauren Lipman

I set out to learn about eurythmy – an art of movement created by Rudolf Steiner and taught as part of the curriculum at Waldorf schools throughout the world. As a Montessori educator focusing on theater and dance, I was interested in learning how this other method of "alternative education" uses movement. I hoped to determine whether or not eurythmy is something that is transferable to a Montessori environment.

In my experiences with eurythmy classes, I was struck by the very simple music that was used. Children always moved to the music and were very aware of it. The teacher explained that the music they use is very "concrete" and uncomplicated. They select the music based on the age of the children. For instance, music with strong beats are used to bring young children down to earth while more melodic pieces are used to lift up the adolescents who tend to be hunched and close to the earth. They do not use background music. This is one concept I found particularly interesting and can easily incorporate into my movement work. Montessori believed in following the child and making decisions based on the child's needs. Therefore, I believe that the selection of music is another way to follow the child's developmental needs. Montessori believed in educating the whole child. Eurythmy exercises encourage dexterity, coordination, balance and rhythm in addition to an assortment of moral lessons. In a holistic approach to education these are important skills to include.

Barbara Mettler: Influenced by H'Doubler, Duncan and Wigman – Promoter of Creative Dance

Mary Ann Brehm

Born in 1907, Barbara Mettler grew up north of Chicago near Lake Michigan in a family that practiced arts of all kinds within the home. Close to nature as a child, Mettler created her own dances freely, but was uncomfortable with most formal dance classes she encountered. An exception to this was a course she took with a dance teacher from the University of Wisconsin, who was influenced by Margaret H'Doubler. As a young woman, she was inspired by a performance of a group led by Isadora Duncan's daughter, Irma Duncan. Her influence in using creative dance in schools can be seen in *Creative Dance and Learning: Making the Kinesthetic Link* by Brehm and McNett.

While touring Germany, Mettler found a toehold for her artistic searching when she visited the Mary Wigman School in Dresden. Mettler returned to study dance there and later was influenced by Rudolf Laban and the zeitgeist of expressionism, artistic freedom and experimentation that was flowering during the time of the Weimar Republic in pre-World War II Germany. Upon returning to the US, Mettler opened a dance studio in New York City and was part of the thriving modern dance movement there during the Depression. She moved out of the city in 1940 to be closer to nature and have her work be more fully integrated with the natural world. She offered summer dance courses in New Hampshire from 1940 to 1952. During this time an annual scholarship was annually offered to a student from H'Doubler's dance program at the University of Wisconsin – Anna Halprin. Halprin worked with Barbara Mettler for a summer during this period. In the winters Mettler commuted to teach dance and in 1943 established a Department of Expressive Movement.

The year 1963 marked the opening of Mettler's Tucson Creative Dance Center, in Arizona, with its stunning, architecturally acclaimed round studio built by the Frank Lloyd Group at Taliesin West. Here she lived and worked until her death in 2002. During this time her summer courses became very large and she directed several dance companies that toured and made films. For a few years, H'Doubler came as a guest teacher. Her student Norma Canner founded Lesley University's Expressive Arts Therapy department, now affiliated with a Laban/Bartenieff Certification program as well. Her students and former dance company members include people cited in this book – Nancy Topf's sister, Peggy Schwartz of the University of Massachusetts-Amherst and Willis Ward of the University of Illinois at Champagne-Urbana. Her archives are housed at Hampshire College where Moshe Feldenkrais and Bonnie Bainbridge Cohen ran training programs.

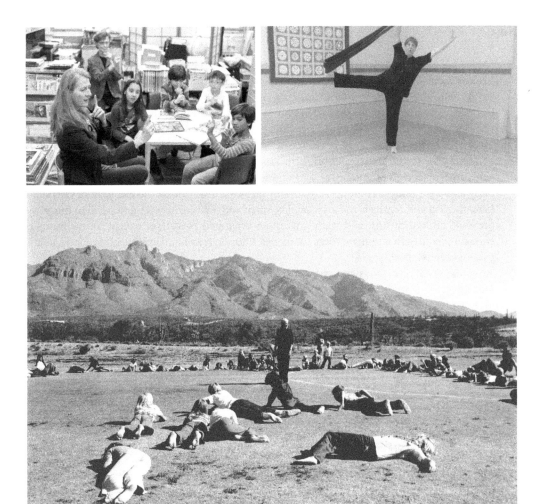

Figures 24–26: (top left) Martha Eddy teaching EyeOpeners in New York City public schools. Courtesy of EyesOpenMinds. Photo credit: Crystal Blake; (top right) Anne Green-Gilbert demonstrating Whole Body Core-Distal Coordination. Courtesy of Creative Dance Center of Seattle; (bottom) Adults and children rolling and crawling outdoors with Barbara Mettler. Courtesy of MaryAnn Brehm.

Notes

1 "Ms. Alys" was the key teacher to inspire Margaret H'Doubler as she set off to create a healthy form of dance for young women. She may also have been an influence on Ruth Doing, whose Rhythms and Fundamentals classes continue at the City and Country school today. Alys Bentley's songs are cited in a book written in 1918 by the faculty of Horace Mann, the elementary school within Teachers College. Here students study rhythm and dance with music. In the final pages there is a description of the physical education – open air training, as well as classes of first through fourth grades boy and girls together exploring rhythm, skills with objects, marching, free play and locomotor patterns. Chopping strengthens the body and then underlies group activities in plays etc. Dance and the enacting of curricula from English and Maths is not atypical. Joy, spirit and posture are all mentioned in the same breath. Children of fifth and sixth grades are separated by gender except for swimming. Boys do exercises that prepare them for games. Girls do free-hand exercises, simple apparati, games, exercise and dances.

2 A version of this essay was first published in 2008 as 'Learning the Fundamentals', *Currents: Journal of The Body-Mind Centering Association,* 10: 1, pp. 13–24.

3 This is a term seen in both Ruth Doing's essays and the notebooks of Constance Ling and Sylvia Miller, Rhythms teachers and protégés of Doing. At this time we do not know if Constance Ling is any relation to Dr Ling of Europe.

Part 3: Current Trends in Somatic Thinking and Being

Chapter 11

Healthy Movement, Healthy Mind: Neuroscience Connections to Somatic Healing and Action

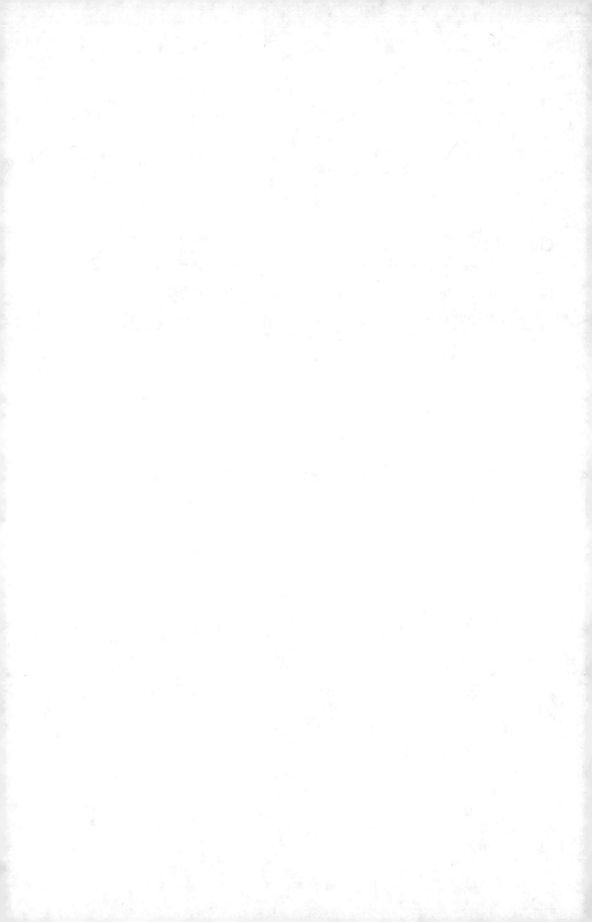

As humans, we perceive feelings from our bodies that relate our state of well-being, our energy and stress levels, our mood and disposition. How do we have these feelings? What neural processes do they represent? Recent functional anatomical work has detailed an afferent neural system in primates and in humans that represents all aspects of the physiological condition of the physical body. This system constitutes a representation of "the material me," and might provide a foundation for subjective feelings, emotion and self-awareness.

(Craig 2002: 655)

Clyde Ford speaks on the sleep-like state that both the practitioner and client may experience during somatic therapy involving touch:

A body of knowledge has accumulated on this half-way condition called a hypnagogic state (different from hypnotic). It is noted for dramatic changes in brain wave activity, psychosomatic healing and ready access to the unconscious mind – in short, the barriers between mind and body are relaxed. What the mind ponders, the body enacts. What the body experiences, the mind absorbs. It is not surprising then that touch can evoke a state that engages two people in a healing process beyond the bounds of conventional therapy.

(Ford 1989: 13)

The nervous system – the brain, spinal cord and nerves and their relationship to the senses – is at the heart of engaging somatically. All facets of what has been shared about gaining somatic awareness throughout this book are based on the awakening of neural connections. Neural connections are the nerve pathways between body parts and parts of the Central Nervous System – the brain and spinal cord. The brain includes many parts including cortical and subcortical areas. Frequently when speaking of the brain people are referring only to the cortex – the outer layer of each of the right and left cerebral hemispheres, which in total is the cerebrum. A study of movement and somatic awareness must include sub-cortical areas such the areas that govern emotional, automatic movement and autonomic vegetative responses. These functions involve the limbic system, the basal ganglia and the brainstem, respectively. Examples of neural connections include connections from muscle to brain (neuromuscular pathways including the sensory and motor nerves), endocrine gland to brain (neuroendocrine),

within the brain (interneurons) and from the retina of the eyes to the midbrain and visual cortex (optic nerve). BMC also uses the term "neuro-cellular" to describe the nervous system connections to each and every cell. The information that arrives through the nerves of the senses to the spinal cord as well as to low, middle, and high brain areas influences our motor responses. Our movement is, in turn, monitored by sensory feedback. It is this cycle of information that makes somatic awareness possible – we sense, we interpret these sensations (as perceptions and feelings) and we reflect on them – making meaning from our experiences.

The somatic process began whenever the first human realized that paying attention to her or his body was a key to self-care and self-healing. In other words, somatic awareness was occurring long before it got named "somatic" and also long before the advent of the field of neuroscience. Now it is of interest to learn what neuroscience can contribute to the understanding of how somatic education works. Neuroscience can also provide insight into how somatic movement is key in developing new neural pathways (Batson and Wilson 2014; Braude 2015).

Figure 27: Nervous system, anterior view. Courtesy of Artist: Marghe Mills-Thysen.

The Neural Mechanics of Somatic Attention

Somatic movement requires the use of proprioception and kinesthesia (see Chapter 1). These sensory apparati are not always included in standard anatomical, kinesiological and physiological texts on the nervous system or the senses. In part this is because what defines human senses is a bit elusive. When books do include the neurological mechanisms for those senses that support bodily awareness they may also include a newer construct – graviception. The combined experience of these three internally focused senses together with five well known external senses expands sensory sensitivity (Batson and Wilson 2014) and bridges to emotional awareness (Craig 2011; Germer 2010). Proprioception is the sensory apparatus in the muscles and joints that allows one to perceive the body's static or changing tension and positioning. The kinesthetic sense combines joint and muscle proprioception with vestibular awareness – sensations of changes in speed, location in relationship to gravity and stopping and starting that are perceived through the organs of equilibrium inside the inner ear. The experience of tone is registered through the inner ear – sound tone through the cochlea and postural tone through the rest of the vestibular apparatus. This includes a clustering of interoceptors that respond to gravity – graviceptors (Mittlestaedt 1996) registering sensations from the fat, fascia, muscles, tendons and joints. Batson and Wilson (2014) notes that even the autonomic organs are responsive to the line of gravity. In this text, and many others, proprioception is considered a type of interoception, grouped together with the sensing of autonomic functions of the organs (Batson and Wilson 2014; Germer 2010). In a more pure context, proprioception is not focused on the viscera; it is therefore not considered interoception and is grouped separately. The main point of this is that the definition and registration of internal sensory experience is still in flux; the terms are being developed as the science of understanding how humans perceive their bodies is being discovered. Craig goes further to say that those sensations that relate to autonomic functioning are the domain of interoception and those sensations that relate to voluntary activity such any cutaneous mechanoreception and proprioception that guide somatic motor activity are part of exteroception. What is important is that science is uncovering the mechanisms of self-awareness and the medical community is also recognizing the neurophysiological links for the bodymind connection.

Interoception: it is perhaps surprising that this word is not common medical parlance since amongst the other terms introduced by Sherrington, proprioception certainly is. As originally defined interoception encompassed just visceral sensations but now the term is used to include the physiological condition of the entire body and the ability of visceral afferent information to reach awareness and affect behaviour, either directly or indirectly. The system of interoception as a whole constitutes "the material me" and relates to how we perceive feelings from our bodies that determine our mood, sense of well-being and emotions.

(Fowler 2003: 1505)

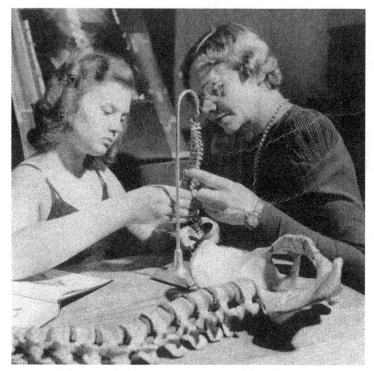

Figure 28: Lulu Sweigard, Ideokinetic expert, working with a student at Teachers College, NY. Courtesy of the University of Illinois-Urbana Archives.

What is lacking are studies about how and to what degree these sensory inroads lead to a richer palette of both perception and motor responses. It can be hypothesized that neural pathways increase in response to somatic explorations and that these pathways lead to more behavioral choices. We know from the life stories of the first generation of somatic founders that they experienced neuroplasticity long before the term was commonly used – they had complete recoveries when the medical system said they would not walk, talk or breathe normally again. Hence, somatic movement helps a person to practice not just "mindful awareness" but also "mindful responses." Somatic education, in part, teaches the art of staying aware of one's internal psychophysical experience while also responding through movement to external and indeed some internal sensory stimuli.

The Sensory-Motor Cycle

One of the simplest components of the nervous system is the idea of a neural loop – usually perceived as an arc with stimulus flowing in and a response arcing out. In somatic movement terms this loop may begin with a person moving and then becoming aware of

her or his movement through internal sensory awareness – interoception. Typically, the sensory-motor loop is described with examples such as pulling away from touching fire, or choosing to run when one sees something scary – sensations that cause reflexive movement responses. However, every voluntary movement also begins with some sort of stimulation (an experience or a thought) and most sensations resolve in some sort of movement – be it speech, a change in position, an emotional reaction or a large movement through space. The nature of the sensory-motor cycle is that information is received by the nervous system from sensory organs – the exteroreceptors (skin, mouth, nose, ears and eyes) and the interoreceptors (proprioceptors, graviceptors and kinesthetic apparati) and that this often is happening simultaneously. This flood of sensation requires humans to make choices about what they will pay attention to, a process referred to as "filtering." People with attention difficulties are often paying attention to multiple stimuli and have a hard time filtering out what is not important in a given situation. The simple sensory-motor loop is not that simple.

Somatic awareness occurs in response to both stimulation of the internal and external senses. There are many sensory experiences possible in a somatic movement session – the tactile experience of somatic bodywork, listening to the tone of one's own voice or that of the practitioner, the sensation of the joints and muscles while moving (kinesthesia), the feel of the eyes in different positions, the sensations of the viscera, the experience of falling or stabilizing in different directions in space are all examples. A creative teacher will integrate activities that activate a combination of these sensory experiences or isolate out a specific one as needed. In general all somatic lessons include giving attention to motor sensations that highlight postural and movement habits, exploring those habits and their variations, and then checking in on how this learning process impacts hearing and seeing (and occasionally even tasting and smelling) as well as one's bodily self-perception.

What Aspects of Our Current Knowledge of Neuroscience Support a Better Understanding of Somatic Awareness?

> Mindfulness training develops the ability to modulate between the states of alertness and sleepiness, and the capacity to monitor mind-wandering and focus attention. It develops cognitive "top-down" control over mind-wandering and focused attention via the Central Executive of the working memory system. It also engages the *espisodic buffering function1* to hold online multimodal information and allow it to be manipulated in the service of higher order intentions (and behavioral control).
>
> (Russell and Arcuri 2015: 5)

Most frequently in the early twenty-first century, research in neuromotor science focuses on cortical functioning – the high brain. In particular, neuroscience research, and especially neuromotor research, has been focused on discovering what parts of the cortex control behavior. There are hundreds of articles describing the specificity of functions being

attributed to each region of the right and left hemispheres of the cortex. How the cortex, "the high brain," contributes to motor planning and movement memory is also often described in texts on the neuroscience of movement/dance (Batson and Wilson 2014; Schiphorst, Bradley and Studd, 2013; Hanna 2015). This is in part because the technology exists to map how the brain registers movement in the cortex and how movement is remembered (Schiphorst et al. 2013; Kohn 2014). On a more sophisticated level, the concepts and science of enaction, neuro-phenomenology and embodied cognition are being researched and discussed across the disciplines of psychology, performance, sports and health. They are eloquently defined in the context of dance and somatic education by Batson and Wilson (2014).

However, when feeling or moving, all impulses do not always proceed from or to the high brain – the cortical areas – and much movement is regulated in lower areas such as the cerebellum and the basal ganglia. Even more simple is that limbs can move reflexively from nerve sensations that are processed exclusively in the spinal cord. However, the higher cortical brain is important in processing the movement experience. For instance, in order to perceive what happened, the sensation of the movement is carried by "tracks" up the spinal cord and then goes to the deep sub-cortical structures of the brain like the thalamus that registers sensation, while other signals may go to the cerebellum or limbic system where they interact to help with balance and with emotional regulation, respectively. In order to form an idea (picture or words) about the body's movement experience, nerve impulses travel from different parts of the low brain further up into different parts of the cerebral cortex. There is also a large web of nerve fibers – the corpus callosum – that connects the cortical tissue in the right and left hemispheres of the cerebrum, helping the two halves of the brain to communicate.

How movement is controlled and processed is still under great scrutiny. If all the answers existed, humanity would have solutions to illnesses like Parkinson's disease. The ability of injured nerves to repair and to share functions is one key to healing. From the stories of the somatic pioneers it can be hypothesized that changing movement habits by using somatic movement: slowing down to feel, breathing fully while relaxing, experiencing novel coordination in varying directions of movement (Eddy 2004; Eddy et al 2014) stimulates novel coordination, new neural pathways, new options and new behaviors.

Neuroplasticity

Nueroplasticity is a term that has emerged and was popularized during the same decades that somatic education became codified as a field. Plasticity refers to being moldable, adaptive or capable of changing form. The process of "opening new neural pathways" is possible because of neuroplasticity. Neuroplasticity is the ability of our nervous system to reroute messages traveling along a nerve pathway that is defunct to another nearby nerve or section of a nerve. It involves developing new connections between nerves, mostly within the peripheral nervous system. More radical is the idea that the brain and spinal cord could also have plasticity.

Somatic education also involves opening up new roadways, and/or taking down barricades to unused roads. It is likely the "miracles of somatics" are due to the ability of movement to stimulate neural changes. Deane Juhan in his book *Job's Body* (1987) describes the nervous system as one integrated whole. The parts of the nervous system have been labeled as separate for convenience, so humans can better identify and talk about the part of the brain and nerves. However, it is because all parts of the nervous system are connected that one can use the nervous system to become conscious of diverse phenomena such as movement, thoughts and internal sensations. It is because of the simultaneous connection to the cortex during these phenomena, that one can consciously remember engaging in movement and express what has been experienced through words.

The Role of the Nervous System in Growth and Change

The ability to open more neural pathways appears almost limitless, and is an entry point into lively old age. Neuroscience has revealed the abounding potential for growth throughout the lifespan and the importance of change, creativity and the arts to activate the plasticity of the nervous system. The somatic experiences of the first generation of pioneers were hard to explain; now we can attribute their transformation to the neural plasticity stimulated by their conscious, mindful somatic movement exploration. The neural mechanisms for how Todd and F. M. Alexander regained their voices or how Moshe Feldenkrais came to walk again are still perfect fuel for research. The longevity of many of the first- and second-generation pioneers is another phenomenon worthy of study. What do we know of their brains and the state of their nervous systems? Selver lived until she was 102. Halprin continues to perform into her nineties; Bartenieff demonstrated "flying and falling" in her ninth decade; and Summers continued to perform outdoors site-specific multimedia art into her eighties. Each of these people remained quick-witted and mobile until very close to the end of their lives. The quality of life, beyond motor performance, is another important factor to consider in understanding the benefits of somatic education. It would be a step forward to have the research tools to better know what benefits somatic education brings to not just the physical but also the cognitive and affective realms. With the growth of understanding about the physiology of responses to traumatic events and the emergence of the concept of emotional intelligence (Goleman 1995), the importance of the limbic system – the emotional center of the brain – is also better recognized. The interaction between the limbic system and motor function of the brain are only beginning to be charted. The cerebellum, long known for its role in balance is now becoming known for its role in trauma. How these phenomena are in interplay may be explored somatically through working with reflexives movements (e.g., the Moro/Startle response) or with exploring metaphors like being "thrown off kilter." The development of more advanced neural imaging of the deep structures of the brain for functional use during movement will be groundbreaking.

Somatic Movement and Neural Functioning: How does Somatic Study View Neuroscience and Interact with It?

A key feature of somatic movement education is the process of being more attentive to one's bodily messages – more mindful of oneself. In somatic inquiry, attention is initially directed inward to the body and is supported by ideally being in a relaxed state. Enhanced attention involves sharpening sensory awareness and the state of relaxed alertness, also experienced as being "present" or "mindful." Attention can also be directed outward toward the world and the people around or to complex psychophysical experiences. Attention has many purposes. In somatics, important features include its enhancement of physical safety, perception and cognition. Mindful movement prevents accidents. Mindful movement allows one to perceive life situations with new perspective, which, in turn, impacts cognition and can be a baseline for creativity. Studies show test performance improves with meditation practice. While there is limited research on the impact of somatic awareness, mindfulness research is abounding (Greater Good 2015).

The positive physiological effects of meditation are well known: Professor Herbert Benson of Harvard University studied Transcendental Meditation, a meditation with the use of personalized mantras; Benson developed the secular tool Relaxation Response (Benson 1975); Edmund Jacobson (1938, 1990) researched the yogic practice of systematically tightening and releasing muscles of the entire body, renaming it Progressive Relaxation.

Somatic movement education and therapy and somatic movement dance education bring together the body, cognition, affect and movement, for starters. This holistic paradigm is hard to research, as most quantitative research requires that small discrete parts be isolated for study. It is also hard to research because the neural structures that govern these areas are deeply embedded in the brain, making it hard to take measurements of its activity (Eddy 2010b).

What's Important about the "Lower Brain"? It Modulates Motion and Emotion!

Many parts of the brain that are heavily stimulated by movement are sub-cortical areas below the right and left hemispheres of the cortex. For instance, the processing of visual and auditory information initially happens in the midbrain, balance and movement in the cerebellum, breath rate and blood pressure are controlled by the brain stem. Given that it is hard to study the activity of deep brain structures, much of what happens in the brain during somatic movement explorations is still unresearched. There is so much to learn about what initiates subtle changes in movement and what enhances kinesthetic and proprioceptive awareness. This type of information could help to teach dance and somatic movement more efficiently and help with understanding the positive effects of specific movement programs

such as Dance for protocols for disorders like Parkinson's Disease or to develop programs for Multiple Sclerosis, Autism, Spinal Stenosis (narrowing of the spinal canal) or syndromes impairing motor abilities.

The Importance of Language in Neuromotor Enhancement

Neuro-anatomy continues to unfold as a science, and as a tool for exploring what might be happening during mindful movement. The anatomical study and language of neurology is joined by neuroaesthetics, neurobiology, neuroendocrinology, and even psycho-neuroendocrinology. The interconnections are endless. Anyone studying neuro-anatomy soon finds out that the same brain areas get clustered into a different component of brain functioning for different purposes. In other words, there are different names for the same parts of the brain depending on what aspect of neural functioning is being discussed – the anthropological, the physiological, the pathological and so on.

Given the limitations of researching deeply recessed areas like the midbrain and limbic system, it makes sense that most fMRI studies investigate predominantly superficial areas of the brain, such as the cortex. Some examples are: Feldenkrais lessons guided verbally by a teacher; Ideokinesis use of mental rehearsal of postural improvement supported by the use of carefully selected images, often expressed or cued through words; and Skinner Releasing lessons that encourage students to actively explore nature imagery to invoke ease and expression in the body. Having a rich vocabulary to describe movement experience advances the sharing of somatic information: Bainbridge Cohen refers to these verbally guided sections of her workshops as "somatizations."

The use of language to guide movement experiences is supported by the highly developed LMA taxonomy. LMA has been used as a research tool in varied types of movement scholarship (Bradley 2008; Davis 1987; Kestenberg 1977; Kestenberg Amighi et al. 1999; Tortora 2006). Learning a vocabulary about movement provides concepts and a framework through which to view the world and experience one's own bodily experience. Again, imagery that enhances body posture as is done with Ideokinesis or broadens dance expression as in Skinner Releasing must be expressed through language. A sophisticated language for movement and movement literacy are two mechanisms that make it possible to think about movement and the body. The links between movement and language may support people who need to "move to think" (Robinson 2006).

Language can reframe experiences or can even reshape expectations. The process of hearing and responding to verbal movement cues involves sensitivity and intelligence through the body. Bodies keep an imprint of movement and it may be that movement lessons are further remembered because of the accompanying dialogue.

In order to respond or express an idea in language – to speak – movement is involved and must be organized – the movement of the mouth, larynx, pharynx, the diaphragm or

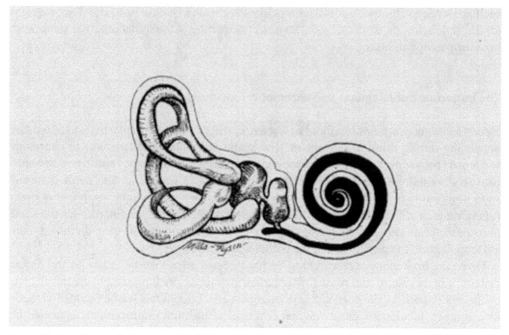

Figure 29: Inner Ear: vestibular apparati (on left), semi-circular canals, utricle and saccule (contain otoliths); auditory (on right), cochlea. Artist: Marghe Mills-Thysen.

intercostal muscles within the rib cage. To do this the motor cortex must send a message back through the brainstem, through the spinal cord and to the outward flowing efferent nerves (often with visits along the way to collect information from the other parts of the brain – midbrain and cerebellum) that connect with the muscles that will be needed in verbal (mouth, neck and jaw) or nonverbal (movement of different body parts) expression. When speaking, there is an interconnection of the movement of speech and the movement of the rest of the body, since it is natural to gesticulate while talking (unless trained to resist it). Speech is a verbal process indeed, *and* it takes nonverbal processes to learn and execute speech.

Neuro-Developmental Movement in Infants and Adults

A minimum of seven of the pioneers in somatic education drew from observation of infants or animals, or knowledge of babies' early movement development. They also used images or observations in creating or explaining their work. The most notable somatic systems that include a perspective on the importance of the first year of life in motor performance are Alexander, in association with Dart; Bartenieff, who trained as a physical therapist;

Feldenkrais in learning to walk again; Halprin in practicing H'Doubler's rolling regimens; Bainbridge Cohen in observing infants, studying as an occupational therapist and working with Berta Bobath and Irmgard Bartenieff; Conrad in returning to a primordial source as revealed through Haitian dance and Topf through her studies with Barbara Clark (who also influenced Bainbridge Cohen). Somatic movement experts agree upon the need to return to the ground and to resting in order to begin at neutral, and then to systematically gain more supported motor control. This is true whether one is exploring for the first time (like an infant or child with a motor disorder) or re-patterning as with an older child or adult. Theories about how movement patterns relate to the stimulation of brain development vary (Geddes 2009). Opinions also vary regarding how best to apply developmental movement constructs with adults. Here again, the mechanisms for research are limited, given the deep brain structures and the difficulty in collecting hard data about them (Eddy [2005] 2011; Siegel 2007).

It is widely accepted that practicing movement lying down allows for the isolation and activation of small and more subtle movements of the trunk – working with core support. If one refrains from using ones arms or legs, one can describe the movement as inchworm or fishlike movement, or even neonatal movement. It is agreed by most that these articulations can help people to access and strengthen the deep musculature needed for an improvement in postural tone (core support, a concept brought to the United States from Germany through the Lotte Berk Method and now used in Core Fusion® Barre and other somatic fitness approaches) (Bainbridge Cohen 1993; Eddy [2005] 2011; Long et al. 2014). It is not known whether this type of neonatal movement activates a particular neural structure in the brain.

The developmental theory that needs to be tested is whether moving through different movement patterns calls upon the brain (different areas by different movement coordinations) to work in new ways. Learning to lift the head, wriggle, roll, belly crawl, come to sitting, crawl, come to standing, cruise along tables and eventually walk assisted and unassisted are each new types of movement coordination. These developmental patterns unfold as if miraculously, but there is actually controversy about how a baby learns these patterns of movement. Are these patterns totally hardwired? Are they learned in coordination of elicited reflexes? Do they only occur if stimulated, or do they unfold "naturally"?

The idea that the movements of an infant stimulate the brain is a neuro-maturational concept from the 1920s that has gone in and out of favor. Early developmental studies of infants by Arnold Gesell has been furthered by the work of practitioners like physical therapist Berta Bobath (Neuro-Developmental Treatment) and those researchers, doctors and lay practitioners who use reflexes in their work with children and adults (Goddard 1996, 2002; Goddard Blythe 2003, 2007, 2009, 2011; Masgutova 2008; Miller 2014; Rentschler 2008). However, most of these practitioners not only believe in the hard-wiring of movement patterning in the brain, they believe that neuromotor learning can continue throughout life, beyond what used to be termed as "critical periods" – the

optimal time to efficiently learn. The concept of neural plasticity reinforces the theory of this continued ability to learn or to adapt both movement patterns and other types of cognitive process.

The Nature of Developmental Movement Patterns or Sequencing

The somatic movement leaders engage older children and adults in movements similar to those made during the babies' first year of life when their brains are developing rapidly. These practitioners do so for different reasons: to break up habits that are fixated with sitting or standing up, to find grounding or to re-pattern embryological or fetal trauma, to name a few. In her work as an occupational therapist and somatic movement pioneer, Bainbridge Cohen has mapped out a theory of how specific early baby movements correlate to brain development (Eddy Interview 2012). The full spectrum of the nervous system is thought to be stimulated – from the notochord, to spinal cord, brainstem, cerebellum-pons, to midbrain and cerebrum (Hartley 1995). Each of these neuro-developmental coordination patterns repeat in different levels in space – while lying down, while seated, while crawling on hands and knees, and when on two feet. They can even be studied at the highest level – in the air – by watching movement performed on trapezes or silks or while swinging through trees or along monkey bars. It is not yet confirmed that these deep structures of the brain are indeed "awakened" by movement patterning during infancy. Nor has it been proven that they can be stimulated in older children or adults. However, anecdotal evidence among the thousands of practitioners of somatic movement would indicate that specific movement may indeed stimulate specific neural functioning as seen by improvements not only in motor performance but behavioral regulation and cognition.

Dynamical systems theory of motor development (Thelen and Smith 1994) convey a different scenario of how neuromotor development occurs – it is not the emergence of a specific movement at a particular time during the first year or two of life that causes a specific neural stimulation but rather the confluence of the person, the task and the environment. Feldenkrais conferences have espoused this theory strongly. Bartenieff Fundamentals, BMC and the Dart Method are more likely to believe in a combination of the two theories (Eddy [2005] 2011). The idea that "context makes a difference in a person's movement" is by definition a part of the somatic paradigm. The belief that there is some kind of neural pre-wiring in every human was commonly taught for decades, but the teaching of that theory is now more variable. Neuromaturational theory is mostly upheld by the protégés of those somatic pioneers who were trained in traditional health and educational settings; schools of physical therapy and occupational therapy or neuromotor development. Parents and professionals working with children with disabilities (learning, behavioral or physical) who benefitted from developmental movement, often inclusive of the practice of motor reflexes, also support

neuromaturational approaches to therapy. These theories all beg for avid research and perhaps new research models.

There is much that is not known about the relationship between movement and the brain, as well as between movement, health and learning because it is a difficult topic to research. Movement is complex and causes disruption when studying brainwaves on EEGs and MRIs – it either causes the data to scramble or the machines make it difficult to move (Eddy [2005] 2011, 2009a). On the other hand, some qualitative research exists. For instance, case studies depict how movement is healing for the body and psyche as well as instructive and transformative in moving forward in life (Hanlon Johnson 1995). Research has shown that aerobic exercise helps circulate endorphins and other neuropeptides (Pert 1999) and is a substantial force in curbing dementia, especially in verbal memory amongst women (Friedman 2015). It is also known that exercise is helping children to learn new concepts; this kinesthetic inroad to learning needs further study (Gardner 1983, 1993; Jensen 2005). Dance and movement therapists can report detailed changes in their client's attitudes, behaviors and physical health as a result of engaging in movement exploration and expression (Foster 2007; Hanlon Johnson 1995; Levy 1992; Peterson 2011). Similarly somatic movement educators and therapists have thousands of stories about the power of movement to bring balance and contentment into lives. These reports are in positive alignment with the somatic paradigm and establish a basis for further investigation.

Potential Neuromotor Directions for Somatic Movement

Neuro-developmental programs vary in the frequency, duration and intensity of movement practice. Some experts encourage students to repeat a childhood movement pattern for five minutes a day – like lying on the belly and changing the rotation of the head and the movement of the limbs (Lamont 2014), others recommend integrating the new patterns emergent from a lesson into one's everyday movement so it becomes a new habit. For children with motor delays there is a system that asks four or five people to "pattern" the child daily for several hours, although there is a controversy about the usefulness of this type of forced "re-patterning" of developmental coordination (Hines 2001).

Other questions are: do different parts of the brain get stimulated by specific movement patterns? One somatic system is certain that they do. The field is ripe to undergo research on this subject once brain wave activity can be correlated with a moving subject (Eddy 2000c). Other questions are: how much repetition is needed to encode a movement? New research shows that when working with tools repeatedly humans even incorporate the tool into our brain's body schema (self-image) (Geddes 2009). And what happens if someone learns an inefficient pattern? What effort is needed to break poor movement habits or to improve movement efficiency?

Application of Neuroscience to Dance and Movement

In neuromotor research the higher cortical functioning of the brain is most often described as the "functioning of the brain." One cortical intervention that is typical in somatic explorations involves a technique of "feedback". Batson adeptly distinguishes between feed-forward and feedback in movement learning. For instance, imagining a movement, visualizing it and then doing it (e.g., as in Ideokinesis, which relies heavily on the visuo-motor imagery process) is a type of feed-forward learning. When feedback arrives through language, it is predominantly a cortical process. Having, developing and communicating thoughts, especially through words, activate the cortex. The limbic and cerebellar areas of the brain are important in somatic awareness as well. In Dynamic Embodiment, practitioners postulate that learning the skills to recover from falling can be both physically and emotionally empowering. To catch oneself gracefully from falling or to fall with ease and without injury creates resilience and freedom to move. We begin with using physical movement, touch and sound to teach people to pay attention to sensory indicators – sensations of the feet, inner ear and joint proprioceptors are critical. This type of skill-building adds to the paradigm that pleasure and confidence in movement supports advancement in social-affective neuropsychology. The somatic education model continues to include these holistic features no matter how difficult it is to study its effectiveness or what part of the brain is involved.

Somatic Work's Links to Health, Fitness and Wellness, and Integrative Medicine

Most somatic movement disciplines are "health identified." Somatic movement is sometimes positioned within the field of alternative medicine, even though it is now mainstream knowledge that movement and exercise are critical in the prevention and treatment of disease (Abrahamson et al. 2006; Essig 2013; Fortin 2009; Galvao and Newton 2005; Kern et al. 2014). Movement education and therapy is listed with the department of education under mind-body practices. For instance, some jobs as a somatic movement therapist or somatic movement educator can be found within integrative medicine centers or group practices. In part, this is because people are often most motivated to dedicate time and money to their bodies when they are in pain or unable to perform a necessary task.

As neuroscience has advanced to allow for integration of multiple neurologically derived disciplines, so has medicine and healing. The integration of allopathic and traditional forms of medicine is much like the integration of somatic education and indigenous/traditional movement forms. New models of integrative medicine invite a dialogue between client and practitioner so that people can weigh in on their own health protocols. This allows for physical and emotional well-being and promotes psychological maturity and personal authority. Indeed, it involves reclaiming authority.

The healing of stress patterns involves integrating somatic awareness with socio-emotional awareness. Ideally somatic leaders also become educated in social emotional learning (SEL) practices. Daniel Siegel served as a motivational speaker and educator across the disciplines of psychology, child development, neuropsychology, trauma recovery and socio-emotional learning. His books and speeches echo the tenets of these fields and provide the neurobiological facts that explain numerous aspects of the psychophysical learning process.

Much is being learned about the brain with the study of abuse and trauma (Herman 1997). Somatic movement approaches also arise in reporting on trauma recovery, and its impact on the brain, yet while the role of mindfulness in reducing stress has been studied using meditative practices (encouraged by the advent of yoga therapy), there is little research on how mindful movement contributes. The perceptual process is integral in somatic movement practice. Perception is deeply influenced by the particularities of the ecological dynamics present – what the environmental factors are. These environmental factors include human interactions and bring into focus the arena of social-affective neuroscience (Conzolino 2006; Damasio 1994, 2000, 2014; Siegel 2007). A few books discuss these aspects of brain activity and they mostly have an eastern perspective, an experiential anatomy approach or an understanding of trauma (Ornstein and Thompson 1991; Simpkins 2010).

Somatic Education for Habits, Stress and Trauma

The world today is burgeoning with expression of its wounds – from full-out war, to racial, ethnic and religious tensions. Many people also experience societal or familial abuse. Somatic education gives us tools to recognize the stress symptoms, and to investigate the underlying causes of the stress symptoms. Somatic inquiry provides guidelines for feeling what has happened and is happening with our bodies and helps us connect with our bodies' natural ability to heal. This is similar to wellness models like naturopathy and homeopathy. Somatic work is done on the physical level, while other wellness models use vitamins, herbs and supplements for biochemical support. Both are geared toward gradual "self-regulation," during which our bodies (and minds) make fine-tuned adjustments (Ballentine 1996).

Our somatic experience may guide us to a combination of medical interventions as well as complementary methods – real integrative medicine. Movement is so obvious a solution that it is often overlooked. However, the idea of being aware of one's movement is novel and the health impact of the mindfulness in somatic movement is not fully known or valued as of yet. This may also be because mindful movement is challenging, as is doing research about it.

It can feel threatening to be conscious while moving, because it brings awareness to our habits and may indicate a need for change. This is a process of challenging of the status quo. The good news is that somatic education provides numerous movement options, including gradual changes that can reduce stress instead of shocking our body-mind

system with a big change. The somatic process is most often gentle and gradual and it can be facilitated by a teacher, trainer, coach, friend or your own "inner witness." Somatic education involves exploring new pathways and integrating these new sensations and perceptions over time with conscious practice. If trauma is identified it is helpful to have a cadre of somatic psychologists, dance therapists and other professionals in psychology to team up with somatic movement educators and therapists. It is equally important for professionals of psychodynamic work to recognize that somatic movement educators and therapists are great allies in recovery from trauma. The hands-on, developmental skills of a somatic movement therapist are often what are keenly needed in complete healing (Shafir 2015). A somatic movement educator or therapist also trained in somatic psychology is able to work slowly and sensitively with a person's movement to uncover meaningful associations that can positively impact the healing process. Somatic movement sessions led by skilled educators or therapists help a client or student to practice new healthy, organized behaviors, empowering them to ACT from these new non-traumatized perspectives.

Everyone agrees that change (learning) occurs in the nervous system through new experiences. Somatic education is quintessentially a learning process through physical exploration – learning by doing is what connects the body to the mind (Eddy 2007; Jensen 2005; Schiphorst et al. 2013). Reflecting on the doing connects the mind to the body. To experience somatics, whether to prevent disease, relax or to heal, one needs to pay attention to the body, often first in stillness. Then, to gain even more insight and automaticity of response it is best to learn to keep this mindfulness while moving. This takes practice. Classes are one way to practice healthy patterns.

Awareness of the body and listening to its cues supports bodily and psychological health. It is this very same awareness that can support life-long movement. It informs therapeutic processes for rehabilitation and it also guides lifestyle that can prevent the accumulation of stress and lack of resiliency to trauma. While somatic psychology is its own field, somatic movement informs it. It is a natural next step when working through unresolved issues and trauma to complete the sensory-motor cycle and MOVE to healing. This movement can be dance, which also often brings joy.

Impairments to Sensory-Motor Expression: Dealing with Numbness and Habits

Open and honest exchange about the somatic learning experience is especially important in cases where short-term macro-trauma or long-term micro-trauma have established a habitual use of the body with deadened nervous system responsiveness. The protective response that dulls sensation results in confusions within the proprioceptive system. Hanna Somatics recognizes somatic motor amnesia (SMA) as a typical response to surgery, injury, accident and the micro-trauma of ongoing stress. SMA is usually referring to chronic

contracture of the musculature. Other somatic systems recognize a sympathetic "freeze pattern" in any of the tissues of the body (Bainbridge Cohen 1993).

A type of deception of information about oneself is a normal part of how the nervous system handles chronic imbalances, pain and trauma (Axis Syllabus 2016). Regaining a truthful perspective is a focus of re-education. When there has been trauma or disregulation of the basic senses – exteroceptors and interoceptors – there is a need for a sensitive external gauge to deal with confusions such as referred pain (Axis Syllabus 2016; Duhigg 2014; Eddy 2003, 2010a, 2010c; Hanna 1990; Shafir 2015; Weaver 2014) and reconnect with self. Somatic education teaches how to recalibrate the internal measuring instruments of the proprioceptive and kinaesthetic senses (Sacks 1990; Saltonstill 1988). An empathetic outside perspective is often instrumental in positive adaptations. This may relate to the need for neuro-developmental attachment training as well – a type of therapeutic process whereby trauma or disregulation based on not-good-enough parenting is healed, often with a somatic psychotherapist (Shafir 2015).

During intense life experience or trauma, the body works to shut down the sensory-motor cycle as a type of self-protection. If one experiences a traumatic event repeatedly, sensation can stop altogether and emotional feelings can get confused. Somatic work often involves a period of testing out what is still "dangerous," what is now safe and therefore what physical and sensory defenses are working overtime. One learns what can be "let go of," helping to balance the sympathetic (fight, flight, freeze) and parasympathetic (nurturing, healing) branches of the autonomic nervous system.

Humans are known to be creatures of habit. It is hard to "let go." As customs become familiar, habits or "ways of being" use the same nerve pathways over and over again. Roadways are developed as main routes and others rarely get used. Roadways can even be worn down. Humans are said to use about 20 per cent of the brain's capacity. Habituation is an attempt at efficiency and leads to using the smallest degree of brain-power necessary. While it can be perceived as a type of efficiency, evolutionary biology teaches that it is typical for a species to adapt to the "lowest common denominator." In other words, species survive by making a useful change. Once that change, no matter how basic, proves helpful for the whole group, it predominates. However, the change is not actually refined. Fine-tuning is not included with the evolutionary package! It is optional. Somatic educators have found that while mindful exploration and refinement of movement behavior, may not be necessary for the whole species to survive, it can help improve the quality of each person's individual daily life.

Quite often, moving habitually is "being stuck in a rut." It is like not being satisfied with life and making the same choices over and over again. One loses awareness that there are other options (or the courage, willpower, support or resources to make the change). Uncomfortable posture and movement, and especially discomfort, pain or limited movement, can reveal "ruts." With injury or trauma one is forced into finding new pathways in order to continue to live life "as usual." Some of the new patterns are

compensatory. Or one may choose to return to old pathways, even though they involve pain. It can feel safer to choose familiar discomfort rather than deal with the discomfort of adapting to change. Change is stressful. Indeed the definition of stress is change, a move from homeostasis (Selye 1978). Interestingly, movement is also change – change of positioning, rhythm, organization of body parts, quality of movement. The question becomes: Which is preferable?

Stress = change

Movement = change

therefore

Movement = stress!!

… so what do we do?

Movement Is Change, Stress Is Change; New Movement Can Feel Stressful

It is important to recognize that stress in and of itself is not bad. It is needed for growth and development. Indeed, from the perspective of wellness or well-being it is inevitable that humans go through life with stressors and that some will be bigger and harder to deal with than others. In this model, even an injury or illness can be perceived as a "healing crisis," a growth opportunity, a "wake-up call."

Somatic awareness builds a toolbox of skills that makes it possible to note the signs of disequilibrium as they are emerging (instead of once a full-blown crisis has taken effect). Somatic movement also provides the skills that allow one to respond or cope during times of challenge (Fortin and Vanasse 2011; Kern et al. 2014; Albert, Eddy and Suggs 2013) by remaining alert to one's internal and external environment; responsive. Continuing to move, mindfully, and the appropriate use of somatic touch, supports expression that reduces physical blockages settling into the body.

Inquiries into the mind – whether it be thinking or emotional experience through somatic exploration – have led to models of holistic activism. Somatic processes highlight the self-organizing elements in wellness or well-being in individuals and in systems (organizations and societies) as well as styles of education that are learner-centered and holistic. One way to work with overwhelming stress is to focus on prevention. Coaching people to live fitter lives can be a somatic process. Indeed, somatic movement programs

include educational components that include training as "wellness coaches" or "holistic health practitioners" (Eddy and Smith 2016; See www.DynamicEmbodiment.org).

Change of habits requires a bit of courage. Well-trained somatic professionals should be skilled in providing the emotional, physical and intellectual support to meet these challenges. The result should be that the student/client feels empowered to take on future challenges on his or her own. When a somatic approach is woven into education, including dance, physical education and fitness regimens, it can be a cultural shift.

Merging Somatic Awareness in Diverse Health and Fitness Professions

Some fitness centers including Pilates and Gyrotonic conditioning centers seek out somatic movement professionals. Fitness has been evolving, and while it is true that humans need to incrementally stress muscles in order to grow stronger (some discomfort will be felt during a work-out in order to tax the body to grow stronger), somatic educators know how easy it is to traumatize or re-traumatize the body. To tax the body is part of the process of getting stonger, but it is now more common to recommend gradual increases in stressors. The phrase "no pain no gain" is less popular, and this may be in large part because of the infiltration of somatic awareness.

While fitness may have its roots in the physical culture movement, the entire Personal Fitness Training industry has its roots in somatic education. A group of Laban/Bartenieff-trained specialists who were employed by Sports Training Institute in New York City developed individualized and small-group programs in the late 1970s. Several practitioners also went on to become physical therapists and other allied health professionals. Another practitioner, Risa Friedman, started a business called One-to-One Fitness. The one-to-one personal fitness movement took off like wildfire in New York City and then went national and international. Canyon Ranch is a fitness spa in Lenox, Massachusetts that developed a movement therapy department in the 1980s. It was one of the first residential fitness settings to hire somatic movement therapists as part of a wellness team. Many of the movement therapists were trained in Laban/Bartenieff studies or Dynamic Embodiment SMT.

The term "somatic fitness" was coined in the US in 1993 when Theresa Lamb and Martha Eddy developed a Laban/Bartenieff-infused fitness training. The name was contracted to Som'Fit and then morphed into the BodyMind Fitness Certification for personal trainers and movement educators designed by Martha Eddy and taught by Martha Eddy, Doris Hall and Lesley Powell. Since the 1990s other personal trainers have developed methods that parallel somatic principles but emerged from other sources. A recent one is a system of strength training called Animal Moves, and is based in repeated actions from developmental movement – crawling on the belly and creeping on all fours. One could easily see Animal Moves becoming even more effective if performed with somatic awareness.

Since the 1990s the term "somatic fitness" has gradually come to describe a subset of the somatic movement field.[2] It can be an umbrella term for the conditioning aspects of Aston Patterning, Emilie Conrad's slant board and somatic-based personal fitness. From Chapter 4 one can see that some of the early influences on somatic exploration – the Movement Cure – also had a preventive health goal. Gindler's Gymnastik still has an offshoot called Holistic Fitness – Ehrenfried's Gymnastique Holistique is operative in Canada, Germany and Greece.

The realms of meditation, alternative healing practices, occupational therapy, physical therapy and even yoga therapy are also being altered by the influence of somatic movement professionals, often because professionals hold dual registrations across one or more professions. Similarly, educators who focus on kinesthetic awareness are recognizing that their goals and methods are related to somatic education and delighted to find a name and community for what was sometimes experienced as lonely or isolated, albeit cutting-edge work (Eddy Interview 2015e; Joseph 2014; Seidel 2015).

Authentic Movement, Katsugen Undo, dance improvisation and somatic explorations all trust that every person has natural body wisdom. Authentic Movement practice has similarities with the Japanese movement practice Katsugen Undo, described in Chapter 4. These techniques invite the mover to access her or his inherent bodily intelligence. By simply letting what is natural unfold, the body will "unwind," and sometimes cognitive associations – both thoughts and feelings – can be culled. The facilitator is key in determining and inviting the degree of psychological depth these groups engage in. From a somatic perspective allowing movement initiation to come from the subconscious or autonomic nervous system is a letting go into oneself, and a confidence that the body has intelligence worth gleaning. Dance/Movement therapy is hence a somatic process. It differs from somatic movement therapy, in that there is minimal education about how to use touch to amplify healing and balance, and often less sophistication of knowledge in movement efficiency, anatomy, kinesiology and physiology.

Somatic Practitioner as External Feedback/Reinforcement

Somatic practice helps people gain confidence by practicing being in touch with their bodies and accessing the regulatory resources that dictate what is needed to be as healthy as possible. The somatic process is a listening process. When help is needed in using this listening process, the somatic expert assists by observing in a nonjudgmental manner, with minimized preconceived notions. She or he listens, feels and watches.

Somatic educators teach through questioning, using minimal demonstration to stimulate a new movement experience, generally using guided vocalization and skillful touch. These are entry points for the students/clients to do their own investigations and assess the quality

of "rightness" from internal cues. When a student is stuck in a habitual pattern that is not serving her or him, then the somatic educator gives feedback in the form of suggestions or questions. A well-trained or seasoned practitioner will exchange words of feedback using diverse multisensory channels, attuning to the particular learning style and physiological conditions of the student. Most often the student/client is presented with numerous options and asked to determine what "feels" or "is" true. Outside feedback from the somatic educator can be supportive, provocative or factual. In all cases there is ideally an underlying compassion in its delivery. What is most important is that the mover always has the choice to differ with the teacher/practitioner, have her or his own opinion, and maintain personal authority.

Somatic exploration can be much like detective work for the practitioner, ideally undertaken together with the student. There is give and take from different sources, constant surveillance to learn more, checking in to see what clues resonate with the entire scenario and a sense of wholeness when a mystery is solved; when a deeply unconscious, or slightly subconscious experience becomes conscious; when a restricted body (and correlated soul) without language is liberated from restriction. Then one can give voice to the new choices, the new confluence of sensations.

Often the penultimate feature of this process is to demonstrate a new movement, be able to discuss it and even be able to return to the old habit but to no longer get stuck using the same habits. Somatic psychologists and those somatic movement educators trained in psychodynamics find that there are also psychological corollaries to this process. When a student/client is restricted emotionally or in the mind, new options can be found through accessing appropriate support, and then sensations of both emotional and physical well-being often emerge. An effective model for working through embedded psychophysical habits or trauma has been to have a client work with both a somatic movement therapist (who also does somatic bodywork) and a somatic psychologist. With this combination of care a person can work deeply with her or his entrenched emotional and physical restrictions. When both are addressed in a conscious way the change has been seen to move forward expeditiously.

> Growth is a constant deconstruction and reconstruction of inner reality as new information is internalized. In this constructive process, clients progress through social and psychobiological stages. Their journeys of discovery reveal new ways of understanding, feeling and behaving. It is a difficult task. Those who have learned to exist reasonably (or not so reasonably) well without basic organizational patterns like the ability to manage feelings, feel secure in one's body or experience trust must face the disorganized impulses that cloud their inchoate potential. Only by giving space and time to the tumbled and unsettled threads of nervous potential can the tangles be untangled and coalesce into new arrangements.
>
> (Chutroo 2007: 417)

I Can't Get the Movie *Selma* Out of Me[3]

Martha Eddy

I can't get my stomach to fully settle out of my throat and back down into my body. It's 3 January 2015 and this chapter on health, wellness, the nervous system and trauma is without a story. After seeing the movie *Selma* on Dr Martin Luther King and the Civil Rights Movement efforts in Alabama and Georgia I am drawn to write my story; my story of how unconsciously my body (mind/spirit/soul) through my love of dance led me to begin healing from trauma that I wasn't even aware I was living with.

I happen to have two close friends, each trained in Body-Mind Centering as well as in psychology – social work in one case and somatic psychology in another. Each has confronted me on my defensiveness, my quick-to-explode nature – a side of me that most people don't see or they graciously excuse as an anomaly. It's not an anomaly; and sadly, it's often so surprising it's all the more hurtful. It took one of these friends to say "You grew up in a War Zone" and to hand me the book *Third Culture Kids* for me to realize that I really was responding to many stressors as a traumatized person. Years prior to that – 1988 and 1989 to be exact, I had danced about my childhood but it wasn't enough to move me out of my old response patterns. I had created a piece called *BorderStories: Life Across 96th Street* that I was invited to perform in order to elicit dialogue between high school students of different races. One goal was talking about why the black students choose to sit together at lunchtime. I knew why they sat together, it was comfortable; a time to share with those who "understood." I'm glad to have shaped art around being raised to the music of Nina Simone at a time when she chose to shun this country for its bigotry; to tell about being eleven and knowing my dad was with a group of black and Latino community members forming a linked-arm chain across our street (now named the Revs Norm and Peg Eddy Way) as rioters pushed down the avenue looting and bludgeoning in response to the murder of Dr Martin Luther King, just after seeing my mom cry for the first time, tears for this senseless death. I used background tapes of a radio show on FBIs CoIntelPro – a mandate begun in 1956 and active until 1971 – upheld by J. Edgar Hoover to "expose, disrupt, misdirect, discredit, neutralize or otherwise eliminate the activities of these movement and their leaders" referring to, for examples, the civil rights movement, the socialist and communist movements, the Vietnam war protestors, the Young Lords.[4] Ah the Young Lords, the "gang" that was operative in our neighborhood and that my father worked with, to help get churches (one of which they occupied) to serve lunches to children. The performance served its purpose but it wasn't a complete healing, my anger patterns remained.

During my childhood, I lived in a bubble of self-perceived safety established by a loving community, all of whom lived amidst the myriad of human acts that merge

from legitimate anger and unjust poverty – fights, fires, drug addiction, crime, murder, neglect and more neglect. And there were those who organized, rehabilitated (health and homes), improved some jobs and schools and overcame whatever small smart groups of often-uneducated people engaged in "Spiritual Coordination" could overcome. I was a baby, toddler, child – cared for by ever-changing hands – mothers, sitters, church members, teenagers. I observed and I adapted, fit in like any good *Third Culture Kid*, gifted with reading body language and rhythm – the ability to fit in while dancing, despite my white skin. Mostly this worked fine, but sometimes I was tormented with words or pressured to do things I did not want to do, acts I was fearful of. And my parents and older siblings were busy – fighting injustice or just living their own lives of creativity and survival, respectively.

I left home at 16, leaving East Harlem and finding the beauty of western Massachusetts. I also found Laban Movement Analysis in a college course called The Self That Moves, taught by Diana Levy and Francia/Tara McClellan Stepenberg. Thanks to Tara, my college dance professor, I was introduced to Janet (Braca Boettiger) Adler and Authentic Movement in 1975, Bonnie Bainbridge Cohen and Body-Mind Centering in 1976 and Irmgard Bartenieff and the Laban Institute of Movement Studies in 1978. The rest is history. Inch by inch, year by year, more of me relaxes, other parts get stronger – cells, glands and my amygdala recognize my moments of isolation and need and bring me back to finding human support through touch, caring, friendship and movement. My nervous system is less reflexive, edgy, and I am more cognizant of my signals prior to flare-ups. I still get extremely angry in the face of injustice. I still do my best to focus that anger toward establishing systems for peace (www.EmbodyPeace. org; Eddy 1998, 2010). Specifically I strive to find concrete actions to care for myself as a woman, for people with less privilege than myself, for the environment and for seemingly endangered phenomenon: the art of dance, the transmittal of caring touch versus confusing/sexualized touch, the gift of time, space and awareness to engage in self-healing, conscious movement. It is a gift to have had years of somatic experience to build up my resiliency. And I take time to breathe, deeply. And dive in.

Notes

1 The episodic buffer is described as a "limited capacity, temporary, multimodal, storage system which is at the interface between long-term memory and both the VSSP and phonological components. [It] can be accessed by the Central Executive (section of the brain) via the medium of conscious awareness."

2 http://www.thankyourbody.com/somatics-a-different-approach-to-fitness-and-health/

3 *Selma* came out December 2014 and tells the story of violence in Selma, Alabama including the Selma to Montgomery walk and the role Dr Martin Luther King and many people along with him played in this slice of the Civil Rights Movement for Afro-American rights.

4 Others include the Rainbow Coalition and the American Indian movement; 15 per cent of the funds were earmarked to temper the doings of the Ku Klux Klan, the other 85 per cent to preserve the existing social order.

Chapter 12

Conscious Action and Social Change: "Social Somatics"

Conscious Action and Social Change: "Social Somatics"

> [...] our hunger was of the type that arrives unannounced and unauthorized, making itself at home without an end in sight. A hunger that, if it was not softened as ours was, would take over our bodies, molding them into angular shapes. Legs, arms, and fingers become skinny. Eye sockets become deeper, making the eyes almost disappear. Many of our classmates experienced this hunger and today it continues to afflict millions of Brazilians who die of its violence every year.
>
> (Freire 1996: 15)

While somatic activities can be imagined as a type of navel gazing – simply relaxing on the floor, walking in slow motion, sitting carefully – the term *somatic* was always intended by early proponents of somatics to be applied to external action, and more specifically to social change. Hanna defined somatic study as a study of the "soma embedded in the environment." Awareness of self and other in relationship permeates most of the somatic teachings.

As people improve their sense of well-being from somatic education or somatic dance, many become aware that cultural contexts, personal and communal values and beliefs, and broader environmental features contribute to health, and likewise human values and social structures can contribute to its demise. One emergent response to these levels of awareness has been the advent of an area of inquiry and action called "social somatics."

Social somatics implies taking context, culture and relationships into account whenever practicing and applying somatic education. It can also include striving for somatic models to become embedded in all aspects of life, and actively counter inequalities – making somatic education available to all people who would like to pursue this type of inquiry. Thus, a key point is that social somatics is a form of activism. This concept is encapsulated in "somaction" a term coined by Eddy at Moving On Center (MOC) School for Participatory Arts and Somatic Research (Eddy 2002a). Here students spent 200 hours learning to go deeply inward and then were asked the question: "Somatics for what?" (Eddy 1996, 2000a, 2006a).

Somatic Myths

To be effective, social somatics has to battle myths as far apart as: 1) somatics is only for the privileged classes and 2) somatics is the same as indigenous practices. Hence this chapter will discuss how social somatics strives to address inequities and situations of injustice, conflict and violence, as well as pay homage to the influence of indigenous wisdom within some of these practices.

History and Definitions of Social Somatics

Similar to the original somatic pioneers, early social somatic advocates worked independently. Each chose to delve into the role of somatics in establishing social justice in their local community with unique strategies. Some were in scholarly settings and others were performers or somatic psychologists. Each realized that somatic awareness could be useful in addressing some facet of inequity whether it be domestic violence, feminist issues, racial disparities, ecological imbalances or health abuses, among others. Today, social somatic experts are those somatic activists who train themselves and others to be astutely aware of body-mind experience while simultaneously engaging in social justice.

Social somatics was a natural outgrowth of a desire among somatic educators to use somatic awareness for common good. Author Clyde Ford (author of *Where Healing Waters Meet*, 1992) and Professor Jill Green (dance educator and Kinetic Awareness practitioner) were key investigators and continue to be leaders in this field. John Vasconcellos, California's longest standing assemblyman was a spokesperson for social somatics as well (Miller 2014). He spoke from his personal experience of Stanley Keleman's somatic psychology work (Keleman 1981), expounding the need to combat degradation of self-esteem and supporting research that loss of self-esteem can be a root cause of joblessness and drug abuse. In an email thread with another leader David Boulton, the one-time advisor to the Chair of the California Senate Education Committee, Vasconcellos writes "How do we assure each child a set and series of relationships which accept and encourage her/him to appreciate and trust themselves, in their entirety?" (Boulton 2002: 1).

Carol Swann (Alexander Teacher and Hakomi practitioner) defines social somatics in this way:

Social somatics uses awareness of cultural complexity and contexts of privilege and oppression to engage in creative and embodied action. These practices aim to bridge disconnections and transform cycles of injustice into new paradigms of mutual respect for all.

(Leguizaman et al. n.d.)

Engaging in social somatics typically involves striving to improve conditions, laws and delivery systems that support social structures and relationships that are healthy and sustainable.

Swann continues:

> Social somatics is committed to transforming relational, structural and cultural dynamics according to the highest integral wisdom of our social bodies. In social somatics leaders collectively examine the social body formations, functions and movement patterns in human behavior, with an emphasis on transforming, rather than treating degenerative conditions.
>
> (Leguizaman et al. n.d.)

Social somatics can take many forms and is constantly evolving when it centers on the application of diverse somatic practices in counteracting injustice across domains. There are small and some larger examples addressing disparities within economics, culture, education, the prison system and environmental conditions, as well as of power imbalances, threats to democracy and active citizenship. Embodied Leadership is an emerging field that is capable of integrating somatics for social change, especially within the context of community organizing (Eddy, Williamson et al 2014; Roth 2007). The tension between concentrating on individual experience and group behavior is ongoing in this subfield. For example, specific strategies include programs developed to counteract the experience of torture, as well as other programs that teach people to avoid the escalation of conflict and violence. Don Hanlon Johnson's writing spans many of these themes.

Another theme within social somatics is that of community building. For instance, this could manifest as using somatic activities to counter lack of embodied "facetime" in an ever-increasingly technological world. This process becomes a more overtly social-somatic force when Vincent Yong's "soma social" elements (2015), described further below, are emphasized, and causative elements of what impacts our environment and interpersonal behavior are addressed. "Social somatics" aims to address inequities across race, class, gender, ability and sexual orientation, becoming a social justice of the living body. Individual or group activists can bring somatic attention to all arenas related to the body – most notably environmental, humanistic and health justice issues – or use somatic practices to enhance their own sustainability, avoiding burn-out.

All in all, the priority to value self-regulation and personal authority can be considered a challenge to mainstream education, health and even philosophy. Social somatics strives to maintain these self-empowering values despite apparent adversities. "Somaction" is the moral and physical force that energizes social somatic work. At MOC, when teachers ask, "Somatics for what?", they want to know for what end does one choose to engage in somatic awareness? What action will be taken with this somatic knowledge? Somatics certainly is of benefit when working to evolve oneself. Social somaticists strive for an even broader end. They choose to move beyond personal self-investigation to impact the forces that are causative of health distress and inhumanity. The social somatic perspective

is that these conditions must be overcome in order to establish a global experience of well-being. This value is capsulated in the South African word "Ubuntu."

Much like the MOC, Generative Somatics is a non-profit entity that helps organizations focused on social and environmental justice to strengthen their missions and effectiveness through somatic awareness. They choose to tackle organizational conflict and development through personal and systemic healing. Their methods involve engaging in somatic activities. Their goals involve individual and societal transformation.

Social Somatics within the Health Arena

Somatic movement combines a mindful approach to movement, can be meditative in nature and uses imagery. It has all the benefits of movement and exercise *and* includes an incredibly safe approach – moving slowly and with the teacher and student sharing minute by minute feedback about their psychophysical experiences. However, as pointed out in prior chapters, somatic practices – whether somatic movement education and therapy, somatic psychology or somatic bodywork – when practiced separately from physical therapy, social work/psychotherapy or massage therapy are often not part of the allied medical profession within a country's health insurance and medical systems. Health equity asks that all of humanity should have equal access to life-enhancing strategies. This ideally includes the wellness impacts of somatic experiences. A component of social somatics is to work to counteract unequal access to health knowledge as well as to practice. A starting place is within somatic education – by making somatic sessions and sometimes somatic training more available to all.

It is a challenge to provide affordable ways to receive somatic sessions. This goal is deterred further if one's culture positions alternative or non-allopathic health care as a high-priced commodity. This is further exacerbated in the US by a system where therapeutic sessions are limited to just 15–30 minutes. The implications of this go further – they relate to cost, to time, to space and to interpersonal process.

Economic Ironies of Somatics: Why Is It Expensive to Access Knowledge that Is Free?

Cost

Somatic movement therapy is in the US White House Commission on Alternative Medicine's 2002 final report as one of five types of complementary and alternative types of medicine; listed within the category of massage, bodywork and somatic movement therapies (White House Commission on Complementary and Alternative Medicine Policy 2002). That somatic movement interventions are considered "alternative" is ironic,

since movement is accepted as a therapeutic intervention for recovery from illness and for rehabilitation in hospitals. This is evident from the integration of physical therapy, rehabilitative medicine, exercise physiology and therapeutic exercise into allied medicine. Unfortunately, however, somatic movement usually does not get insurance repayments or get situated within national medicine plans. A 2015 LinkedIn survey among Feldenkrais practitioners resulted in about a dozen possible venues where one can find Feldenkrais somatic educators at work. It revealed universities, private clinics, community and fitness centers and so on. Aside from some community agencies most somatic private lessons cost between $60 and $180 per hour. There are huge debates about how to address the issue of guiding the public to wellness in the nutritional realm (e.g., Couric and David's film, *Fed Up*; Soechitig 2014), and similar challenges exist in the somatic movement and fitness domains.

It has become a privilege to formally study somatic education due to its expense, despite the fact that the resources needed are basically free: access to our own proprioceptive self. Anyone can choose to pay attention to the body and breath process, even while walking down the street. However, when one needs guidance from a professional to deal with pain or challenges, financing is needed. Group lessons are a less expensive way to study, although with the change in the teacher-student ratio, participants necessarily receive less touch and related proprioceptive feedback, which may be crucial to a learning or healing process.

Time

Somatic education is a process. It takes time, and time is money. The process of learning is typically through mentorship and guidance – often one-on-one education. This personalized process is more costly than group lessons. Any somatic lesson takes time. It often takes a shared cultural value to spend time listening within. Budding dancers beginning their careers or still in school will ask, "How will I have time outside of this class, when my work schedule, my rehearsal schedule and my performance schedul are already packed?", "How can I find time to expand my somatic capabilities, if I don't even have time to sleep?" Many are working several jobs in order to survive, or studying several topics in school in order to have multiple skills and hopefully better paying jobs than what is available as dance or theater professionals.

Access to Clean Space

Open space is needed for somatic learning – clean, open, unencumbered floors. How is this kind of space made accessible to all? It is no wonder dance programs are among the only

academic subject to provide in-depth somatic studies – they provide adequate space. There are exceptions as with SUNY – Empire State College, which sees somatic education as integral to cultural studies and an important facet of social change. They allow for their multipurpose rooms – carpeted with mobile furniture on wheels that can be moved aside for activity – as well as their gallery classroom space with tile floors to be used for somatic inquiry. A plus to these spaces is that they also are fully equipped with technological equipment for display of information. Columbia University, Teachers College was the academic home for John Dewey, Alys Bentley and Maxine Greene. Their dance studio that had been the first in the country for a graduate degree in dance education and home for the work of Martha Hill and teachers of Lulu Sweigard and Irmgard Bartenieff's lineage is now filled with cubicles – offices (see Eddy's 2013 performance, *This Old House,* YouTube video). Space is at a premium. Many are being torn down and shifted into office. High rental fees make somatic workshops expensive. On top of that, Somatic Movement and Dance Education may not yet be perceived as building one's potential for income, nor understood as anything more than a luxury, as in relaxation.

Access to Quiet

The need for quiet is yet another requirement. In order to slow down and feel the body, it is important to also be able to hear one's breath, heart rate and physiological rhythms. Quiet supports sensitization to subtle body cues. Quiet is not easy to find in many places. In public schools or noisy cities, quiet is a luxury. On the other end of the spectrum, part of the somatic process can be vocalization – understanding the vocal apparatus and how speech, chanting and singing relate to the health of the body. In order to explore vocalization consider using a sound proof room out of respect for others nearby. The common solution is to place somatic classes in spaces shared with actors, singers, dancers and other performing artists. This can work well, as performing arts' learning and rehearsal spaces are often creative, uninhibited environments. However, they represent a small percentage of all spaces and sometimes are bustling with noise, loud singing and other distractions. The trend toward including yoga in work environments again will be helpful. As people become more used to movement and chanting happening in a work room, it may mean that there are more clean, quiet, creative spaces for moving in diverse institutional settings. Nevertheless, noise pollution is ubiquitous – air travel, trucks, emergency vehicles, radios, television, advertising all invade quiet space. Quiet has become a luxury, a luxury that even the wealthy cannot always access. Around the world, whether urban or rural, quiet space is an endangered phenomenon.

Other Ironies – Neutrality to Activism

Somatic activity often appears as if it is simply resting or at most very relaxed quiet movement. This quietness is, of course, important for kinesthetic awareness, somatic

listening. Quiet is also a healthy antidote in highly stressed urban or suburban cultures. This quiet movement is linked to what LMA refers to as "neutral state." It involves breath-based movement that is easygoing and as effortless as possible. The neutral state establishes a baseline of ease from which someone can discover their muscular tensions and postural habits as well as their underlying physiological rhythms. Psychiatrist Dr Judith Kestenberg postulated that 33 per cent of life is meant to be at rest, in a more neutral state, a time of nonaction, such as in sleep, stillness, waiting and reflecting (Loman and Brandt 1992). This neutral flow time is recuperative and can serve as time for inspiration. However, as discussed throughout, another end-goal from a more social somatics model is to go beyond neutrality to applying the knowledge that has been gained during relaxed movement to a wide range of actions. A value is placed on applying one's somatic awareness to everyday life and expressive movement. Both are especially important for performers. LMA and Bartenieff Fundamentals are somatic systems that provide models of making efficient transitions from neutral state into diverse styles of activity. Laban-derived systems (inclusive of BMC) are particularly well suited to bridging between somatic awareness and somatic activism (Eddy 1995b) because of the wide range of movement qualities that are practiced.

Bartenieff focused on level change as a primary focus of her Fundamentals of Movement work. During every one-hour class she would repeatedly demonstrate how the principles that were being learned in the body while lying on the floor could (and should) be applied to coming to standing and maintained in all other upright activity. Even at the age of 75–80 she demonstrated jumps and falls that could be done using "spatial support" and breath rhythms. The basic themes and elements within LMA and Bartenieff Fundamentals are practiced in supine positions until they become more automatic and more easily transferred into a person's range of expression. Bartenieff insisted that the new information, such as "body-level organization" be experienced with varied movement dynamics – varied flow fluctuations and other changes in quality of movement – from relaxed to strong, from sustained to quick and focused, from heavy to light or forceful. Practicing these diverse movement qualities is also preparation in readiness for taking a stance, moving out, self-assertion and engaging in group movements – the hallmarks of activism (Eddy 1998, 2016). Dance and performing arts educators are well suited to understand this practice of embodying diverse statements both as a creative process and as a democratic one.

Alliances between movement and dance organizations can support a paradigm shift as well as heighten access to "social somatic" experiences through scholarships, sharing of information on websites, offering free events, doing outreach to the surrounding communities who do not often have access and choosing to locate in varied neighborhoods for classes and performances. Professionals can also choose to translate what might be alienating words within the somatic language to more accessible language.

Access to Professional-Level Somatic Education – Advocacy to Activism

Many dance, theater, arts and movement educators have taken a potent stand, step or leap for the need for somatic education within their schools, and many, like Martha Myers, would like the privilege of studying more or even obtaining certification in at least one if not several somatic systems. It costs quite a lot of money to become educated in most renowned somatic systems: Alexander Method, Bartenieff Fundamentals, BMC, Feldenkrais ATM, as well as others. Generally, the somatic education world has been a world of the privileged.

More employers could be encouraged to view somatic education workshops as a valuable form of continuing education for their employees or new hires. Advocating for somatic education with one's administrators is a type of activism. Advocates argue that somatic awareness can help workers to be more efficient because they are more rested and now understand how to build recuperation into the workday (Lamb and Watson 1979, Moore 2014) and that somatic education can guide professionals to be more confident during presentations (Heckler 1993, 1997, 2003). When university professors strive to include somatic education in the curriculum they are advocating for a new paradigm. These forms of advocacy may not directly address inequity but they empower the field of somatic education that, in turn, allows for efficacy in other types of activist endeavors.

The establishment of university courses and programs in somatic movement and dance has helped the growth of the field. It has done so 1) through exposing people to the somatic body of knowledge, 2) supporting research studies as well as the advent of new research methodologies, and 3) housing occasional, or periodic conferences. This type of advocacy continues. Examples are the annual and/or biennial convening of groups of people at the Centre for Dance Research (C-DARE) at the Coventry School of Art and Design in Coventry, England (C-DARE); Dance and Somatic Practices conferences in England (Whatley et al. 2015); The Festival of the Moving Body at the State University of New York-Stonybrook; the somatics-based Dance Education Conferences produced by Cynthia Williams and others in the Bill Evans' professional community; and the various independent symposia that are held among professional members of any one somatic movement system. Many of these groups, and especially these latter groups, have met or still meet in independent dance or wellness studios or through university dance departments. This is the case of the Freedom to Move conferences in New York City, where the Performing Arts (alternating years focus on music, theater or dance) are investigated through the lens of the Alexander Technique. The Body-Mind Centering Association (BMCA) is extremely inclusive, bringing together all the various offshoots of BMC as well as inviting all other somatic practitioners to participate, present and publish through BMCA.

Whether or not there is institutional support, each of these symposia exists due to the dedication of inspired and hardworking advocates. When producing an event with administrators, technical support staff and hospitality workers who have never been exposed to somatic studies, there is usually more need for dialogue. This process of explaining the need to use a clean floor, the possibility of sound making and chanting as well as projectors and web services is an educational one that, in turn, serves as a type of advocacy for the field. Advocates

choose to explain what we are doing to gain access and fiscal support for the convening and research of somatic practitioners. This supports a continuum of advocacy to activism.

Lack of Institutional Support: Edges and Barriers

While symposia and conferences may be housed in universities, most somatic certifications have lived outside of the mainstream of educational and health institutions. There are still only a few partial graduate programs that also provide the education needed for registering somatic movement educators or therapists. One impact of not being supported by larger institutions is that there is limited economic and related racial and ethnic diversity within the somatic community. Public institutions, while often cumbersome, also abide by laws that serve to enforce equity. There, support is needed as somatic education seeks to expand its reach. Some social somatic leaders work to bring diversity and equity into the somatic community and others work to bring somatic inquiry into those institutions that are willing to advocate for the somatic paradigm.

One stylistic clash of teaching somatics in larger institutions is that students may only be exposed to a brief introduction or be asked to only read and discuss somatic practices. There is not enough experiential education. Somatic practice is experiential by nature – it needs to be learned through the doing of it. The body only gains greater kinesthetic sense if actual movement takes place. If students do explore a sampling of movement, it may simply be gestural movement seated in chairs. This is a beginning of course, but just a beginning.

These conditions also impact the growth of the field. Unless somatic education programs are affiliated with major institutions or nonprofit organizations, there will be limited access to student loans and scholarships that make these studies affordable. Upon certification, many somatic professionals would like to share their work with people with varying economic means but find it difficult to make a living doing so. Unless the practitioner is licensed professional in another discipline – massage, physical or occupational therapy, or psychology and choosing to take a somatic approach to this work – the work is usually paid for out of pocket. This narrows the pool of potential clients, making it difficult to earn a strong living. Nevertheless, those practitioners and organizations that value "social somatics" find ways to provide access to somatic movement to people across class backgrounds through sliding fees scales, free clinics (e.g., the Feldenkrais center in Berkeley has a sliding-scale clinic; Dynamic Embodiment practitioners will provide free sessions for people waiting at the food pantry at Riverside Church) special educational events and health fairs. Some somatic organizations are established as non-profits to address economic inequality. Moving on Center and Moving for Life are two examples.

The Internet has slowly provided a forum for somatic education and other "free" informational sources. One example is Alexander teacher, Jessica Wolf's *Art of Breathing* DVD, which that teaches three-dimensional breathing, components of which can be found on the web. Understandably these Internet lessons cannot include the transmission of touch

or the personalized feedback about someone's movement that are among the essential somatic ingredients for changing a deeply engrained habit. Internet resources can convey the idea of self-discovery and basic movement principles though. The somatic value of empowering each individual to find her or his bodily authority can be challenging to mainstream medicine. Unfortunately, the space, time and cleanliness needed to release the tension that can block somatic awareness are not always easy to access in the city or in rural areas.

The most limiting factors to the widespread use of somatic education in the health arena are the lack of publicity and the lack of research on the effectiveness of somatic movement in health. The most common type of evidence is anecdotal, compelling but not verified for reliability, replication and validity. The need for research is great.

In summary, to enhance access to somatic education there needs to be more time, space and quiet. These provide the conditions for supporting body-mind learning and somatic action. Unfortunately, time, space and quiet have become expensive. Issues of time include the funding of the time to learn about the body and the time it takes to embody somatics, let alone integrate new levels of consciousness. Long enough periods of time would be needed during the day or at school to learn about the body, relax, learn from the body and practice new habits. Furthermore, more teachers are needed to grow this profession. Schools, colleges and universities need to value this work and allow more time for students to engage in the experiential activities of somatic education and gain degrees in it by making it affordable. Outside of distinct dance, theater and psychology programs it is rare for universities to teach mindful movement or somatic education. Yet moving into conscious embodiment – the practice of moving with mindful attention – may be exactly what we need to address a host of educational quandaries and even contribute to societal balances. Degree programs in somatic education would also foster more research on related topics.

Somatic Access to One's Own Power and Moving It into Community

Somatic education is based in the conception that everyone has the ability to know how to self-regulate. A corollary is that everyone knows best how to take care of her or himself, given the chance to "tune in". Then it is also important to know how best to interact with others in a safe and productive way. It becomes important for educators, whether somatic leaders or leaders of dance-making and dance education, to instill these values. This involves setting up time for inner reflection and then a shift from neutral time and space to empowerment and communication. Classroom teachers can choose to dedicate three minutes of their class time to somatic practice. They can also create peace corners (a place for angry or frustrated students to retreat and self-regulate). Administrators can value the skills of kinesthetically aware educators. Everyone can help with translating alienating terminology into more accessible language. Schools and hospitals can choose to counter anonymity, build accountability and community interaction around shared values of self-care, as well as affirm learners' holistic needs (Eddy 1998).

Community building and community dance have existed forever, wherever there are groups of people. Community dance as a term has returned to represent the many groups of dancers and non-dancers alike that take time to dance, often in public spaces including parks, community centers, schools and places of worship. Movement skill-building and somatic awareness have been helpful tools for community dance. The inclusivity of community dance also opens the door to reviewing how dance somatics is helpful in making dance more accessible to people with diverse physical abilities.

Each professional somatic education association (e.g., BMCA, Feldenkrais Guild, Alexander Teacher Institute) prides itself on those practitioners who have found ways to work with diverse ranges of people with special needs. They also attempt to do research or provide services to a broader constituency. ISMETA strives to make the field known, to have all somatic movement modalities work together, supports research and encourages community-building projects. Alliances between movement and dance organizations can support a paradigm shift of competitiveness to cooperation, as well as choose to heighten access to "social somatic" experiences supported by scholarships, website information, free events, outreach and locating somatic activity in diverse neighborhoods.

The Somatic Arts and Communication

In the domains of art-making and performance, somatic education can fuel communication through the body along the continuum of development of personal rituals, classic proscenium concert productions or public forums for communication (participatory arts). Skill in communication and in somatic awareness can support conflict resolution. When sharing work in different communities there will be experiences of naturally occurring misunderstandings. These conflicts can be addressed somatically (Eddy 2015; LeBaron et al. 2013). As a humanist engages in research there is an acceptance that there will be bumps, "disruptors" along the path that are distractors – opportunities for learning and transformation. These, when handled well, ultimately bring the people involved into closer relationships and deeper engagement in working together. Working together in communities with diverse belief systems is another opportunity for growth. The improvisational skills of the somatic arts include learning to listen/watch, accept and share without judgment. These are skills that need to be advocated for and that can also serve to teach advocacy.

Somatic Advocacy

The Dancing in the Millennium conference in 2000 in Washington DC brought together eight different associations and their membership to do Arts Advocacy with American politicians, sharing the expertise of dance educators. It was a call to action, emphasizing the importance of building networks and supporting political action from diverse body-based

perspectives (Eddy 2000a). As part of the Arts Advocacy training at the conference on 19 July 2000, the public advocate Ozlu advised following the heart in speaking to politicians. Activism can be driven by somatic cues. A few years prior the Dalai Lama suggested people listen to the movement and sensation of the solar plexus in dealing with trauma and violence (Dalai Lama and Cutler 1998). Dance professionals can assist in applying somatic theory by following the natural flow of health and communication that stems from body sensitivity and even from dancing.

Taking action in the face of inertia or adversity is dependent on strong core beliefs and deeply held values. Three examples of the type of values that emerge from the lives of the somatic pioneers and somatic education itself include: 1) Living the model in which "clues to difficult dilemmas also live inside the body" and can be accessed through *kinaesthetic awareness,* movement and caring, skillful touch; free and inalienable rights of all people. 2) Advocating for the right of all to have substantial time and space for embodied learning, self-reflection and dialogue about meaningful applications of body wisdom because everyone benefits from others' experience of wholeness and strength. 3) Recognizing that traditional forms have a long history of holism and honor them by crediting them.

Actions include: share experiences that encourage insights from within, leading to empowerment. Be ready to change in response to experiencing newly, which can itself include learning ago-old movement forms. Determine ways to embrace somatic theory with inclusion of all and activism for all in mind.

Dealing with Injustice – Social Somatic Approaches

A burgeoning number of somatic professionals and organizations are linking dance and performance to a myriad of social issues. As one considers the challenges that the stories of the human body tell, it is possible to imagine how somatic investigation brings up histories of injustice. Within a few schools of somatic education, (e.g. Moving On Center, Global Somatics, ISMS-Netherlands, California Institute of Integral Studies), educational dialogue includes critical inquiry and a desire to offset these injustices. In some instances this is through public community forums (Roth 2005, 2008). The University of Maryland has paired with the Laban/Bartenieff Institute to establish Dancers without Borders, and Tampala Arts Corps is working with an anti-human trafficking campaign.

Somatics in Action: Feelings, Empathy and Conflict Management

The somatic process of being mindful of one's movement in everyday life or performance evokes the following question: What are the conditions that support "mindful movement" during action? Bainbridge Cohen provides a helpful model in the title of her book *Sensing,*

Feeling and Action. Her system of BMC teaches that while sensory focus is critical to becoming aware and becoming embodied, the next stage of integration is to let go of the process of acutely sensing. Let feeling and action take over. Dance students often ask, "Do I have to keep attending proprioceptively while performing?" The answer is that it is quite difficult to do so. Given this, a major goal in training in somatics is to expand one's bandwidth of sensitivity so that when out and about, engaged in life, performing or striving for a better world, one is still open to sensory information but not dwelling on it. With this ability to simply act, sensations and emotions will now register as feedback on the action and can inform more attuned responses for the future. When directed toward others, this empathy can support social somatics for the greater good.

For instance, when experiencing developmental movement, one awakens one's own healing capacity and often an appreciation for babies and animals; when exploring in groups, one perceives the interactive nature of our global and personal health. With this awareness the challenges and limitations on this exchange also become apparent. Social awareness can emerge from self-investigation, but it is most obvious in partner and group work. Vincent Yong, CMA, RSMT, CTBMD of Singapore writes:

> Each "soma" affects change in the shared general environment. His or her presence can cause a direct or indirect change in us. A direct change occurs when he or she enters shared space or through a direct connection with our bodies. Indirect affects occur when the other person has influenced the space or environment that we are co-existing in. These spaces transform and in turn affect our soma. Understanding this on a general level helps us to appreciate and accept that we are not alone and we are all connected directly or indirectly. Appreciating this on a deeper level would allow us to know each other in ways that can transform our inter-soma relationships. As we work authentically in the inter-soma relationship, we begin to empathize by sensing another's ups and downs, the choices, the difficulties and challenges but also what makes a person joyful or elated. This happens by means of somatic appreciation, an experience that comes with participation. As we empathize, we also start to learn and know more about ourselves and thus begins the journey of growing and healing.
>
> (2015: 1)

Kinesthetic and proprioceptive awareness leads to empathy with self. It can be postulated that this heightened sensitivity leads to questions about environmental constraints. A desire to have more compatible conditions for healthy living is a typical outgrowth. The caring that occurs in somatic (especially when feeling the healing touch of another person) is an opportunity to experience and share empathy. What many people report is that the relational aspect of the somatic experience, its "soma-social" nature, awakens the feeling and sensations of interconnectedness and vice versa.

Somatic awareness is related to the building of socio-emotional intelligence (Lantieri 2008). By being somatically aware one can register physical markers of stress, joy, fear,

anger, satisfaction, effectiveness and also of pain and of being pain-free. Being aware of one's bodily experience in the moment, not after-the-fact, can provide greater insight into one's feelings (Eddy 2006a, 2006b, 2010a, 2010b). This identification of feelings – both emotional and pain-related – underlies behavioral choices and action. This identification becomes extremely beneficial in cases of conflict and potential violence (Eddy 2016).

Social somatics moves a step beyond the soma-social by speaking to inequities within society or by seeking to extend somatic privileges to people with economic disadvantages or for other purposes of social good.

A Curricular Sample of "Social Somatics" Activities

Moving On Center (MOC) – School for Participatory Arts and Somatic Research, established in 1994, chose to situate itself in downtown Oakland, California in order to make somatic information available to inner city community members. MOC's tag line is "bridging the somatic and performing arts for social change." In developing ways to teach "social somatics," movement and dance educators from MOC report that they worked to develop programs that recognize the influences within the somatic theories (e.g., the strong influence of eastern philosophies and the confluence with traditions from Africa); consciously determine when the use of Euro-centric models of health (e.g., language of anatomical sciences; research models from Enlightenment) is useful or limiting for larger goals at hand; give students opportunities to share their knowledge through and at performances, in classes and at home, with people who otherwise have less access. This includes use of language and experiences that community members value; hence, the development of programming to address real issues in community member's lives (Eddy 2006a). Various outcomes included: free performances in outdoor public spaces such as Jack London Square (Gooden 1997), offering free somatic movement and touch clinics inside and outside of the school building, engaging audience with participatory arts, awarding scholarships to students from countries that have economic disadvantages and learning from their perspectives, engaging students in a group community activism project, cooperation in creating an event that's explicitly focused on performing for peace, integrating open communication in all facets of working together (Eddy 1996). Students are also given reading from somatic philosophers – Don Hanlon Johnson, Seymour Kleinman, Thomas Hanna and social somatics experts Clyde Ford, Jill Green, Ray Schwartz, Carol Swann, among others. They are encouraged to engage in internships with schools, prisons (Llambellis n.d.), museums, clinics and specialized programs to work somatically with people who are the most in need (Fortin 2009; Fortin and Vanasse 2011; Johnson 1998; Roth 2005; Roth 2008; Sims 2014). Each of these social somatic activities served to promote community building as well. One faculty member models conflict transformation, and dynamic embodied group processing as well as leading workshops on white privilege and other related topics.

Struggles to achieve these goals included students feeling insecure with their recent somatic knowledge when being asked to share it (but then reporting confidence gained from the process of applying what they had learned about somatics and embodiment); adjusting to sub-cultures within the community of Oakland (e.g., sensitizing to the quiet of the somatic studio and then going out into the urban streets – finding appreciation for each); and somatic dance-making that goes beyond personal ritual and into content that is pertinent for the audience. It was of value to students to partner with other organizations, such as the Alice Arts Center (renamed Malonga Casquelord Center), Koncepts Cultural Gallery and local public schools, as well as the Museum of Children's Art (MOCHA) for teaching experiential anatomy as an inroad to somatic awareness. The MOC mission was buoyed by awareness of nearby social somatic work going on, for instance, with the department of Somatic Psychology at CIIS and their work with victims of torture, dialogues at John F. Kennedy University and the Lomi community clinic in Marin. Social somatics also works to tune in to emotions and enhance socio-emotional intelligence (Goleman 1995, 2009) known as EQ and is built upon with Theatre of the Oppressed workshops; in this way it contributes to conflict resolution and violence prevention.

Somatic Education as an Antidote to Injustice, Conflict, Violence and Trauma

Just as Vasconcellos espoused, many somatic movement professionals find that using a somatic approach builds self-esteem and self-worth. Engaging in somatic movement and dance can also lead to forms of activism that seek to establish equity and better relationships across competing groups (Jackiewicz 2015) or people dealing with stress and emotional trauma (Sieff 2015). Somatic movement expert and dance educator Nancy Beardall, CMA, chose to teach middle school students to regard the "body sense" and was encouraged by her principal to build a district-wide curriculum using kinesthetic and proprioceptive listening as a central premise in avoiding bad habits with food, drugs and relationships. This work also led to research to establish effective dialogues at school within and across gender (Eddy 1998; Beardall et al. 2007).

It is well known that stress is not the limit of negative experience in school cultures and in the public. A huge percentage of people have experienced trauma at home or in the world. Domestic violence, sexual abuse, psychological and physical abuse, head injuries, harassment and bullying are common concerns. There are many victims of war and torture, people with bodily traumas and diverse forms of post-traumatic stress disorder. Children come to school with developmental trauma disorders that may have begun in utero, in the birth process or in early infancy (Lamont 2014; Eddy 2007). Somatic education can be a baseline for healing, and social somatics includes both anti-violence and educational reform activism.

EmbodyPeace is one project that encourages people to engage in peace-making through the embodied arts, movement and body awareness (Heifitz 2005; Linden 2007; Eddy 2016). It gathers information about embodied movement practices that meet the objectives identified by the dissertation *The Role of Physical Activity in Educational Violence Prevention Programs for Youth*, an ethnographic cross-case analysis of six programs across the US (Eddy 1998). The objectives of programs were revealed to include: teaching self-control, increasing awareness of potential violence (with the goal to avoid or deflect it), developing the strength to stand up to injustice and violence and/or pointedly engaging in peace-making. Further findings included a set of emergent "tactics" used by excellent movement teachers. For instance, excellent teachers of embodied approaches to conflict resolution and violence prevention employ tactics such as holism, acceptance of complexity, sharing their own vulnerability and expression of feelings, providing synthesis at the end of a lesson or teachable moment and are respected for "being real" (Eddy 1998, 2010a). This research also provides a matrix of how to physically engage in violence prevention curricula in relationship to the curricular objectives.

Access to One's Own Power: Moving Forward with Somatics in Community

Dance, spirituality, research, environmental sustainability, social justice and visual perception may seem like unrelated topics. Yet, in the holistic model of somatic movement education and therapy and in somatic dance such as Contact Improvisation, they all connect. They weave together to contribute to more humane compassionate action (Ford 1993; Fraleigh 2015; Novack 1990; Williamson et al. 2014). Somatic wisdom fosters a depth of awareness in making personal, social and political decisions. It can also help to align with spiritual dimensions if desired.

If it is the job of each person to awaken to what is most supportive from within, individually and also for the community as a citizen of this planet, one can ask – "What is for the common good?" and "What beliefs support the common good?", "What environmental conditions allow a person to find truth and forgiveness in order to stop operating from bitterness or from the wounds received through experiences of derision and violence?" Trauma recovery through somatics embraces inclusion for all, and social somatics advocates for empowerment for all.

The stories of the lives of the somatic pioneers were meant to reinforce the view that there are multiple pathways for exploring the gift of being human and that bringing awareness to the physical body unpacks solutions for the body, the mind and the spirit. Further goals are to keep creativity streaming, inviting engagement with any of the somatic arts. Each person is capable of garnering the wisdom of the thinking body and moving mind. The somatic path can be a path that helps in identifying one's life purpose while also being a vehicle for sharing it. By embracing social somatics one can strengthen perceptions, self-awareness and efficiency and, in turn, have the energy to choose to build a stronger community of

thinkers, movers and activists to overcome injustices. Using somatic perception supports making informed and impassioned decisions.

Personal Practice and the Power of Conflict

In the domains of art-making and performance, somatic education can fuel the development of personal rituals, public forums for communication – participatory arts, as well as classical proscenium productions. Any of these events can communicate new possibilities and engage audiences to become more self-aware and more empathetic. Interpersonal conflict can be addressed somatically. Working within homogeneous communities or with people who hold diverse belief systems provides opportunities for growth by identifying issues and moving through them (Eddy 2010c; Heckler 1993, 1997, 2003; Mindell 1992). One model of embodying peace is the curriculum for Conflict Resolution through Movement and Dance, taught at the Dance Education Laboratory in New York City (Eddy 2016). It includes an array of strategies derived from the 1998 cross-case analysis of six expert teachers of violence prevention from throughout the US – New York (two sites), Los Angeles, Oakland, Chicago and suburban Boston. A key finding was that these expert movement educators used creative conflict resolution, holistic principles, inclusion and the provision of choices as baselines for their work with youth (Eddy 1998). These self-empowering tactics lend themselves well to somatic practices, and more somatic education has been introduced since the course's inception post-9/11 (Eddy 2010a, 2010c, forthcoming).

Moving *Out* from Within

The improvisational nature of somatic awareness and movement includes securing the ability to listen/watch, accept and share without judgment. With awareness of the politics of gender, race, disability, age, religion and cultures perceived through a somatic lens, one discovers more similarities than differences. New paradigms for living emerge, whereby personal authority lives hand in hand with social responsibility. Through somatics there is a new level of awareness and an appreciation of individuality infused into the community-led rituals and even the movement forms of antiquity. With social somatics, somatic systems that have been well known for at least a century take on a less provincial nature and extend globally in their impact. Ideally, there is also an honoring of what has existed for millennia and a desire to respectfully learn more from indigenous cultures. Social somatics teaches how to use activism to preserve indigenous wisdom and creativity and integrate it into the present.

A full interplay of somatic values can be quite exciting. These values include the freedom to make mistakes as long as one takes ownership for these moments of unawareness or ignorance; appreciation for support and interconnectedness with other humans as well as with the planet; social factors such as friendships within communities, based on common

humanistic concerns; intrinsic rewards from giving and receiving with compassion; and full-bodied joyfulness and humor among communities-in-the-making. These values quickly emerge when people gather to learn, dance, share healing, touch, and create together with mutual respect. Social somatics uses these values and tools *and* also includes active pursuits to rectify injustice and inequality, with awareness of the basic imbalances that result from haves and have nots – the politics of privilege. This empathy may also lead to caring for the earth, objects and the cosmos.

A subset of social somatics addresses a type of chronic, violent disregard for the needs and "feelings of the earth". Human neglect and human greed in harvesting the goods of the earth without concern for sustainability results in potentially catastrophic problems, as are being experienced from climate change. Somatic awareness of the body's need for breath and water can heighten one's concern about access to oxygen, the growing carbon footprint and a quickly changing water footprint (Marks 2001). In this way, somatic awareness extends through social somatics to "attuning with the needs of the earth", and to various forms of ecological actions based in health concerns; motivating people to act more sensitively toward themselves and the environment. Dozens of these cases of somatic movement and dance that strive to restore a healthy balance to the earth also experience an emergent connection to universal physical forces, and a subset of these leaders weave a spiritual component into their somatic movement paradigm. The next chapter speaks to these spiritual concerns.

A Review of Don Hanlon Johnson's Book *Everyday Hopes, Utopian Dreams* (first appearing in ISMETA News)

Don Hanlon Johnson has had to deal with injustices and some of his major lessons were in relationship to the land he was raised on.

In *Everyday Hopes, Utopian Dreams*, Don Hanlon Johnson asks: "What is *sane idealism*?" (2006). And he answers: "We know that when idealism is gone despair sets in. And yet when our idealisms remain disconnected with the earth we are left groping between a spare materialism and a fanatic utopianism."

"So how do we arrive at grounded idealism? There is no seven-point answer. How do we sort through what works?" Johnson, echoing the cross-cultural findings of Angeles Arrien's study of healing practices across cultures, points to the importance of answers through stories. He delves into the life of his own family. Recall that Alex Haley also encouraged everyone to reflect upon personal heritage and if at all possible interview elders and loved ones to reconnect with life's deeper meaning through family roots.

Johnson writes:

Sacramento was like a paradise. My father and grandfather built many of the original houses in this lush valley, which was like ancient Mesopotamia – farmers,

fresh chickens and eggs abounded. Dad hunted dinner. We had huge rivers and wetlands. There were also great contrasts in Sacramento – as expressed in the memoirs of Joan Didion and Richard Rodriguez who lived there. People come from all over – from Asia, poor people from everywhere. Sacramento is the 4th most diverse city in the nation. It was a lower class working town; we had bandits and other dark things [...] murder, theft, marginalization. The upper crust evolved over time, they were pioneers that worked at making a living, developed success stories, and helped to shape modest sorts of idealism. This is key – people worked at making a living, in their community. And today while great change is occurring that is damaging the valley, there are still families striving for the best – for instance the Lundbergs doing organic rice farming on a large scale – an industry that supports others, just like some of the dairy farmers there. This is in contrast to areas where you find people buying up land and hiring other people to run it.

His great-grandmother, his mother's mother, had been a Baptist and then became a proselytizing Jehovah's Witness, distributing the WatchTower on Sacramento street corners. His father never went to church but was just and fair; however, there was boredom in his life. Johnson notes that in not going beyond himself there was no vision. However his mother and *her* father were Irish Catholic and held the idea that only Catholics knew the full meaning of life. Their dogmatic beliefs were the foundation for the idealism in Hanlon Johnson's life. He experienced profound energy in that zealousness, despite its problematic judgmentalness that eventually led to his alienation from the Church. Today Johnson sees that people are returning to religion because life is too meaningless to give them the energy to survive its torments. Religious beliefs give meaning to life and from them idealism can stir. And yet these experiences remain compartmentalized and often divisive. He notes that people may live their lives thinking and acting as follows: now I will do this fitness exercise, now I will go to church; this compartmentalization happens over years and years. The somatic experience is an antidote to this deep-seated habit of separation.

"A seamless blend is a key" – Johnson sees this in his encounters with Japanese Shinto practices where there is a deep feeling for the body and the earth. Monks and teachers alike do rigorous practices of hiking in the hills as part of their spiritual practice, physicality is linked with spirituality. Somatic education is another entry to this seamless blend. For many, a blend of scientific inquiry, embodied education, caring about others, artistic expression, taking naps and eating well are among the necessary elements that define a somatic lifestyle (Eddy and Zak 2001; Lamont 2014). Read Hanlon Johnson to learn more.

Chapter 13

Somatic Dance and Environmental Activism: Is this Spirituality?

In an interview discussing the "Wisconsin Idea" Marcia Lloyd asks Joan Woodbury questions about what emerged from the dance program at the University of Madison under Margaret H'Doubler and the nature of their dance:

JW: I think it was the philosophy and maybe it was the sense of what is dance, why are you dancing, where is your psyche, where is your spirit when you're dancing? What's the spiritual side of dance? And it was a spiritual experience.

(Woodbury in Wilson et al. 2006: 102)

Beyond the body and mind, beyond emotions and thoughts, beyond matter and energy lies this domain of wholeness. It is a place of healing, for healing and wholeness are but different words (actually the same word, at root) for the same truth. It is also a realm of "spirit," when the meaning of that word is abstracted from its common religious interpretation. Spirit originally meant that which gives life, and this domain of wholeness is common ground for the diverse aspects that constitute living and being. We can touch this place of wholeness where body and mind, emotions and thought, matter and energy are given to us as one. We can touch this place where healing waters meet.

(Ford 1993: 202)

Rudolf Laban wrote decades ago "[...] but we must never forget that in our second innocence we shall not be striving toward fulfilment with a dancing body only but also with a dancing mind – which reveals in its spatial reality an exact counterpart of all the radiating patterns in the dance of electrons. Real space is not merely the interval between terrestrial bodies and objects but is, what scientists called 'empty space.' It is full of mysterious paths of motions and provides an inexhaustible field for research into motor activities such as is apparent in doing and dancing."

(Laban and Ullman 1984: 48)

The theory of evolution doesn't consider that genes mirror consciousness.

(Chopra and Tanzi: 251)

Before the earth there was space. We can enter into space, empty space, the center of that empty space, and embody it. There is space outside of us and within us, and when we enter space we can meet consciousness [Bainbridge Cohen].

(Eddy Interview 2015l)

Somatic movement experts, many of whom are dance educators, share with social somatics leaders the goal of expanding consciousness in diverse domains. This chapter addresses two directions evolving in the early twenty-first century – using somatic movement to appreciate nature and to protect against threats to the environment and locating the awakening of somatic movement awareness as transcendent. Many somatic educators find that one informs the other; for instance, dancing in nature with somatic awareness leads to both a desire to take care of the earth and a communion with something greater than oneself. The attunement with that which is greater than self may be defined as tackling life's mysteries through deep science or psychology or through what might be described as a relationship with the divine, or some combination of each. This chapter does not seek to categorize the transcendent experience in solely spiritual or religious contexts but to recognize its pluralities of form and meaning in multiple domains. One common ground for the "personal experience, searching for the sacred and connectedness" that Williamson (et al 2014: 164), cites as germaine to spiritual inquiry, Batson attributes to the "meta-kinesthetic" (Williamson et al. 230–233) – whereby one is simultaneously able to experience oneself from within and from outside of oneself. When engaged in meta-kinesthesia somatic movement joins other forms of contemplative and expressive dance that practice listening to "the subtle" (Ronald K. Brown, personal communication, 5 August 2015) and that link to systematic and embodied investigations of the great unknown. In some traditions engaging with the meta-kinesthetic while dancing could be called liturgical dance while for people not-aligned with religious beliefs it might simply be referred to as self-discovery. Moving alone or with others, in sacred space or in the outdoors also shape the quality of these investigations and how they are named (Olsen and McHose 2002; Ford 1989, 1993; Reeve 2014; Williamson 2010). To fully capture the inclusiveness of the meta-kinesthetic or transcendent nature of somatic dance the subfield has been named broadly as "dance, somatics and spiritualities" (Williamson et al. 2014; Leguizaman et al. n.d.; Williamson 2009, 2010). Another branch of somatic movement has come to be referred to as eco-somatics (Bauer 2008; Eddy 2006a; Enghauser 2007b).

Experts in somatic awareness support the importance of relaxed, non-effortful movement often in quiet as a baseline for action and as recuperation for well-being. Quiet contemplation is fuel for connecting to the universal and for activists strategizing and sustaining their activism over time. Mindful moving using somatic movement and dance explorations helps connect bodily awareness lessons to activities in everyday life as well as potentially intertwining contemplation and recuperation with activism. Somatic dance and movement activists also take their work out-of-doors. Once outside, somatic movement and dance in connection with nature can lead to moments that contain awe and a sense of great interconnectedness, which for some is a definition of spirituality. Most notably the shape

that this form of spirituality takes is rarely institutionalized. Millions of people are choosing not to align with religion on moral grounds given the history of faith-based conflict and injustice or because they choose to live in a consciousness of rationality and scientific inquiry. No matter what one's philosophical framework, spending personal somatic time (whether alone or in a group) celebrating the miracle of life by moving one's own human body with reverence is becoming important. This embodied appreciation of the gift of life forms a basis for glory, awe, love and joy within oneself and in relationship to others. Numerous somatic movement experts share that this type of experience is powerful in its ability to increase feelings of human empathy, helping to bond with "the other" – those with whom there has been conflict, those who are outside one's own kinship circles, and even with ideas and things that are unfamiliar, including the "great beyond."

While somatic pioneers have brilliantly shaped educational tools for exploring the body, it is also known (see Chapter 5) that powerful inroads to bodily wisdom have been passed down from generation to generation through a multitude of cultures. Some of these traditions have a spiritual or religious base. Somatic explorations are generally secular yet inclusive. What is shared is a morality of caring for self and others. Other social somatic tenets that link to both environmental activism and spirituality are: 1) the desire to honor how traditional health knowledge (often embedded in a spiritual philosophy) has impacted the development of somatic practices and 2) a concern about the post-colonial recognition of co-optation of indigenous healing practices and how to contend with it. As discussed in Chapter 12, the social somatic goal is to be respectful of both indigenous influences and the new directions that somatic investigations reveal.

In some people somatics involves a melding of spiritual or religious beliefs, in others an awe-inspiring somatic experience may be explained as opening up to perceptions through the left cerebral hemisphere or being receptive in the back of the brain – the sensory-cortex. Whatever the route, the experience of interconnectedness through somatic exploration is helping to shape conscious action in the domains of environmentalism, sustainability and community building.

Eco-Somatics Defined and One Take on Its History

Somatic education has become a powerful force in art-making and educational venues by adding to the cry for caring about people and the environment. Dancers are key players in advocating active engagement in re-envisioning our behavior in the world. Key proponents of the field of eco-somatics even before it was named as such were somatic dance educators Andrea Olsen and Caryn McHose together with Kevin Frank. Formative influences were the work of San Raphael in the development of eco-psychology, the research and writing of Jungian James Hillman, advocate Bill McKibben, activist Joanna Macy, and author Theodore Roszak. Further branches of this work include eco-therapy and specific practice forms such as Terra Dance cultivated by Peggy Vissicaro.

Eco-somatics as a term first emerged in the US circa 2008 with the convening of SEEDS: Somatic Experiments in Earth, Dance and Science, held at EarthDance, a residential somatic dance center steeped in the art of Contact Improvisation. Eddy first used the term in reflecting on the ongoing work of Anna Halprin's Circle the Earth, describing how the Life/Art Process became embedded in the Moving On Center (MOC) curriculum and was furthered through the work of Jamie McHugh and other environmental explorations created by the MOC faculty (Bauer 2008; Eddy 2006c). Meanwhile, Enghauser (2007a, 2007b) was using the term eco-listening to describe using "natural intelligence" and other perceptual paradigms that are used in ecology within the context of dance pedagogy. Eco-somatics refers to somatics applied to addressing environmental issues, but also serves as a call to attune with the earth or more specifically, to become aware of oneself participating with the natural environment. This philosophy stems from a strong sense of understanding as human beings living within an eco-system, and that the health of the earth is critical for human survival as well as for other animal and plant life. Sylvie Fortin (see Sparwasser et al. 2008), was an early proponent, using the term "eco-somatic" in contrast to "ego-somatic" to emphasize a shift from focus on self to focus on community and others. Eco-somatics frames the question: How does somatic awareness within the human body extend to the rest of our planet – the plants, the animals, the waterways, and to the built environment?

In teaching and interviews, Emile Conrad spoke passionately of how intense storms are being expressed in the behavior of water (floods). Fluid absorbs everything around it, water reflects everything else and the water absorbs the various elements going on. For example, an acid ocean has a direct effect on humans because "we are in a resonant stream." The connection between what is being expressed in the climate and what is going on with humans cannot be separated. Fluids in our planet, in our galaxy, in our body [...] all the fluids of different densities [...] are resonating with the galaxy. Conrad goes on to describe an analogy of water's relationship with people and with the galaxy as functioning similarly as the umbilical cord and the embryo, totally interdependent. She suggests self-empowerment as the solution for rebalancing our species inclusive identity. The planet speaks to us through movement. We don't need to have an opinion or answer but rather to participate, listen (to the "social body" as well), be quiet (as an antidote to the speed created by the light of electronics) and be open to the outcome and new pathways for self-regulation to help counteract our hybridization as humans (McNay 2013).

Laban's Movement Choirs and Environmental Action

There is already history within the fields of somatic education and dance somatics of getting large groups of dancers together outside to do simple but powerful dances about a social goal. Themes span from cultural values, work experiences to environmental concerns. The forms that these community participatory events have taken include Laban's movement choirs (Bradley 2008; Green 1986; Hodgson 2001; Hodgson and Preston-Dunlap 1990), Anna

Halprin's Planetary Dance (Halprin 1995; Ross 2009) and current movement events that incorporate different mixes of flash dancing, movement choirs and tableaus (Eddy 2011). At the SEEDS festival in 2008, eco-somatics and related curricula for teaching ecological concepts through somatic movement were presented by Martha Eddy, Melinda Buckwalter, SEEDS organizer and Feldenkrais practitioner Margit Gallander and Daniel Lepkoff. Prior to that Marylee Hardenburgh, CMA coordinated simultaneous site-specific dances for the public in seven cities along the Mississippi River, bringing awareness to the relatedness of these cities and their legacy with the river, as well as other site-specific pieces.

One type of flash-dance-movement-choir amalgam has been called EarthMobbing. In 2009 several students of Dynamic Embodiment infused information on environmental sustainability within movement choirs for the Bioneers conference in Ithaca, New York (Eddy 2011). Members of the team continue to lead movement choirs under the name EarthMob. The concept of helping bring awareness to ecological disasters through dance is not always considered positively. The following sarcastic statement "I am sure your flash mob will reverse the laws of physics" was in response to an invitation to join another mob protesting BP's response to their Gulf of Mexico disaster (Eddy 2011). This type of response has not deterred another growing movement concerned with the world's water ways. Global Water Dances (www.GlobalWaterDances.org) invites people around the world to gather for biennial world site-specific outdoor free dances. The choreographic structure is modeled after Laban's movement choirs. Groups of widely ranging sizes dance for awareness about their local water issues. On 25 June 2015, dancers and the public performed in more than 77 countries water concerns for the third time since 2011.

There has been debate as to whether performing in "movement choirs" results in diminishing one's individual self-expression, amplifying an experience of nihilism as performers dedicate themselves to a larger cause (Bradley 2008; Manning and Ruprecht 2012). A contemporary view of Laban's movement choir invites a dialogue between self expression and group cohension. With awareness of the popularity of flash mobs and the urgency of the physical and social need for help on our planet, it can be useful to capitalize on the joy and camaraderie of movement choirs. Elements that support successful community building include a high degree of inclusion – for instance, including the option for pedestrian movement and basic dance (with or without integration of virtuosic dance), the heterogeneity or homogeneity of the participants, costuming with pedestrian clothes instead of special clothes (keeping costs down), with or without messages delivered on them, orchestrating dances with either live or popular music depending on what is available, video documentation on either cell phones or cameras. And of course another key feature is the degree to which the event involves the audience, has no audience or surprises the local community into becoming the audience or even participants.

Another key theme in Laban Movement Analysis and its off-shoots – such as Body-Mind Centering, Dynamic Embodiment and Integrated Movement Studies – is learning to balance internal and external experience during any action. In Body-Mind Centering this is called the balance of inner and outer focus. This balance is core to activism and especially

to being aware of the environment. This balance involves being able to experience one's own cues of well-being or dis-regulation while also being active and caring in relationships with people, organizations, animals or the planet. Laban Movement Analyst, Suzi Tortora has been likened by Malcolm Gladwell (2006) to being a "child whisperer." This skill abounds amongst those who have focused on the developmental movement therapy branch of somatic movement. These concepts also apply to another branch – somatic movement experts work with both the healing of animals and the garnering of animal's healing energy for human benefit. Horses and dogs have been the key foci.

Body Conscious Design – Sustainable Aesthetics, Somatic in Style

Applications of somatic education and healthy lifestyles are also more present now in the built environment. People are designing shoes, chairs, desks and buildings with the body and ecology in mind. "Body conscious design" is a term coined by Galen Cranz, PhD, who is also an Alexander Teacher and avid student of BMC. Her book *The Chair* (1998) is at the heart of numerous public discussions (LinkedIn). BodyConsciousDesign has an online global community through social media (www.BodyConsciousDesign.com). The major tenets of this field are joining the goals of comfort, ergonomics, aesthetics and sustainability. These values impact on the processes in manufacturing, sales and design.

It can be posited that these goals of sustainability and healthy living can emerge from dancing with others as well as from dancing outside. This was the case in the Labor Day celebrations in the 1920s in Germany and with the Laban's movement choirs at Ascona, Switzerland. Moving in nature can also evoke spiritual feelings, as in practicing yoga out of doors or dancing with sensitivity for the earth, and has been done across global cultures for eons (McHose and Frank 2006; Olsen and McHose 2002; Williamson et al. 2014). This connection to nature sometimes becomes a celebration of the universal.

Shared Cultural Values Supports Somatic Development: Where Indigenous and Somatic Converge

Attuning with nature and natural forces is an age-old practice. Ancient philosophies and modern-day indigenous cultures value a holistic paradigm inclusive of spirit. The traditions around this body-mind-spirit connection were guided by "group consciousness" but often led by curanderas, yogis and shamans. Today this group consciousness is not easy to find; conditions for somatic awareness are no longer commonly present in the culture at large, whether one is religious or atheist. Shared rituals of engagement certainly help. These are most often found in places of worship however there is a trend to build ecumenical centers for expression of communal experiences of contemplation, awe and connectedness internally and with a positive moral compass (Loos 2015). Somatic inquiry would allow

all people across race, class and culture to find the biological and anatomical truths that are shared. Another feature is that people may report spiritual moments, some who are not professing any religion and others who explore and share within an interfaith context tolerating beliefs from diverse communities of social and environmental justice (Loos 2015). The somatic community shares methods that can be ritualized in secular or religious contexts. This includes rituals passed down through the millennia.

The adaptation or sourcing of somatic experiences from age-old practices raises the question: Is somatic education a rebranding or even a co-optation of the holistic models that already exist from ancient traditions? It is the intention of this book to honor ancient movement forms – yoga, tai chi, chi kung, kung fun – as being our antecedents and as practices that trace back thousands of years and stand independent from somatic education. Somatic education was informed by yoga and chi kung, but it is not the same as either of these practices. There are, of course, overlaps. And there are more and more people teaching these forms from a somatic perspective. Teaching the traditional movement forms together with the somatic tenets of the importance of self-authority and listening to body cues using sensitive touch and verbal feedback may be the "millennial approach" to indigenous celebration. What is also interesting is that western somatic practitioners are being invited to Asia to train dance educators, therapists and psychologists. One specific example is advising on themes such as the conscious experience of feeling "center" (Eddy 2002c). Another is how to find one's own creative impulse or the process of sensitizing to each member of a group while maintaining the integrated experience and importance of the group itself (Eddy 2015). These skills are discussed and whenever possible explored within the context of dance, theater, sciences and the humanities.

The process of attending to self and also communing and caring for others extends to caring for the earth. One direct link is that of breathing. As somatic work is so fully rooted in allowing for fuller more relaxed breathing and in particular deepening the exhalation – people are reminded that the process of exhaling is humanity's gift back to plant life. The interdependency between humans and plants is experienced through this nurturing exchange and can extend to other physiological functions as well (Eddy Interview with Bainbridge Cohen 2015).

These experiences of embodied empathy extend to the experience of interconnectedness. For some this has been an entrance into the numinous or the liminal – the overlapping domains of appreciating the sacredness of life, celebrating connection and recognizing how little is known about life. This can lead to a somatic dance that focuses on celebration of or investigation into the realms of the mysterious, the unknown.

Somatic Inquiry as a Link to Spiritual Inquiry

All humans have bodies. Bringing new levels of awareness to the shared experience of being human ironically allows for individuality. Somatic awareness is layered with an identity as a new paradigm that also has respect for age-old wisdom and, traditional movement forms from varying countries and time periods. Most somatic practitioners honor that which

has been "well known for ages," recognizing the likenesses to the perceptual experience of being in the present. By including direct connections with indigenous cultures and traditional practices in the teaching of somatic practices, stronger networks can be built. Often the practical questions that emerge from somatic investigation address moral issues. This morality can be linked to religion or spirituality or remain humanistic. In other words, beliefs are often related to cosmologies or a moral code. These are part of religious, ethical and spiritual standards, variable for each person or sub-group. Somatic awareness can be infused into these, become a connecting force in interfaith events or serve as inspiration for new brands of humanistic gatherings that exist apart from religion.

Somatic education can introduce or deepen an experience of immanence, lead to spiritual practice or simply be "connecting" and rejuvenating. The following list takes Eddy's core somatic concepts and shows how they can link to contemplation, listening to the "subtle", exercising the "moving mind" (Chopra 2015), attuning with the divine or, in physiological terms, registering experience through the right brain (Taylor 2008).

1. Slowing down and breathing are quintessential features of meditation; to "feel" the nostrils, the belly, the movement of air within and without through attunement with the breath is celebration of the body, which can be a sacred act.
2. Letting go of bodily tension makes palpable the maxim "let go and let god."
3. Connecting to "to the universe" or universal energy can occur through the somatic experience of carefully aligning the body with three-dimensional space and feeling the expansiveness of this alignment in all three cardinal directions (up and down, side to side and forward and back).
4. Enacting novel or "renewed" movement from the first year of life (the neuro-developmental movement patterns of rolling, crawling, sitting, creeping, cruising and walking) is akin to living from a philosophy that connects all humans and animals to each other.

Over the past decade, small and large, private and public somatic dance trainings that engage the living body, the soma, in art, education and health are reporting a spiritual component in their research, journals and books. Indeed, a new journal was launched – *Dance, Movement and Spiritualities* – as well as a book by a similar title and inclusive of somatic inquiry published (Williamson et al.) in 2014.

Somatic Dance and Spiritualities

Yoga sets the stage for somatic consciousness and mindful movement. It also provides reminders to beware of authoritarianism in teachers and schools of thought. Recall that a baseline for all somatic education is the empowerment that results from discovering or being guided to experience that one's own body has wisdom. In particular, alertness to body

sensations supports self-regulation and healing. This message is not always the case in the yoga or spiritual communities. There are indeed still cases of sexual and psychic abuse by leaders in power within ashrams, and other spiritual communities, just as there are within the Catholic and Episcopal Church. Yoga is one movement system that shows how the body can be part of one's spiritual practice, emphasizing the value of treating the body as sacred. The body as the temple for the soul/spirit/psyche/creative self can be a secular, spiritual or religious construct. What is important is the idea of having reverence for the body and the gift of being alive. Choosing to engage in somatic education is choosing to appreciate the soma – the living, conscious experience of being alive and embodied, no matter what the limitations of our physical bodies may be.

The rise of yoga in the West between 1960 and 2000 has actually set the conditions for more belief and access to somatic thinking and activity. As yoga, especially secular yoga, has become popular, more people are 1) paying attention to their bodies, 2) recognizing there is a body-mind connection and 3) creating environments for contemplation through movement. This has helped people wake up to their bodies and to the body-mind-spirit connection. However, each of these conditions that support somatic exploration does not make yoga necessarily somatic.

If the yoga teacher shares the values or has experienced and absorbed the somatic tenets of guiding students to follow their own sensations, she or he may be aligned consciously or unconsciously with a somatic model. However, yoga can be taught in an authoritarian style with directives to do as the guru or teacher commands, with a belief that the guru has greater knowledge of the student's needs than does the student.

This range of style begs the question, "When is it appropriate for a teacher to take the lead with a student and tell them what to do?" Some teachers are so highly attuned that they have profound insight into another person's experience; this is the aim of a good somatic movement professional as well. Nonetheless, it is the somatic norm to ask a student to listen to her or his own experience. This is safer, since not every teacher has an ability, the gift or the skills to attune to others; nor do they have the right to order someone else to do something. While there is much beauty in surrendering to that which is greater than oneself the somatic model is foremost one of self-empowerment – reminding everyone to follow their own guts. A common somatic model is to inquire and dialogue about experience. It is the common tendency amongst teachers/leaders to generalize about an entire class or group, or make assumptions about students, or to pass down decrees or mandates that may have led to the sentiments of Anna Halprin stated in Chapter 3, "I don't know enough about yoga. I wonder if awareness is part of yoga? It is often so dogmatic."

Whether yoga classes are led by leaders who dictate what should be done by every member of the group or who pressure students to stretch a little more or behave in a certain way, the fact that thousands of people are willing to take a part of their day to lie down on the floor, attune with their breath and move their bodies is a *huge* step toward mindful movement, providing an inroad to somatic practice. Injuries that, ironically, often happen in yoga classes are another motivator for approaching yoga more somatically.

Many modern-day yoga classes encourage people to do activity outside of their range, and do so in large groups with teachers who may only be briefly trained in anatomy, kinesiology and touch practices. If teachers are either pushing students to go beyond their limits or not directing students to pay attention to their own sensations, it is easy for the students to become injured. People with yoga injuries, post physical therapy, are beginning to make their way into somatic education as recourse for healing.

Another facet of yogic practice is that of seva and service. Learning to give freely and to serve others is important to consciousness and moral growth. Working to balance emotions to invite more gratitude, caring, love and appreciation of awe, wonder and beauty also contribute. These tenets find their way into somatic studies to varying degrees in different somatic traditions. Those that include elements of contemplation often also include a component of being generous toward others in need.

Mindfulness, Movement and Meditation

Mindful movement is being present whilst moving. It is aligned with "mindfulness" but does not require the practice of Buddhist or other forms of meditation per se. The secular form of mindfulness developed by Jon Kabat-Zinn at the University of Massachusetts Medical Center in 1979 has become the baseline for Mindfulness-Based Stress Reduction programs applied throughout the world in diverse educational, health, community and activist settings (Kabat-Zinn 2003; Kaparo 2012; *Psychology Today* 2015).

Somatic exploration requires deep presence and is equivalent to mindfulness if one does not become preoccupied or judgemental of one's bodily sensations. Meditation practice can make somatic awareness much easier, and the reverse is also true. Many people are unable to sit still comfortably for either physical or mental reasons; engaging in somatic work as a mindful movement practice is another inroad into comfortable, seated meditation. If the body softens and stretches and the mind calms down as a result of somatic practices, a sitting or still meditation practice can also become easier. Movement and attention can also be improved by a mindfulness practice.

Kee et al. (2012) sought to determine if young men's ability to balance on one leg would improve with a brief intervention in mindfulness. The question was whether they could increase their ability to pay attention and negotiate their weight while on a force plate that was recording postural changes. They screened the study subjects for a pre-disposition to mindfulness and they also introduced mindfulness in a one-session activity. Their findings indicated that brief mindful attention can benefit postural control and balance performance as well as positively affect the use of attentional focus strategies during movement. This study is included to reinforce that mindfulness not only increases mental awareness but also can increase physical performance. It further supports the notion that somatic awareness and mindfulness are interrelated in their ability to impact movement–action.

Spiritualities, Somatic Dance and Movement: Does Somatic Movement Link to Spirituality?

Dance and spirituality has a strong link to the arena of somatics and spirituality. In somatic classes and in some dance classes the sacredness of being human and of being an inhabitant of the earth is related to rituals of thanksgiving, appreciation, surrender, supplication and faith-based activism. Amanda Williamson has been a major spokesperson for naming the many trajectories of these vast realms and growth of this field, having published widely on the topic (Williamson 2009, 2010; Williamson et al. 2014; Williamson and Hayes 2014).

Beliefs are often related to cosmologies or a moral code. These are part of religious, ethical and spiritual standards, variable for each person or community. Somatic education can be an inroad to a three-dimensional spirituality where there is a "seamless blend" of life practices supported by the "truth" or personal integrity of inner life. If the intent of spiritual practice is humanistic, it can engage communication across individual and group differences to foster the continuation of goodness in humanity. This model can be a force for seeing human power freshly; the power of conscious interdependency vs. ownership and dominance. This basic belief can have a potent effect in all domains of human behavior.

F. M. Alexander's work has been compared with "practical eastern spiritual philosophies" (Johnson 1995: 88). His niece Marjory Barlow shares many of his principles through the lens of eastern spiritual traditions. She quotes him as saying, "I believe in everything and I believe in nothing." And she goes on to say "To me, he was the most religious person, in the real sense, of anybody I have ever met" (Johnson 1995: 88). For Dewey and pragmatists such as Alexander there is an echo to constructs from other cultures: Thought and action are inseparable; therefore, the mind cannot be located in a specific place, but is everywhere in the body. The implication of this position is that human behavior cannot and must not be subdivided into bits and pieces. We think and act as total, unified organisms. Therefore, our approach to teaching and learning should reflect this (Goldberg 2001).

Kleinman said:

For me, spirituality has emerged in my teaching and writing because it's "in the air," and, more so than ever, has become dramatically immersed in the culture in the past decade. It's become visible in a variety of ways, both constructive and destructive – from religious fundamentalism and ethnic cleansing to religious studies and scholarship in academia. And, of course, as a Somaticist, the union of body/mind/spirit is a given.

(Eddy Interview 2004c)

In 2005 *Somatic Magazine* published "Spirituality at School", an article originally written in 1995. To quote: "Finally, Spirituality is out of the closet. But can it be 'out' at school?"

(Eddy, 1995; Eddy 2006c; Eddy et al. 2014). Various issues still stand from that initial inquiry: If a school relies on government funding – what about separation of church and state? More and more educators are looking to educate holistically without imposing dogma, or imposing models, forms, rituals or beliefs. They also encounter, intentionally or not, the reality that education about the living, conscious body – the soma – seems to also invoke spirit.

Spiritualities within a Somatic School

At MOC relationships to the movement of *ruach* (the Hebrew word for spirit, breath and wind) found its place, idiosyncratically – changing form each year. The co-directors, Carol Swann, Jon Weaver and Martha Eddy, "rather quietly acknowledged our acceptance of spirit moving" as a part of individual beliefs but did not establish these into the program's somatic curriculum (Eddy 2005). First of all, the experiences were quite different for each of faculty member. Secondly, the intention of the school "focuses on the participatory and evolutionary, if you will" (Eddy 2005). Observation, and then waiting for what emerges, leads the inquiry, along with improvisation. Aside from a small question in the application "What is your experience with body-mind-spirit intensive trainings" no reference is made to spiritual practice in the promotional literature. Students arrive to learn about the body, how to enter their bodies through somatic dialogues and find and activate personal and cultural wisdom. They seek to learn how to share this wisdom through performance, movement education and in therapeutic settings.

In the original article "Spirituality at School," Eddy (1995c) shares that:

> The year begins and anatomy is taught, somatic practice begins, hands are laid on, and dancing emerges from hearts, legs, fluids, consciousness. There is singing, lots of singing – spirituals, songs from around the world, and utterances from within. These songs reveal the group's reach, both inward and outward. The assignments provide structure for these revelations. A few activities provide further wind, blowing on the doors just a bit more: Assignment One is to go off into nature and meditate – contrasting the experience of contemplation in stillness with contemplation in movement. Each person records their experiences as they like – through dance, poetry, essays and statements. Conversations about these experiences emerge intermittently. Students report back that these contemplative moments at the beginning of the year "set the tone" for culminating projects they pursued at the end of the year.

Authentic Movement is introduced in the MOC "spirituality at school" example. It is the process of moving from within (originally with eyes closed) with another person as witness. The mover speaks first and then the witness shares in a truthful yet compassionate manner. This is not easy and takes practice. It can also include speaking with "I statements" or with

Hakomi "contact statements." The core of MOC's somatic work is driven home with repeated reminders that the school moves away from negative judgment toward acknowledgment and acceptance – allowing, observing, being-with. Criticism is given but is given using creative models from Liz Lerman (2008) and Robert Ellis Dunn (Eddy 1997). Day after day the skill of opening up to options and checking in with bodily experience to confirm choices is practiced. Performances, rich with stories of the body's revelations, song, music and tales of healing, are a regular part of the daily interchange. Even visitors are steeped in soma fullness – as audience members, volunteers, clients or witnesses. Each of these engagements invoke more than the body, the mind or the spirit separately. It is a wholesome shake-up, often full of laughter that integrates feelings with thoughts and action (Eddy 1996, 2006c). Ten years later, training programs in nations across the globe are blossoming with thousands of such stories emanating from diverse members of the student body within training centers, colleges and universities.

Awaken Sensation and Feeling; Motivate Activism

Emotional feelings can be the drivers for activism, and being pain-free can enhance the ability to act more effectively. Joyfulness and shared experience of happiness and humor fuel activism and even helps to heal vicarious traumatization. The professional and caring exchange of touch does so as well.

Through embodied experiences of holism, people can become more comfortable with the vulnerabilities and imperfections of the body, the outrage and outcries of emotions and the insights of spirit. Weaving dance and movement back into the social fabric supports this process of embodied empowerment.

Inside *Selected Readings in Participatory Arts – Studies of the Body, Somatics, Culture, Creativity, Dance, Movement and Social Action* – a course pack for MOC published in 1995, there are slips of papers with comments by Rev. Eddy, a Congregational minister.[1] The first page begins with a list of words – new vocabulary to be defined: "movement therapist, somatic movement therapy, tissue types, somatic, cybernetics, soma."

And at the bottom of the page is written [...]

Soma – I need a definition. I have known since the 1940s, early 50s that we creatures are mind, body, emotions, soul and that our unity as part of creation is in the worship of Spirit and the loving of our neighbours as ourselves. Is this "soma"?

(Norman Eddy 1997)

In another document called "The Great Spirit, Chi and the Teachings of Jesus," Rev. Eddy muses:

> Recently I was talking with my two grandchildren about the Spirit. A memory from my school days when I was eight or nine suddenly came to mind. We were told that the American Indians believed in the Great Spirit. I immediately understood it to be the positive force in all of life, all creation. I believed in it. This belief had nothing to do with Christianity or the Bible, or church teachings.
>
> Then two weeks ago I read essays about "Chi" given to me by an acupuncturist who is both treating and educating me. This ancient Chinese concept which teaches the universality of the positive energy that flows through the whole body and the whole being struck me as being akin to the Great Spirit.
>
> As I have been reflecting on my own experiences of the Spirit ever since my amazing hour on the road to Damascus in Syria in 1943, I see, once more, the universality of the Spirit. Certainly "Chi" came before Christ. I don't know how long ago the American Indians experienced and believe in the Great Spirit; certainly long before they had heard of Christianity.
>
> I have always been drawn to people who know the Spirit and to others who manifest the Spirit of love, of truth, of beauty, of openness to all total humanity by their lives but who in their commendable rational search for truth are in conflict with much of the phoniness, and often the injustices of the churches and their Bible teaching and theology. I often agree with them.
>
> The challenge, for me, is to try to help such people learn that "chi" is already working through them, that the Great Spirit is universal, and that Jesus's teaching about the Spirit coincide with and enrich these two.
>
> (Norman Eddy 2002: 1–2)

Figures 30–31: (top) Emilie Conrad. Photo credit: Jamie McHugh; (bottom) Montage of classes taken by Sondra Fraleigh (pictured in bottom right image). Courtesy of EastWest Somatics.

Note

1 More can be found about Reverend Eddy in Chapter 11, "I Can't Get the Movie *Selma* Out of Me" or https://www.youtube.com/watch?v=6sX-zjVMWB4.

Chapter 14

Concluding Thoughts: Does Somatic Awareness Interplay with Genetics, Ecstasy and Space?

Concluding Thoughts: Does Somatic Awareness Interplay with Genetics, Ecstasy and Space?

Judyth Weaver speaking of Heinrich Jacoby, musician and educator, who worked with Elsa Gindler beginning in 1925:

> His aim was to diminish the gap between knowing and being; to think on the basis of having experience instead of the basis of what has been thought.
>
> (Weaver 2014)

> One of my favorite lines from *The Art of War* by Sun Tzu, an ancient manual for dealing effectively with conflict in war, business, and throughout life, is "Attain both hard and soft." To me, this means that in any given moment we need the ability to be firm and simultaneously the ability to be gentle. This can be challenging but Martin Luther King Jr. offered us an example of holding hard and soft together. He pointed out that love without power is ineffectual, and power without love is destructive.
>
> When human beings combine these qualities they're drawing on their innate mindfulness, awareness, and kindness. And neuroscience is starting to prove that all of these can be cultivated in greater measure, giving us an increased capability to approach our problems and challenges with nuance and awareness of the whole picture, the perspectives of other people and the unfolding patterns that allow us to be insightful about dangers and opportunities that lie ahead. [...] We can't determine exactly what the future will be, what tomorrow will bring, what the next moment will bring, but we can determine how we will be in our body and mind, whatever may come.
>
> (Ryan 2012: 169–170)

This chapter re-contextualizes the contents of this book using the framework of ongoing questions, controversies and new trajectories (such as epigenetics, ecstatic dance and time-space exploration) that are circulating in these times, and relating them to the somatic arts. It also comments on specific controversies that exist regarding somatic education today, such as: does somatic education need to exist at all? Is the term *somatic* helpful? Are somatic movement educators doing meaningful work and is the field growing? Why are somatic movement or dance practices not as popularized as ecstatic dance or yoga? Does somatic education have a viable presence in the mainstream healthcare, arts and/or fitness industry?

Should it? Are there accepted types of somatic research? If so, how are their findings being used? Is somatic movement terminology understandable and contributing to the growth of the field? What is useful about the somatic arts today? How does somatic dance continue to inform this inquiry?

Chapters 1–13 demonstrated that somatic movement paradigms and practices have been useful to individuals, have informed cultural trends that began in the twentieth century, and are continuing today in diverse domains. It hypothesizes that both the philosophy and practice of the somatic arts are both still needed and that this is true even if the concept of the integrated body and mind has become assumed (and can be taken for granted) in cultures across the world. If somatic awareness has become mainstream, does it still need to be taught? This list suggests several matters speak to the nascent status of somatic movement and the need for its continuance in order to prove its value:

1. *Multiple Applications.* The somatic arts as applied in everyday life, dance, fitness, theatre, music, education, health, neuroscience, research, organizational management, community organizing and more are actually thriving and are being reported to be compelling tools for bringing people together to improve upon the skill of listening to sensory, perceptual and expressive capacities. It is postulated that this awareness heightens well-being and that this could be available at low cost to many more people.

2. *Dealing with Stress and Trauma.* Attention to the living body through somatic movement as applied to expression and action can guide individuals to safety through past or present experiences of stress, distress and trauma (Shafir 2015). It can even be helpful for whole communities during times of conflict or war (Eddy 2001a, 2010b, 2010c; LeBaron et al. 2013).

3. *Community Activism.* The nature of dialogue in groups can be shaped to provide somatic awareness as an on-going support for environmental awareness and action, guiding a balanced and sustainable process of taking humanistic and equitable action in the world. Somatic education can contribute to the care of others within one's educational group as well as extend to "others" – groups that represent different values, cultures and disciplines. The outcome of these dialogues can also be an embodied way of working toward creative solutions for resolving disparities of resources (e.g., healthcare, access to water, the protection of oxygen sources and the affordable distribution of healthy food) (Hardenburgh et al. 2016).

4. *Joy, Connectedness and Resiliency.* Somatic practices can also be fun, bring joy and establish interpersonal and transcendent connections (Albert, Eddy and Suggs 2013; Brodie and Lobel 2012; Williamson 2009; Trager and Guadagno 1987).

The human stories of the somatic pioneers inspire and reinforce the view that there are multiple pathways for exploring the gift of the conscious and moving human body. Further directives are to keep dancing, or at least moving with awareness. The invitation is to garner the wisdom of the thinking body and moving mind. Numerous vantage points suggest that

the somatic methods of moving mindfully not only supply pathways for identifying one's bodily capacity, but also may guide discovery of one's life purpose, or at least an experience of connectedness with others and with the awe of being a sensing and feeling human being. The somatic arts provide vehicles for sharing both "functional movement" and expression. This creative space opens us to both the "felt sense" and "imagination", combining to discover "the possible" (Greene 1995). While in the final decade of her life Maxine Greene investigated the somatic arts, recognizing its challenges for an activist intellectual. Even in her eighties she found it difficult to turn off technology to attend within, even though she cognitively understood its merits, saying "this process of listening to the body that you are trying to teach me is what it means to be an existentialist" (Eddy Interview 2006). Her understanding was such that whenever she could she mentioned the importance of movement and dance as inroads to creativity and conscious action towards equity.

There are various reasons for needing somatic awareness and education to become visibly and audibly stronger. Why? Narratives and case studies have demonstrated hundreds if not thousands of positive scenarios brought about through somatic awareness. While not all somatic education experiences may be as "miraculous" as those of the pioneers, people report relief with just one session, even after suffering for months and having received the most expensive medical interventions. However, scientific investigations are not easily designed to address how somatic practices are contributing to global issues (White House Commission On Complementary and Alternative Medicine 2002) and commercial endeavors show mixed favor for somatic inquiry.

The somatic field is growing active in diverse everyday arenas. Yet its very existence is sometimes questioned. This may be because somatic education, full of philosophical ideas that run counter to mainstream commercialism, need to be more visible, more researched, better articulated and better understood.

This chapter is a call to action, and preferably *conscious action*. It is time to devise research, and research methodologies, as well as educational processes that help people better understand and regard relevant applications of somatics and the process of embodiment. Research is needed to substantiate somatic education's claims of success. To help shape research, scholars, practitioners and lay people all need to support the development and understanding of somatic terminology; finding the language that best communicates what is often sub-cortical, non-verbal. To do this across academic disciplines and workplace domains, somatic scholarship and application needs to continue to expand.

Somatic Education Is Growing

It is exciting to report that the work of the first generation somatic pioneers is alive and well. All are strong in the Americas and Europe. Only Gerda Alexander's work (GAE) was less known in the Americas in the 1970s to 1990s but now is also growing in its familiarity worldwide. Ideokinesis, the most disparate of the systems, with no professional association,

headquarters or school, is beginning new training programs, and more Ideokinetic books (Matt 1973, 1993, 2014), and films (Rolland 1984, 2008). The second generation is also having profound influence in the world. Anna Halprin is dancing at age 95 and using social media to draw an international audience to celebrate with her. Elaine Summer's legacy continues in inter-media formats and through her protégés and their research (Green 2002, 2006). Emilie Conrad has also recently passed on (see Appendix 2), but her work is linked to universities and her video interviews are watched daily. Bonnie Bainbridge Cohen's graduates have started numerous training programs, and certification level BMC work is being taught in the US, UK and Central Europe in diverse formats with applications to yoga and work with babies.

As the field of somatics grows, there are also people delving into the global roots of the work. Amongst these educators are some historians who are returning to the wisdom of the originating forces. For instance, research is being done on Katsugen Undo and its impact is being felt in Europe. Aspects of the Movement Cure are resurrecting – both in publications and in education. Steiner's influence is strong in Waldorf schools and these schools are growing. Other schools continue to teach movement education based in Rhythms and rhythmic movement. Delsarte's views of rhythm are being researched by French and Swiss educators with an eye on best practices in education, asking "How is movement rhythm helpful to a child's physical, cognitive and emotional development?". Dalcroze's Eurhythmics continues to be taught. Offshoots of Eurhythmy such as Spacial Dynamics® demonstrate the power of using space to align the body and mind. This spatial awareness is also central to Body-Mind Centering, Dynamic Embodiment and Integrated Movement Studies as they are all steeped in Laban Movement Analysis. Just as Gregg Lizenberry, CMA resurrected his dance career post-injury by studying with Irmgard Bartenieff, people continue to be transformed or surprised by some of the newer somatic amalgam methods or from doing their own "somatic research." Roberto Villanueva of Dance Theater of Harlem was able to name his own self-healing process as somatic after taking a BodyMind Dancing workshop in 2015 sponsored by the Joyce Dance Theater in New York City. Benita Cantieni has investigated her own scoliosis and developed a method to heal spinal imbalance using awareness and movement. Thousands of these examples exist.

Applications of Somatic Awareness in Everyday Life

Humans have awareness and choice. In order to critique both historical and prevailing modern-day beliefs the ongoing conviction of somatic educators is that through mindfulness of bodily experience any human can discover new attitudes, behaviors or responses. With somatic awareness one is more equipped to "intuit" what is needed in the present moment. Somatic wisdom fosters a depth of awareness in making personal, social and political decisions. For some this is akin to aligning with cosmic or spiritual dimensions when making life choices, for others it is a rarified experience of right-brainedness. In somatic parlance it may be reframed as "connectedness".

The work of Conrad and Bainbridge Cohen supports the experience of finding the universality of being human through relating to all aspects of the soma. This extends to feeling connected to an overall human culture or tribe; an awareness that does not necessarily negate the unique manifestations of personal and group embodiment in our socially constructed lives. However, aligning with the natural includes acknowledging our place as animals as well as the responsibility as humans to use our capacity for consciousness. Access to somatic awareness helps defy the myth that what is animal or "primitive" is lesser, and allows humans to relate to one another apart from race, class, ability or ethnicity. Somatic dance teachers guide experiences that allow people to understand their patterns, and also to ideally track students' participation. In more intimate sessions the teacher acts as a student's guide, shaping lessons that meet her or his specific needs and goals. Different somatic systems exist on a range – providing more or less structured interventions, more improvisation or more technique, more exploration time or more protocols. Each person has the right to determine which practice is best suited for her or himself. Having familiarity with the different somatic systems and their stylistic differences (Knaster 1996; Allison, 1999; Chrisman 2005; Brodie and Lobel 2004; Eddy forthcoming) leads to informed decisions. Children can make these decisions too. Sometimes they are too exhausted or overstimulated to connect with their self-regulatory or somatic capacity (Bainbridge Cohen and Mills 1980; Bainbridge Cohen 1993; Eddy 2007; Morgan 2007). They need the support of a welcoming environment both in place and personage.

Somatic Movement and Dance: An Existential Question

Fortin's challenge: Does somatics need to exist? Is it important today in dance?

As far back as 1991 Sylvie Fortin astutely raised the question as to whether somatic education needs to exist any more, especially in the field of dance. Contemporary dance is completely infused with somatic philosophy (listen to your body, adjust the movement accordingly, do not be judgmental, experience what is), as is much yoga, fitness, body and energy work. Most universities and many progressive dance studios include a somatic component, especially within modern dance, composition and improvisation classes (Eddy forthcoming). Now teachers of contemporary ballet are using somatic imagery in class, starting on the floor with a somatic approach to Floor Barre®, or integrating Bartenieff Fundamentals into class (e.g. Collette Barry – Bartenieff's patient; Jackie Villamil CMA, Tessa Chandler – Feldenkrais; Augusta Moore – Body-Mind Centering; Barbara Forbes – Feldenkrais; Amy Miller – Release-Based). Applications of specific somatic movement pedagogy to dance includes principles from Alexander, Bartenieff, BMC, Feldenkrais, Ideokinesis, Rolf Movement, Skinner Releasing, Todd and an assortment of Release Techniques. The writings of Gilmore, Nettl-Fiol and Vanier, Hackney, Franklin, Fortin et al.,

and numerous others are filled with these connections. There are also DVDs supporting somatic awareness (Kosminsky and Caplan 2000; Albert et al. 2013). Improvisational forms are particularly acculturated to a somatic mindset. The growth of Contact Improvisation and of improvisational scores as a basis for performance supports somatic thinking (Novack 1990; Halprin 1995; Ross 2007). Multi-media performance heightens sensory experience, as seen in Elaine Summers' projects, and Steve Paxton's 2016 collaboration with Robert Ashley, *Quicksand*. No See-Um Dance blindfolds the audience to heighten kinesthetic and auditory awareness.

Indeed, dance so naturally begs us to pay attention to our bodies that it is hard to believe dance classes can be taught without this awareness. However, a simple look at western cultural commercialism will find that many dance schools and forms of dance commerce still focus on the external look of the dancing, the competition and the role of dance in pleasing others. While the externalized aesthetic and desire to please others are not necessarily bad in and of themselves, related dance preparations for this form of commercial dance typically leave out education in self-care and certainly the power of listening within. Somatic tools can shift the body from being experienced as an instrument to being a powerful expressive vehicle for self-advocacy. How exactly professional dance practices can be better infused with somatic awareness is the topic of another book (Eddy forthcoming).

For instance, in modern dance the current trend is simply to refer to those dance styles that have a somatic base as contemporary dance. The notion is that every contemporary dance lesson or performance is somatic. It remains to be seen if this is actually the case. Some people teach a release-based movement vocabulary in an authoritative way or without conveying any somatic tenets – self-regulation, slowing down to center or heal, embodying three-dimensional space with breath support etc.

In the US, the National Dance Education Organization has had a hard time finding a place to represent somatics as a separate strand. As it turns out, about one-fifth of all national presentations at the national conference make reference to somatics in general or a somatic system. What is still evident however is that even more presenters use somatic ideas but don't know their sources. The growth of a literary base for this work through publications like the *Journal of Dance & Somatic Practices* and the journal of *Dance, Movement & Spiritualities* will ideally help to rectify this.

Also of interest is the number and type of courses offered by the academy. A survey done in preparation for the publication of this book and a related manuscript found that university arts courses such as Body Wisdom, Conditioning and Wellness, Movement and Body Awareness, Survey of Somatics, Embodied Anatomy, Movement Retraining, The Dancer's Body, Movement Analysis, Somatics and Dance are growing, not subsiding, in number.

The somatic process of finding time and valuing the slowing down process continues to be hard to access. However, the varying migrations of travelers to India and other ashrams and spiritual centers around the globe appears to be growing, indicating a desire to slow down

and take stock. The desire for well-being is still a viable driver of somatic action especially as the planet and lifestyle habits continue to lack balance.

Relative to the modern culture at-large it can be posited: has the world moved out of the Cartesian split of the mind superseding the body? Do we no longer need to talk about soma? Many people posit that saying bodymind or body-mind is dualistic and not useful when indicating holism. Some cite the worldwide acceptance of yoga as proof that people are accepting a holistic view. Indeed it is this holism (often secularized) and the practice of holistic movement that is radically altering people's perspective. Spas called Exhale, and political marches and demonstrations that echo the phrase "I can't breathe" are core to the shifting paradigm – recognizing that working with the rhythms and tensions of the breath and the breathing body is essential to cultivating desirable lives and lifestyles. This holistic vantage separate from the specific Hindu tenets of yoga is now a "household phenomenon," spreading like wildfire. Somatic education and somatic movement practices are being absorbed into everyday life, indirectly pulled by the market and media forces of commercialism.

Marketing Somatics: Personal, Social and Cultural Considerations

Why does the somatic model get adopted or not? Much like politics, the use of somatic tools or full-fledged somatic education systems is dependent on *values*. People still need to come to value the experience of paying attention. Anecdotally, those that explore somatics find that they hurt less, are more comfortable with the pain or discomfort they do feel, are more energized, become focused on meaningful activities, breathe more efficiently, are healthier and happier. When they experience these benefits they often want to share somatics with others, as well as provide tips for how others may benefit. As discussed in Chapter 11, attention to the living body through somatic movement and somatic dance guides us in a world of change and distress.

Body-mind integration is not always easy. Many people are disconnected from this process; it can be perceived as a lost art. Another deterrent to somatic study could be how much people are willing to learn about themselves and their habits, and take the time to make behavioral changes. It is heartening that even fifteen years ago, in the US over 80 per cent of American citizens were found to be engaging in "alternative medicine" (Eisenberg 2001) to any extent, including taking vitamins, or having sessions with acupuncturists and chiropractors. Fewer people have been documented in learning about themselves through somatics and listening to their own body cues. There is much to find out about what degree of "being taken care of, or fixed" limits a person's choice to explore the self-empowering process of somatics.

Relief from pain is a huge motivator for investigating somatics, especially when the medical system has failed people. Given that overcoming pain, increasing intelligence and creativity are commonly sought-after goals, why is it that somatic awareness and somatic

education are not already valued in a widespread way? Why have yoga classes – a more "exotic" form within EuroAmerican circles – become more widely known and available than somatic awareness and education, systems based in western science and personal development? These ideas may not be of interest to mainstream media and the commercial sector, or may be perceived as threatening. Within the somatic paradigm, health is defined as having a body free from disease, but also includes having successful outlets for creative expression.

As the medical profession makes shifts and there is greater recognition of the science and philosophy behind somatic education, it is possible that somatics will become more sought after. Somatic education may best become known by piggy-backing on endeavors that share these values and are valued in the mainstream, such as fitness, neuroscience, consciousness studies, spirituality and yoga, and discourses about technology and performing arts.

The *fitness* movement did not always exist. It took some time to become popularized in the 1960s and 1970s. It remains a major force in commercial culture worldwide today. Meanwhile, the term *somatic fitness* is popping up. *Neuroscience* research is beginning to coalesce with somatic inquiry either by the nature of the question or because of the people involved. However, Judith Lynne Hanna's book *Dancing to Learn: The Brain's Cognition, Emotion and Movement* cites Bartenieff's research in movement analysis but not somatics or the "felt sense."

Research and published works are important in all fields. Books on artificial intelligence and the body do refer to the "felt sense" (Pfeifer and Bongard 2006) and scientists are beginning to extol intellectual inquiry about movement and the process of embodiment. The blossoming of creativity and choice and the experience of increased brain potential as a result are worthy of research to support the somatic paradigm. Neural plasticity and the impact of somatic movement on neural change are not new concepts. Todd (1937) in exploring the impact of mental ideation on posture, Bartenieff (1970) in her essay on neurophysiological concepts and movement, Feldenkrais in the *Elusive Obvious* (1989), all wrote about the impact of somatic awareness on movement performance, cognition and learning and movement. Research is definitely needed to further substantiate their innovative and prescient work. This includes the need to better understand the deeper structures of the brain that relate to movement and connect movement expression to emotions and behavior.

Relief from bodily and/or emotional discomfort can be perceived as primary or secondary benefits of the somatic arts. The somatic goal of expansion of intelligence, facilitated by the opening up of more neural pathways and related consciousness through being mindful of the moving body, has naturally extended to social activism, community building, health advocacy, artistry and spiritual awareness. It is the confusion of the body that is caught up in and by trauma that thwarts some somatic efforts. This is compounded by ongoing challenges to the body from our environmental and sociological conditions as well as intergenerational trauma that keep cycling into the present time. There is a great need to seek balance for

the society and planet at large. Working holistically across the somatic domains – somatic movement, somatic touch/bodywork and somatic psychology has some promising results (Ford 1989; Smith et al. 1998; Shafir 2015). Jill Bolte Taylor's (2008) experience of losing access to the left side of her cortex and the connectedness and holism she felt when living from the perceptions of the right side of the cortex is another area of inquiry ripe for investigation, especially regarding potential definitions and causes of spiritual experiences, and how we come to perceive "oneness."

When the politics of gender, race, disability, age, religion and cultures are perceived through a somatic lens, human similarities often emerge – the universality of having a body no matter how different it may be from the next person's, the universality of having cells, blood, the need to breath, pain receptors all impact how we relate. Of course each culture (whether a nation or a sub-culture) helps shape how one perceives these sensations – what is disregarded and what is paid attention to. How people think probably also stems from the body and the environmental features that have shaped them growing up. In other words, how people sense is based in bodily experience and how sensations are then perceived or interpreted is dependent on different parts of the brain (also parts of the body). Each of these experiences have been lived by the soma (Pfeifer and Bongard 2006). However, these interpretations are always culturally coded – every interpretation of an experience happens in a sociological context. Swann (2008) at Moving On Center has shaped somatic curricula called "The Socially Conscious Body" and Eddy (2012b) has lectured on it. Reflection on somatic experience can help create bridges across beliefs, moral codes, and thoughts if humans are willing to release those constraints for even a short period of time. This can only be done through personal choice.

Through somatics there are new paradigms for living. These are particularly important in light of how much time is spent in engagement with technology – the impact of a more sedentary lifestyle where work demands less whole-body movement and the eyes are taxed by around-the-clock light (King 2015). Nancy Carlsson Page (2008) builds a compelling case culling much research to show how media exposure and technology impacts children and promotes violence. What is often neglected in urban and even rural educational and work planning is the basic need for physical education to instill skills and attitudes that promote lifelong physical activity. This includes the importance of establishing environmental conditions for physically engaging leisure. It takes discipline to actually choose to engage the body in large motor acts beyond eating and working. If there is a fear of injury in taking up movement practices this can be relieved by introducing a new level of awareness while moving. Remembering the power of the body-mind connection during the practice of mindful movement has been shown to make exercise a positive option; this has also been observed amongst people with mental illnesses (Russel and Arcuri 2015). It takes public policy to create the conditions for being safe and creative (e.g. arts in the schools and quality physical education) and physically active (e.g., dance and physical activity in schools, parks, and community centers for all age groups). Finding

the motivation to move mindfully may be supported by technology or diverted by it. Some technology can actually support somatic inquiry. Working with highly calibrated light may be both the antidote to being thrown off one's circadian rhythm and a route back to sensory well-being (King 2015; Lockley and Gooley 2015). It is again, a matter of balance. Young people today are riding that continuua – some are self-professed techno geeks and proud to be couch potatos, others are compelled to work-out in a fitness club daily. Others are seeking community through physical activity. These are all potential domains for motivating somatic learning. Ecstatic dance, epi-genetics and relating to the multidimensionality of space are others.

Somatic Dance or Ecstatic Dance?

There is a burgeoning of community dance, ecstatic dance and dancing in general. This is a breakthrough. More men are participating and not always as leaders. A valuing of female wisdom, the feminine in all people and the anima in general is a helpful force in valuing the human body as worthy of care and dance as a worthy art form (Shapiro 1998; Fortin 1998). The corroboration of healthy dance with healthy and graceful aging is gaining traction worldwide (Nagrin 1988; Hanna 2006). The shift into more dancing at home, within families, in places of worship or in public outdoor venues is a marker of a culture that dances without inhibition, celebrating dance without needing to be intoxicated. Including self-authority and somatic awareness during these cultural events is the next frontier.

Ecstasy is a big pull in this decade. Why? Some see ecstatic dance as similar to recreational drugs – a move into altered states that may or may not heighten daily consciousness (Kurtz and Prestera 1976). Others perceive it as a type of spiritual bypassing (Masters 2010) or an endorphin shift that may help people heal from difficult emotions and situations. For those people who are emotionally stable, ecstatic dance can provide great joy and liberation – to reach altered states without the use of harmful and illegal substances. However, when ecstatic dance or raves are used exclusively as an escape from problems, they do not meet the call for conscious action. Mindfulness during movement as taught through somatic movement can work together with somatic psychology to help people address their underlying emotional and relational needs (Shafir 2015). Somatic dance is relative to ecstatic dance. Ecstatic dance is fun and has a strong community. Numerous graduates of Dynamic Embodiment have chosen to get involved with the ecstatic dance community by being a DJs, selecting music, setting a mood for dance inquiry. They use their somatic sensitivity to match music to changes of mood, bodily needs and timing of the individuals as a group. Other Dynamic Embodiment practitioners report leading movement lessons or breaks at raves and within ecstatic dance gatherings. As somatic experts they generally focus on community building supported by sensitive movement and musical choices that foster well-being. This includes demonstrating ways to use embodied anatomical information to "stay inside" the body, even while dancing with full-out rigor and

endorphins surging. How teachers, DJs, movement therapists, massage therapists, physical therapists, occupational therapists and psychotherapists integrate a view of wholeness into their practice is dependent on their own embodiment and knowledge. This knowledge is best gained through sensory awareness, kinesthetic awareness and heightened perception using all bodily capabilities – interoception, exteroception and graviception (Batson and Wilson 2014; Russell and Arcuri 2015; King 2015).

Genetics and Epi-Genetics?

Another theme involves reconnecting with "a perfect pattern," returning to innocence, natural movement states and childlike ease, mostly flow. It is shown that the neutral state of mindfulness focuses attention (Russell and Arcuri 2015), and with the proper conditions (e.g. of quiet, nature and/or light sources) provides rest (Batson and Schwartz 2007; Batson and Wilson 2014; Damasio 1994, Lockley and Gooley 2015; Todd 1937). This calming of the nervous system may even act as a profound source of feeling 'at one with the cosmos' (Williamson, Eddy and Webber 2014) or being better aligned with our genetic material (Eddy Interview 2015l). Both BMC and Bio-Dynamic Cranio-sacral work are steeped in detailed embryology and use touch, imagery, movement, breath to help people to reconnect to images if not actual memories of embryological growth, contending to reset movement patterning at this very deep level.[2] The resulting deep rest has a purity of neutral state, a common feature in somatic work, and it may be the best baseline to help realignment from stress and trauma. "Re-setting" the body through somatic awareness may even change the cellular levels of the body and create a more favorable epi-genetic environment. Recovery from cancer is being perceived as including a change in the micro-nutrients and micro-organisms around a tumor. Food is one strong influencer (Gaynor 2015; Chopra and Tanzi 2015). How can movement that is caring and self-regulating support epigenetic factors? Chiropractic and osteopaths have been investigating the self-regulation of proper alignment and physiological rhythms within the body for years; many dancers have been feeling it. Ford (1989) perceives these disciplines as part of the somatic profession. Chiropractors align the body, as does anatomically aware dance. Alignment in physical space may be helpful in awakening consciousness. This is certainly a basic yogic concept – take time to improve posture, align the chakras (the body's energy centers) and more vitality will flow – whether this is physiological fluids or the meridians and energy systems. With flow a person has choice, she can move toward or away, with consciousness. With somatic awareness applied to the releasing of tensions and blockages choices become easier, and ostensibly more healthy.

The primal needs of moving away from what is noxious and toward what is pleasant and nourishing are strong acts of choice. They are decisions. As Maxine Sheets-Johnstone (2007) espoused, finding the kinesthetic sense and responding to it and with it may be at the root of consciousness itself, and mindfulness in action even at the cellular level

(Bainbridge Cohen 1993; Thornton 1971). However, sensory-motor amnesia exists (Hanna 1988) and many behaviors and somatic methods call upon the need for inhibition (Jones 1987; Grey 1990; MacDonald 1994, 1999; Park 1998; Goldberg 2001; Gelb 2005). When the person runs amuck too often, instincts are disregarded and one may no longer trust one's own self-protective reflexes or have easy access to self-regulation. It takes re-establishing at least one trusting, positive relationship in order to truly self-regulate. If that can't be found, one may in healthy self-defense establish overly rigid boundaries – what in LMA is referred to as extreme bound flow, during which one doesn't let feelings that are stirring within out or the outside environment in even if it could be helpful.

The key point is that the body reveals just where we are "stuck" or "free" through posture and movement, especially in somatic dancing – where a person may explore sensation and experiment fully.

The need for kinesthetic learning and movement is particularly important in places that have a high percentage of people with attention deficit and hyperactivity. Schools in the mid-twentieth century used to have time in nature, allowing children to naturally attune with the mystery of life – that which is bigger than oneself – the clouds, trees many years older than themselves, the earth, the smells. In doing so children expended energy as well, and used their imaginations in play. As nature is harder to come by, the need for body-conscious design is more evident. Designed environments are substitutes but can also be highly nuanced and creative. Playgrounds can be safe and wonderfully sensorily stimulating. Dances can be about gardening and include music that trains the ears or the eyes to be alert yet relaxed (Eddy 2010c, behaviors and somatic methods Eddy and Lyons 2002; Chiate et al. 2016). As teachers, parents, administrators and even merchandizers recognize the benefits of bodily astute objects and places, the need for somatic expertise will also be more in demand.

Even without thousands of somatically inspired objects in the market place, the field of somatic movement education and therapy is faring well. Each independent somatic school, especially those of the first generation, is busy with global growth patterns. The second-, third- and fourth-generation graduates are benefitting from the collaborative efforts of working with professional associations including the overarching one – ISMETA. This is despite economic challenges, lack of affordable clean and quiet space and guaranteed job prospects.

The Power of Embodied Space

The somatic arts build upon genetic knowledge, cultural evolution, and especially the feminine sides of traditions of antiquity – that there is a power in humans to align with nature, nature's designs in space (spirals, tetrahedrons, cubes), and the geometry of space. Whether finding internal space to free up from pain, or aligning more profoundly with the yogic chakras by embodying the endocrine glands, or practicing the Space Harmony scales

of Rudolf Laban, or feeling the balanced spatial pulls of tensegrity in Rolf Movement (or any of the somatic systems), an important outcome of exploring geometry somatically is an experience of balance. Stress can be relieved by "being as big as you are" – a principle of Dynamic Embodiment. The somatic arts guide people to take the time needed to feel the body as a constantly breathing, shape-changing, three-dimensional cylinder with internal forces. This body benefits from lining up with the three cardinal directions – the horizon, the up-down earth-sky dimension or the front-back dimension (often felt to represent time; backward to our ancestors, forward to the future). The popularity of Spacial Dynamics, Spiral Dynamics and Spiral Praxis is an indicator of a growing value in situating the body and physical experience in the environment, in space. Once "established in space" other aspects of bodily health and movement expression are sometimes reported to more easily fall into place.

Rudolf Laban's view of the importance of spatial pulls and movement qualities appears throughout the world in diverse dance pedagogy and can be found applied to every field involving movement or nonverbal communication. The media recognizes this perspective in its analysis of politician's movement during electoral seasons, or office workers' postures at desks (Brody 2015). Conrad saw a continuum between the watery basis of the human body, our planet and the galaxy. More people are coming to understand the positive health benefits of an awareness to posture, and to the volume and spatial dimensionalities of the body as a connector to both near-space (shoes, clothes, furniture and homes) and far-space (buildings, cities, our planet and galaxy). The Alexander, Bartenieff, Body-Mind Centering, Dynamic Embodiment, Feldenkrais, Ideokinetic, Rolf and Trager approaches to somatic education all teach students to breath and move in all three-dimensions, albeit using different modalities (Eddy 2008, 2014).

Somatic movement as it relates to health and consciousness and especially in its role in the arts has been included in academic programs, children's education and in healing settings. Where do we go from here? Chapters 4 and 5 spoke of the use of body awareness and conscious movement for health and healing in most cultures and through numerous eras. In the cultural framework of a global-village, much of history has been drawn together into a new perspective with a wide variety of evolving movement approaches. Integrative medicine embraces energy work from diverse cultures, different bodywork practices, and recognizes the need for movement and exercise (along with herbal and nutritional supports). It is slowly coming to understand the potency of bringing somatic-based movement and dance into healing protocols (Fortin 2009; Kern et al. 2014; Kestenberg et al. 1999) The hypothesis is that when the conscious awareness of somatics is brought to these movement practices, there is the possibility of greater self-regulation and focus (Russell and Arcuri 2015), less injury, including brain injury (Eddy 1995a; Goodchild 2010; Lamont 2014) and more empowerment (Clias 1825; Mechner 1998; Shapiro 1998; Fortin 1998; Rosas and Rosas 2004; Tortora 2006; Green 2007; Gay 2009) – in particular among women and men who are open to their feminine sides.

Research

Research is needed to substantiate these claims. Until research methods are developed, and research funding and systems of dissemination of research findings are available, one can expect to *not* see somatic awareness finding its way quickly in different cultural venues. On the other hand, the new waves in integrative medicine and neuroscience provides an opening to the systematic study of the impact of somatics (Sacks 1970, 1996; Ramachandran 1998; Schore 1999; Buchanan and Ulrich 2001; Anderson 2002–2003; Damasio 2010; Overby and Dunn 2011; Pilecki 2012; Schiphorst, Bradley and Studd 2013; Russell and Arcuri 2015; Greater Good 2015; Hanna 2015).

Research can reflect upon or spawn new behaviors. Research is only beginning to include somatic methodologies in diverse fields (anthropology to zoology) or to focus on the effectiveness of somatic movement in health (Eddy and Becker 1993; Oschman and Oschman 1997; Eddy 1998; Smith et al. 1998; Unrau 2000; Buchanan and Ulrich 2001; Eddy 2002b; Skelton 2002; Anderson 2002–2003; Fortin and Siedentop 1995; Dyer 2009a, 2009b; Germer 2010; Osumare 2010; Overby and Dunn 2011; Russell and Arcuri 2015; Greater Good 2015; Hanna 2015; Feldenkrais Commentary n.d.; Igweonu 2010). Much research requires that we conceptualize the world as it is in language that articulates its parts and recognizes variables that cause changes.

Somatic movement can be viewed as a phenomenon that impacts genetics, and how the body responds to "genetic cocktails." Research into how both movement and consciousness have implications for epi-genetics could be joined to the study of scientific trends in twenty-first-century research (O'Connor and Crystal 2006). A 2014 article on cloning has been circulating widely, describing that perfection is not needed in the genetic make-up for offspring to actually be quite healthy (Long et al 2014); this aligns with the evolutionary biology concept that it is rarely the most efficient pattern that survives. What survives is the pattern that supports survival with the least amount of effort – the shared lowest common denominator. How does one even begin to talk about these concepts or shape good research questions inclusive of somatic exploration? What types of physical movement might be introduced for controlled studies on this topic? One somatic fitness program, Moving For Life, has demonstrated the ability to improve Body Mass Index with eight weeks of twice weekly practice. It is part of a longitudinal study with New York University Medical Center to observe on-going trends in the patients involved. It is conceivable that this data could eventually be linked to observations of breast cancer patients with the BRCA gene and those with other genetic proclivities toward cancer (Kern et al. 2014).

Having a clear language supports scholarship. For instance, there is much more to be investigated on the genetic front. However, until the worlds of somatic genetic research meet with the somatic education world, much will be left unresolved. One question at hand for somatic educators is as genetic modifications become more commercially viable (Geddes 2009) will somatic awareness be useful in helping people adjust to the bodily impact of

these modifications? All change is a stressor (Selye 1978), and somatic exploration helps in integration of new experiences no matter whether a positive or a negative stressor. There will be moral implications of this work as well.

A related milestone has been researched – the integration of somatic movement awareness into helping adoptive families bond more fully with their babies or toddlers (Schore 1999; Cozolino 2006; Shafir 2015; Tortora 2006). Current-day successes have their antecedents in the work of pediatric psychiatrist Judith Kestenberg (Kestenberg 1977; Kestenberg and Sossin 1979) who chose to study the somatic work of Irmgard Bartenieff to better understand infant and toddler's movement in order to be more sensitive to their pre-verbal emotional expression (Lewis and Loman 1990; Eddy 1993; Kestenberg et al 1999; Eddy 2000c; Bender and Koch 2007).

The Call for Clear Language

The lack of consistent usage or a single-shared definition of the term "somatic" signals the need for the clarification and amplification, in order for "somatics" to be understood as an experiential, contemplative basis for holism. Hanna emphasized that the soma is replete with cellular intelligence and has a capability of perceiving itself that, in turn, allows it the knowledge to be self-guiding. "Living organisms are somas: that is they are integral and ordered processes of embodied elements which cannot be separated either from their evolved past or their adaptive future" (Hanna 1979: 7). As the somatic perspective is framed and investigated, it furthers the body-mind link that supports both human evolution and the evolution of the fields of somatic education, SME&T and somatic dance.

However, the use of the word *somatics* remains confused. It is used in other contexts with quite different meanings. Anyone who encounters somatic education and anyone studying SME&T must confront the contradictions in usage. The most common definition, especially in the biological sciences, refers to the body only (as distinct from the mind). It is, for instance, still common to use the word *somatic* to simply mean physical – as in one-half of the term *psychosomatic*. Furthermore, the somatic nerves are those nerves that govern the voluntary physical action of muscles and bones, even though the term *soma* refers to consciousness in all of the living body. These purely corporal definitions of the word *somatic* are echoes of Webster's primary definition of somatic – "of the body, as separate from soul, or psyche" (Webster's Dictionary 1992: 919).

Somato-genetic is another common term that arises when encountering somatic terms. It refers to either bodily or cellular "variations due to the direct influences of the environment" (Webster's Dictionary 1992: 919). This definition most relates to an understanding of the soma as the living container of the individual survival process that exists in relationship to its environment, but contrasts with the idea that "soma cells" or neurons are able to reproduce themselves. The soma is able to adapt by self-regulating in response to a changing world.

While these uses of the word somatic lead to an understanding of bodily intelligence they are also obscured, existing mostly in the domain of biological inquiry. The good news is that more people are curious and knowledgeable about biology and neuroscience, spurred by interests in staying healthy while living longer. The explosion of genetic information and its relationship to both potential morbidity and quality of life while aging is capturing attention inside medical offices and on the news.

Language of Somatics – Elitist, Mind-Stretching or Consciousness-Shifting?

"Somatic language" is a highly nuanced set of terminology, images and constructs that supports this clarification of concepts of varying facets of the body, movement and the body-mind relationship. If the world is leaning toward reintegrating body and mind, it is important to embrace holism in a differentiated way, noting that there are different "brands" or styles of holism. The 150 years of feeling and naming movement that underlies the somatic field is a starting point. More thinking and theoretical constructs are available for this dialogue through using a combination of taxonomies from varied professional fields, plus language that is emergent from somatic movement education (e.g., movement patterning, re-education, navel radiation, dynamism, connectivity, yielding, breath support), from somatic psychology (e.g., somatic transference, disassociation, deprivation, boundary setting, intersubjectivity, altered states of consciousness – Ford 1989; Shafir 2015; Tortora 2006) and from somatic bodywork/touch (good bad and confusing touch, permission, somatic ethics, deep or superficial touch, dynamics of touch – Eddy 2003, 2012a; Ford 1989; Smith et al. 1998). Both the language and the concepts are worthy of funding for investigation. Small organizations (BMCA, Feldenkrais Guild) have, but they have limited funds; they are miniscule by today's commercial and scientific standards.

And yet, starting with any scale of somatic research is critical. The specificity that somatic education provides in proprioceptive and kinesthetic mindfulness may not be being used because research methodologies have not yet encountered somatic experience, language, or the concepts behind them. Language helps to create clarity and in the case of somatic terminology it allows what has been non-verbal to become expressed, allowing for differentiation of the myriad of subtleties within "the universe" of bodily experience. Taxonomies open consciousness. The first thesaurus of somatic movement language has been postulated by Amory (2010). To strengthen confidence in somatic models, research is needed about the language itself. New words can feel alienating. Learning the meaning of the word *somatic* and other somatic terminology is best done through actual experience. This becomes a vicious circle. One cannot learn what somatic education is until it is experienced, but there are many barriers to experiencing it – expense of time, space, quiet, finding personnel trained to lead it and having the media promote it.

While some universities have been legion in their leadership, others are still reticent to support a discipline with unfamiliar taxonomy, that is experientially based, and that has so little beyond the personal narrative research that happens in the studio every time one explores somatically (Topf 1980). Defining vocabulary and shaping research methodologies, questions and investigations that are critically evaluated are essential to this next stage of discourse. The growth of adult experiential education as a discipline is also helpful (Bainbridge Cohen 1993; Hanlon Johnson 1995; Bauer 1999/2000; Kerka 2002; Eddy 2005/2011; Olson and McHose 2002; Emslie 2006; Linden 2007; Anttitla 2008; Dragon 2008; Homann 2010; Bloom et al. 2014; McHugh 2015).

Somatic professionals need to not only know somatic language, but also how to translate somatic concepts into a vernacular language that all people can understand. Martha Myers has been ingenious in doing this across the disciplines of the arts, philosophy, psychology, medicine and the media. Somatic programs linked to research can provide the opportunity to test applications of somatic education and invite somaticists to return for more study as needed. In humanistic research there is an acceptance that there will be bumps along the path that are actually "detractors" or "distractors," opportunities for learning and transformation. These challenges, when handled well, ultimately bring the people involved into closer relationships and deeper engagement in working together. This could be a positive outcome of interdisciplinary work across highly specialized fields. In any of these fields experts in Embodied Leadership (a term that connotes training in somatic education) can help guide new paradigms of communication and organizational management in diverse settings.

How Does Somatic Education Interface with a World in Flux?

Somatic movement skills guide us through a world of change and distress. Somatics is embedded in many of the approaches to trauma recovery. The ongoing, quiet, but steadily growing existence of somatic practices and their burgeoning theories begs the question – how can we get somatic awareness, somatic movement and somatic dance operative on a large scale? Unfortunately some people are still dancing with the body/mind split. Dance is a field filled with options regarding philosophical paradigms, pedagogical models, aesthetic choices and research designs. In the business of dance, daily decisions are made that resist or contribute to the continuation of the Cartesian split. In educational and business settings that still rely on humiliation and fear to maintain control, top-down authority and the belittling of individual wisdom can still be found (Hicks 2011; Linder 2009). The somatic model resists this. A somatic model may or may not be selected by a particular dance specialist or organization. However, no matter what choices are made within dance, from the perspective of societal power, dance is a predominantly marginalized field (of art, of the body, of women). It is also because of this the somatic model may be shunned – for fear of becoming "too sensitive."

Furthermore, somatic work often involves touch. There are ever-shifting currents about the appropriate role of touch in school, in therapy, in healing. When good, bad and confusing touch become well sorted-out, each person (supported by community) may be able to nonviolently protect her or himself from abuse. The power of touch in this discourse is huge. When will good touch make its way back into schools and families so that it too becomes a healing force that is transformative and caring?

A Somatic Treatise

All in all, through embodied experiences of holism people can become more comfortable with the vulnerabilities and imperfections of bodies, the outrage and outcries of emotions and the insights of the intuitive or mysterious realms. By weaving dance and movement more fully into the social fabric, the global cultural story moves forward. Through somatics people can be ready at all times to face the "expected and unexpected" in life's lessons and move into action. By embracing "social somatics" individuals can strengthen perceptions, self-awareness, efficiency and energy to strive to build stronger communities of thinkers, movers and activists. Using somatic perception everyone is better equipped to open to new awareness as well as make personally informed and impassioned decisions. Activists need to recognize that their bodies as well as time and space are precious (Van Gelder 2016); this forces the issue that current cultural belief in commercialism co-opts basic needs, such as time for quiet reflection and clean space. Time, space, water and air are all becoming commodities. Somatics helps to construct a new expectation that all people benefit from each other's experience of wholeness and strength. Whenever possible, it is worth giving due recognition to traditional cultures that have a long history of holism, and honor them by crediting them and continuing to learn from them.

Dancers continue to take their somatic knowledge in hundreds of other arenas, many share personal aesthetic stories and values and make statements or work for social change. With that in mind somatic professionals gifted in working with children are at the forefront of weaving somatic activities into schools. The skills required to work with Pre-K-12 students, of course, are honed in adult education and teacher preparations. There are more programs of adult education that are seeking multidisciplinary inroads, accepting the importance of kinesthetic intelligence for every child. Special educators, in particular, are quick to absorb new somatic strategies for teaching children to self-regulate and express themselves. They recognize the primal need to move, the importance of movement in the curriculum and the role of dance – an equally, if not more, important art form for all children to partake in. *PS Dance* is a new film created by Jody Gottfried Arnhold that makes the case that the model for dance education in the New York City public school system makes dance a tool for transformation for all children, because serious and effective dance education informs the body, the mind and the heart. The film shows children and youth talking about how their thinking is affected by their dance lessons.

Other young ones speak of the range of emotions they can express and the new ways of relating with their colleagues, their exposure to other art forms and subject matter that fuels their dance-making, and its usefulness in dealing with bullying. The pedagogy is strongly based in LMA. The LMA system is used to expand movement range and to extend dance literacy. LMA and Language of Dance provide the tools that allow children to speak and write about their experiences. This publicly available advocacy film conveys important messages about the role of being educated in dance in building informed citizens who are capable of expressing themselves physically, confident to use their bodies and minds, willing to communicate across cultures. It is a concept-driven dance model where children learn movements as stepping-stones to making movement sentences that form the basis of stories – full dances. The collaboration involved in creating a production is another testament to how dance teaches cooperation, negotiation, accommodation, listening and courage (Eddy 1998).

Recall how Sy Kleinman's early movement and dance experience connected to his deep investigation of philosophy and led him to start the first doctoral program in the world where any facet of mindful, somatic movement applied to any sub-discipline could be researched. Imagine what could come of all children having informed dance education, much in the way that existed in Britain and Canada during the second half of the twentieth century. Now picture that dance infused with experiential anatomy, somatic wellness principles, time for proprioceptive skill-building and somatic movement. The Inner Resilience Program, developed to contend with post-9/11 stress, includes many of these features. This multi-sensory, multi-arts approach to socio-emotional learning inclusive of meditation, creative expression, and movement was developed by Linda Lantieri (2008, 2014). She often says all of these methods were actually needed before 9/11. They are still greatly needed today.

St. Catherine's University near Toronto has a history of teaching physical education with bare feet. This method began long before the phenomenon of barefoot running took off. They based their pedagogy in the concept of modulating weight with kinesthetic awareness suggested by Rudolf Laban (Sternberg 2008). More physical education, dance education, and classroom education needs to include pathways for awakening the proprioceptive sense and related body-mind-emotional connections.

The Role of Dance

Just as *PS Dance* demonstrates the socio-emotional intelligence that emerges when students dance together, there are many examples of learning empathy through dance. In the realm of social somatics another question emerges. Might somatic awareness increase if one first becomes sensitized to the needs of others? When a dance piece focuses on social issues, the empathy that develops may be an opening for becoming more somatically aware. Research could be done to find out if the youth involved with Jacques D'Amboise in the National Dance Institute's 2015 production *This Land is Our Land: The Power of American*

Song now have 1) a more solid understanding of US history; 2) greater socio-emotional learning; 3) an interest in or perspective on somatic awareness. 200 young people from numerous underprivileged and some privileged New York City neighborhoods danced to live music, including a professional vocal ensemble singing songs of America over time. The direction came from choreographers with many Broadway shows under their belts, but more importantly the music chosen told a story of American life from pioneering years through slavery, the Civil War, the Civil Rights movement, the Vietnam War and into today. Some of the video projections were grim and the movement challenging. The discussions, collaboration and heartfelt music and dance could easily have instilled new sensitivities into each student. Of course, the way pre- and post-performance discussions are led and the way children are treated throughout a production is a major testament to any group's success in developing kinesthetic empathy, somatic awareness and socio-emotional intelligence.

Adult learners can be privy to this type of integrative learning as is evidenced through the book the *Choreography of Resolution* (LeBaron et al. 2013), which resulted from a four-year project between lawyers, dancers and artists who wanted to investigate the ways in which the body is missing in mediation and conflict.

Book reviewers Aileen O'Brien and Mary Lloyd write:

> To these ends they highlight the significance of the physical realm in our lives, how conflict affects our bodies, how "modes of engagement in conflict are filtered through complex systems of somatically braided cognition" [xxvi], and how artistic endeavour informs conflict resolution.
>
> (2015: 1)

Many of their discoveries support the prior investigations of numerous Laban Movement Analysts as in Goldman's work *The Geometry of Movement* (Eddy 1998, 2000d, 2001a, 2009b, 2010a, 2010b; Goldman 2008). They expand the work into the international domain with stories of embodied action in successfully developing somatic empathy and socio-emotional attunement across people of diverse ages, gender and cultures, and most notably those who have dealt with the trauma, torture and war.

Dance generally happens in community – with at least another person, or with music – even if alone it is visible to others and communicates what the body is expressing. This communication can be extended to interpersonal caring. When somatic elements are introduced to dance, the wisdom of the body and related compassion for self and others is called upon (Eddy 2016). The somatic approach also enforces the role of personal authority within large groups – staving off possible fascistic tendencies (Eddy Interview 2001a). Re-humanization through awareness of the ever-changing body provides skills to cope with life's stressors (Todd 1953; Matt 1973; Bartenieff 1980; Halprin 1995, 2000; Rolf 1977; Trager and Guadagno 1987; Saltonstall 1988; Feldenkrais 1989; Bond 1993; Michener 1998; Roberts 1998; Conrad n.d.; Green 2002; McNay 2013). Drawing on the creations of the early pioneers and their students is like a stroll through

a field of wildflowers with much beauty to select from – each different and independent, with choices to suit different people's tastes and needs.

The Somatic Arts and Conscious Action: Keep Moving, Mindfully

The ongoing, quiet, but steadily growing existence of somatic movement practices and its burgeoning theories begs the question: If the body is a conveyor of multi-faceted messages how can we cope with a threatened world without listening to its messages? Whether in stillness or movement by accessing physical mindfulness there is an opportunity to respond with fuller attention, and a more self-regulated brain (Russell and Arcuri 2015; Kaparo 2012; Kee et al. 2012; Eddy 2007). This is the potency of the living body – the soma can be well studied in the art of listening to feelings – the feeling of body sensations, the feeling of emotions and the feeling of one's personal and inter-relational truth. Somatic awareness can touch any part of life – it is simply awareness of being alive, being present and conscious of the physicality of life while in action. Somatic education increases our mindfulness not just at rest but while moving. It can be a link to a sense of community that some experience as spirituality, "connectedness", or sharing the sacredness of the body of life, as well as to deeper relaxation and improved cognition and empathy. Somatic processes are still evolving. However, they have begun to find a way into all aspects of daily life, as well as organizations and communities. Daily life includes work, recuperation and creative expression – the great healing salves of music, storytelling (including acting, writing, drawing), and dance (Arrien 1993).

Dance integrates attunement with feelings, capacity for expression, engagement with creativity, and inroads to improved health. Dance performed with compassion and awareness (somatically) can support wellness, community and communication. The somatic arts have evolved from the lives of great individuals dealing with diverse stressors and working together with others to convey the importance of being conscious while moving. Hence, "mindful movement" is the fine balance of staying attentive and being aware not only in stillness but during every aspect of life, including dancing with attention and awareness, sometimes to solve problems now and for the future. This process is still evolving. It may be absorbed into our culture or become a more articulated language (Amory 2010; Eddy 1990) and field. Language must become simpler and more widespread for conscious action and mindful behavior to become the norm. If the words proprioception, kinesthesia and somatic cannot be easily understood, spelled or spoken there is a need for the words that are more immediate. Suggestions are: body sensing, movement awareness, and somatic education. Of course, in this day and age of di- and trisyllabic simplification we could also claim new sounds: ba-dum, chi-ma, and bodymind.

In this phase in human history, there is a trend to transform the body to meet ideals of "perfection" using chemicals, surgery, make-up etc. Rankine (2016) found that dozens of cultures worldwide use advertising to promote the whitening of skin. This commercial drive to be other than ourselves is in antithesis to the type of self-acceptance that is the root of

somatic education. By beginning with what *is* and accepting it, the human body heals and finds the capacity to do what it can fully. As part of this nonjudgmental acceptance it is crucial to remember that while many of the somatic pioneers experience seeming miracles – overcoming great physical challenges while expanding their awareness and creativity – there are many conditions that don't completely heal or miraculously transform. Self-acceptance must underscore caring for whatever bodily shape and form we take, all types of disabilities, embracing physical and enculturated idiosyncracies and uniqueness. This acceptance underlies social somatic work and can emerge from embracing self with no pressure to change, and identifying self without being pushed to align only with a commercial idealism. No matter what direction it takes, somatic education is coursing through the world today, and especially into the arts.

Dance professionals have been critical players in both developing and promoting the philosophy of reclaiming bodily awareness, and the shaping of practical experiences that teach people of all ages to feel again. There are tensions within our multifaceted cultures, pulls that have parents and educators teaching children to ignore body signals. Children are often told that they are too loud in the face of danger; too hot in an overheated subway; too desirous of expensive food or unaffordable toys. They are uncomfortable from lack of understanding about stretching and alignment, or just from needing to move in a sedentary society, but the signals that underlie these feelings are not really there, they don't exist – no, you don't feel that. The mindful approach is to learn to follow the messages of the body, and this type of somatic listening may be the only route to both self-regulation and support for the bodily health of our planet. As more humans dance, the possibility of becoming more kinesthetically aware and mindful while moving can be practiced. This ability to dance a full range of honest emotions and celebrate the beauty and wonder of life is supported by the existence and growth of the somatic arts. With somatic awareness at its foundation, mindful movement is a baseline for conscious action.

Somatic dance continues to play a role beyond dance injury reduction when applied to the creative process within choreography, dance production and teaching. The creative process can draw on a myriad of somatic sources. One rich one is the developmental paradigm. For instance, MilkDreams by Alexandra Bellar was a three-year investigation of the movement of her two-year-old son. The troupe explored every facet of the child's dancing; he was encouraged to dance with them, even leading movement as the dancers followed. It became a YouTube sensation that took off with other dance companies as well. Innocence and pure movement became the source for choreography. When interviewed, the dancers spoke of the mind shifts that entering the movement repertoire of a two-year-old led to. "I feel more sensitive to everything, softer, more vulnerable." Another said, "Living with this movement is like an intergalactic trip from microcosm to macrocosm and back again" (Interview with Bellar Company, Eddy Interview 2015k).

Notes

1 21 January–1 May 2016 The California Historical Society displayed *Experiments in Environment: The Halprin Workshops, 1966–1971.*

2 See Breme 2012.

3 Master Wei in Taipei, Taiwan, reportedly cured himself of prostate cancer through blending forms of Tai Chi and creating Tai do.

Appendices

Appendix 1: Elaine Summers in Memoriam

Skytime 2014/Moon Rainbow
7–9 pm, 28 September 2014

Solar One
Stuyvesant Cove Park, 24–20 FDR Drive Service Road East,
New York, NY 10010
http://www.solar1.org

Skytime 2014/Moon Rainbow is an ongoing series of collaborative Intermedia artworks conceived in 1982 by choreographer, filmmaker and Intermedia pioneer, Elaine Summers. The project explores the collaborative process with emphasis on the interrelationship between art and technology. Summers' SKY works have seen many incarnations, varying from site-specific multidisciplinary performance events, to a web-based concept artwork (skytime.org) – all of which are based on the sky as the origin and continuum of time in the human experience. The project was made possible by the NYSCA Grant – Film & Media/New Tech Production.

Director: Elaine Summers
Choreographers: Elaine Summers, Kiori Kawai
Dancers: Kiori Kawai, Thomas Körtvélyessy, Kanako Yokota, Logan Scharadin and more
Composers: Pauline Oliveros, Carman Moore, Ione
Musicians: Pauline Oliveros, Carman Moore, Ione, Marianna Rosett, Premik Russell
 Tubbs, Eli Fountain and more.
Visual Artists: Raphaele Shirley, Aaron Sherwood
Documentation: Adolfo Estrada Vargas and more

About Solar One: Solar One is New York City's Green Energy, Arts and Education Center. Originally founded in 2004 to manage Stuyvesant Cove Park and a small environmental education center ("Solar 1"), Solar One quickly grew into an award-winning organization with a thriving array of programs promoting urban sustainability and education. Solar One's programs reach all five boroughs.

Solar One manages Stuyvesant Cove Park, an architect-designed, sustainably managed two-acre jewel of a Park on land that was once an abandoned industrial site. The Park is now home to hundreds of indigenous plants, flowers, trees and berry bushes, and a site for many free public events.[1]

Note

1 The Cove Park has also been the site of Global Water Dances. See Chapter 11. Elaine was active in Global Water Dances and wrote on the occasion of the first performance – 25 June 2011,

> HI Martha WOW YES it is all exciting I am trying to see everything via Internet & you Tube at the different locations. You have constructed an amazing GLOBAL WATER event. I will try to let you know one way or another streaming in different countries. MY HOW splendid. love elaine OH the images are lovely and sparkling THANK YOU> TO EVERYBODY who made it happen. more cheers & delight Elaine.
>
> (Eddy 2011)

Appendix 2: Emilie Conrad in Memoriam

Celebration of Life
Emilie Conrad
14 June 1934 – 14 April 2014

1) **Welcome – Sounding**

> Donnalea Van Vleet Goelz
> Beth Pettengill Riley
> Elaine Colandrea
> Sharon Weil Aaron

2) **Invocation**

The concert of existence places me in resonance with our biosphere…
at this moment there is no "body" no separation; I am
part of the swirl of bio-morphic unfolding. I am not bound by culture
or language. The deepening of sensation allows me to be without
category. I transfer the moisture of my cells, join the wet of the
grass, the pour of the ocean, the stars that watch over the night. The
plants breathe, my skin is wet, we are here.

– Emilie Conrad, Life on Land

3) **Guest speakers: Personal Visions of Emilie**
Sharon Weil Aaron
Joan Hochkiss
Melissa Converse with a Tribute from Joan Tweksebury
Gary David
Don Johnson
Susan Harper
Rebecca Mark
Elaine Colandrea: CMA Film
Malcolm Groome

4) **Slide Show with Music**
Thank You Beth!

5) **Community Sharing**

6) **Continuum Teachers**
Donnalea and Teachers Share

*Hors d'oeuvres and drinks
to be served in courtyard.*

*Emilie's desire was for us to
hold a three day dive together.
It is scheduled for 31 August – 2 September.*

Appendix 3: Ruth Doing's Rhythms Fundamentals Compared with Body-Mind Centering BNP as presented by Kate Tarlow Morgan[1]

Rhythms Fundamentals	Basic Neurocellular Patterns (BNP) and Reflexes of Body-Mind Centering®	Notes and Comments
Rolling (from center of spine or navel)	Navel Radiation Star Fish Rolling Reflex Spinal Pattern Underlying Contralateral Pattern Underlying	This pattern is done on the floor in the Horizontal Plane.
Shoulder Roll (from prone position)	Turning of Head Neck Reflexes: ATNR, Hand to Mouth Homologous Pattern Homolateral Underlying	This pattern is done, belly down, with upper body raised from floor like the Cobra Position in Yoga. This Pattern remains in the Horizontal Plane with beginnings of the Vertical Plane with Sagittal Underlying.
Spine Roll or Undulation (on knees)	Spinal Pattern The Fish	Body is upright, and kneeling, legs under pelvis. Head and Tail extend away, as chest leads down to floor curling back up; the Head and Tail condense towards one another. Sagittal Plane
Spine Roll or Undulation (on hands and knees)	Homologous Pattern The Frog	Continue flexion and extension of Head and Tail but in the Vertical Plane with Sagittal Underlying.
Crawling Bear (travel across floor, body prone, limbs follow spine movement)	Homolateral Pattern The Lizard Homologous and Spinal Underlying	The Spine is the primary mover for this pattern. During the flexion phase same arm as leg are drawn along from the spine until extension must occur. The next Flexion phase draws on the opposite side of the body. Sagittal Plane.

Walking Bear (walking on feet and hands following spine undulation)	Homolateral Pattern The Bear	Sagittal Plane
The Frog	Advanced Contralateral Patterning Homologous transitions back and forth between Contralateral. Equilibrium Responses Optical Righting	This is a very strenuous pattern that requires lifting of the central pelvic area off of the legs into the air. Upon descent opposite leg to arm extends outward to floor (leg) and air (arm). Done as continuous alternating jumping.
Wings	Brachiating Spinal Pattern primarily All Patterns Underlying	Wing is a fundamental that is done standing and is initiated from the spine. The arms move as a reflection of Spinal flexion and extension, or undulations. Arms formally move in Homologous Patterns, but can branch out to all other patterns.
THE SPIRALS		The Spirals are patterns that can be done in sequence or be interspersed throughout the basic Fundamentals
Leg Spiral (lying on side)	Rolling Reflex Contralateral Pattern Spinal Underlying	
Sitting Spiral II (one knee bent in front, other knee bent to the back)	Neck Reflexes Spinal Pattern Transition to Contralateral	
Sitting Spiral II (legs straight, sitting in second position)	Same as above	
Side-Kneeling Spiral (on one knee, with other leg extended)	Same as above Equilibrium Responses Tonic Lumber Reflexes	
Standing Body Spiral (Standing)	Spatial Reflexes with Rolling Reflex Underlying Homologous and Spinal supporting	

Note

1 Body-Mind Centering® is the licensed work of Bonnie Bainbridge Cohen. Kate Tarlow Morgan and Martha Hart Eddy are licensed teachers of BMC.

Bibliography

Abbott, Dianne and Elson, Joan (2006), 'Aikido, the Way of Harmony', http://aikidonapa.com/aiki_harmony.html. Accessed 9 September 2014.

Abrahamson, Page E., Gammon, Marilie D., Lund, Mary Jo, Britton, Julie A., Marshall, Stephen W., Flagg, Elaine W., Porter, Peggy L., Brinton, Louise A., Eley, William and Coates, Ralph J. (2006), 'Recreational Physical Activity and Survival among Young Women with Breast Cancer', *Cancer*, 107: 8, pp. 1777–1785.

Adler, Janet (2002), *Offering from the Conscious Body*, Rochester, VT: Inner Traditions.

Adshead-Lansdale, Janet (2001), 'London Contemporary Dance Theatre: Its Legacy in 1964, Higher Education in the UK', *Choreography and Dance*, 6: 4, pp. 65–89.

aikidohistory.com (n.d.), 'History of Akido', http://aikidohistory.com/. Accessed 9 September 2014.

Albert, Jan, Eddy, Martha and Suggs, Jeanne (2013), *Dance to Recovery/Moving for Life DanceExercise for Health*®, [DVD], New York: Moving for Life, www.MovingForLife.org. Accessed 25 September 2015.

Alcantara, Pedro de (1997), *Indirect Procedures: A Musician's Guide to the Alexander Technique*, New York: Oxford University Press.

Alexander, Frederick Matthias (1932), *The Use of the Self*, London: Orion Books.

——— (1990), *Alexander Technique: The Essential Writings of F. M. Alexander: Constructive Conscious Control [Abridged]*, London: Thames and Hudson.

Alexander, Kirsty (1999), 'You Can't Make a Leaf to Grow by Stretching It: Some Notes on the Philosophical Implications of Skinner Releasing Technique', *Performance Journal*, 18: Winter/Spring, pp. 8–9.

——— (2008), conference notes and papers from *Somatic and Creative Practices Conference*, John Moores University, Liverpool, UK, 2 September, unpublished.

Alford, Emily (1979), *Reminiscences*, New York: City and Country School.

Alhadeff-Jones, Michel (forthcoming), *Time and the Rhythms of Emancipatory Education*, London: Routledge.

Allison, Nancy (ed.) (1999), *Illustrated Encyclopedia of Body-Mind Disciplines*, New York: The Rosen Publishing Group.

American Dance Festival Archives (1980–1996), 'Body Therapy Course Offerings', *American Dance Festival Catalogue Listings*, Durham, NC: ADF Archives.

Amory, Matt (2010), 'Somatic Movement Education and Therapy Thesaurus', personal paper, unpublished.

Anderson, Rosemarie (2002–2003), 'Presencing the Body in Somatic Research: Part II: Using Embodied Writing in Literature Reviews, Data Collection and Analysis, and Presentation of Findings', *Somatics*, 14: 1, pp. 40–44.

Anttila, Eeva (2008), 'Dialogical Pedagogy, Embodied Knowledge, and Meaningful Learning', in Sherry Shapiro (ed.), *Dance in a World of Change: Reflections on Globalization and Cultural Difference*, Champaign, IL: Human Kinetics, pp. 159–180.

Aposhyan, Susan (2004), *Body-Mind Psychotherapy: Principles, Techniques, and Practical Applications*, New York: W. W. Norton & Company.

——— (2007), *Natural Intelligence: Body-Mind Integration and Human Development*, Boulder, CO: Now Press.

Arnaud, Angelique and Delaumosne, L'Abbe (1893), *Delsarte System of Oratory: Including the Complete Works of M. L'Abbe Delaumosne and Mme. Angelique Arnaud (Pupils of Delsarte) with the Literary Remains of Francois Delsarte*, New York: E. S. Werner.

Arrien, Angeles (1993), *The Four-Fold Way Walking the Paths of the Warrior, Teacher, Healer and Visionary*, San Francisco, CA: HarperCollins.

Association Suisse d'Eutonie Gerda Alexander® (ASEGA) (2003), *Biography of Gerda Alexander*, pp. 1–4, http://www/eutonie.ch/. Accessed 21 May 2003.

astonkinetics.com (n.d.), 'Aston Kinetics', http://www.astonpatterning.com/. Accessed 7 January 2015.

Bachmann, Marie-Laure, Stewart, Ruth and Parlett, David (1993), *Dalcroze Today: An Education Through and Into Music*, Oxford: Oxford University Press.

Bainbridge Cohen, Bonnie (1984), 'Perceiving in Action', *Contact Quarterly*, 9: 2, pp. 24–39.

——— (1993), *Sensing, Feeling and Action*, Northampton, MA: Contact Editions.

——— (1994), *Sensing, Feeling and Action, C: The Experiential Anatomy of Body-Mind Centering*, Northampton, MA: Contact Editions.

Bainbridge Cohen, Bonnie and Mills, Marghe (1980), *Developmental Movement Therapy*, Northampton, MA: The School for Body-Mind Centering.

Bakal, Donald (2001), *Minding the Body: Clinical Uses of Somatic Awareness*, New York: Guilford Press.

Bales, Melanie and Nettl-Fiol, Rebecca (2008), *The Body Eclectic: Evolving Practices in Dance Training*, Urbana, IL: University of Illinois Press.

Ballentine, Rudolf (1996), *Radical Healing Integrating the World's Great Therapeutic Tradition to Create a New Transformative Medicine*, New York: Three Rivers Press.

Barad, Elizabeth (1994), 'Haiti Dances to a Different Drummer: A Country in Turmoil Turns to Ancient Folk Religion, with Rich Results for Dance', *Dance Magazine*, http://www.highbeam.com/doc/1G1-15651880.html. Accessed 9 September 2014.

Barber, Mark (n.d.), 'What is Aston Patterning?', http://www.ndhealingarts.com/aston-patterning. Accessed 7 January 2015.

Barlow, Wilfred (1973), *The Alexander Technique*, New York: Warner Books.

Barnard, Kathryn E. and Brazelton, T. Berry (1990), *Touch: The Foundation of Experience*, Madison, CT: International Universities Press.

Barragán Olarte, Rosana (2006–2007), 'El eterno aprendizaje del soma: Análisis de la educación somática y la comunicación del movimiento en la danza'/'The eternal learning of the soma:

Analysis of somatic education and communication of movement in dance', *Cuadernos de Música, Artes Visuales Y Artes Escénicas/Journal of Music, Visual and Performing Arts*, 3: 1, pp. 105–159.

Bartenieff, Irmgard (1970), *Four Adaptations of Effort Theory*, New York: Dance Notation Bureau.

—— (1977), *Notes from a Course in Correctives*, New York: Dance Notation Press.

—— (1980), *Body Movement: Coping with the Environment*, New York: Gordon and Breach.

Batson, Glenna (1990), 'Dancing Fully, Safely, and Expressively – The Role of the Body Therapies in Dance Training', *Journal of Physical Education, Recreation and Dance*, 1, pp. 28–31.

—— (2007), 'Revisiting Overuse Injuries in Dance in View of Motor Learning and Somatic Models of Distributed Practice', *Journal of Dance, Medicine and Science*, 11: 3, pp. 70–76.

—— (2009), 'Update on Proprioception: Considerations for Dance', *Education Journal of Dance Medicine and Science*, 13: 2, pp. 35–41.

Batson, Glenna and Schwartz, Ray Eliot (2007), 'Revisiting the Value of Somatic Education in Dance Training through an Inquiry into Practice Schedules', *Journal of Dance Education*, 7: 2, pp. 47–56.

Batson, Glenna and Wilson, Margaret (2014), *Body and Mind in Motion: Dance and Neuroscience in Conversation*, Bristol: Intellect.

Bauer, Susan (1999–2000), 'Somatic Movement Education: A Body/Mind Approach to Movement Education for Adolescents', *Somatics Journal*, Spring/Summer, pp. 38–43; Fall/Winter, pp. 38–42.

—— (2008), 'Body and Earth as One: Strengthening Our Connection to the Natural Source with EcoSomatics', *Conscious Dancer*, Spring, pp. 8–9.

Beardall, Nancy, Bergman, Stephen and Surrey, Janet (2007), *Making Connections: Building Community and Gender Dialogue in Secondary Schools*, Cambridge, MA: Educators for Social Responsibility.

Behnke, Elizabeth A. (1990), 'Friends Passing: Thomas Hanna (1928–1990)', *Prime Somatics Institute/Magazine*, http://somatics.org/library/bea-passing.html. Accessed 7 January 2015.

Bender, Susanne and Koch, Sabine (2007), *Movement Analysis – Bewegungsanalyse: The Legacy of Laban, Bartenieff, Lamb and Kestenberg*, Berlin: Logos Verlag.

Benson, Herbert (1975), *The Relaxation Response*, New York: HarperCollins.

Berceli, David ([2008] 2011), *The Revolutionary Trauma Release Process: Transcend Your Toughest Times*, Vancouver: Namaste Press.

Bergqvist, Theodor (1913), *Strödda gymnastiska notiser (1813–1913)*, Stockholm: Royal Central Gymnastic Institute.

Bernard, Andre, Steinmuller, Wolfgang and Stricker, Ursula (2006), *Ideokinesis: A Creative Approach to Human Movement & Body Alignment*, Berkeley, CA: North Atlantic Books.

Bernstein, Ran, Shafir, Tal, Tsachor, Rachelle, Studd, Karen and Schuster, Assaf (2015), 'Laban Movement Analysis using Kinect', *World Academy of Science, Engineering and Technology: International Journal of Computer, Electrical, Automation, Control and Information Engineering*, 9: 6, pp. 1532–1536.

Bersin, David (1995), 'Moving Intelligence: Interview with Gerda Alexander', in Don Hanlon Johnson (ed.), *Bone, Breath and Gesture: Practices of Embodiment*, Berkeley, CA: North Atlantic Books, pp. 255–272.

Bertherat, Therese and Bernstein, Carol (1989), *The Body Has Its Reasons: Self-Awareness through Conscious Movement*, Rochester, VT: Healing Arts Press.

Bishop, John (1995), 'Judo, Jujitsu, Aikido: What's the Difference?', http://www.kajukenboinfo.com/judoju.html. Accessed 9 September 2014.

Blackburn, Jack (2004), 'Trager Mentastics-Presence in Motion - Part 4', *Journal of Bodywork and Movement Therapies*, 8, pp. 265–277.

Blakeslee, Sandra and Blakeslee, Matthew (2008), *The Body Has a Mind of Its Own*, New York: Random House.

Bläsing, Bettina, Puttke, Martin and Schack, Thomas (2010), *The Neurocognition of Dance, Mind, Movement and Motor Skills*, New York: Psychology Press.

Block, Alan (1997), *I'm Only Bleeding: Education as the Practice of Violence Against Children*, New York: Peter Lang.

Bloom, Katya, Galanter, Margit and Reeve, Sandra (2014), *Embodied Lives: Reflections on the Influence of Suprapto Suyodarmo and Amerta Movement*, Devon: Triarchy Press.

Bluethenthal, Anne and Sontag, Jerry (n.d.), 'The Alexander Technique and the Teaching of Dance', http://www.dancestudiolife.com/alexander-technique/. Accessed 26 June 2015.

Boedicker, Freya and Boedicker, Martin (2014), 'Tai Chi Ch'uan: The Written Tradition', http://taiji-europa.eu/tai-chi-taiji/tai-chi-philosophy/tai-chi-writings/. Accessed 26 June 2015.

Bond, Mary (1993), *Balancing Your Body: A Self-Help Approach to Rolfing Movement*, Rochester, VT: Healing Arts Press.

Boulton, David (2002), 'David Boulton to John Vasconcellos', www.implicity.org/ethics. Accessed 17 May 2015.

Boydston, Jo Ann (1986), *The Later Works of John Dewey: 1925–1953*, Carbondale, IL: Southern Illinois Press.

Bradley, Karen (2008), *Rudolf Laban*, New York: Taylor and Francis.

Braude, Hillel (2015), 'Radical Somatics', in Sondra Fraleigh (ed.), *Moving Consciously*, Champaign, IL: University of Illinois Press, pp. 125–134.

Brehm, Mary Ann and McNett, Lynne (2007), *Creative Dance and Learning: Making the Kinesthetic Link*, New York: McGraw-Hill.

Breme, Christian (2012), *Embryology: Experienced Through Modeling in Clay, A Path of Exercises in 7 Stages*, Chatham, NY: Waldorf Publications.

Brinson, Peter (1991), *Dance as Education: Towards a National Dance Culture*, Binsted, UK: Dance Books.

Brockman, Jeff (2001), 'A Somatic Epistemology for Education', *The Educational Forum*, 65, pp. 328–334.

Brodie, Julie and Lobel, Elin Elizabeth (2004), 'Integrating Fundamental Principles of Somatics Practices into the Dance Technique Class', *Journal of Dance Education*, 4: 3, pp. 80–87.

——— (2012), *Dance and Somatics: Mind-Body Prinicples of Teaching and Performance*, Jefferson, NC: McFarland & Company.

Brody, Jane (2015), 'Posture Affects Standing, and Not Just the Physical Kind', *New York Times*, 28 December.

Brook, Annie (2000), *Contact Improvisation & Body-Mind Centering: A Manual for Teaching & Learning Movement*, Boulder, CO: Ann Brook Publisher.

—— (2001), *From Conception to Crawling: Foundations for Developmental Movement*, Boulder, CO: Ann Brook Publisher.

Brown, Beverly (1971–1972), 'Training to Dance with Erick Hawkins', *Dance Scope*, Fall/Winter, pp. 8–30.

Bruser, Madeline (1997), *The Art of Practicing: A Guide to Making Music from the Heart*, New York: Bell Tower.

Buchanan, Patricia A. and Ulrich, Beverly D. (2001), 'The Feldenkrais Method: A Dynamic Approach to Changing Motor Behavior', *Research Quarterly for Exercise and Sport*, 72, pp. 315–323.

Buckwalter, Melinda (2012), 'Release – A History', *CQ Chapbook*, 3: 37, pp. 3–9.

Calais-Germaine, Blandine (1993), *Anatomy of Movement*, Seattle, WA: Eastland Press.

Calamoneri, Tanya and Eddy, Martha (2006), 'Combing the Pathways of Dance and the Body', *Dance Chronicle*, 29: 2, pp. 249–255.

Caldwell, Christine (1996), *Getting our Bodies Back*, Boston, MA: Shambhala.

Calouste Gulbenkian Foundation (1980), *Dance Education and Training in Britain*, London: Calouste Gulbenkian Foundation.

Calvert, Robert Noah (2002), *The History of Massage*, Rochester, VT: Healing Arts Press.

Cantell, Marya, McGehee, Darcy and Eddy, Martha (2004), 'The Usefulness of Qualitative Observation in Complementing to Standardized Motor Assessments in Children with Developmental Delays', *ADTA 39th Annual Conference*, American Dance Therapy Association, New Orleans, LA, 6–9 October.

Cantieni, Benita (2012), *Tiger Feeling: The Back Program for Men and Women. No More Back Pain*, Munich: SuedWest and Random House.

Carlsson-Paige, Nancy (2008), *Taking Back Childhood – Helping Your Kids Thrive in a Fast-Paced, Media-Saturated, Violence-Filled World*, London: Hudson Street Press.

Carmona, Victoria (1990), 'In Memory of Thomas Hanna', *Massage*, November/December, p. 73, https://somatics.org/library/mm-inmemoryofhanna.html. Accessed 3 January 2015.

Carrington, Walter (1970), 'Balance as a Function of Intelligence', *Systematics*, 7: 4, pp. 295–306.

Cavanaugh, Carol (2005), 'Beyond Relaxation: The Work of Milton Trager', *Yoga Journal*, http://www.tragerus.org/index.php?option=com_content&view=article&id=32%3Abeyond-relaxation-work-of-milton-trager&catid=11%3Arelaxation&Itemid=22. Accessed 3 January 2015.

Centered Riding, Inc. (n.d.), 'Welcome to Centered Riding!', http://www.centeredriding.org/. Accessed 21 May 2015.

Cheever, Olivia (2000), 'Connected Knowing and Somatic Empathy among Somatic Education and Students of Somatic Education', *ReVisio*, Spring, pp. 15–23.

Chiate, Barry, Eddy, Martha and Suggs, Jeannne (2016), *EyeOpeners*, [DVD], New York: www.EyesOpenMinds.

Chopra, Deepak (2015), 'Is Enlightenment the New Normal?', https://www.deepakchopra.com/blog/article/5414. Accessed 1 November 2015.

Chopra, Deepak and Tanzi, Rudolph (2015), *Super Genes: Unlock the Astonishing Power of Your DNA for Optimum Health and Well-Being*, New York: Harmony Books.

Chrisman, Linda and Frey, Rebecca (2005), 'Movement Therapy', *Gale Encyclopedia of Alternative Medicine*, Michigan: Gale Group, http://www.healthline.com/galecontent/movement-therapy. Accessed 3 April 2013.

Chutroo, Barbara (2007), 'The Drive to Be Whole: A Developmental Model Inspired by Paul Schilder and Lauretta Bender in Support of Holistic Treatment Strategies', *The Arts in Psychotherapy*, 34, pp. 409–419.

Claid, Emilyn (2006), *Yes? No! Maybe ... Seductive Ambiguity in Dance*, London: Routledge.

Clarke, G. (2002), in person conversation with Sara Reed, unpublished.

Clias, Peter Heinrich (1825), *An Elementary Course of Gymnastic Exercises Intended to Develop and Improve the Physical Powers of Man: With the Report Made to the Medical Faculty of Paris on the Subject* (4th ed.), London: Sherwood, Gilbert and Piper, http://archive.org/stream/anelementarycou00cliagoog#page/n8/mode/2up. Accessed 21 May 2015.

Clough, Rosemary (n.d.), 'Creative Kids Yoga', http://www.creativeKidYoga.com. Accessed 1 July 2015.

Cohen, Kenneth S. (n.d.), 'What Is Qigong?', http://www.qigonghealing.com/qigong/qigong.html. Accessed 9 September 2014.

Cohen, Lorenzo (2006), 'Yoga Improves Quality of Life during Radiation', *Journal of Clinical Oncology, ASCO Annual Meeting Proceedings, Part 1*, 24: 18, p. 8505.

Cohen, Michael M. (1999), *Complementary & Alternative Medicine Legal Boundaries and Regulatory Perspectives*, Baltimore, MD: Johns Hopkins University.

Cole, Christine (2015), 'The Motor Sensory Loop: Six Ways In and Out of the Synapse', paper presented at *Body-Mind Centering Conference 2015*, Portland, OR, 25 July.

Cole, Jonathan (1998), *About Face*, Cambridge, MA: MIT Press.

Conrad, D'oud (n.d.), *Life on Land*, Santa Barbara, CA: Continuum.

Couch, Nena (2012), 'Pauline Sherwood Townsend: American proponent of Expression and Pageantry', in P. Fryer (ed.), *Women in the Arts in the Belle Epoque: Essays on Influential Artists, Writers and Performers (1890–1910)*, Jefferson, NC: McFarland & Company, pp. 28–47.

Cowan, Thomas S. and McMillan, Jaimen (2004), *The Fourfold Path to Healing: Working with the Laws of Nutrition, Therapeutics, Movement and Meditation in the Art of Medicine*, White Plains, MD: New Trends Publishing.

Cozolino, Louis (2006), *The Neuroscience of Human Relationships: Attachment and the Developing Social Brain*, New York: Norton & Co.

Cranz, Galen (1998), *The Chair: Rethinking Culture, Body, and Design*, New York: W. W. Norton & Company.

Crossman, Alan R. and Neary, David (2005), *Neuroanatomy: An Illustrated Colour Text* (3rd ed.), Philadelphia, PA: Churchill Livingstone.

Czikszentmihalyi, Mihaly (1996), *Creativity: Flow and the Psychology of Discovery and Invention*, New York: HarperCollins.

Csikszentmihalyi, Mihaly and Csikszentmihalyi, Isabella (1992), *Optimal Experience: Psychological Studies of Flow in Consciousness*, Cambridge: Cambridge University Press.

Cuckson, Marie and Reitterer, H. (1993), 'Bodenwieser, Gertrud (1890–1959)', *Australian Dictionary of Biography*, Canberra: National Centre of Biography, Australian National University, http://adb.anu.edu.au/biography/bodenwieser-gertrud-9532/text16785, Accessed 2 November 2015.

Dalai Lama and Cutler, Howard C. (1998), *The Art of Happiness: A Handbook for Living*, New York: Riverhead.

Damasio, Antonio (1994), *Descartes' Error: Emotion, Reason and the Human Brain*, New York: G. P. Putnam.

—— (2000), *The Feeling of What Happens: Body and Emotion in the Making of Consciousness*, New York: Mariner Books.

—— (2010), *Self Comes to Mind: Constructing the Conscious Brain*, New York: Vintage.

Dart, Raymond A. (1950), 'Voluntary Musculature of the Human Body: The Double-Spiral Arrangement', in Raymond A. Dart (ed.), *Skill and Poise: Articles of Skill, Poise and the F. M. Alexander Technique*, London: STAT Books, pp. 57–72.

Dass, Ram (2000), *Still Here: Embracing Aging, Changing and Dying*, New York: Riverhead Books.

Davis, Bridget Iona (1974), 'Releasing into Process: Joan Skinner and the Use of Imagery in Dance', MA thesis, Urbana, IL: University of Illinois Urbana-Champaign.

Davis, Martha (1987), 'Observer Reliability', *Movement Studies*, 2, pp. 7–19.

DeGiorgi, Margherita (2015), 'Shaping the Living Body: Paradigms of Soma and Authority in Thomas Hanna's Writings', *Brazilian Journal on Presence Studies*, 5: 1, pp. 54–84.

Dellon, Gabriel and Bower, Archibald (1819), *An Account of the Inquisition at Goa in India*, Pittsburg, PA: R. Patterson and Lambdin.

Deutsch, Judith and Anderson, Ellen (2008), *Complementary Therapies for Physical Therapy: A Clinical Decision Making Approach*, St Louis, MI: Saunders Elsevier.

Dewey, John (1932), 'Introduction', in Frederick Matthias Alexander (ed.), *The Use of the Self*, London: Orion Books.

Diamond, Debra (2013), *Yoga: The Art of Transformation*, Washington, DC: Smithsonian Museums of Asian Art.

Dilley, Barbara (2015), *This Very Moment: Teaching, Thinking, Dancing*, Boulder, CO: Naropa University Press.

Dimon, Theodore Jr. (2003), *The Elements of Skill: A Conscious Approach to Learning*, Berkeley, CA: North Atlantic Books.

—— (2011), *The Body in Motion: Its Evolution and Design*, Berkeley, CA: North Atlantic Books.

Dispenza, Joe (2007), *Evolve Your Brain: The Science of Changing Your Mind*, Deerfield Beach, FL: Health Communications, Inc.

Doing, Ruth (1932), 'Rhythm and the Dance in Child Development', *Rhythms*; Reprint from *Progressive Education*, IX: 4, paper presented at Baltimore, 19 February.

Douglas, Bill (2002), *The Complete Idiot's Guide to T'ai Chi and Qigong*, Upper Saddle River, NJ: Pearson Education.

Dowd, Irene (1981), *Taking Root to Fly: Articles in Functional Anatomy*, Northampton, MA: Contact Editions.

Dragon, Donna A. (2008), 'Toward an Embodied Education 1850s–2007: A Historical, Cultural, Theoretical and Methodical Perspectives Impacting Somatic Education in United States Higher Education Dance', PhD dissertation, Temple University.

—— (2015), 'Creating Cultures of Teaching and Learning Conveying Dance and Somatic Education Pedagogy', *Journal of Dance Education*, 15, pp. 25–32.

Drake, Jonathan (1996), *The Alexander Technique in Everyday Life*, London: Thorsons.

Draper, E. (2002), 'A Teacher of Dancing', *Gurdjieff International Review*, 5: 1, pp. 1–72, http://www.bythewaybooks.com/cgi-bin/btw455/7288.html?id=7QZEEYk3. Accessed 7 January 2015.

Duhigg, Charles (2014), *The Power of Habit: Why We Do What We Do in Life and Business*, New York: Random House.

Duncan, Isadora (1927), *My Life*, Garden City, NY: Garden City Publishing.

Dunham, Katherine (1969), *Island Possessed*, Chicago, IL: University of Chicago Press.

Durivage, F. (1871), 'Delsarte', *Atlantic Monthly*, Boston, MA: Houghton, Mifflin & Co.

Dyer, Becky (2009a), 'Increasing Psychosomatic Understanding through Laban Movement Analysis and Somatic Oriented Frameworks: Connections of Performance Processes to Knowledge Construction', in Lynette Young Overby and Billi Lepyzyk (eds), *Dance: Current Selected Research*, Vol. 7, Brooklyn, NY: AMS Press, pp. 59–81.

—— (2009b), 'Theories of Somatic Epistemology: An Inspiration for Somatic Approaches to Teaching Dance and Movement Education', *Somatics: Magazine-Journal of the Bodily Arts and Sciences*, 16: 1, pp. 24–39.

Dyer, Becky and Löytönen, Teija (2012), 'Engaging Dialogue: Co-creating Communities of Collaborative Inquiry', *Research in Dance Education*, 13: 1, pp. 121–147.

Dyke, Dorit (1989), *Total Body Fitness: Conference Proceeding of the Personal Fitness & Bodywork Professionals Association*, 1: 7, New York.

Eddy, Martha (1984), 'Children, Vision and Movement', *Contact Quarterly Movement Journal*, 2, pp. 48–49.

—— (ed.) (1990), *Laban Movement Analysis Compendium of Terminology*, New York: Laban/Bartenieff Institute of Movement Studies.

—— (1991), 'Past Beginnings: Bartenieff Fundamentals and Perceptual-Motor Theory', *Movement News*, 16, pp. 12–15.

—— (1992a), 'BodyMind Dancing', in Susan Loman and Rosemary Brandt (eds), *The Body-Mind Connection in Human Movement Analysis*, Keene, NH: Antioch New England University Press, pp. 203–227.

—— (1992b), 'Overview of the Science and Somatics of Dance', *Kinesiology and Medicine for Dance*, 14: 1, pp. 20–28.

—— (1992c), 'The Physiological Underpinnings of Effort', *Movement News*, 17, New York: Laban/Bartenieff Institute of Movement Studies, pp. 5–6.

—— (1993), 'The Use of Kestenberg Movement Profile in Gender Analysis', *Movement Studies: Cultural Diversity*, 1, p. 5.

—— (1995a), 'Holistic Approaches to Dance Injury Assessment and Intervention', *Impulse: The Journal of Dance Science, Medicine and Education*, 3: 4, pp. 270–279.

—— (1995b), 'Movement Communicates: Overview of Dance and Somatic Education Approaches to Non-verbal Communication', paper and workshop at *International Somatics Congress: The Living Body*, San Franciso, CA, 18 October.

—— (1995c), 'Spirituality at School', occasional paper presented at Moving on Center, Oakland, CA, http://www.wellnesscke.net/downloadables/Spirituality-at-School.pdf. Accessed 7 January 2015.

—— (1996), 'The Educational Mission of Moving on Center: A Radical Curriculum', http://www.movingoncenter.org/Articles.htm. Accessed 7 January 2015.

—— (1997), 'Another Way of Looking', *Performance Journal*, 14, p. 22.

—— (1998), *The Role of Physical Activity in Educational Violence Prevention Programs for Youth*, Ann Arbor, MI: UMI Research Press.

—— (2000a), 'Access to Somatic Theories and Applications: Socio-Political Concerns', *Proceedings of the International Joint Conference: Dancing in the Millennium*, Washington, DC, 19–23 July, pp. 144–148.

—— (2000b), 'Body Cues and Conflict: Somatic Approaches to Violence Prevention', *National Dance Association Conference Proceedings*, Reston, VA.

—— (2000c), 'Developing a Perceptual Motor Screen for Quantitative and Qualitative Assessment', *Currents: Journal of The Body-Mind Centering Association*, 3: 1, pp. 14–23.

—— (2000d), 'Movement Activities for Conflict Resolution', *The Fourth R*, 92, pp. 13–16.

—— (ed.) (2001a), *Conflict Resolution through Dance & Movement*, North Chelmsford, MA: Anthology Pro/Xanedu Press.

—— (2002a), 'Dance and Somatic Inquiry in Studios and Community Dance Programs', *Journal of Dance Education*, 2, pp. 119–127.

—— (2002b), 'Research in Somatic Movement Education and Therapy', White Paper, *Report of the White House Commission on Complementary and Alternative Medicine: Final Report*, Washington, DC: White House Commission.

—— (2002c), 'Somatic Practices and Dance: Global influences', *Dance Research Journal*, 34, pp. 46–62.

—— (2003), 'One View of the Somatic Elephant', *Dynamic Embodiment SMTT Curricular Papers*, New York: Moving on Center.

—— (2004), 'Somatic Awareness and Dance', *Dynamic Embodiment Curricular Papers*, New York, unpublished.

—— (2005), 'Spirituality at School', *Somatics: Magazine-Journal of the Bodily Arts and Sciences*, 14: 4, pp. 22–24, http://www.wellnesscke.net/downloadables/Spirituality-at-School.pdf. Accessed 7 January 2015.

—— ([2005] 2011), *Perceptual-Motor Development: Experiential Perspectives from Bartenieff Fundamentals, Body-Mind Centering and Other Somatic Disciplines* (3rd ed.), North Chelmsford, MA: Anthology Pro/Xanedu Press.

—— (2006a), 'A Radical Curriculum', http://www.movingoncenter.org/Articles.htm#radical. Accessed 14 December 2014.

—— (2006b), 'The Practical Application of Body-Mind Centering® (BMC) in Dance Pedagogy', *Journal of Dance Education*, 6: 3, pp. 86–91.

—— (2007), 'A Balanced Brain', *SPINS Newszine*, 3: 1, pp. 7–8.

—— (2008), *Laban Movement Analysis Course Reader*, New York: Barnard College.

—— (2009a), 'A Brief History of Somatic Practices and Dance: Historical Development of the Field of Somatic Education and its Relationship to Dance', *Journal of Dance & Somatic Practices*, 1: 1, pp. 5–27.

—— (2009b), 'The Role of Dance in Violence Prevention Programs for Youth', in Lynette Young Overby and Billie Lepczyk (eds), *Dance: Current Selected Research*, Vol. 7, New York: AMS Press, pp. 93–143.

—— (2010a), 'The Role of the Arts in Community Building', *Currents: Journal of The Body-Mind Centering Association*, 13: 1, pp. 5–9.

—— (2010c), 'The Role of the Arts in Healing Trauma in Communities', in Gill Wright Miller, Pat Ethridge and Kate Tarlow Morgan (eds), *Exploring Body-Mind Centering*, Berkeley, CA: North Atlantic Books, pp. 391–398.

—— (2011), 'Contemporary Movement Choirs – Dance in Public Space Connecting People, Place, and Sometimes "Issues"', Global Water Dances, http://globalwaterdances.org/choreos/docs/Contemporary%20Movement%20Choirs.pdf. Accessed 27 June 2015.

—— (2012a), 'The Ongoing Development of "Past Beginnings": A Further Discussion of Neuro-Motor Development: Somatic Links between Bartenieff Fundamentals, Body-Mind Centering® and Dynamic Embodiment™', *The Journal of Laban Movement Studies*, 3: 1, pp. 54–79.

—— (2012b), 'The Socially Conscious Body', paper presented at Hampshire College, Five College Dance Department, Amherst, MA, 15 October, https://www.youtube.com/watch?v=mVwJg1quwpk. Accessed 12 March 2016.

—— (2013), 'Somatic Awareness & Dance: Applying Body Mind Dancing Concepts through the Life Span', personal paper, unpublished.

—— (2014), *This Old House*, YouTube, https://www.youtube.com/watch?v=6_wXimMypqU. Accessed 14 January 2016.

—— (2015), 'Early Trends: Where Soma and Dance Began to Meet – Keeping the Meeting Alive', in Sarah Whatley, Natalie. G. Brown and Kirsty Alexander (eds), *Attending to Movement: Somatic Perspectives on Living in This World*, London: Triarchy Press, pp. 285–292.

—— (forthcoming), 'Dancing Solutions to Conflict: Field-tested Somatic Dance for Peace', *Journal of Dance Education*.

—— (forthcoming), *Somatic Awareness and Dance*, Chamapagne, IL: Human Kinetics Press.

Eddy, Martha and Becker, Svea (1993), 'The Effect of Bartenieff Fundamentals on Range of Motion of the Ilio-Femoral Joint for Dancers', *Research Quarterly for Exercise and Sport*, 64, Supplement, pp. A–22.

Eddy, Martha and Calamoneri, Tanya (2006), 'Combining the Pathways of Dance and the Body: Book Review, *Dancing Identity: Metaphysics in Motion* by Sondra Fraleigh', *Dance Chronicle*, 29: 2, pp. 249–255.

Eddy, Martha and Lyons, Scott (2002), *Somatic Movement Therapy with Children*, New York: Center for Kinesthetic Education, http://www.WellnessCKE.org. Accessed 5 June 2015.

Eddy, Martha and Martin, Lynn (1986), 'Designing Fitness Programs', *Movement Studies: Sports and Fitness*, 2, pp. 5–6.

Eddy, Martha and Smith, Shakti (2015), *Glandular Balancing Through the Sun Salutation: A Holistic Approach to Health*, New York: Dynamic Embodiment SMTT.

Eddy, Martha and Suggs, Jeanne (2014), *Viva! Movimiento Para La Vida. Ejercicios y Bailando Para Sobrevientes de Cancer de Seno/Moving For Life: DanceExercise for Breast Cancer Survivors*, [DVD], New York: Moving for Life, http://www.MovingForLife.org. Accessed 25 September 2015.

Eddy, Martha, Swann, Carol, Weaver, Jon with Hackney, Peggy (2005–2010), *Selected Readings in Participatory Arts: Studies of the Body, Somatics, Culture, Creativity, Dance, Movement and Social Action*, Oakland CA: Moving On Center.

Eddy, Martha, Williamson, Amanda and Weber, Rebecca (2014), 'Reflections on the Spiritual Dimensions of Somatic Movement Dance Education', in Amanda Williamson, Glenna Batson,

Sarah Whatley and Rebecca Weber (eds), *Dance, Somatics and Spiritualities: Contemporary Sacred Narratives*, Bristol: Intellect, pp. 159–194.

Eddy, Martha and Whitacre, Joan (1984), 'The Uses of Bartenieff Fundamentals of Movement', *Conference Proceedings: LMA Conference at Rutgers*, Laban/Bartenieff Institute of Movement Studies, New York, 14–16 June.

Eddy, Martha and Zak, Eyen (2011), 'Conscious Fitness', *Epoch Times*, 12 July.

Eddy, Norman (1997), Notes found in *Selected Readings in Participatory Arts – Studies of the Body, Somatics, Culture, Creativity, Dance, Movement and Social Action*.

———— (2002), 'The Great Spirit, Chi and the Teachings of Jesus', personal paper, New York: N. C. Eddy Estate/Burke Library Columbia University.

Eisenberg, David M. (2001), 'Report on Complementary and Alternative Medicine in the United States: Overview and Patterns of Use', *Journal of Alternative and Complementary Medicine*, 7: 1, pp. 19–21.

Eisenberg, David M., Davis, Roger B., Ettner, Susan L., Appel, Scott, Wilkey, Sonja, Van Rompay, Maria, Kessler, Ronald C. (1998), 'Trends in Alternative Medicine Use in the United States, 1990–1997: Results of a Follow-Up National Survey', *Journal of the American Medical Association*, 280: 18, pp. 1569–1575.

Ekenberg, Anna, Haglund, Lotta, Jäppinen, Karin and Karlsson, Helene (2013), 'The Oldest Sports Library in the World Celebrates 200 Years', *Journal of the European Association for Health Information and Libraries*, 9, pp. 1–5.

Ellingson, Lyndall (2010), 'Women's Somatic Styles: Rethinking Breast Self-Examination Education', *Health Care for Women International*, 24: 9, pp. 759–772.

Emerson, Charles Wesley (1981), *Physical Culture of Emerson College of Oratory Boston*, Boston, MA: Emerson College.

Emslie, Manny (2002), *The Secret Life of the Creative Self*, Liverpool, UK: John Moores University.

———— (2006), 'Developing the Dance Performer as an Experiential and Dynamic Physical Self', paper presented at *The Changing Body: Symposium*, Department of Drama, University of Exeter, 6–8 January.

———— (2010), 'Skinner Releasing Technique: Dancing from Within', *Journal of Dance & Somatic Practices*, 1: 2, pp. 169–175.

Enghauser, Rebecca (2007a), 'Developing Listening Bodies in the Dance Technique Class', *Journal of Physical Education, Recreation and Dance*, 78: 6, pp. 33–37, 54.

———— (2007b), 'The Quest for an Eco-Somatic Approach to Dance Pedagogy', *Journal of Dance Education*, 7: 3, pp. 80–90.

Engs, Ruth (2003), *The Progressive Health Reform Movement*, Santa Barbara, CA: Praeger.

Erkert, Jan (2003), *Harnessing the Wind: The Art of Teaching Modern Dance*, Champaign, IL: Human Kinetics.

Essig, Todd (2013), 'Breast Cancer Dance Parties with Beyoncé are Even Better after Surgery', http://www.forbes.com/sites/toddessig/2013/11/10/breast-cancer-dance-parties-with-beyonce-are-even-better-after-surgery/. Accessed 2 January 2015.

Ethridge, Pat, Miller, Gill Wright and Morgan, Kate Tarlow (eds) (2011), *Exploring Body-Mind Centering: An Anthology of Experience and Method*, Berkeley, CA: North Atlantic Books.

Eutonie Gerda Alexander (2002–2014), http://www.eutonie.ch/. Accessed 8 January 2015.

Feitis, Rosemary (1995), 'Introduction to "Ida Rolf Talks about Rolfing and Physical Reality"', in Don Hanlon Johnson (ed.), *Bone, Breath and Gesture: Practices of Embodiment*, Berkeley, CA: North Atlantic Books, pp. 151–170.

Feldenkrais Commentary (n.d.), 'Research Goldfarb Podcast: Feldenkrais Podcast #4', http://utahfeldenkrais.org/blog/2007/02/feldenkrais-podcast-4-dr-larry-goldfarb discusses-feldenkrais-research/. Accessed 17 September 2009.

Feldenkrais Guild of North America (2002), *Learning by Doing: A History*, Seattle, WA: FGNA.

Feldenkrais Method of Somatic Education (2006), 'Horseback Riding', http://www.feldenkrais.com/article_content.asp?edition=1§ion=27&article=37. Accessed 31 December 2014.

Feldenkrais, Moshe (1949), *Body and Mature Behavior*, New York: International Universities Press.

—— (1972), *Awareness through Movement: Health Exercises for Personal Growth*, New York: Harper & Row.

—— (1977), *Body Awareness as Healing Therapy: The Case of Nora*, Berkeley, CA: Frog Ltd.

—— (1989), *The Elusive Obvious*, Capitola, CA: Meta Publications.

—— (1992), *The Potent Self: A Guide to Spontaneity*, San Francisco, CA: Harper San Francisco.

—— (1993), *Body Awareness as Healing Therapy: The Case of Nora* (2nd ed.), Berkeley, CA: Somatic Resources and Frog Ltd.

—— (1997), *Awareness through Movement: Health Exercises for Personal Growth*, New York: Harper & Row.

—— (2001), *The Master Moves*, Soquel, CA: Meta Publications.

Fernandez Moliner, Sylvia (2007), *Universo, Vida. Emoción y Danza*, Mexico City: Cynthia Jeannette.

Fitt, Sally Sevey (1996), *Dance Kinesiology* (2nd ed.), New York: Schirmer Books.

Fitzgerald, Ara (2012), 'Experimental Dancers Reunite – A 45 Year Reunion of Dancers of the Experimental Movement Lab at Connecticut College', *Realize Magazine*, http://www.realizemagazine.com/content/experimental-dancers-reunite. Accessed 2 January 2015.

Flatt, Kate (1977), 'New Project and Late Collection', *New Dance*, 1, pp. 7–8.

Ford, Clyde (1989), *Where Healing Waters Meet: Touching Mind and Emotion through the Body*, Barrytown, NY: Station Hill Press.

—— (1993), *Compassionate Touch: The Role of Human Touch in Healing and Recovery*, New York: Simon & Schuster.

Forti, Simone (1974), *Handbook in Motion: An Account of an Ongoing Personal Discourse and Its Manifestations in Dance*, New York: New York University Press.

Fortin, Judy (2009), 'Television Special: Moving On Aerobics Rebranded as *Moving for Life/Moving On from Cancer*®', February, USA: Cable News Network (CNN).

Fortin, Sylvie (1993), 'When Dance Science and Somatic Enter the Dance Technique Class', *Kinesiology and Medicine for Dance*, 4: 1, pp. 3–19.

—— (1995), 'Towards a New Generation: Somatic Dance Education in Academia', *Impulse: The International Journal of Dance Science, Medicine and Education*, 3: 4, pp. 253–262.

—— (1998), 'Somatics: A Tool for Empowering Dance Teachers', in Sherry Shapiro (ed.), *Dance, Power and Difference: Critical and Feminist Perspectives on Dance Education*, Champaign, IL: Human Kinetics, pp. 49–71.

Fortin, Sylvie and Girard, Fernande (2005), '"Dancers" Application of the Alexander Technique', *Journal of Dance Education*, 5: 4, pp. 125–131.

Fortin, Sylvie and Siedentop, Daryl (1995), 'The Interplay of Knowledge and Practice in Dance Teaching: What We Can Learn from a Non-Traditional Dance Teacher', *Dance Research Journal*, 27: 2, pp. 3–15.

Fortin, Sylvie and Vanasse, Chantal (2011), 'The Feldenkrais Method and Women with Eating Disorders', *Journal of Dance & Somatic Practices*, 3: 1&2, pp. 127–141.

Fortin, Sylvie, Vieria, Adriane and Tremblay, Martyne (2009), 'The Experience of Discourses in Dance and Somatics', *Journal of Dance & Somatic Practices*, 1: 1, pp. 47–64.

Foster, Mary Ann (2007), *Somatic Patterning: How to Improve Posture and Movement and Ease Pain*, Longmont, CO: EMS Press.

Fowler, Clare (2003), 'Book Review: *Visceral Sensory Neuroscience: Interoception*', *Brain: A Journal of Neurology*, http://dx.doi.org/10.1093/brain/awg120. Accessed 22 October 2015.

Fraleigh, Sondra H. (1993), 'Good Intentions and Dancing Moments: Agency, Freedom and Self-Knowledge in Dance', in Ulrick Neisser (ed.), *The Perceived Self: Ecological and Interpersonal Sources of Self Knowledge*, Cambridge, UK: Cambridge University Press, pp. 102–111.

—— (1999), *Dancing Darkness: Butoh, Zen, and Japan*, Pittsburgh, PA: University of Pittsburgh Press.

—— (2015), *Moving Consciously: Somatic Transformations through Dance, Yoga, and Touch*, Champaign, IL: University of Illinois Press.

Frank, Kevin (2014), 'What is Rolf Movement Integration? The Challenge of Coordinative Learning', *Structural Integration*, 42: 2, pp. 40–42, http://resourcesinmovement.com/wp-content/uploads/2014/09/What-is-Rolf-Movement-and-Coordinative-Challenge.pdf. Accessed 2 November 2015.

Franklin, Eric (1996a), *Dance Imagery for Technique and Performance*, Champaign, IL: Human Kinetics.

—— (1996b), *Dynamic Alignment through Imagery*, Champaign, IL: Human Kinetics.

Freeman, Harold P. and Rodriguez, Rian L. (2011), 'History and Principles of Patient Navigation', *Cancer*, 117: 15, Supplement, pp. 3537–3540.

Freire, Paulo and Pereira, Donaldo M. (1996), *Letters to Christina: Reflections on My Life and Work*, London: Routledge.

Friedman, Philip and Eisen, Gail (1980), *The Pilates Method of Physical and Mental Conditioning*, Garden City, NY: Doubleday & Company.

Friedman, Richard A. (2015), 'Can You Get Smarter? Health Review', *New York Times*, 25 October, http://www.nytimes.com/2015/10/25/opinion/sunday/can-you-get-smarter.html Accessed 26 October 2015.

Frye, Paul (ed.) (2012), *Women in the Arts in the Belle Époque: Essays on Influential Artists, Writers and Performers (1890–1910)*, Jefferson, NC: McFarland & Company.

Fulkerson, Mary (1999), 'Release Work, History from the View of Mary Fulkerson', *Movement Research Journal*, 18, p. 4.

Galeota-Wozny, Nancy (2002), 'Ouch: Dancers Find a Path out of Pain with the Feldenkrais Method', *Dance Magazine*, 76: 11, p. 36.

Gallivan, Jason, McLean, Adam D., Valyear, Kenneth and Culham, Jody (2013), 'Decoding the Neural Mechanisms of Human Tool Use', *ELife*, pp. 1–29, http://www.ncbi.nlm.nih.gov/pmc/articles/PMC3667577/pdf/elife00425.pdf. Accessed 15 July 2015.

Galvao, Daniel A. and Newton, Robert U. (2005), 'Review of Exercise Intervention Studies in Cancer Patients', *Journal of Clinical Oncology*, 23: 4, pp. 899–909.

Gardner, Howard (1983), *Frames of Mind: The Theory of Multiple Intelligences*, New York: Basic Books.

——— (1993), *Creating Minds: An Anatomy of Creativity Seen through the Lives of Freud, Einstein, Picasso, Stravinsky, Eliot, Graham, and Gandhi*, New York: Basic Books/Perseus Book Group.

Gay, Michelle (2009), *Brain Breaks for the Classroom: Quick and Easy Breathing and Movement Activities that Help Students Reenergize, Refocus, and Boost Brain Power-Anytime of the Day*, Secaucus, NJ: Scholastic.

Gaynor, Mitchell (2015), *The Gene Therapy Plan: Taking Control of Your Genetic Destiny with Diet and Lifestyle*, New York: Viking Press.

Geddes, Linda (2009), 'Brain Could Adapt Well to Cyborg Enhancements', *New Scientist Magazine*, 22 June.

Gelb, Michael ([1981] 1994), *Body Learning: An Introduction to the Alexander Technique*, New York: Holt & Co.

Gendlin, Eugene (1982), *Focusing*, New York: Bantam Books.

Georgii, Karl A. (1850), *A Few Words on Kinesipathy, or Swedish Medical Gymnastics: The Application of Active and Passive Movements to the Cure of Disease According to the Method of P. H. Ling*, London: Hippolyte Bailliere.

——— (1852), *The Movement Cure*, London: Hippolyte Bailliere.

Germer, Mark (2010), *Handbook of Music and Emotion: Theory, Research, Applications* (eds Patrik Juslin and John A. Sloboda), Oxford: Oxford University Press.

Gesell, Arnold (1934), *An Atlas of Infant Behavior*, New Haven, CT: Yale University Press.

——— (1943), *The Infant and Child in the Culture of Today*, New York: Harper & Row.

Geuter, Ulfried, Heller, Michael and Weaver, Judyth (2010), 'Elsa Gindler and Her Influence on William Reich and Body Psychotherapy', *Body, Movement & Dance in Psychotherapy – An International Journal for Theory, Research and Practice*, 5: 1, pp. 59–73.

Gilmore, Robin (2005), *What Every Dancer Needs to Know about the Body: A Workbook of Body Mapping and the Alexander Technique*, Portland, OR: Andover Press.

Gladwell, Malcolm (2006), 'What the Dog Saw', *The New Yorker*, 22 May, p. 48.

Glass, Barbara (2007), 'Global Steps: African Influences in Modern Dance', http://globalsteps.blogspot.com/2007/01/african-movement-vocabulary_5519.html. Accessed 26 June 2015.

Goddard, Sally (1996), *A Teacher's Window into the Child's Mind: And Papers from the Institute for Neuro-Physiological Psychology*, Eugene, OR: Fern Ridge Press.

——— (2002), *Reflexes Learning and Behavior: A Window into the Child's Mind: A Non-Invasive Approach to Solving Learning & Behavior Problems*, Eugene, OR: Fern Ridge Press.

Goddard Blythe, Sally (2003), *The Well-Balanced Child: Movement and Early Learning*, Stroud, UK: Hawthorn Press.

—— (2007), *What Babies and Children Really Need: How Mothers and Fathers Can Nurture Children's Growth for Health and Wellbeing*, Stroud, UK: Hawthorn Press.

—— (2009), *Attention, Balance and Coordination: The A, B, C of Learning Success*, Hoboken, NJ: Wiley-Blackwell.

—— (2011), *The Genius of Natural Childhood: Secrets of Thriving Children*, Stroud, UK: Hawthorn Press.

Godfrey, Phoebe and Torres, Denise (eds) (2016), *Emergent Possibilities for Global Sustainability: Intersections of Race, Class and Gender*, New York: Routledge.

Goldberg, Marian (2001), 'The Alexander Technique: The Insiders' Guide', Alexander Technique Center of Washington, http://www.alexandercenter.com/index.html. Accessed 5 October 2015.

Goldman, Ellen (1994), *As Others See Us: Body Movement and the Art of Successful Communication*, New York: Gordon and Breach.

—— (2008), *The Geometry of Movement: The Structure of Communication*, New York: Goldman Associates.

Goleman, Daniel (1995), *Emotional Intelligence: Why It Can Matter More than IQ*, New York: Bantam.

—— (2009), *Ecological Intelligence*, New York: Broadway Books.

Gomez, Ninoska (1988), *Movement, Body and Awareness: Exploring Somatic Processes*, Costa Rica: Gomez.

Goodchild, Sargent L., Jr. (2010), 'Neurological Reorganization for Brain Injury: The Relationship of Structure and Function with Therapeutic Applications', *Autism One Media*, The Autism File USA, http://podbay.fm/show/419215767/e/1282028400?autostart=1. Accessed 20 November 2015.

Gooden, Alicia (1997), 'Unusual Showcase Melds Art and Science of Body', *Oakland Tribune*, http://www.movingoncenter.org/Articles.htm. Accessed 7 January 2015.

Graham, George, Holt, Shirley Ann Hale and Parker, Melissa Graham (2001), *Children Moving: A Reflective Approach to Teaching Physical Education* (5th ed.), New York: McGraw-Hill Humanities/Social Sciences/Languages.

Grandin, Temple (2006), *Thinking in Pictures: My Life with Autism*, New York: Vintage.

Greater Good (2015), 'Mindfulness in Education Research Hightlights', Berkeley, CA: Greater Good, http://greatergood.berkeley.edu/images/uploads/Mindfulness_in_Education_Research_Highlights.pdf. Accessed 25 October 2015.

Green, Jill (2002), 'Somatics: A Growing and Changing Field', *Journal of Dance Education*, 2: 4, p. 113.

—— (2007), 'Student Bodies: Dance Pedagogy and the Soma', in Liora Bresler (ed.), *International Handbook of Research in Arts Education*, Dordrecht: Springer International, pp. 1119–1132.

Green, Martin (1986), *Mountain of Truth: The Counterculture Begins Ascona 1900–1920*, Medford, MA: Tufts University.

Greene, Maxine (1995), *Releasing the Imagination: Essays on Education, the Arts, and Social Change*, San Francisco, CA: Jossey-Bass Publishers.

Green Gilbert, Anne (2002), 'Somatic Knowledge: The Body as Content and Methodology in Dance Education', *Journal of Dance Education*, 2, pp. 113–118.

—— (2006), *Brain-Compatible Dance Education*, Reston, VA: National Dance Association.

—— (2016), Brain Dance: Move your Body, Grow your Mind, [DVD], Seattle, WA: CreativeDance.org.

Grey, John (1990), *The Alexander Technique: A Complete Course in How to Hold and Use Your Body for Maximum Energy*, New York: Saint Martin's Press.

Griffin, Tim (2003), 'Exhibition Review: *Trisha Brown: Dance and Art in Dialogue 1961–2001*, An Exhibition of the Works of Trisha Brown at Addison Gallery of American Art in Massachusetts', *Artforum*, 4: 42, p. 142.

Grunwald, Peter (2004), *EyeBody: The Art of Integrating Eye Brain and Body*, Wellington: EyeBody Press.

Guest, Ann Hutchinson (1983), *Your Move: A New Approach to the Study of Movement and Dance*, New York: Gordon and Breach.

Guild for Structural Integration (n.d.), 'History of Ida P. Rolf, PhD: 19 May 1896–19 March 1979', http://www.rolfguild.org/about/ida-p-rolf-phd. Accessed 5 November 2002.

Guttman, Oskar (1882), *Gymnastics of the Voice for Song and Speech: Also a Method for the Cure of Stuttering and Stammering* (3rd ed.), New York: Edgar Werner, http://archive.org/details/gymnasticsvoice00guttgoog. Accessed 2 July 2015.

Haag, Marianne (2002), 'Elsa Gindler', http://www.JacobyGindler.ch/gindler.html. Accessed 12 May 2004.

Haag, Marianne and Ludwig, Sophie (2002), *Elsa Gindler: Von ihrem Leben und Wirken/Elsa Gindler: Her Life and Work*, Munich: Christians Verlag.

Hackney, Peggy (1998), *Making Connections: Total Body Integration through Bartenieff Fundamentals*, London: Gordon & Breach.

Haglund, Lotta, Ekenberg, Anna, Jäppinen, Karin and Karlsson, Heléne (2013), 'The Oldest Sports Library in the World Celebrates 200 Years', *Journal of the European Association for Health Information and Libraries*, 9: 1, pp. 10–14.

Hagood, Thomas K. (ed.) (2008), *Legacy in Dance Education: Essays and Interviews on Values, Practices, and People*, Amherst, NY: Cambria.

Halfpapp, Elisabeth and DeVito, Fred (2016), *Barre Fitness: Barre Exercises Anywhere for Flexibility, Core Strength, and a Lean Body Flexibound*, Beverly, MA: Fair Winds Press.

Halprin, Anna (1995), *Moving Toward Life: Five Decades of Transformational Dance*, Hanover and London: Wesleyan University Press.

—— (2000), *Dance as a Healing Art: Returning to Health through Movement and Imagery*, Mendocino, CA: LifeRhythm Books.

Hamlin, Richard (2011), 'Historical Background of Tai Chi Chuan', http://www.ntcca.co.uk/TaiChi/content/History.html. Accessed 21 May 2015.

Hamil, Pete (2013), *Embodied Leadership: Somatic Approach to Leadership*, Philadelphia, PA: Kogan Page Ltd.

Hammond, Holly (2007), 'Yoga's Trip to America', *Yoga Journal*, 29 August, http://www.yogajournal.com/wisdom/467. Accessed 9 September 2014.

Hanna, Eleanor Criswell (2004–2005), 'The Horse as Somatic Educator', http://www.skyhorseranch.com/wp-content/uploads/2010/07/7horseassomaticmedicine1.pdf. Accessed 31 December 2014.

Hanna, Judith Lynne (2006), *Dancing for Health: Conquering and Preventing Stress*, New York: Altamira Press.

—— (2008), 'A Nonverbal Language for Imagining and Learning: Dance Education in K-12 Curriculum', *Educational Researcher*, 37: 8, pp. 491–506.

—— (2015), *Dancing to Learn: The Brain's Cognition, Emotion, and Movement*, New York: Rowman & Littlefield.

Hanna, Thomas (1970), *Bodies in Revolt: A Primer in Somatic Thinking*, New York: Holt Reinhart.

—— (1976), 'The Field of Somatics', *Somatics: Magazine-Journal of the Bodily Arts and Sciences*, 1: 1, pp. 30–34.

—— (1977), 'The Somatic Healers and the Somatic Educators', *Somatics: Magazine-Journal of the Bodily Arts and Sciences*, 1: 3, pp. 48–53, http://somatics.org/library/htl-somatichealed. Accessed 22 June 2015.

—— (1979), *The Body of Life*, New York: Knopf.

—— (1980), *The Body of Life: Creating New Pathways for Sensory Awareness and Fluid Movement*, New York: Healing Art Press.

—— (1985), *Bodies in Revolt: A Primer in Somatic Thinking*, Novato, CA: Freeperson Press.

—— (1988), *Somatics: Reawakening the Mind's Control of Movement, Flexibility, and Health*, Cambridge, MA: Perseus Book Groups.

—— (1990–1991), 'Clinical Somatics Education: A New Discipline in the Field of Health Care', *Somatic Journal*, Autumn/Winter, pp. 4–10.

—— (1993), *The Body of Life: Creating New Pathways for Sensory Awareness and Fluid Movement*, Rochester, VT: Healing Arts Press.

—— (2004), *Somatics: Reawakening the Mind's Control of Movement, Flexibility, and Health* (2nd ed.), Cambridge, MA: Da Capo Press.

Hannaford, Carla (1995), *Smart Moves: Why Learning is Not All in Your Head*, Arlington, VA: Great Ocean Publishers.

Hardenbergh, Marylee, Bradley, Karen and Levinson, Laura (2016), 'Global Water Dances: Embodying Water Solutions', in Phoebe Godfrey and Denise Torres (eds), *Emergent Possibilities for Global Sustainability: Intersections of Race, Class and Gender*, New York: Routledge.

Hartley, Linda (1995), *The Wisdom of the Body Moving: An Introduction to Body-Mind-Centering*, Berkeley, CA: North Atlantic Books.

Hashimoto, Keizo (1977), *Sotai Natural Exercise*, Oroville, CA: Ohsawa Macrobiotic Foundation.

Hashimoto, Keizo and Kawakami, Yoshiaki (1983), *Sotai Balance and Health through Natural Movement*, Tokyo: Japan Publications.

H'Doubler, Margaret N. (1940), *Dance, a Creative Art Experience*, Madison, WI: University of Wisconsin.

—— (1946), *Movement and Its Rhythmic Structure*, Madison, WI: University of Wisconsin.

Hebert, Donald Francis (1997), 'Steele Mackaye: Actor Training Methods', PhD dissertation, Texas Tech University.

Heckler, Richard Strozzi (1993), *The Anatomy of Change: A Way to Move through Life's Transitions*, Berkeley, CA: North Atlantic Books.

——— (1997), *Holding the Center Sanctuary in the Time of Confusion: Writings on Place Community and the Body*, Berkeley, CA: Frog Ltd.

——— (2003), *Being Human at Work: Bringing Somatic Intelligence into Your Professional Life*, Berkeley, CA: North Atlantic Books.

Heifitz, Deborah (2005), 'Choreographing Otherness: Ethnochoreology and PeaceKeeping Research', paper presented at the *First International Congress of Qualitative Inquiry*, Urbana, IL, 5–7 May, http://www.iiqi.org/C4QI/httpdocs/qi2005/papers/heifetz.pdf. Accessed 25 September 2015.

Hellison, Don (1995), *Teaching Responsibility through Physical Activity*, Champaign, IL: Human Kinetics.

Henriksson, Olle and Rasmusson, Margareta (2003), *Fysiologi: med relevant anatomi*, Lund: Studentlitteratur.

Herman, Judith (1997), *Trauma and Recovery: The Aftermath of Violence – From Domestic Abuse to Political Terror*, New York: Basic Books.

Hicks, Donna (2011), *Dignity: The Essential Role it Plays in Resolving Conflict*, New Haven: Yale University Press.

Hiller, Susan (2014), 'The Explainer: The Feldenkrais Method', *The Conversation*, http://theconversation.com/explainer-the-feldenkrais-method-34007. Accessed 7 January 2015.

Hine Tai Chi School (2014), 'History of Tai Chi', http://taichi-europe.com/history-of-tai-chi/. Accessed 9 September 2014.

Hines, Terence M. (2001), 'The Doman-Delacato Patterning Treatment for Brain Damage', *The Scientific Review of Alternative Medicine*, 5: 2, pp. 80–89.

Hitzmann, Sue (2015), *The Melt Method*, New York: Harper One.

Hoare, Syd (2007), 'Historical Development of Judo', paper presented at European Judo Union Foundation Degree Course, Bath University, July.

Hodgson, John (2001), *Mastering Movement: The Life and Work of Rudolf Laban*, New York: Routledge.

Hodgson, John and Preston-Dunlop, Valerie (1990), *Rudolf Laban: An Introduction to His Work & Influence*, Plymouth: Northcote House.

Holmes, M. D., Chen, W. Y., Feskanich, D. Kroenke, C. H. and Colditz, G. A. (2005), 'Physical Activity and Survival after Breast Cancer Diagnosis', *Journal of the American Medical Association*, 293: 20, pp. 2479–2486.

Homann, Kalila B. (2010), 'Embodied Concepts of Neurobiology in Dance/Movement Therapy Practice', *American Journal of Dance Therapy*, 32, pp. 80–99.

Horace Mann School (1913), *The Curriculum of the Horace Mann Elementary School*, New York: Teachers College, Columbia University, https://archive.org/stream/curriculumofhora00colu/curriculumofhora00colu_djvu.txt. Accessed 14 February 2016.

——— (1917), *The Curriculum of the Horace Mann Elementary School*, New York: Teachers College, Columbia University, https://archive.org/stream/curriculumofhora01colu/curriculumofhora01colu_djvu.txt. Accessed 17 June 2015.

Houston, Jean (1980), *LifeForce: The Psycho-Historical Recovery of the Self*, New York: Delta.

Hutchinson, Marcia Germaine (1985), *Transforming Body Image: Learning to Love the Body You Have*, Freedom, CA: Crossing Press.

Ideokinesis.com (2011a), 'Dance Generation: John Rolland', www.ideokinesis.com/dancegen/rolland/rolland.htm. Accessed 8 April 2014.

—— (2011b), 'Dance Generation: Nancy Topf', www.ideokinesis.com/dancegen/topf/topf.htm. Accessed 8 April 2014.

—— (2011c), 'Dance Generation: Pamela Matt', www.ideokinesis.com/dancegen/matt/matt.htm. Accessed 8 April 2014.

—— (2011d), 'The Pioneers: Barbara Clark', www.ideokinesis.com/pioneers/clark/clark.htm. Accessed 8 April 2014.

Igweonu, Kene (2010), *Feldenkrais Method in Performer Training: Encouraging Curiosity and Experimentation*, Swansea: Centre for Innovative Performance Practice and Research (CIPPR).

International Feldenkrais Federation (n.d.), http://feldenkrais-method.org/de/. Accessed 7 July 2015.

International Somatic Movement Education and Therapy Association (ISMETA) (2003), 'Scope of Practice', www.ISMETA.org. Accessed 5 May 2003.

Jackiewicz, Sara (2015), 'Social Justice and the Ballet Technique Class', paper presented at the *2nd International Somatics-Based Dance Education Conference*, Dean College, Franklin, MA, 18 July.

Jacobson, Edmund (1990), *Relaxation as Therapy: Progressive Relaxation in Theory and Practice* (7th ed.) (trans Karin Wirth), Stuttgart: Klett-Cotta.

—— (1938), *Progressive Relaxation*, Chicago: University of Chicago Press.

James, William (1950), *The Principles of Psychology*, Mineola, NY: Dover Publications.

Jensen, Eric (2005), *Teaching with the Brain in Mind* (2nd ed.), Alexandria, VA: Association for Supervision and Curriculum Development.

Johnson, Don Hanlon (1993), *Body: Recovering Our Sensual Wisdom*, Berkeley, CA: North Atlantic Books.

—— (1994), 'Way of the Flesh: A Brief History of the Somatics Movement', *Noetic Sciences Review*, 29, pp. 26–30.

—— (1995), *Bone, Breath and Gesture: Practices of Embodiment*, Berkeley, CA: North Atlantic Books.

—— (1997), *Groundworks: Narratives of Embodiment*, Berkeley, CA: North Atlantic Books.

—— (1998), *The Body in Psychotherapy*, Berkeley, CA: North Atlantic Books.

—— (2006), *Everyday Hopes, Utopian Dreams: Reflections on American Ideals*, Berkeley, CA: North Atlantic Books.

—— (n.d.), 'Body Recovery', http://donhanlonjohnson.com/bodyrecovery.html. Accessed 5 January 2015.

Johnson, Mark (1979), *The Body in the Mind*, Chicago, IL: University of Chicago Press.

Jones, Frank Pierce (1987), *Body Awareness in Action: A Study of the Alexander Technique*, New York: Schocken Books.

Joseph, AnnRene (2014), 'The Effects of Creative Dramatics on Vocabulary Achievement of Fourth Grade Students in a Language Arts Classroom: An Empirical Study', doctoral dissertation, Seattle Pacific University, http://digitalcommons.spu.edu/cgi/viewcontent.cgi?article=1014&context=etd. Accessed 30 July 2015.

Jowitt, Deborah (1988), *Time and the Dancing Image*, Berkeley and Los Angeles, CA: University of California Press.

Juhan, Deane (1987), *Job's Body: A Handbook for Bodywork*, New York: Station Hill Press.

Kabat-Zinn, Jon (2003), 'Mindfulness-Based Interventions in Context: Past, Present and Future', *Clinical Psychology: Science & Practice*, 10: 2, pp. 144–156.

Kaparo, Risa F. (2012), *Awakening Somatic Intelligence: The Art and Practice of Embodied Mindfulness Transform Pain, Stress, Trauma and Aging*, Berkeley, CA: North Atlantic Books.

Kee, Adrian, Chatzisarantis, Nikos L. D., Kong, Pui Wah, Chow, Jia Yi and Chen, Lung Huang (2012), 'Mindfulness, Movement Control, and Attentional Focus Strategies: Effects of Mindfulness on a Postural Balance Risk', *Journal of Sport and Exercise Psychology*, 34: 5, pp. 561–579.

Keleman, Stanley (1981), *Your Body Speaks Its Mind*, Berkeley, CA: Center Press.

Kendall, Elizabeth (1987), *Where She Danced*, Berkeley, CA: Center Press.

Kepner, John ([2003] 2009), 'Alternative Billing Codes and Yoga: Practical Issues and Strategic Considerations for Determining "What is Yoga Therapy?" and "Who is a Yoga Therapist?"' *International Journal of Yoga Therapy*, 13, pp. 93–99.

Kerka, Sandra (2002), 'Somatic/Embodied Learning and Adult Education', http://www.calpro-online.org/eric/docs/tia00100.pdf. Accessed 26 December 2014.

Kern, Elizabeth, Chun, Jennifer, Schwartz, Shira, Billig, Jessica, Friedman, Erica, Eddy, Martha, Diely, Deirdre, Guth, Amber, Axelrod, Deborah and Schnabel, Freya (2014), 'The Breast Cancer Lifestyle Intervention Pilot Study', *Journal of Cancer Therapy*, 5: 12, pp. 1031–1038.

Kestenberg Amighi, Janet, Loman, Susan, Lewis, Penny and Sossin, Mark (1999), *The Meaning in Movement: Developmental and Clinical Perspectives of the Kestenberg Movement Profile*, London: Taylor & Francis.

Kestenberg, Judith S. (1977), *The Role of Movement Patterns in Development 1*, New York: Dance Notation Bureau Press.

Kestenberg, Judith S. and Sossin, K. Mark (1979), *The Role of Movement Patterns in Development 2*, New York: Dance Notation Bureau Press.

King, Georgia Frances (2014), 'The Meaning of Light', *Kinfolk*, 14, http://www.kinfolk.com/meaning-light/. Accessed 18 October 2015.

Knauff, Theodore Christian (1894), *Athletics for Physical Culture* (2nd ed.), New York: J. Selwin Tait and Sons.

Knaster, Mirka (1996), *Discovering the Body's Wisdom*, New York: Bantam Books.

Knowles, Patricia (2014), 'Dance at Illinois, In the Beginning…', Dance at Illinois, University of Illinois Urbana-Champaign, http://www.dance.illinois.edu/about/history/rich-past. Accessed 11 June 2014.

Koch, Sabine and Bender, Susanne (2007), *Movement Analysis-Bewegungsanalyse: The Legacy of Laban, Bartenieff, Lamb, and Kestenberg*, Berlin: Logos Verlag.

Koch, Sabine, Fuchs, Thomas, Summa, Michela and Müller, Cornelia (eds) (2012), *Body Memory, Metaphor and Movement*, Amsterdam: John Benjamins Publishers.

Kofler, Leo (1887), *The Art of Breathing as the Basis of Tone-Production*, London: J. Curwen & Sons.

Kohn, David (2014), 'How Dancers Think When They Dance', http://terp.umd.edu/new-study-unravels-how-dancers-think-when-they-dance/#.VKpA_2TF89Y. Accessed 7 January 2015.

Kosminsky, Jane and Caplan, Deborah (2000), *The Alexander Technique for Dancers,* [DVD], New York: Wellspring Media.

Kovarova, Miroslava and Miranda, Regina (2006), *Laban & Performing Arts*, Bratislava: Bratislava in Movement Association and Academy of Music and Dramatic Arts.

Kreidler, William J. (1994), *Creative Conflict Resolution: More than 200 Activities for Keeping Peace in the Classroom K-6*, Glenview, IL: Scott, Foresman and Company.

Kreidler, William J. and Furlong, Lisa (1995), *Adventures in Peacemaking – A Conflict Resolution Activity Guide for School Age Programs*, Hamilton, MA: Project Adventure, Inc.

Kulbach, J. (1978), 'Interview by Mary Alice Roche', *The Charlotte Selver Foundation Bulletin: Elsa Gindler 1885–1961*, 10: 1, pp. 14–18.

Kurtz, Ron and Prestera, Hector (1976), *The Body Reveals: An Illustrated Guide to the Psychology of the Body*, New York: Harper & Row and Quicksilver Books.

Laban, Rudolph (1980), *The Mastery of Movement* (rev. by Lisa Ullman), Alton, UK: Dance Books Ltd.

Laban, Rudolph and Ullman, Lisa (1984), *A Vision of Dynamic Space*, New York: Taylor & Francis.

Laeng-Gilliatt, Stefan (2001), 'A Conversation with Charlotte Selver', *Sensory Awareness Foundation Newsletter,* Spring, p. 6, http://www.pathwaysofsensoryawareness.com/Pages/conversation.html. Accessed 19 May 2016.

Lake, Taylor (2008), 'Mapping Meaning, Making Being: Genevieve Stebbins: Delsartism and the Performance of Womanliness', paper presented at the *Annual Meeting of the NCA 94th Annual Convention,* San Diego, CA, 20 November.

Lamb, Warren and Watson, Elizabeth M. (1979), *Body Code: The Meaning in Movement*, London: Routledge & Kegan Paul.

Lamont, Bette (2014), 'Traumatic Brain Injury', http://neurologicalreorganization.org/. Accessed 15 June 2015.

Lantieri, Linda (2008), *Building Emotional Intelligence Techniques to Cultivate Inner Strength in Children*, Boulder, CO: Sounds True.

———— (2014), 'From the Inside Out: Helping Teachers and Students Nurture Resilience', *Mindful,* October, pp. 10–11.

Lantieri, Linda and Patti, Janet (1996), *Waging Peace in Our Schools*, Boston, MA: Beacon Press.

Lau, Din Cheuk (1963), 'Introduction', in Lao Tzu, *Tao Te Ching*, New York: Penguin, pp. vii–xiv.

Lawlor, Debbie A., Smith, George Davy and Ebrahim, Shah (2004), 'Hyperinsulinaemia and Increased Risk of Breast Cancer: Findings from the British Women's Heart and Health Study', *Cancer Causes & Control*, 15, pp. 267–275.

LeBaron, Michelle, Macleod, Carrie and Ackland, Andrew Floyer (2013), *The Choreography of Resolution: Conflict, Movement and Neuroscience*, Chicago, IL: American Bar Association.

Leguizaman, Zea, Grant, Sam, Swann, Carol and Eddy, Martha (n.d.), 'Key Principles of Social Somatics', http://www.carolswann.net/social-somatics/principles/. Accessed 14 October 2014.

Lempa, Heikki (2007), *Beyond the Gymnasium: Educating the Middle Class Bodies in Classical Germany*, Lanham, MD: Lexington Books, Rowman & Littlefield Publishers, Inc.

Leonard, Fred Eugene ([1915] 1922), *Pioneers of Modern Physical Training* (2nd ed.), New York: Association Press.

——— (1923), *A Guide to the History of Physical Education*, Philadelphia, PA and New York: Lea & Febigei, http://archive.org/stream/guidetohistoryof00leon/guidetohistoryof00leon_djvu.txt. Accessed 21 May 2015.

Lepkoff, Daniel (1999), 'What is Release Technique?', *Movement Research Performance Journal*, 19: 1, p. 19.

Lerman, Liz (2008), 'Lerman's Critical Response Process', *Contact Quarterly*, Winter/Spring, pp. 16–20.

Levy, Fran (1992), *Dance/Movement Therapy: A Healing Art* (rev. ed.), Reston, VA: American Alliance for Health, Physical Education, Recreation, and Dance.

Lewis, Penny and Loman, Susan (eds) (1990), *The Kestenberg Movement Profile: Its Past, Present Applications and Future Directions*, Keene, NH: Antioch New England Graduate School.

Linden, Paul (2007), *Embodied Peace-Making: Body Awareness, Self-Regulation and Conflict Resolution*, Columbus OH: CCMS Publications.

Linder, Evelin (2009), *Emotion and Conflict: How Human Rights Can Dignify Emotion and Help us Wage Good Conflict,* Westport, CT: Greenwood Publishing Group.

Ling, Hjalmar (1866), *Rörelselära*, Stockholm: Tryckt Hos E. Westrell.

Llambellis, Tania L. (2002), 'Teacher Metamorphosis – Working with People in Recovery', *Contact Quarterly*, 27: 1, pp. 56–58.

Locke, Marion (2004), *Music, Math and Dance! Activity Plan and Song Book*, San Rafael, CA: Young Imaginations.

Lockley, Steve and Gooley, Joshua (2006), 'Circadian Photoreception; Spotlight on the Brain', *Dispatches*, R795, August, Boston, MA: Division of Sleep Medicine, Harvard Medical School & Brigham and Women's Hospital, pp. 1–3.

Loman, Susan and Brandt, Rose (1992), *The Body-Mind Connection in Human Movement Analysis*, Keene, NH: Antioch New England Graduate School.

Long, Charles R., Westhusin, Mark E., and Golding, Michael C. (2014), 'Reshaping the Transcriptional Frontier: Epigenetics and Somatic Cell Nuclear Transfer', *Molecular Reproduction and Development*, 81: 2, pp. 183–193.

Loos, Ted (2015), 'The Spiritual and Spectacular Meet at an Ultramodern Community Center in Connecticut', *New York Times,* 17 October, http://www.nytimes.com/2015/10/17/arts/design/thespiritual-and-spectacular-meet-at-an-ultramodern-community-center-in-connecticut.html. Accessed 13 January 2016.

Lurie, Margot (2010), 'Jumping with Dance', *Jewish Ideas Daily,* 28 October, http://www.jewishideasdaily.com/746/features/jumping-with-dance/. Accessed 1 February 2016.

MacDonald, Glynn (1994), *Alexander Technique*, London: Headway.

——— (1999), *The Complete Illustrated Guide to the Alexander Technique: A Practical Program for Health, Poise, and Fitness*, Rockport, MA: Element Books.

Macdougal, Allan Ross (1960), *Isadora: A Revolutionary in Art and Love*, New York: Thomas Nelson and Sons.

Mackeye, Percy (1927), *Epoch: The Life of Steele Mackeye, Genius of the Theater, in Relation to his Times and Contemporaries*, New York: Boni and Liveright.

Maletic, Vera (1987), *Body, Space, Expression: The Development of Rudolf Laban's Movement and Dance Concepts*, Berlin: Walter de Gruyter.

Malina, Debra (2014), 'The Inside Story: Debbie Malina Takes a Look in to the History, Development and Growth of Somatic Education', *Dancing Times*, 104: 1242, pp. 73–77.

Mangione, Michele Ann (1993), 'The Origins and Evolution of Somatics: Interviews with Five Significant Contributors to the Field', doctoral dissertation, Columbus, OH: The Ohio State University.

Manning, Susan and Ruprecht, Lucia (2012), *New German Dance Studies*, Champaign, IL: University of Illinois Press.

Marks, William (2001), *The Holy Order of Water*, Great Barrington, MA: Bellpond Books.

Masgutova, Svetlana (2008), 'Masgutova Method of Reflex Integration for Children with Cerebral Palsy', http://masgutovamethod.com/_uploads/_media_uploads/_source/article_valerie-cp. pdf. Accessed 22 May 2015.

Masters, Robert Augustus (2010), *Spiritual Bypassing When Spirituality Disconnects Us from What Really Matters*, Berkeley, CA: North Atlantic Books.

Matt, Pamela (1973), 'Mabel Ellsworth Todd and Barbara Clark – Principles, Practices, and the Import for Dance', MA thesis, Urbana, IL: University of Illinois Urbana-Champaign.

—— (1993), *A Kinesthetic Legacy: The Life and Works of Barbara Clark*, Tempe, AZ: CMT Press.

—— (2014), 'Barbara Clark', http://www.ideokinesis.com/pioneers/clark/clark.htm. Accessed 9 September 2014.

McArthur, Benjamin (2000), *Actors and American Culture, 1880–1920*, Iowa City, IA: University of Iowa Press.

McCarthy, Kathie (1995), *Wisdom in the Body: Engaging the Body within a Psychotherapeutic Context*, Bainbridge Island, WA: Kathie McCarthy.

McCormick, Brian (2011), 'Banishing Bullying', *Dance Studio Life*, 11 November, http://www. dancestudiolife.com/banishing-bullying/. Accessed 22 May 2015.

McHose, Caryn (2003), 'Interview with Hubert Goddard', *Contact Quarterly*, August, pp. 32–38.

McHose, Caryn and Frank, Kevin (2006), *How Life Moves: Exploration in Meaning and Body Awareness*, Berkeley, CA: North Atlantic Books.

McHugh, Jaimie (2015), 'Embodied Mindfulness Chair Practices for Navigating the Inner Landscape', paper presented at *Body-Mind Centering Conference*, Portland, OR, 24 July.

McIntosh, Nina (2005), *The Educated Heart: Professional Boundaries for Massage Therapists, Bodyworkers and Movement Teachers*, Philadelphia, PA: Lippincott Williams & Wilkins.

McLean, Don (2002), 'History of Butoh', http://www.zenbutoh.com/history.htm. Accessed 9 September 2014.

McNay, Renate (2013), 'Emilie Conrad "Continuum: My Story", Interviewed by Renate McNay', 13 June, London: Conscious TV, https://www.youtube.com/watch?v=xh4LfhaNLDg. Accessed 30 July 2015.

McPartland, Terence (2012), 'Moshe Feldenkrais and Modern Judo: The Strange Forgotten Tale of a Physicist Who Learned Judo', http://dcjudo.com/feldenkrais-and-judo/. Accessed 9 September 2014.

Mechner, Vicki (1998), *Healing Journeys: The Power of Rubenfeld Synergy*, Chappaqua, NY: OmniQuest Press.

Michael, Chester P. and Norrisey, Marie C. (1984), *Prayer and Temperament: Different Prayer Forms for Different Personality Types*, Charlottesville, VA: The Open Door, Inc.

Middendorf, Ilse (1990), *The Perceptible Breath*, Paderborn: Junfermann-Verlag.

Miller, Gray (2006–2014), 'History of Africa Dance', http://dance.lovetoknow.com/History_of_African_Dance. Accessed 9 September 2014.

Miller, Jim (2014), 'John Vasconcellos, Long-Time California Lawmaker Who Championed Self-Esteem, Dies at 82', *Sacbee News*, 24 May.

Miller, Lucy Jane (2014), *Sensational Kids: Hope and Help for Children with Sensory Processing Disorder*, New York: Perigee Trade.

Miller, Sylvia (1933), *Rhythms Notebook*, notes from Rhythms Camp, Adirondacks, Summer, courtesy of Kate Tarlow Morgan, unpublished.

Milz, Helmut (1991), 'A Conversation with Thomas Hanna, PhD', *Somatics: Magazine-Journal of the Bodily Arts and Sciences*, 8: 2, pp. 50–56.

Mindell, Arnold (1992), *The Leader as Martial Artist Techniques and Strategies for Resolving Conflict and Creating Community*, San Francisco, CA: Harper Lao Tse Press.

Mittelstaedt, Horst (1996), 'Somatic Graviception', *Biological Psychology*, 42, pp. 53–74.

Montagu, Ashley (1986), *Touching: The Human Significance of the Skin*, New York: William Morrow Books.

Moore, Carol-Lynne (2014), *Meaning in Motion: Introducing Laban Movement Analysis*, Denver, CO: MoveScape Center.

Morgan, J. Z. (n.d.), Archives and notes, courtesy of Kate Tarlow Morgan and City and Country School, unpublished.

Morgan, Kate Tarlow (1989–1990), 'Carrying the Message', practitioner training thesis and BMCA Grant Project, unpublished.

——— (2007), *Program Notes on the Teachings of Bonnie Bainbridge Cohen*, Amherst, MA: School for Body-Mind Centering.

——— (2008), 'Learning the Fundamentals', *Currents: Journal of The Body-Mind Centering Association,* 10: 1, pp. 13–24.

——— (2011), 'Carrying The Message [Thesis Project 1989–1990]', in Gill Wright Miller, Pat Ethridge and Kate Tarlow Morgan (eds), *Movement & Experience: A Body-Mind Centering Anthology,* Berkeley, CA: North Atlantic Press.

Mullan, Kelly Jean (2012), 'The Art and Science of Somatics: Theory, History and Scientific Foundations', PhD thesis, Saratoga Springs, NY: Skidmore College.

——— (2014), 'Somatics: Investigating the Common Ground of Western Body–Mind Disciplines', *Body, Movement and Dance in Psychotherapy: An International Journal for Theory, Research and Practice*, 9: 4, pp. 253–265.

——— (2016), 'Harmonic Gymnastics and Somatics: A Genealogy of Ideas', *Currents: The Journal of Body-Mind Centering Association*, 19: 1, pp. 16–28.

Murphy, Michael (1992), *The Future of the Body: Explorations into the Further Evolution of Human Nature*, Los Angeles, CA: Jeremy Tarcher.

Murray, Alex (2005), 'Raymond A. Dart and F. M. Alexander', in Martha Eddy (ed.), *Perceptual-Motor Development: Experiential Perspectives from Bartenieff Fundamentals, Body-Mind Centering and Other Somatic Disciplines* (3rd ed.), North Chelmsford, MA: Anthology Pro/Xanedu Press, pp. 57–60.

Myers, Martha (1988), 'What Dance Medicine and Science Mean to the Dancer', in Priscilla Clarkson and Margaret Skrinar (eds), *Science of Dance Training*, Champaign, IL: Human Kinetics, pp. 3–15.

Myers, Martha and Horosko, Marion (1989), 'When Classes are Not Enough: Body Therapies Why, Which and When', *Dance Magazine*, July, pp. 47–50.

Nagrin, Daniel (1988), *How to Dance Forever: Surviving against the Odds*, New York: HarperCollins.

Naismith, James and Halsey, Guilick Luther (eds) (1884), *Physical Education*, Vols 1–5, Springfield, MA: Triangle Publishing.

National Institute for Dispute Resolution (1998), *Special Report on Conflict Resolution, Education Research and Evaluation*, Washington, DC: NIDR.

National Institute of Health (2010), 'Mind-Body Medicine Practices in Complementary and Alternative Medicine', http://report.nih.gov/nihfactsheets/Pdfs/MindBodyMedicine PracticesinComplementaryandAlternativeMedicine(NCCAM).pdf. Accessed 22 May 2015.

Naul, Roland (2010), *Olympic Education* (2nd ed.), Maidenhead, UK: Meyer and Meyer.

Nemecek, Sarah and Chatfield, Steven (2007), 'Teaching and Technique in Dance Medicine and Science: A Descriptive Study with Implications for Dance Educators', *Journal of Dance Education*, 7: 4, pp. 109–117.

Nettl-Fiol, Rebecca and Vanier, Luc (2011), *Dance and the Alexander Technique: Exploring the Missing Link*, Urbana and Chicago, IL: University of Illinois Press.

Newcombe, Suzanne (2009), 'The Development of Modern Yoga: A Survey of the Field', http:// modernyogaresearch.org/wordpress/wp-content/uploads/2011/07/Pre-Pub-Religion-Compass.pdf. Accessed 9 September 2014.

North, Marion (1971), *An Introduction to Movement Study and Teaching*, London: MacDonald & Evans.

Novack, Cynthia J. (1990), *Sharing the Dance: Contact Improvisation and American Culture*, Madison, WI: University of Wisconsin Press.

O'Brien Aileen and Lloyd, Mary (2015), 'Book Review: *The Choreography of Resolution*', *Maynooth University News*, https://www.maynoothuniversity.ie/edward-m-kennedy-institute. Accessed 2 June 2015.

O'Conner, Thomas P. and Crystal, Ronald G. (2006), 'Genetic Medicines: Treatment Strategies for Hereditary Disorders', *Nature Reviews Genetics*, 7, pp. 261–276.

Olsen, Andrea, and McHose, Caryn (2002), *Body and Earth: An Experiential Guide*, Hannover, NH: Middlebury Press.

Orlick, Terry (1982), *The Second Cooperative Sports & Games Book*, New York: Pantheon.

Ornstein, Robert and Thompson, Richard (1991), *The Amazing Brain*, New York: Mariner Books.

Oschman, James and Oschman, Nora (1997), *Readings on the Scientific Basis of Bodywork, Energetic, and Movement Therapies*, Dover, NH: Nature's Own Research Association.

Osumare, Halifu (2010), 'In Dancing the Black Atlantic: Katherine Dunham's Research-to-Performance Method in Migration of Movement: Dance across Americas', *AmeriQuests*, 7: 2, pp. 1–12, http://www.ameriquests.org/index.php/ameriquests/article/view/165/182. Accessed 3 January 2015.

Otero, Marisol (2010), *ViaDanza*, Lima, Peru: LaMovil Arte, Educacion y Movimiento.

Overby, Lynnette Young, and Dunn, Jan (2011), 'The History and Research of Dance Imagery: Implications for Teachers', *The IADMS Bulletin for Teachers*, 3: 2, pp. 9–11.

Overby, Lynette Young and Lepczyk, Billie (eds) (2009), *Dance: Current Selected Research*, Vol. 7, New York: AMS Press.

Papenfuss, Tony ([1995] 2014), 'Mikonosuke Kawaishi: Judo Teacher in Europe', http://judoinfo.com/kawaishi.htm. Accessed 9 September 2014.

Pare, Stephen (2001), 'Interview with Judith Aston', *Structural Integration: The Journal of the Rolf Institute*, Summer, pp. 5–8.

––––––– (2002), 'Interview with Judith Aston Part II', *Structural Integration: The Journal of the Rolf Institute*, Winter, pp. 8–11.

Park, Glen (1998), *Art of Changing: A New Approach to the Alexander Technique: Moving Toward a More Balanced Expression of the Whole Self*, Freedom, CA: Crossing Press.

Pearsall, Paul (1998), *The Heart's Code: New Findings about Cellular Memories and Their Role in the Mind/Body/Spirit Connection*, New York: Broadway Books.

Pellitier, Kenneth (1977), *Mind as Healer, Mind as Slayer: A Holistic Approach to Preventing Stress Disorders*, New York: Dell.

Pert, Candace (1999), *Molecules of Emotion: The Science Behind Mind-Body Medicine*, New York: Simon & Schuster.

Peterson, Martha (2011), *Move Without Pain*, NY: Sterling Press.

Pindola, Joyce (1990), 'Your Body, Her Job', *New York Woman Magazine*, 8, p. 93.

Pinker, Steven (2011), *The Better Angels of Our Nature: Why Violence Has Declined*, New York: Penguin Books.

Pfeifer, Rolf and Josh Bongard (2006), *How the Body Shapes the Way We Think: A New View of Intelligence*, Denver, CO: Bradford.

Pfister, Gertrud (2003), 'Cultural Confrontations: German Turnen, Swedish Gymnastics and English Sport – European Diversity in Physical Activities from a Historical Perspective', *Culture Sport and Society*, 6: 1, pp. 61–91.

Pierpont, Margaret and Myers, Martha (1983), 'Body Therapies and the Modern Dancer', *Dance Magazine*, August, pp. BT1–BT24.

Pilecki, W., Masgutova, S., Kowalewska, J., Masgutov, D., Akhmatova, N., Poreba, M., Sobieszczańska, M., Koleda, P., Pilecka, A. and Kałka, D. (2012), 'The Impact of Rehabilitation Carried Out Using the Masgutova Neurosensorimotor Reflex Integration Method in Children with Cerebral Palsy on the Results of Brain Stem Auditory Potential Examinations', *Advances in Clinical and Experimental Medicine*, 21: 3, pp. 363–371.

Posse, Nils (1890), *The Swedish System of Educational Gymnastics*, Boston, MA: Lee and Shepard, http://babel.hathitrust.org/cgi/pt?id=uc2.ark:/13960/t41r6pf5k;view=1up;seq=41. Accessed 22 May 2015.

Pratt, Caroline (1948), *I Learn from Children*, New York: Simon & Schuster.

Preston-Dunlop, Valerie (2005), *The American Invasion 1962–72*, London: Bloomsbury.

––––––– (2008), *Rudolf Laban: An Extraordinary Life*, Hightstown, NJ: Princeton Book Company.

Price, Diana (2008), 'Moving Bodies, Changing Lives', *Women and Cancer Magazine*, http://news.cancerconnect.com/moving-bodies-changing-lives-2/. Accessed 3 January 2015.

Psychology Today (2015), 'Mindfulness: Present Moment Awareness', https://www.psychology today.com/basics/mindfulness. Accessed 26 June 2015.

Ralph, John (2009), 'Frequently Asked Questions', in John Ralph, *Discover Eurhythmy,* Aberdeen: Discover Eurythmy, http://www.eurythmy.org.uk/assets/defaq.pdf. Accessed 25 October 2015.

Ramachandran, Vilayanur S., Blakeslee, Sandra and Sacks, Oliver (1998), *Phantoms in the Brain: Probing the Mysteries of the Human Mind*, New York: William Morrow.

Rankine, Claudia (2014), *Citizen: An American Lyric,* Minneapolis, MN: Greywolf Press.

Reed, Sarah (1998), 'Postal Survey of Dance Higher Education Providers', personal paper, unpublished.

———— (2006), 'Desktop Survey of Dance Higher Education Providers', personal paper, unpublished.

———— (2011) 'Comparison of Data From 1998 and 2006 Surveys of Higher Education Providers', personal paper, unpublished.

Reese, Mark (n.d.), 'The Feldenkrais Method and Dynamic Systems Principles', http://semiorganized.com/articles/other/ReeseDynamic_systems.html. Accessed 22 May 2015.

Reeve, Sandra (2014), 'The Sacrum and the Sacred: Mutual Trasformation of Performer and Site through Ecological Movement in a Sacred Site', in Amanda Williamson, Glenna Batson, Sarah Whatley and Rebecca Weber (eds), *Dance, Somatics and Spiritualities: Contemporary Sacred Narratives*, Bristol: Intellect, pp. 417–436.

Rentschler, Mary (2008), *The Masgutova Method of Neuro-Sensory-Motor and Reflex Integration: Key to Health, Development and Learning*, San Francisco, CA: Catipas.

Reynolds, Dee (2007), *Rhythmic Subjects: Uses of Energy in the Dances of Mary Wigman, Martha Graham, and Merce Cunningham*, London: Dance Books Ltd.

Roberts, Joseph (1998), 'The Body Tells the Truth: Marion Rosen and Bodywork: An Interview', *Common Ground Magazine*, March, http://www.rosenmethod.com/articles/Body%20 Tells%20the%20Truth.pdf. Accessed 26 June 2015.

Robinson, Ken (2006), 'Do Schools Kill Creativity?', http://www.ted.com/talks/ken_robinson_ says_schools_kill_creativity/transcript. Accessed 27 June 2015.

Robinson, Lynne and Knox, Jacqueline (2006), *Pilates Pregnancy Guide: Optimum Health and Fitness for Every Stage of Your Pregnancy*, Ontario: Firefly Books.

Rolf Guild (n.d.), 'Biography of Ida Rolf', http://www.rolfguild.org/about/ida-p-rolf-phd. Accessed 28 September 2015.

Rolf, Ida (1977), *Rolfing: The Integration of Human Structures*, New York: Harper & Row.

Rolland, John (1984), *Inside Motion: An Ideokinetic Basis for Movement Education*, Amsterdam: John Rolland.

Rolland, Peter (2008), 'Foreword', http://www.paulrolland.net/foreword.html. Accessed 14 April 2014.

Rosas, Debbie and Rosas, Carlos (2004), *The NIA Technique: The High-Powered Energizing Workout that Gives You a New Body and a New Life*, New York: Broadway Books.

Rosen, Marion and Brenner, Susan (1991), *The Rosen Method of Movement*, Berkeley, CA: North Atlantic Books.

Rosenberg, Bobby (2002), *Energia: Postura y Movimiento*, Bogota: Grupo Norma.

Ross, Janice (2000), *Moving Lessons: Margaret H'Doubler and the Beginning of Dance in American Education*, Madison, WI: University of Wisconsin.

—— (2007), *Anna Halprin: Experience as Dance*, Berkeley, CA: University of California Press.

Rossi, Ernest (1993), *The Psychobiology of Mind-Body Healing: New Concepts of Therapeutic Hypnosis*, New York: W. W. Norton & Company.

Rossi, Ernest and Cheek, David (1994), *Mind-Body Therapy: Methods of Ideodynamic Healing in Hypnosis*, New York: W. W. Norton & Company.

Roth, Daniel (2005), 'Deep Embodied Democracy: Moving On Center and Carol Swann', personal paper, Cornell University, Ithaca, NY, unpublished.

—— (2007), 'The Spatial Dimensions of Community Organizing: A New Direction for Theory and Practice', MA thesis, Ithaca, NY: Cornell University.

Roth, Mathias (1853), *The Gymnastics Free Exercises of P. H. Ling Arranged by H. Rothstein* (trans. Mathias Roth), London: Groombridge, http://babel.hathitrust.org/cgi/pt?id=ien.3555800537 0735;view=1up;seq=9. Accessed 26 June 2015.

Roubicek, Sasha (2009), 'Hara Breathing Applied to Dance Practice', *Journal of Dance & Somatic Practices*, 1: 2, pp. 255–262.

Rouhianien, Leena (2010), 'The Evolvement of the Pilates Method and its Relation to the Somatic Field', *Nordic Journal of Dance*, 2, pp. 57–68.

Ruiz, Fernando Pagés (2007), 'Krishnamacharya's Legacy: Modern Yoga's Inventor', *Yoga Journal*, http://www.yogajournal.com/wisdom/465. Accessed 9 September 2014.

Russell, Tamara and Arcuri, Silvia (2015), 'A Neurophysiological and Neuropsychological Consideration of Mindful Movement: Clinical and Research Implications', *Frontiers in Human Neuroscience*, 9: 282, pp. 1–17.

Ruyter, Nancy Lee Chalfa (1973), 'American Delsartism: Precursor of an American Art', *Educational Theatre Journal*, 25: 4, pp. 420–435.

—— (1979), *Reformers and Visionaries: The Americanization of the Art of Dance*, New York: Dance Horizons.

—— (1988), 'The Intellectual World of Genevieve Stebbins', *Dance Chronicle*, 11: 3, pp. 381–387.

—— (1999), *The Cultivation of Body and Mind in Nineteenth-Century American Delsartism*, Westport, CT: Greenwood Press.

—— (2005), 'Essays on Francois Delsarte: Introduction', *Mime Journal*, 23, pp. 1–7.

Ryan, Tim (2012), *A Mindful Nation: How a Simple Practice Can Help Us Reduce Stress, Improve Performance and Recapture the American Spirit*, Carlsbad, CA: HayHouse.

Sacks, Oliver (1970), *The Man Who Mistook His Wife for a Hat*, New York: Simon & Schuster.

—— (1996), *An Anthropologist on Mars: Seven Paradoxical Tales*, New York: Vintage.

Saltonstall, Ellen (1988), *Kinetic Awareness: Discovering Your BodyMind*, New York: Kinetic Awareness Center.

Sapolsky, Robert (1998), *Why Zebras Don't Get Ulcers: An Updated Guide to Stress*, New York: W. H. Freeman.

Sargant, William (1997), *Battle of the Mind: A Physiology of Conversation and Brainwashing*, Cambridge, MA: Malor Books.

Sargent, Dudley Allen (1906), *Physical Education*, Boston, MA: Ginn and Co.

Schiphorst, Thecla (2008), 'The Varieties of User Experience: Building Embodied Methodologies from Somatics and Performance to Human Computer Interaction', doctoral dissertation, Plymouth: University of Plymouth.

Schilder, Paul (1999), *The Image and Appearance of the Human Body*, Farnam: International Library of Psychology.

Schiphorst, Thecla, Bradley, Karen and Studd, Karen (2013), 'From Motion Capture to Meaningful Movement: LMA as a Design Resource for Digital Technology', http://www.movcap.org/symposium/presenters/thecla-schiphorst/. Accessed 17 June 2015.

Schneider, Meir (1989), *Movement for Self-Healing: An Essential Resource for Anyone Seeking Wellness*, Novato, CA: New World Library.

Schore, Allan (1999), *Affect Regulation and the Origin of the Self: The Neurobiology Emotional Development*, Oxford: Taylor & Francis.

Schriefer, Gayatri (n.d.), 'Neurophysiology Relevant to Somatic Movement Education', *Living Somatics*, http://www.livingsomatics.com/info/neurophysiology. Accessed 17 October 2015.

Schwartz, Peggy (1995), 'Laban Movement Analysis: Theory and Application', *Journal of Physical Education, Recreation and Dance*, 66: 2, pp. 25–26.

Schwartz, Ray Elliot (2006), 'Exploring the Space Between: The Effect of Somatic Education on Agency and Ownership within a Collaborative Dance-Making Process', MFA thesis, Austin: University of Texas.

Scurlock-Durana, Suzanne (2008), *Full Body Presence: Explorations, Connections, and More to Experience Present Moment Awareness*, Reston, VA: Healing from the Core Media.

Selye, Hans (1978), *The Stress of Life*, New York: McGraw-Hill.

Seidel, Andrea (2015), *Isadora-Duncan in the 21st Century: Capturing the Art and Spirit of the Dancer's Legacy,* Jefferson, NC: McFarland & Company.

Seiff, Daniela (2015), *Understanding and Healing Emotional Trauma: Conversations with Pioneering Clinicians and Researchers,* New York: Routledge.

Seitz, Johnny (2004), *Bio-Typing: Beyond Body Language*, New York: iUniverse.

Selver-Kassell, Eve (2010), 'Moving through Learning and Learning through Movement: A Practical Analysis of the Benefits of Incorporating Movement into the Elementary School Day', MA thesis, New York: Bank Street College of Education.

Shafarman, Stephen (1998), *Awareness Heals: Practical Feldenkrais for Dynamic Health*, London: Thorsons.

Shafir, Talia (2015), *External Manifestations of the Internal Working Model: An Examination of the Relationship between Somatic Movement Patterns and Adult Attachment Status*, doctoral dissertation, Makawao, HI: International University of Professional Studies, unpublished.

Shafir, Tal, Tsachor, Rachelle and Welch, Kathleen (2016), 'Emotion Regulation through Movement: Unique Sets of Movement Characteristics are Associated with and Enhance Basic Emotions', *Frontiers in Psychology,* 11 January, http://dx.doi.org/10.3389/fpsyg.2015.02030. Accessed 28 February 2016.

Shapiro, Sherry (1998), *Dance, Power and Difference: Critical and Feminist Perspectives on Dance Education*, Urbana, IL: Human Kinetics Publisher.

Sharma, Sita Ram (ed.) (1994), *Encyclopedia of Sport Health and Physical Education*, New Delhi: Mittal Publications.

Sheera, M. (2005), 'Minding the Body: Visualization', *Dance Magazine*, November.

Sheets-Johnstone, Maxine (2007), 'Consciousness: A Natural History', personal paper, Eugene, OR, University of Oregon, unpublished.

Shelton, Suzanne (1978), 'The Influence of Genevieve Stebbins on the Early Career of Ruth St. Denis', *Essays in Dance Research: From the Fifth Congress on Research in Dance Conference*, Philadelphia, PA and New York.

Sieff, Daniela (2015), *Understanding and Healing Emotional Trauma: Conversations with Pioneering Clinicians and Researchers*, New York: Routledge.

Siegel, Daniel (2007), *The Mindful Brain: Reflection and Attunement in the Cultivation of Well-Being*, New York: W. W. Norton & Company.

Simonson, Mary (2013), *Body Knowledge: Performance, Intermediality, and American Entertainment at the Turn of the Twentieth Century*, Oxford: Oxford University Press.

Simpkins, C. Alexander (2010), *The Dao of Neuroscience: Combining Eastern and Western Principles for Optimal Therapeutic Change*, New York: Norton.

Sims, Caitlin (2014), 'Dancing to Heal', *Dance Teacher*, http://www.dance-teacher.com/2014/03/dancing-to-heal/. Accessed 3 January 2015.

Singleton, Mark (2010), *Yoga Body: The Origins of Modern Posture Practice*, Oxford, UK: Oxford University Press.

——— (2011), 'The Roots of Yoga: Ancient + Modern', *Yoga Journal*, 4 February, http://www.yogajournal.com/article/philosophy/yoga-s-greater-truth/. Accessed 9 September 2014.

Skelton, Rebecca (2002), 'Exploring Counter Balance: Aligning the Roles of Dance Artist, Educator and Researcher within Higher Education', *Conference Proceedings: Finding the Balance: Dance in Further and Higher Education in the 21st Century*, Liverpool John Moores University, UK, June.

Skinner, Joan, Davis, Bridget, Davidson, Robert, Wheeler, Kris and Metcalf, Sally (1974), 'Releasing into Process: Joan Skinner and the Use of Imagery in Dance', MA thesis, Urbana, IL: University of Illinois Urbana-Champaign.

Skinner, Joan, Wheeler, Kris and Metcalf, Sally (1980–1988), 'Mind/Body Integration in the Training of the Dancer', personal paper, unpublished.

Skinner Releasing Network (n.d.), 'About Joan Skinner', http://www.skinnerreleasingnetwork.org/about-joan-skinner. Accessed 11 June 2014.

Skura, Stephanie (1990), 'Releasing Dance: Interview with Joan Skinner', *Contact Quarterly*, Fall, pp. 11–18.

Smith-Autard, Jacqueline M. (1997), *The Art of Dance in Education* (2nd ed.), London: Black.

Smith, Edward, Clance, Pauline and Imes, Suzanne (1998), *Touch in Psychotherapy: Theory, Research and Practice*, New York: Guildford Press.

Soechitig, Stephanie (2014), *Fed Up*, [DVD and VOD], Burbank, CA: Anchor Bay.

Soquet, Annie and Ted Shawn (2005), *Chaque petit mouvement: à propos de Françios Delsarte*, Paris: Éditions Complexe et Centre National de la Danse.

Sparwasser, Gabriele, Fortin, Sylvie, Rouquest, Odile and Ricci, Serge (2008), *Somatic Approaches to Movement*, [DVD], Pantin: Recherche en Mouvement.

Speads, Carola (1978), 'Interview by Mary Alice Roche', *The Charlotte Selver Foundation Bulletin: Elsa Gindler 1885–1961*, 10: 1, pp. 19–24.

Stebbins, Genevieve (1885), *Delsarte System of Expression*, New York: Edgar Werner; Reprint 1977, New York: Dance Horizons.

——— (1888), *Society Gymnastics and Voice Culture: Adapted from the Delsarte System*, New York: Edgar Werner.

——— (1892), *Dynamic Breathing and Harmonic Gymnastics: A Complete System of Psychical, Aesthetic, and Physical Culture* (2nd ed.), New York: Edgar Werner.

——— (1893), *The New York School of Expression Prospectus*, New York: Edgar S. Werner.

——— (1898), *The Genevieve Stebbens System of Physical Training* (2nd ed.), New York: Edgar S. Werner, http://www.USArchive.org. Accessed 28 September 2015.

——— (1913), *The Genevieve Stebbins System of Physical Training*, New York: Edgar Werner.

——— (1977), *Delsarte System of Expression, Dance Horizons*, New York: Edgar S. Werner.

——— (1988), *Society Gymnastics and Voice Culture: Adapted from the Delsarte System*, New York: Edgar Werner.

Steiner, Rudolf ([1932] 1977), *Eurhythmy as Visible Music: Eight Lectures Given at Dornach 19–27 February 1924*, London: Rudolf Steiner Press.

Steinman, Louise ([1986] 1995), *The Knowing Body: The Artist as Story Teller in Contemporary Performance*, Berkeley, CA: North Atlantic Books.

Sternberg, Adam (2008), 'You Walk Wrong: It Took 4 Million Years of Evolution to Perfect the Human Foot. But We're Wrecking It with Every Step We Take', *New York Magazine*, http://nymag.com/health/features/46213/. Accessed 27 June 2015.

Stevens, John (1996), *The Shambhala Guide to Aikido*, Boston, MA: Shambhala.

Stinson, Susan W. (1979), 'Effort Qualities and the Development of Psycho-Sexual Identity in Early Adolescents', in Araminta Little (ed.), *National Dance Association Conference Proceedings: Dance As Learning*, Garland, TX: National Dance Association, pp. 89–95.

Stockman, Jan (n.d.), 'A Personal Account of the Formation of the University of Illinois Department of Dance', http://www.dance.uiuc.edu/about/history/personal-account. Accessed 11 June 2014.

Swann, Carol (2008), 'The Socially Conscious Body: Course Curricula Module 2 and 3', New York: Moving on Center, http://arc.movingoncenter.org/SCB.htm. Accessed 12 March 2016.

Sweigard, Lulu E. (1974), *Human Movement Potential: Its Ideokinetic Facilitation*, New York: Harper & Row.

Taylor, Charles Fayette (1861), *Theory and Practice of the Movement Cure*, Philadelphia, PA: Lindsey and Blackiston.

Taylor, George Herbert (1860), *An Exposition of the Swedish Movement-Cure: Embracing the History and Philosophy of This System of Medical Treatment, Along with Examples of Single Movements, and Directions for Their Use in Various Forms of Chronic Disease Forming a Complete Manual of Exercises*, New York: Fowler and Wells Publishers.

——— ([1866] 1868), *An Illustrated Sketch of the Movement Cure: Its Principles, Methods and Effects*, New York: The Institute.

Taylor, Jill Bolte (2008), *My Stroke of Insight*, New York: Viking.

Thelen, Esther and Smith, Linda B. (1994), *A Dynamic Systems Approach to the Development of Cognition and Action*, Cambridge, MA: MIT Press.

Todd, Jan (1998), *Physical Culture and the Body Beautiful: Purposive Exercise in the Lives of American Women 1800–1875*, Macon, GA: Mercer University Press.

Todd, Mabel Ellsworth (1937), *The Thinking Body*, New York: Dance Horizons.

————— (1953), *The Hidden You*, New York: Dance Horizons.

Tohei, Koichi (1978), *Ki in Daily Life*, Tokyo: Japan Publications.

Topf, Nancy (1980), 'Somatics', panel presentation at Laban Institute of Movement Studies, New York, 28 April.

Tortora, Suzi (2006), *The Dancing Dialogue: Using the Communicative Power of Movement with Young Children*, Baltimore, MD: Brookes Publishing.

Trager, Milton and Guadagno, Cathy (1987), *Trager Mentastics: Movement as a Way to Agelessness*, New York: Stanton Hill Press.

Trager Organization (n.d.), 'Milton Trager', http://www.trager-us.org/milton_trager.html. Accessed 3 December 2002.

Traugbaek, Else (2000), 'One System, Several Cultures: A Comparative Study of Swedish Gymnastics for Women', *International Sports Studies*, 22: 2, pp. 42–56.

UCAS (n.d.), 'Undergraduate Courses', http://www.ucas.com. Accessed 26 June 2015.

Ueshiba, Morihei (1992), *The Art of Peace: Teachings of the Founder of Akido* (trans. John Stevens), Boulder, CO: Shambala.

Unrau, Sharon (2000), 'Motif Writing in Gang Activity: How to Get the Bad Boys to Dance', *Proceedings of the Congress on Research in Dance: Dancing in the Millennium 2000*, Washington, DC.

Upledger, John E. (1977), *Your Inner Physician and Your Craniosacral Therapy and SomatioEmotional Release*, Berkeley, CA: North Atlantic Books.

Van der Kolk, Bessel, McFarlane, Alexander C. and Weisaeth, Lars (2006), *Traumatic Stress: The Effects of Overwhelming Experience on Mind, Body, and Society*, New York: Guilford Press.

Van der Linden, Mirjam (2004), *Not Just Any Body & Soul: Health, Wellbeing and Excellence in Dance*, Amsterdam: Uitgeverij International Theatre Film and Books.

Van Gelder, Sara (2016), 'The Radical Work of Healing: Fania and Angela Davis on a New Kind of Civil Rights Activism', *Yes*, 18 February, http://us.yesmagazine.com/issues/life-after-oil/the-radical-work-of-healing-fania-and-angela-davis-on-a-new-kind-of-civil-rights-activism-20160218. Accessed 12 March 2016.

Varela, Francisco J., Thompson, Evan T. and Rosch, Eleanor (1992), *The Embodied Mind: Cognitive Science and Human Experience*, Cambridge, MA: MIT Press.

Veder, Robin (2009), 'Arthur B. Davies Inhalation Theory of Art', *Smithsonian Institution*, 23: 1, pp. 56–77.

————— (2011), 'Seeing Your Way to Health: The Visual Pedagogy of Bess Mensendieck's Physical Culture System', *The International Journal of the History of Sport*, 28: 8&9, pp. 1336–1352.

Verbrugge, Martha (1988), *Able-bodied Womanhood: Personal Health and Social Change in Nineteenth-Century Boston*, New York: Oxford University Press.

Waille, Franck (2009), 'Corps, arts et spiritualité chez François Delsarte (1811–1871)', doctoral dissertation, France: Université Jean-Moulin-Lyon.

Wallace, Vesna (2011), 'The Six-Phased Yoga of the Abbreviated Wheel of Time Tantra', in David Gordon White (ed.), *Yoga in Practice*, Princeton, NJ: Princeton University Press, pp. 204–222.

Waller, Pip (2010), *Holistic Anatomy an Integrative Guide to the Human Body*, Berkeley, CA: North Atlantic Books.

Walsch, Neale Donald (2011), *The Storm Before the Calm: Conversations with Humanity*, Alexandria, NSW: Hay House Australia.

Weaver, Judyth (2004), 'The Influence of Elsa Gindler – Ancestor of Sensory Awareness', *The United States Association of Body Psychotherapy Journal*, 3: 1, pp. 38–47.

—— (2014), 'Somatics and Somatic Psychology – Past, Present and Future', keynote speech delivered at Japan Association for Somatics and Somatic Psychology, Tokyo, October, 34:02–39:00, http://judythweaver.com/podcasts-videos/keynote-speech-at-the-jassp/. Accessed 10 August 2015.

—— (2015), 'The Influence of Elsa Gindler', in Gustl Marloc, Halko Weiss, Courtenay Young and Michael Soth (eds), The *Handbook of Body Psychotherapy and Somatic Psychology*, Berkeley, CA: North Atlantic Books, pp. 40–46.

Weber, Jill (2009), *Evolution of Aesthetics and Expressive Dance Boston*, Amherst, MA: Cambria Press.

Weber, Rebecca (2009), 'Integrating Semi-Structured Somatic Practices and Contemporary Dance Technique Training', *Journal of Dance & Somatic Practices*, 1: 2, pp. 237–254.

Webster's Dictionary (1992), *Webster Dictionary*, Chicago, IL: J. G. Ferguson Publishing Company.

Weitz, Shirley (1979), *Nonverbal Communication: Readings with Commentary* (2nd ed.), New York: Oxford University Press.

Welfeld, Renee (1997), *Your Body's Wisdom: A Body-Centered Approach to Transformaton*, Naperville, IL: Sourcebooks.

Welsh, Kariamu (2004), *African Dance*, Philadelphia, PA: Chelsea House.

Westerblad, Carl August (1909), *Ling, the Founder of Swedish Gymnastics, His Life, His Work and His Importance*, Stockholm: P. A. Norstedt.

Whatley, Sarah, Garett Brown, Natalie and Alexander, Kirsty (eds) (2015), *Attending to Movement: Somatic Perspectives on Living in this World*, Devon: Triarchy Press.

White, David Gordon (2013), 'Yoga in Transformation', in Debra Diamond (ed.), *Yoga: The Art of Transformation*, Washington, DC: Smithsonian Museums of Asian Art, pp. 35–46.

White House Commission on Complementary and Alternative Medicine (2002), 'Overview of CAM in the United States: Recent History, Current Status, and Prospects for the Future', http://www.whccamp.hhs.gov/fr2.html. Accessed 8 August 2015.

Wilbor, Elsie M. (ed.) (1890), *Delsarte Recitation Book and Directory*, New York: Edgar Werner.

Wilentz, Joan Steen (1968), *The Senses of Man*, New York: Thomas Y. Crowell Company.

Williams, Drid (2011), *Teaching Dancing with Ideokinetic Principles*, Urbana, IL: University of Illinois.

Williamson, Amanda (2009), 'Formative Support and Connection: Somatic Movement Dance Education in Community and Client Practice', *Journal of Dance & Somatic Practices*, 1: 1, pp. 29–45.

—— (2010), 'Reflections and Theoretical Approaches to the Study of Spiritualities within the Field of Somatic Movement Dance Education', *Journal of Dance & Somatic Practices*, 2: 1, pp. 35–61.

Williamson, Amanda, Batson, Glenna, Whatley, Sarah and Weber, Rebecca (eds) (2014), *Dance, Somatics and Spiritualities: Contemporary Sacred Narratives*, Bristol: Intellect.

Williamson, Amanda, Eddy, Martha and Weber, Rebecca (2014), 'Reflections on the Spritiual Dimensions of Somatic Dance Education', in Amanda Williamson, Glenna Batson, Sarah

Whatley and Rebecca Weber (eds), *Dance, Somatics and Spiritualities: Contemporary Sacred Narratives*, Bristol: Intellect, pp. 159–194.

Williamson, Amanda and Hayes, Jill (2014), 'Dancing the Sacred in Secular Higher Education Contexts', *Dance, Movement & Spiritualities*, 1: 1, pp. 11–20.

Wilson, John M. (2008), 'Margaret Erlanger Remembered', in Thomas K. Hagood (ed.), *Legacy in Dance Education: Essays and Interviews on Values, Practices, and People*, Amherst, NY: Cambria, pp. 61–75.

Wilson, John M., Hagood, Thomas and Brennan, Mary Alice, (2006), *Margaret H'Doubler: The Legacy of America's Dance Education Pioneer*, Youngstown, NY: Cambria Press.

Winblad, Neal E. (2008–2015), 'Biography of Dr Ida P. Rolf', http://www.nwinblad.com/si/si4.php. Accessed 22 May 2015.

Wolf, Jessica (2013), *The Art of Breathing: Collected Articles*, New York: Jessica Wolf.

Woodruff, D. (2008), *Working with Fascia: Treating Soft Tissue Pain in Yourself and in Clients*, Oakville, ON: Body-In-Motion.

Wozny, Nancy (2006), 'Mind Your Body: Somatics 101', *Dance Magazine*, July.

—— (2009), 'Radically Somatic: Jane Hawley Transforms Dance at Luther College', *Dance Magazine*, May, pp. 14–17.

—— (2010), 'Taking Somatics Off the Mat', *Dance Teacher Now*, March, http://www.dance-teacher.com/2010/03/taking-somatics-off-the-mat/. Accessed 3 January 2015.

—— (2012), 'The Somatics Infusion', *Dance Magazine*, May, pp. 36–39.

Wright, Peggy A. (2000), 'Connected Knowing: Exploring Self, Soma, Empathy, and Intuition', *ReVision: A Journal of Consciousness and Transformation*, 22: 4, pp. 2–5.

Yasuo, Yuasa (1993), *The Body Self-Cultivation, and Ki-Energy*, New York: SUNY.

Yong, Vincent (2015), 'BodyMind Dancing Certification Essay', New York: Dynamic Embodiment.

Young, Courtenay (2010), 'On Elsa Lindenberg and Reich', http://www.courtenay-young.co.uk/courtenay/articles/Elsa_Lindenberg_and_Reich.pdf. Accessed 2 July 2015.

Original Interviews

Eddy, Martha (2001a), Interview with Anna Halprin, Kentfield, CA, 3 May.

—— (2001b), Interview with Bonnie Bainbridge Cohen and Len Cohen, Amherst, MA, 22 October.

—— (2001c), Telephone Interview with Sondra Fraleigh, 3 June.

—— (2002a), Telephone Interview with Bonnie Bainbridge Cohen.

—— (2002b), Interview with Emilie Conrad, New York, 25 October.

—— (2002c), E-mail Communication with Sondra Fraleigh, 2–3 March.

—— (2003a), E-mail Communication about Nancy Topf with Peggy Schwartz, January–December.

—— (2003b), Interview with Anna Halprin, Kentfield, CA, 3 November.

—— (2003c), Telephone Interview with Bonnie Bainbridge Cohen.

—— (2003d), Interview with Elaine Summers, New York, 8 November.

—— (2003e), Interview with Emilie Conrad, New York, 26 April.

—— (2003f), Conversation with Valerie Preston-Dunlap, Laban Encuentro Brazil, Rio De Janeiro.

—— (2003g), Interview with Martha Myers, New London, CT, 30 July.

—— (2003h), Telephone Interview with Sondra Horton Fraleigh, 3 July.

—— (2004a), Telephone Interview with Don Hanlon Johnson, 26 April.

—— (2004b), Interview with Seymour Kleinman, Columbus, OH, 4 February.

—— (2004c), E-mail Communication with Seymour Kleinman, 25 August.

—— (2005), E-mail Communication with Rosemary Clough, 8 August.

—— (2006), Interview with Maxine Greene, New York, 13 November.

—— (2009b), E-mail Communication with Tracey Turner-Geyser, 29 September.

—— (2012), E-mail Communication with Bonnie Bainbridge Cohen, 19 July.

—— (2014a), Conversation with Suzi Tortora, New York, 25 September.

—— (2014b), E-mail Communication with Sondra Fraleigh, 12 December.

—— (2015a), E-mail Communication with Joe Williams, 3–5 January.

—— (2015b), E-mail Communication with Joe Williams, 15 January.

—— (2015c), Interview with Martha Myers, New York, 12 March.

—— (2015d), Telephone Interview with Bonnie Bainbridge Cohen, 3 June.

—— (2015e), Conversation with Talia Shafir, New York, 29 June.

—— (2015f), Conversation with Christine Cole, Portland, OR, 26 July.

—— (2015g), Conversation with Jamie McHugh, Whidby Island, WA, 28 July.

—— (2015h), Conversation with Ann Rene Joseph, Seattle, WA, 28 July.

—— (2015i), Conversation with Bette Lamont, 28 July.

—— (2015j), E-mail Communication with Bette Lamont, 8 August.

—— (2015k), Interview with members of Alexandra Bellar's Company, New York.

—— (2015l), E-mail Communication with Don Hanlon Johnson, 25 September.

—— (2015l), Conversation with Bonnie Bainbridge Cohen, 30 October–1 November.

—— (2015m), E-mail Communication with Kelly Jean Mullan, 3 November.

Spector, Alison (2002), Interview with Anne Green Gilbert, 2 May.

—— (2005), Interview with Marion Locke, 19 September.

Notes on Contributors

Mary Ann Brehm, PhD, is a dance educator, author, and researcher. She is President of Mettler Studios and has taught classes there since 1990, including a Creative Dance Teacher Training Workshop offered annually. Dr Brehm was a member of the Barbara Mettler Dance Company and was Mettler's dance assistant from 1990–1994. She is currently researching Mettler's teaching methods and materials. She is co-author, with Lynne McNett, of *Creative Dance and Learning: Making the Kinesthetic Link* (Princeton Books, 2015). She has taught dance courses for several universities, most recently for Lesley University's Creative Arts and Learning Program.

Sangeet Duchane is a former attorney with a deep interest in spiritual practices that has led her to travel in the East and live in India and Japan. She has practiced many of the techniques that have informed somatic practices, such as yoga, tai chi, chi gung, spiritual healing, and others. She has an MA in Theology from Berkeley's Graduate Theological Union, where she specialized in comparative religion. She has also published several books in the area of spirituality.

Martha Eddy, CMA, RSMT, EdD, is a leader in the field of somatic education who has lectured internationally for four decades. Dr Eddy created BodyMind Dancing™ in 1986 and Dynamic Embodiment Somatic Movement Therapy Training (www. DynamicEmbodiment.org) in 1990, combining knowledge from her direct studies and teaching with Irmgard Bartenieff (Laban/Bartenieff Movement Studies) and Bonnie Bainbridge Cohen (Body-Mind Centering®). In 1999 she developed Moving For Life DanceExercise for Health® with a focus first on Breast Cancer Recovery (www.movingforlife. org). Moving For Life is now its own non-profit organization and has been featured on National Public Radio, and TV with NY1, CNN, Fox News, the Today Show and CBS News. These three certifications (Certified Teach of BMD, MFL Certified Instructor, Dynamic Embodiment Practitioner) are offered periodically in the Americas (NYC, UNC-G, Vancouver) and Europe (Cologne, Germany). She also directs the Center for Kinesthetic Education, which provides professional development and workshops for the NYC Department of Education in pre-K-12 "healthy dancing" and teaches classroom teachers to use movement and dance in the classroom. She has taught at Princeton, New York University, Columbia,

State University of New York, San Francisco State universities and Connecticut, Hope and Hampshire. She also works with the Dance Education Laboratory at the 92nd Street Y where she has shaped her doctoral research into a graduate level course entitled "Conflict Resolution through Movement and Dance." Martha's other projects provide a special focus onto how to engage children with disabilities, including those on the autistic spectrum. She applies dance and body awareness to neuro-motor development with children and schools (www.WellnessCKE.net), to socio-emotional learning (www.InnerResilience.org), as well as to peace education/conflict resolution (www.EmbodyPeace.org), social somatics (www.MovingOnCenter.org) and ecological issues (www.GlobalWaterDances.org). She has served on the boards of NDEO, CORD, the Laban/Bartenieff Institute, and ISMETA. Her solo work, *This Open House,* has been performed around the US since 2010.

Agnes Mills (1915–2008). One of the youngest WPA (Works Progress Administration) Artists, Agnes Mills had a life-long commitment to social engagement and the mentoring of young artists. "She draws like an angel," Hans Hoffman said of her. Resident artist for the Alwin Nikolais Dance Company for over a quarter century, and rehearsal artist at Alvin Ailey, Paul Taylor, Joffrey Ballet, Elisa Monte and Jacob's Pillow companies, her vision was of "creating the sense of motion […] in a fugue-like rhythm […] Even the trees and the skies dance for me." For more of Agnes' artwork and further information see: *agnesmillsart.weebly.com.*

Kelly Jean Mullan, MALS, BSc, RYT, is an independent scholar and graduate of Skidmore College's external degree (non-residential based) Masters and Bachelors program in Saratoga Springs, New York. A student of the contemporary dance school École de danse contemporaine de Montreal, Kelly was formerly a professional dancer. Her performance work between 1992–2004 also spanned the circus arts as an aerialist and physical theater artist. In addition Kelly was a lead vocalist for the Montreal jazz group Swing Dynamique for ten years. Kelly had over 500 performances in 22 countries, mainly with the acrobatic movement theater company DynamO Théâtre, with whom she had 2700 hours of training in physical acting and acrobatics. Kelly has taught dance and theater at the Noble and Greenough School from 2004–2011 in Boston, were she participated in Clinical Training in Mind/Body Medicine at Harvard Medical School. She is certified in Phase II of Dynamic Embodiment Somatic Movement Therapy Training (DE-SMTT) with Martha Eddy. She is a full-time mother and an independent researcher. Kelly currently lives in Toronto and is presently preparing a book length manuscript on the history of physical culture in relation to somatics and dance.

Rebecca Nettl-Fiol, Professor of Dance at the University of Illinois, Urbana-Champaign, is a teacher, choreographer, and author specializing in the integration of Alexander Technique and somatic practices in dance training. She is the co-author of *Dance and the Alexander Technique: Exploring the Missing Link* and co-editor of *The Body Eclectic: Evolving Practices*

in Dance Training (both published by University of Illinois Press) and a frequent presenter at conferences nationally and internationally. At the University of Illinois, Nettl-Fiol has been instrumental in establishing somatics as an integral part of the curriculum, and has a long held and keen interest in teaching. In her work, teaching, choreography, and research are inextricably linked. In 2012 she received the University of Illinois Campus Award for Excellence in Undergraduate Teaching. She is also active as a choreographer and her work has been presented nationally.

Lauren Lipman is a certified Montessori educator who teaches drama and creative movement to pre-school and elementary children within a Montessori environment. She holds a BS in Speech from Northwestern University, where she majored in Performance Studies with an emphasis on educational theater. She holds an MA in Liberal Studies from SUNY Empire State College where she created her own interdisciplinary degree related to creative drama and creative movement in Montessori elementary education. Lauren lives in New Jersey with her husband and two children.

Julie Ludwick, certified teacher of Skinner Releasing Technique, is a founder and the Artistic Director of Fly-by-Night Dance Theater, an Aerial Dance company. The company's repertoire has been shown at Lincoln Center's Avery Fisher Hall (among others) and has been recognized by the *New York Times, Backstage*, and *The Village Voice*. She developed a somatic approach to Aerial Dance which has been featured in numerous publications including *Dance Magazine, The Huffington Post, TimeOutNY, Paper Magazine*, and in a documentary from AfterEd TV as an outstanding alum of Teachers College, Columbia University. Her somatic approach is greatly influenced by the teachings of Joan Skinner and Robert Davidson.

Kate Tarlow Morgan, New York City-born choreographer, somatic educator and writer, has been a Rhythms teacher for 35 years and is presently working on the archive of Rhythms materials going back to the 1920s. Editor-in-chief of *Currents Journal* for the Body-Mind Centering Association and editorial consultant for *The Lost & Found Poetics Document Initiative* at CUNY-Center for Humanities, Morgan is also the author of *Circles and Boundaries* (Factory Press, 2011) writings on dance and cultural history of New York City and co-editor of *Movement and Experience: A Body-Mind Centering Anthology* (North Atlantic Press, 2011). Morgan's performance work has recently premiered at Gloucester Writers Center, Trident Gallery and Mole Hill Theater in Alstead, NH.

Sara Reed is Principal Lecturer and Head of Performing Arts at Coventry University, UK. Dr Reed has had a long interest in somatic practices and their historical and current relationship to dance. Her recent research expands this interest into health and wellbeing and the possibilities for improving dancers' resilience and self-awareness through somatics as critical/radical pedagogy and practice. The wider application of somatic practices, beyond

the world of performance, and the Feldenkrais Method® and its relationship to brain neuroplasticity, are also key areas of interest. Sara is a qualified Feldenkrais practitioner and undertook her training with Elizabeth Beringer and Scott Clark in London; she also studies Scaravelli Yoga with Caroline Lang.

Sarah Whatley, PhD, is Professor of Dance and Director of the Centre for Dance Research (C-DaRE) at Coventry University, UK. Her research interests include somatic dance practice and pedagogy, imagery in dance, dance and new technologies, dance analysis, inclusive dance practices and intangible cultural heritage; she has published widely on these themes. She is also Editor of the *Journal of Dance & Somatic Practices* and sits on the Editorial Boards of several other journals. The AHRC, the Leverhulme Trust and the European Union fund her current research, which is interdisciplinary and involves partners across the creative and cultural industries. She led the Siobhan Davies digital archive project, RePlay, and continues to work with Davies on other artist-initiated research projects.

Eve Selver-Kassell, MA, DEP, is a learning specialist working with elementary school aged children with learning disabilities and developmental delays in New York City. She had an MA in Education from Bank Street College of Education and is certified as a Somatic Movement Educator through Martha Eddy's Dynamic Embodiment Somatic Movement Therapy Training. She also serves as a consultant with the Center for Kinesthetic Education.

Index

Printed in the USA
CPSIA information can be obtained
at www.ICGtesting.com
BVHW020707270823
668900BV00003B/15